Must We Kill the Thing We Love?

FILM AND CULTURE
John Belton, Editor

FILM AND CULTURE

A series of Columbia University Press

Edited by John Belton

For the list of titles in this series, see page 303.

MUST WE KILL THE THING WE LOVE?

Emersonian Perfectionism
and the Films of Alfred Hitchcock

William Rothman

 Columbia University Press *New York*

Columbia University Press
Publishers Since 1893
New York Chichester, West Sussex
cup.columbia.edu
Copyright © 2014 Columbia University Press
All rights reserved
Library of Congress Cataloging-in-Publication Data

Rothman, William.
 Must we kill the thing we love? : Emersonian perfectionism and the films of
Alfred Hitchcock / William Rothman.
 pages cm — (Film and culture)
 Includes bibliographical references and index.
 ISBN 978-0-231-16602-7 (cloth : alk. paper) — ISBN 978-0-231-16603-4
(pbk. : alk. paper) — ISBN 978-0-231-53730-8 (ebook)
 1. Hitchcock, Alfred, 1899–1980—Criticism and interpretation. 2. Redemption
in motion pictures. 3. Emerson, Ralph Waldo, 1803–1882—Influence. I. Title.

PN1998.3.H58R683 2014
791.4302'33092—dc23 2013038575

Columbia University Press books are printed on permanent and durable acid-free paper.
This book is printed on paper with recycled content.
Printed in the United States of America
c 10 9 8 7 6 5 4 3 2 1
p 10 9 8 7 6 5 4 3 2 1

COVER PHOTO: AF archive / Alamy

COVER DESIGN: Milenda Nanok Lee

References to websites (URLs) were accurate at the time of writing. Neither the author nor
Columbia University Press is responsible for URLs that may have expired or changed since the
manuscript was prepared.

For Stanley Cavell

Contents

Must We Kill the Thing We Love?

Introduction

Drawing a New Circle

I wrote *Hitchcock—The Murderous Gaze* more than thirty years ago. During that time I was teaching at Harvard and in almost daily conversation with Stanley Cavell, who was completing *Pursuits of Happiness*, his seminal study of the Hollywood genre he calls the "comedy of remarriage" (*It Happened One Night* [Frank Capra, 1934], *The Awful Truth* [Leo McCarey, 1937], *Bringing Up Baby* [Howard Hawks, 1938], *His Girl Friday* [Howard Hawks, 1940], *The Philadelphia Story* [George Cukor, 1940], *The Lady Eve* [Preston Sturges, 1941), *Adam's Rib* [George Cukor, 1948]).[1] *Pursuits of Happiness* presented a profound vision of this genre and, by extension, of all the leading Hollywood genres of the period—such as the genre Cavell calls the "melodrama of the unknown woman," four exemplary members of which he went on to study in *Contesting Tears* (*Stella Dallas* [King Vidor, 1937], *Now, Voyager* [Irving Rapper, 1942], *Gaslight* [George Cukor, 1944], and *Letter from an Unknown Woman* [Max Ophüls, 1948], whose title he appropriates for the genre)—as inheriting concerns of American transcendentalism that enabled the popular American cinema to reach its artistic high-water mark.[2]

In the mid-1980s Cavell broadened and deepened this vision in a Harvard lecture course on moral reasoning (that itself broadened and deepened a course titled "Great Ideas of the Western World," which he had taught twenty years earlier, taking in stride the obstacle of having a very naive young me as one of his teaching assistants). And twenty years after

inaugurating the moral reasoning course, he made its lectures the basis of his remarkable book *Cities of Words*.[3]

Although *The Murderous Gaze* approaches Hitchcock's films primarily through the prism of authorship, it notes that the "Hitchcock thriller" can also be viewed as a genre, or perhaps a cluster of closely related genres, comparable to the comedy of remarriage or the melodrama of the unknown woman. As Cavell's own essay on *North by Northwest* demonstrates, Hitchcock thrillers share the concerns of the genres he studied.[4] And there are differences that can be charted. In the Hitchcock thrillers that revolve around a "girl-at-the-threshold-of-womanhood," for example, the narrative charts the stages of a woman's education, just as in remarriage comedies. And that education goes hand in glove with the development of a romantic relationship.

In comedies of remarriage a woman and a man pursue happiness not by overcoming societal obstacles to their marriage, as in classical comedies, but by overcoming obstacles internal to their relationship, obstacles that are between and within themselves, obstacles they cannot overcome without achieving a radically changed perspective. These Hollywood movies present women and men as equals, as having an equal right to pursue happiness and as being equal spiritually or, we might say, morally—equal in their powers of imagination and thinking and in their capacity to cultivate the better angels of their nature. What is at issue in such films is not simply whether the leading woman and man will marry, or remarry, but whether the kind of marriage they create together will be a relationship worth having, one that enables them, as individuals and as a couple, to embrace every day and every night in a spirit of adventure—a kind of marriage exemplified by Nick and Nora (William Powell and Myrna Loy) in *The Thin Man* (W. S. Van Dyke, 1934), another landmark film made the same year as *It Happened One Night*, the earliest of the films *Pursuits of Happiness* scrutinizes. Hence comedies of remarriage pose, and address, a philosophical question about marriage itself. What is marriage? What, if anything, validates or legitimates a marriage, if a couple can be married according to the church and the laws of the state and yet, by the higher standards of the comedy of remarriage, not have a true marriage?

The Philadelphia Story renders explicit that this question about marriage is also a question about what it is to be human, a question about human relationships in general, a question about community and, as such, a question for, and about, America. Implicitly advocating America's joining the war against fascism already raging in Europe at the time of its

release, *The Philadelphia Story* is a summary statement as to what makes America worth fighting for, what is worth preserving in its heritage. In the comedy of remarriage a woman and man seek, and achieve, a conversation of equals—a relationship with each other, at once private and public, based on mutual trust—that can serve as a model of community and thus as an inspiration for America in its own quest to form a more perfect union.

What is worth fighting for, *The Philadelphia Story* declares, is not America as it is (as the wartime documentary series *Why We Fight* was later to assert, whitewashing reality in a way Hollywood romantic comedies of the 1930s refrained from doing). America as it is, *The Philadelphia Story* asserts (as do all the romantic comedies Cavell studies), is a place where the likes of George Kittredge—the phony "man of the people" trumpeted by cynical Sidney Kidd's media empire—passes for a great American. America's promise has not yet been fully realized. America has not yet become America. And yet, these romantic comedies affirm, this "unattained America," as Ralph Waldo Emerson calls it, is still attainable. The dream of a more perfect union was still alive in 1930s America, though imperiled, as it was in Emerson's time, when, as he wrote, the moral scourge of slavery was keeping America from taking a step toward becoming America. (The dream is still alive today—and still in peril.)

The remarriage comedies Cavell celebrates are grand entertainments that gave pleasure to viewers living through dark times, but they also entered into a serious conversation with their culture that set a high standard of moral purpose. Their commitment to channeling the awesome power of film to help America and Americans to awaken, to change, was not confined to a single genre, a point Cavell fleshes out in *Contesting Tears*. In Cavell's inspiring vision, indeed, all the leading Hollywood genres during this period found stories to tell, and ways of telling their stories, that enabled them to share in the remarriage comedy's way of thinking about morality. In *Cities of Words* Cavell characterizes this way of thinking as a species of moral perfectionism. He names it, more specifically, "Emersonian perfectionism."[5] And he explicitly declares that the philosophical way of thinking exemplified by Hollywood comedies of remarriage is also his own. By characterizing this way of thinking as a form of moral perfectionism, he acknowledged that philosophy, as he practices it, is a *moral* enterprise. And he took the momentous step of giving that enterprise—*his* enterprise—a name. In naming it "Emersonian perfectionism," Cavell declared himself to be an Emersonian perfectionist.

Among the host of major thinkers *Cities of Words* addresses, Emerson plays a privileged role. The book, whose subtitle is *Pedagogical Letters on a Register of the Moral Life*, is Cavell's only work that explicitly declares his abiding commitment to teaching. With breathtaking intellectual assurance, Cavell pairs thinkers of the magnitude of Aristotle, Plato, Shakespeare, Locke, Hume, Kant, Nietzsche, Ibsen, Henry James, Freud, Shaw, and Cavell's Harvard colleague John Rawls with individual films, all classic Hollywood comedies and melodramas, except for Eric Rohmer's *Tale of Winter* (1992), which in its cultivated way is as grand an entertainment as its American cousins. Every chapter on a thinker presents a powerful, utterly original interpretation of that thinker's work, an interpretation that makes clear why it is illuminating to pair the thinker with the particular film Cavell has chosen as a match—given, in each case, his powerful, utterly original interpretation of that film. Taken together, these paired chapters convey, compellingly, that although America has not inherited the European edifice of philosophy, its movies have engaged in conversations with their culture that are no less serious, philosophically. But Emerson is the linchpin that holds together this remarkable book. Cavell uses Emerson's writing, and only Emerson's, as both an object and a "*means, or touchstone*," of interpretation—as a tool for reading and for *teaching* reading (34).

Cavell does not view Emersonian perfectionism as a theory of moral philosophy comparable to Kant's deontological view that there is a universal moral law (the Categorical Imperative) by which we can rationally determine whether an action is right or wrong. Nor does he see it as comparable to Mill's utilitarian view that the good action is that which will cause the least harm, or the greatest good for the greatest number. Instead, moral perfectionism in general is an outlook or register of thought, a way of thinking about morality expressed thematically in certain works of philosophy, literature, and film, that takes it to be our primary task as human beings—at once our deepest wish, whether or not we know this about ourselves, and our moral obligation—to become more fully human, to realize our humanity in our lives in the world, which always requires the simultaneous acknowledgment of the humanity of others (our acknowledgment of them and theirs of us). The questions that couples in remarriage comedies address in their witty give-and-take are *moral* questions, as *Cities of Words* argues. But they are "formulated less well by questions concerning what they ought to do, what it would be best or right for them to do, than by the question of how they shall live their lives, what kind of persons they aspire to be" (11).

In *Bringing Up Baby*, for example, Susan (Katharine Hepburn) teaches David (Cary Grant) that every day and every night is to be lived in a festive spirit, a spirit of adventure. That is, she helps open his eyes to the reality that this is, and always has been, his goal, no less than hers. When the brontosaurus skeleton that he had thought meant the world to him collapses in a heap, he knows that Susan has helped him discover what it is that he really seeks. What is sought, and achieved, in comedies of remarriage is a new perspective. It is a *philosophical* perspective insofar as the knowledge it makes possible is self-knowledge, the self's awakening to its own condition, the reality that it is in the process of becoming, that it stands in need of creation. To become oneself, one must abandon oneself, for there is always a new perspective one must achieve, a new step one must take—and then another step, and then a step after that, and then . . .

The knowledge to which David awakens, with Susan's help, is that he has let others dictate to him what and how to think. In Susan's view, as in Emerson's, letting others do the thinking for one is not thinking badly, not thinking in a bad way; it is not thinking at all. In discovering what he thinks, what he seeks, what really matters to him, David discovers who he has been, who he is, and how and why he wishes to change. Discovering what we really think, achieving a new perspective on who we are, who we have been, *is* thinking, in Emerson's view. The moment David thinks, he discovers what makes thinking necessary. He also discovers that it is necessary for him to take action. Since David's awakening thought is that being with Susan is what really means the world to him, it is to Susan, within their ongoing conversation, that he finds it necessary to express this thought, to marry thinking and purposeful action.

The witty but profound conversations between women and men in the comedies of remarriage Cavell studies are among the glories of world cinema precisely because they manifest, and declare, the possibility, and the necessity, of thinking and of giving expression to our thoughts, of marrying thinking and purposeful action, as David learns to do. For Susan, as for Emerson, thinking has a *moral* dimension. What she helps David discover is that he *should* think, he *must* think, *must* give expression to his thoughts, *must* marry thought and action. The thought that we *must* walk in the direction of the unattained but attainable self, that this is the path toward freedom, is the heart and soul of Emersonian perfectionism. What it means for a film to be an Emersonian perfectionist text, in Cavell's sense, is both that its author, in creating it, took a step on that uncharted path and that the film calls on viewers to do so as well.

What does all this have to do with Hitchcock? That, in a nutshell, is the question the following chapters address. They argue that Hitchcock was profoundly attracted to the worldview that underwrote classical American genres such as the comedy of remarriage. *The 39 Steps* (1935) followed the lead of *It Happened One Night*, the monster hit that marked 1934 as the beginning of the period when Emersonian perfectionism was in ascendancy in Hollywood, by concluding with the union of a woman and a man that holds a hope of being a relationship worth having. In turn, *Secret Agent* (1936), *Sabotage* (1936), *Young and Innocent* (1937), and *The Lady Vanishes* (1938), brilliant films Hitchcock made in the few years remaining before his departure for Hollywood, all followed the lead of *The 39 Steps* by aligning Hitchcock thrillers with Hollywood comedies of remarriage—but only up to a point.

As these films also reveal, Hitchcock found himself unwilling, or unable, simply to abandon himself to the American genre's Emersonian outlook. He was no less powerfully drawn to an incompatible vision. No doubt affected by a Catholic upbringing that impressed on his young imagination a strong and abiding sense of original sin, he never tired of quoting Oscar Wilde's line, "Each man kills the thing he loves."

One feature that distinguishes the Hitchcock thriller from the genres Cavell studies is the key role it accords to the film's author—that is, to Hitchcock himself. A corollary of this is that the genre's membership is limited to Hitchcock's own films. Another of the Hitchcock thriller's defining features is that a murderous villain, who aspires to exercise a godlike power over others, also plays a key role. The Hitchcock villain is a human being who dwells, like the film's other characters, within the world of the film. As *The Murderous Gaze* argues, however, this master of the art of murder is also a stand-in for Hitchcock, master of what he liked to call "the art of pure cinema." The villains in the films Hitchcock authors are his accomplices in artistic creation. And Hitchcock is their accomplice—or they are his—in murder. That is one reason, *The Murderous Gaze* proposes, that his films call for the panoply of motifs that book catalogues (and which we will encounter in the pages that follow). Hitchcock employs these signature motifs, in part, to declare his authorship and link his role as author with that of the murderous villain within the film's world. That his own art has a murderous aspect is a quintessentially Hitchcockian idea. How, then, can a Hitchcock film possibly be an "Emersonian perfectionist text" in Cavell's sense? Although I did not yet have a name for the more affirmative side of his split artistic identity, nor a historical or philo-

sophical context in which to place it, it was already a central claim of *The Murderous Gaze* that a tension, or conflict, between two incompatible world-views runs through Hitchcock's work.

In the introduction to *The Murderous Gaze* I observed that I could imagine a reader coming to the end of the book and being struck by the magnitude of all that separates *Psycho* (1960) from *The Lodger* (1927). "What separates these films," I wrote, "is also what joins them: a body of work that movingly stands in for an entire human life, even as it traverses and sums up the history of an art." But I also observed that I could "imagine the book engendering in the reader the sense that Hitchcock's work ends where it began." I believed that my book had conclusively demonstrated that *Psycho*'s position—the thoughts, inscribed in its succession of frames, on the nature and relationships of love, murder, sexuality, marriage, and theater; on the nature of the camera, the act of viewing a film, and filmmaking as a calling; on the conditions of authorship in film; and on the kind of thinking—hence the kind of reading and writing—films call for if their thinking is to be acknowledged—was already articulated in *The Lodger*.[6]

I no longer believe this.

Must We Kill the Thing We Love? argues that Hitchcock's ambivalence toward the Emersonian perfectionism that was in ascendancy in Hollywood during the period of the New Deal, and his ambivalence toward overcoming or transcending that ambivalence, was the driving force of his work. Beyond this, in tracing the trajectory of Hitchcock's career, the book discerns, in the vicissitudes of his ambivalent relationship to Emersonian perfectionism, a complicated progression from his British thrillers like *The 39 Steps*, *Secret Agent*, and *Sabotage* to his earliest American films, such as *Rebecca* (1940), *Mr. and Mrs. Smith* (1941), and *Suspicion* (1941) (made when the Emersonian moral outlook was beginning to suffer repression in Hollywood); to his wartime films, such as *Shadow of a Doubt* (1943) and its companion piece, *Lifeboat* (1944); to postwar films like *Notorious* (1946) and *Rope* (1948); to his masterpieces of the 1950s, culminating in *The Wrong Man* (1956), *Vertigo* (1958), and *North by Northwest* (1959); to *Psycho*; to *The Birds* (1963); and ultimately to *Marnie* (1964), in which, I suggest, Hitchcock overcame or transcended his ambivalence and embraced the Emersonian perfectionism he had always also resisted.

After *Vertigo*, his most devastating illustration of the principle that "each man kills the thing he loves," Hitchcock no longer wished to be the kind of artist for whom artistic creation was the metaphorical equivalent

of murder. But how was he to create a film that bore his authorial signature yet demonstrated that his role as author had overcome or transcended the murderous aspect that had always been a defining feature of his artistic identity? Hitchcock picked himself up, dusted himself off, and started all over again, to paraphrase Fred Astaire, by making *North by Northwest*, which concludes with a marriage fully worthy of a 1930s remarriage comedy. In effect, by creating *North by Northwest*, Hitchcock vowed that he would never again make a film that equated its own creation with murder. But then why did he next make *Psycho*, a film in which, allegorically, he killed the thing he loved most in the world: the art of pure cinema itself? And how did *Psycho* free him to make *The Birds* and *Marnie*? In creating these last two masterpieces, *Must We Kill the Thing We Love?* argues, Hitchcock decisively overcame or transcended his ambivalence toward the Emersonian way of thinking he had longed to embrace for the sake of humanity but had resisted embracing for the sake of his art.

To embrace Emersonian perfectionism, as I do in this book, means, in part, to abandon oneself to the view that, as Emerson puts it in "Circles," "Every action admits of being outdone," that "our life is an apprenticeship to the truth, that around every circle another can be drawn; that there is no end in nature, but every end is a beginning."[7] Emerson's writings can be understood as constituting a series whose order follows a logical necessity—as if each new essay took a step toward what he calls, in his essay "History," the "unattained but attainable self" (239). A progression can be discerned from his early writings (such as his "Divinity School Address," "The American Scholar," and *Nature*); to *Essays: First Series* (which includes, among others, "History," "Circles," and "Intellect," as well as the famous "Self-Reliance"); to *Essays: Second Series* (which includes "Experience," perhaps his greatest essay); to the later writings (including *Representative Men*, which was a major inspiration to Henri Bergson, a fact that never seems to have piqued Gilles Deleuze's curiosity, more's the pity), and the essays in *The Conduct of Life*, such as "Fate" and "Behavior"). It is, indeed, a defining feature of the Emerson essay that it draws a circle around the essays that came before it, a circle around which another circle can be drawn (by another essay that succeeds it). It is a central claim of *Must We Kill the Thing We Love?* that this is a defining feature of Hitchcock's art as well. Looking back from the perspective *Marnie* achieves, it is possible to perceive the Hitchcock thrillers that precede it as leading up to it—as if with each new film Hitchcock, too, drew a new circle, took a step toward the "unattained but attainable self."

This book does not claim, of course, that Hitchcock consciously planned this trajectory, as if he were following a scenario he had scripted (the way, I argue in my chapter on *Vertigo*, the woman we know as Judy does in the second part of the film). "The one thing which we seek with insatiable desire," the passage from "Circles" goes on, "is to forget ourselves, to be surprised out of our propriety, to lose our sempiternal [i.e., everlasting (having infinite temporal duration); as opposed to eternal (outside time and thus lacking temporal duration)] memory, and to do something without knowing how or why; in short, to draw a new circle" (414). To draw a new circle, in Emerson's understanding, requires us to awaken to powers we had not been conscious of possessing, to open our eyes to the reality that we are not who we had believed ourselves to be, that our being is not limited to who we have been. It requires us to abandon an old self to enable a new self to be born, to acknowledge that the old self is now as dead to us as a heap of brontosaurus bones. This is what Emerson calls the "way of life" (414).

Emerson writes, "The way of life is wonderful: it is by abandonment" (414). In prefacing this with the sentence, "Nothing great was ever achieved without enthusiasm," his wording implies, first, that anything a human being can achieve that is worthy of being called "great"—the creation of a work of art like *Vertigo*, for example—is an instance of drawing a new circle, of being born anew, hence of abandoning a self, a habitation, that once had been new. Second, it suggests that without enthusiasm, it is not possible to draw a new circle; to draw a new circle, we must do so *with abandon*. Thus the sentence "The way of life is wonderful: it is by abandonment" plays, quite characteristically for Emerson, on two senses of the word *abandonment*. And "Nothing great was ever achieved without enthusiasm" plays on two senses of the word *enthusiasm*. In today's parlance the word means possession by an intense interest in an activity, whatever the provenance of that interest. But Emerson is also invoking the word's original implication of divine inspiration, as if a new self cannot be born unless a divinity breathes life into it.

Hitchcock is famous for planning every detail of his films, storyboarding his shots, and in general striving to minimize the accidents of filming so as to exercise as much control as possible over the production—and over our experience of the projected film. As I demonstrated in *The Murderous Gaze*, however, what separates Hitchcock's villains from Hitchcock's protagonists is the villains' hubris, their claim to arrogate to themselves the author's power to preside over the film's world. The protagonists, by contrast, ultimately prove willing to accept that their future is in the hands of

a higher power. And yet, Hitchcock himself resisted ceding control, acknowledging limits to his own powers as author.

In creating *Marnie*, Hitchcock finally abandoned himself to Emerson's wonderful "way of life." The Emersonian side of his split artistic identity prevailed. But for Hitchcock, personally, this proved a pyrrhic victory. *Marnie* achieved a philosophical perspective from which he could see that his way was clear, as an artist, to go on in a spirit of self-reliance, to take further steps, to draw ever greater circles. But *Marnie*'s critical and commercial failure was a catastrophe from which his career never recovered. It hardened Universal's resolve to prevent him from making *Mary Rose*, which would surely have been another masterpiece but which the studio believed—probably not wrongly—would have further diminished the dollar value of the Hitchcock "brand." These reversals precipitated a crisis so traumatic that the films he did go on to make (*Torn Curtain* [1966], *Topaz* [1969], *Frenzy* [1972], and *Family Plot* [1976]), for all their brilliant, beautiful, and profound passages, moved him no closer to the "unattained but attainable self."

Marnie drew Hitchcock's largest circle.

Moods of Faces and Motions and Settings

At a colloquium in Paris occasioned by the publication of *The World Viewed* in French translation, Cavell remarked that thinking about film had left "permanent marks" on the way he wrote. It taught him, as he put it, the "necessity to become evocative in capturing the moods of faces and motions and settings, in their double existence as transient and as permanent."[8]

Cavell refers to the necessity of evoking a film's "moods of faces and motions and settings." In *The Murderous Gaze* I characterized my method as putting into words the thinking inscribed in a film's succession of frames. In writing about films, we have different ways of doing things. *Pursuits of Happiness* and *Contesting Tears* include a handful of images from the films; *Cities of Words* includes none. The original five readings of *The Murderous Gaze* have more than six hundred; the new chapter on *Marnie* written for the second edition adds over two hundred more, about the same number as *Must We Kill the Thing We Love?*, a much slimmer book.

Yet if it is by its "moods of faces and motions and settings" that a film expresses itself, makes its thoughts knowable, and if we cannot put into our own words what the film is saying without finding words that evoke

those moods, then capturing a film's "moods of faces and motions and settings" cannot be separated from following the film's thoughts. Neither can a film's "moods" be separated from the ways the camera frames its "faces and motions and settings," the ways they appear before us, when they are projected onto the movie screen, "in their double existence as transient and as permanent." Hence Cavell's writings about film and my own, for all their differences, are engaged in a common enterprise.

This enterprise—at once philosophy, criticism, history, and practical instruction in viewing and thinking and writing about films—is grounded in a practice—I think of it as an art—that can be characterized, with a nod to Henry James, as tracing the implications—the thoughts expressed by—a film's "moods of faces and motions and settings, in their double existence as transient and as permanent," as they are inscribed in its succession of frames. Both Cavell and I call this practice "reading."

This is a book about Hitchcock, not Emerson. The chapters that compose the body of the book invoke Emerson's name only occasionally, usually in the context of reflections on the Hitchcock thriller's relationship to the Hollywood genres Cavell has shown to be exemplary of Emersonian perfectionism or in the reflections those reflections motivate on the question, "What, if anything, justifies killing another human being?" Hitchcock thrillers, in their darkness, may well seem—in a sense they *are*—further removed from Emerson's way of thinking—not that dark thoughts are alien to his essays—than comedies of remarriage, for example, which manifest none of Hitchcock's ambivalence toward Emersonian perfectionism. Yet *as authors*, Hitchcock and Emerson, for all their obvious differences, have profound affinities—affinities not fully shared by Frank Capra, Howard Hawks, Leo McCarey, George Cukor, or Preston Sturges, significant artists in their own right, who directed the remarriage comedies Cavell has studied.

In the course of writing the chapters that follow, I realized that this book would be incomplete unless I "paid the tuition" for this intuition, to borrow one of Emerson's felicitous terms. To that end I composed a concluding chapter that complements this introduction by looking closely at passages from several of Emerson's essays and tracing some of the implications, for the study of Hitchcock's films, and the study of film in general, of the astonishing fact that the terms in which they speak about reality, about our "flux of moods," about what it is within us that never changes, about freedom, about reading, about writing, and about thinking, are remarkably pertinent—almost uncannily so—to "reading" films, to writing about

them, and to thinking about their medium, and about the art this medium makes possible. My own practice of reading films, and writing about them, is underwritten, philosophically, by Emerson's way of thinking about reading and writing.

Consider, for example, this oft-quoted sentence from Emerson's great essay "Experience": "Life is a train of moods like a string of beads, and as we pass through them they prove to be many-colored lenses which paint the world their own hue, and each shows only what lies in its focus" (244). Insofar as films express themselves by their successions of moods (moods they capture; moods those moods cast over us), a film is a "train of moods," too.

When Emerson adds, "Temperament is the iron wire on which the beads are strung" (244), his formulation invites us to understand that our "temperament" is also the "iron wire"—the iron rail—that enables our "train of moods" to run smoothly, even as at every moment it limits us to moving in a predetermined direction—as if for all their "flux," our moods run along a single track. A film's "train of moods" runs along an "iron wire," too, figuratively speaking. We can think of it as the strip of celluloid, or as the succession of frames it bears, which assures that every time the film is screened, its "train of moods" keeps to the same track. Every film is its own "train of moods." It runs along its own track—the track laid down by its succession of frames. And every master of the art of pure cinema, such as Hitchcock, inscribes his or her own thinking in those frames. Hence we can also think of the "iron wire" on which a Hitchcock film's "colored beads" are strung as its author's own temperament—the temperament, particular to Hitchcock, to which the film's succession of frames gives expression.

And when Emerson observes, later in "Experience," that our "flux of moods" (485) only "plays about the surface" and never "introduces [us] into the reality, for contact with which we would even pay the costly price of sons and lovers" (472–73), but that "there is that in us which changes not" (485), I am irresistibly reminded of Cavell's words, that a film's "faces and motions and settings" (or is it their moods?) have a "double existence as transient and as permanent." Every human being has his or her own temperament, particular to that individual. But we have in common the mind's power—a power that is itself baffling to the mind—to "raise" a "fact in our life" from the "web of our unconsciousness," as Emerson puts it in "Intellect," as if by illuminating it with the "certain, wandering light" of a "lantern," we transform it into a "thought," a "truth," "an object impersonal and immortal. It is the past restored, but embalmed. A better art than that of Egypt has taken fear and corruption out of it" (418). Perhaps it should

not surprise us that André Bazin, a century later, was to employ the identical metaphor in characterizing the film image. For the film projector is literally a lantern. Metaphorically, the camera is a lantern, too.

Films express themselves in the "flux of moods" they capture and in the "flux of moods" those moods cast over us. But there is something in the world on film that remains fixed, unchanging—an unmoving ground that makes films capable of realizing a world at all. Writing about D. A. Pennebaker's classic documentary *Don't Look Back* (1967), I put the point this way: "In the world on film, everything is forever turning, turning, turning again. Film is a medium of the ephemeral, the never-to-be-repeated, a medium of the rain and the wind. That the world is forever changing is the only thing that never changes about the world, part of what makes the world a world. Hence film is also a medium of the unchanging. *Don't Look Back* enables us to return to this moment, fall under its spell, experience its moods, every time we view the film."[9] And this double temporal existence of the projected world, vouchsafed by the ontological conditions of the film medium, is a key to thinking about the work of the director known as the Master of Suspense.

In *North by Northwest*'s art auction sequence, Roger Thornhill, the Cary Grant character, harps on his knowledge that Eve Kendall (Eva Marie Saint) throws her whole body into her job, deliberately arousing the jealousy of the villainous Vandamm (James Mason) and placing Eve in dire jeopardy. Roger is so angry and hurt that he *wishes* her to die. But Roger is no Vandamm. The difference between them, in Hitchcock's eyes, is revealed at the moment the Professor (Leo G. Carroll) tells Roger that Eve is a double agent, and the camera moves in to frame Grant in a medium close-up, his expression underscored by the headlights of a taxiing plane.

This shot powerfully conveys Roger's anguish, the mood his face expresses, at this moment. Beyond this, Hitchcock designs the shot to communicate to us that Roger's pain is engendered by his onset of knowledge that is also self-knowledge. To convey the pain of Roger's enlightenment, Hitchcock creates a shot that perfectly illustrates the point Emerson makes in his essay "Behavior" when he writes, "The eye obeys exactly the action of the mind. When a thought strikes us, the eyes fix, and remain gazing at a distance" (1041).

What Hitchcock's camera captures is the dawning of an intuition in Roger, the birth of a thought. What is particularly striking here is the way the shot underscores the fact that a thought is striking him by having a harsh light momentarily illuminate Grant's face. Within the world of the

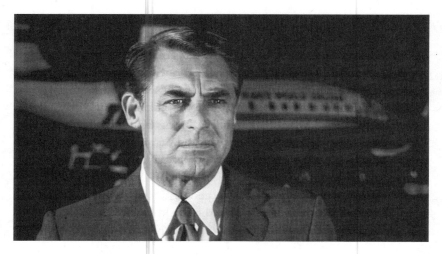

Figure o.1

film this light is cast by the headlights of a taxiing airplane. Metaphorically, it is the light—at times painful, at times blinding—of what Emerson calls "the intellect." Had Hitchcock deliberately sought a way of illustrating, in the medium of film, Emerson's picture of the way the mind works, he could not have come up with a more perfect means.

By choosing to frame Grant frontally as well as closely, Hitchcock not only enables the camera to capture the birth of this man's thought; he designs the shot in a way that identifies the camera—enables the camera to identify itself—with the intellect. The shot at once captures Roger's mood and inscribes his thought—his awakening to the knowledge that it is necessary for him to change. In inscribing Roger's thought, the shot also inscribes—we might say it *realizes*—*Hitchcock's* thought. I have in mind not only Hitchcock's thought about Roger but also his thought about the camera—a thought that can be expressed precisely in Emerson's terms: it is the thought that the camera is a lantern whose certain, wandering light has the power to raise a fact in our life from the web of our unconsciousness, transforming it into a thought, a truth, an object impersonal and immortal. Hitchcock's thought, I would like to say, is that his art of pure cinema is a "better art than that of Egypt."

Hitchcock dissolves from this shot to the Mount Rushmore Monument, viewed from such a distance that the familiar carved figures, standing out against the natural rock face of the mountain, are framed between the in-

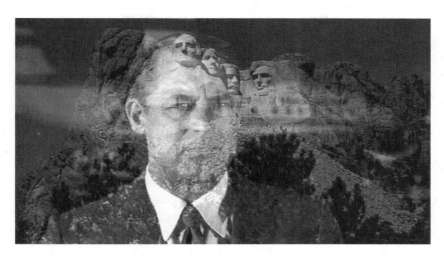

Figure 0.2

tensely blue background of the sky and the tops of tall evergreens in the lower foreground. The dissolve is so slow that for a lingering moment Roger—Cary Grant—shares the screen with these American presidents—heroes all, as our nation's mythology would have it—chiseled permanently into the rock, their human faces, once flesh and blood and animated by the spark of life but now writ in stone, quite literally "raised" into objects "impersonal and immortal."

Their monumental visages, rendered small by being superimposed over Grant's larger-than-life face, convey the impression that these American heroes are standing guard over Roger, although none seems actually to be looking at him. It is as if they have his back, in today's parlance. But it is also as if they are projections of Roger's imagination at this moment—the moment he has opened his eyes, for the first time, to the reality of his own longing to change, to write his own future, to become a man of true character, a new American hero.

By this dissolve, too, Hitchcock expresses a thought about Roger. And this thought about Roger is a thought about Cary Grant as well. "A man is but a little thing in the midst of the objects of nature," Emerson observes in his essay "Manners." "Yet, by the moral quality radiating from his countenance, he may abolish all considerations of magnitude, and in his manners equal the majesty of the world" (529). This is the kind of individual that Roger, at this moment, is wishing to become. It is the kind of individual

Hitchcock's camera reveals Cary Grant, onscreen, to be—even as it reveals its own power to reveal this. Emerson describes this kind of individual when he writes, in a passage that *Pursuits of Happiness* invokes in connection with the character Grant plays in *The Awful Truth*: "I have seen an individual, whose manners, though wholly within the conventions of elegant society, were never learned there, but were original and commanding, and held out protection and prosperity; one who did not need the aid of a court-suit, but carried the holiday in his eye; who exhilarated the fancy by flinging wide the doors of new modes of existence; who shook off the captivity of etiquette, with happy, spirited bearing, good-natured and free as Robin Hood; yet with the port of an emperor,—if need be, calm, serious, and fit to stand the gaze of millions" (529).

At this point Hitchcock has his camera zoom in on Mount Rushmore, isolating the monument from its natural setting, then narrow its field of vision by masking the frame with an iris—an iris as circular as the lens of a camera. He invokes this old-fashioned convention to imply, retroactively, that this shot has all along been from the point of view of someone looking through an optical device, such as a telescope—or the viewfinder of a camera. When Hitchcock now cuts to Grant, framed in profile, looking through a telescope, this gesture implies a connection between his view and the camera's. This is a textbook instance of what in *The Murderous Gaze* I call a "declaration of the camera," one of Hitchcock's signature practices.

These shots, and those that immediately follow, make evident that in thinking about Roger and about the great star who incarnates him, and in thinking more generally about myth and reality, artifice and nature, about heroism, about America, that this sequence is also expressing thoughts about the camera, about the act of viewing, about the film medium, about the art of pure cinema, about change, about transience, about permanence, about the double temporal existence of the projected world.

It is both a premise and a conclusion of this book that Hitchcock's films call for being read with the same kind and degree of attention as Emerson's essays and that, like Emerson's essays, Hitchcock's films are capable of instructing us on how they are to be read. As Cavell elegantly puts it— it takes one to know one—Emerson is a thinker with the "accuracy and consequentiality one expects of a mind worth following with that attention necessary to decipher one's own."[10] Cavell's wording implies that if we follow our own thinking with the attention necessary to follow Emerson's, we will find our minds, too, to be worth following that way. Perhaps the

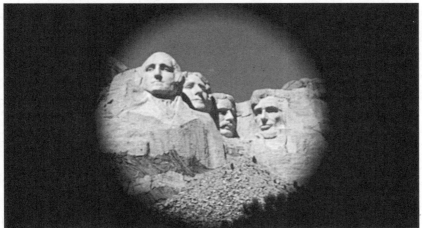

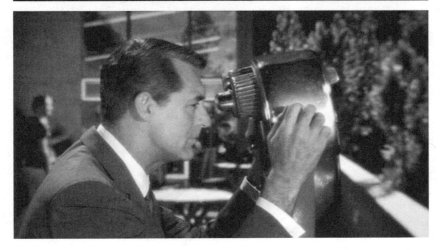

Figure 0.3

same can be said about all the great thinkers Cavell writes about in *Cities of Words*. But the idea that without following our own thinking we cannot know the minds of others, and that without knowing the minds of others we cannot know our own minds—the idea that it is by reading and by writing that we come to know our own minds, as well as the minds of others— is Emerson's teaching, as it is Cavell's.

The Master of Suspense

Emerson's essay "Experience" begins with the question, "Where do we find ourselves?" His answer: "We wake and find ourselves on a stair; there are stairs below us, which we seem to have ascended; there are stairs above us, many a one, which go upward and out of sight" (471). When we awaken to our condition as human beings, we find ourselves suspended, in Hitchcock's view as in Emerson's. Does that mean it is the human condition to be in suspense?[11]

When in *North by Northwest* Roger, pursued by a crop-dusting plane flown by a pilot with murderous intentions, sprints toward the cornfield that is his one hope of refuge, he believes that his fate remains undecided. But Roger's fate *has* been decided. Hitchcock has decided it. Every time the film is screened, the outcome is—can only be—the same. No other outcome is *possible*. Nothing is contingent in the projected world. Nothing is possible that is not necessary. In Hitchcock's remake of *The Man Who Knew Too Much* (1956), Louis Bernard (Daniel Gelin), the French stranger the McKenna family meets on a Moroccan bus, explains that "in the Muslim religion, there are no accidents." There are no accidents in the world of a Hitchcock film either. Whatever happens cannot but happen; the future is as fixed, as immutable as the past. The movie screen does not *have* a frame; it *is* a frame, Cavell remarks in *The World Viewed*.[12] He also says that the projected world is the world as a whole. Hence what is inside the frame has the same reality as what is outside the frame—except for what is on the other side of the screen, so to speak: our world, from which the projected world is separated, spatially, by a barrier that is not possible to cross. But a barrier that cannot possibly be crossed—the speed of light, say—is not a real barrier, not really a barrier, at all. And what is true for film's spatial dimension is no less true for its temporal dimension. Within the projected world, past, present, and future have the same kind and degree of reality. Nonetheless, like sand in an hourglass, a film runs through the

projector in one direction only, one reel emptying as the other fills. The world on film is timeless. It also exists in time.

Hitchcock famously expounded on his understanding of the difference between suspense and surprise:

> We are now having a very innocent little chat. Let us suppose that there is a bomb underneath this table between us. Nothing happens, and then all of a sudden, "Boom!" There is an explosion. The public is surprised, but prior to this surprise, it has seen an absolutely ordinary scene, of no special consequence. Now, let us take a suspense situation. The bomb is underneath the table, and the public knows it, probably because they have seen the anarchist place it there. The public is aware that the bomb is going to explode at one o'clock and there is a clock in the décor. The public can see that it is a quarter to one. In these conditions this same innocuous conversation becomes fascinating because the public is participating in the scene.[13]

Cutting to the clock makes the viewer acutely aware that time is passing. A perfect illustration is the classic sequence from *Sabotage* that ends with an explosion that kills Stevie (Desmond Tester), the protagonist's likable young brother (and, even more shockingly, the puppy he befriends on the bus). We know, as the unsuspecting boy does not, that the film can he has been asked to deliver contains a bomb set to explode at a quarter to the hour. The boy looks at each clock the bus passes on the street. Each time, Hitchcock cuts to Stevie's point of view, so that we see, as he does, that the bus is running late—although he is oblivious of the consequences. The last second before the explosion is represented by a close-up of the minute hand of a clock as it moves, in "real" time, from "44" to "45," signaling the fatal explosion. By this means, Hitchcock is acknowledging or declaring the transience that is one aspect of the temporality of film: the fact that in viewing films we experience every moment—as we experience every moment of our lives—within time, under the sway of one mood or another. Indeed, it is one of Hitchcock's signature devices to include in his suspense sequences an element that functions, like the cuts to the clock faces, to render perspicuous the suspense-inducing condition that, for us as well as for the characters, time moves on like clockwork—and that time is running out.

I am thinking, for example, of the brilliant passage in *Notorious* in which Alicia (Ingrid Bergman) and Devlin (Cary Grant) descend into

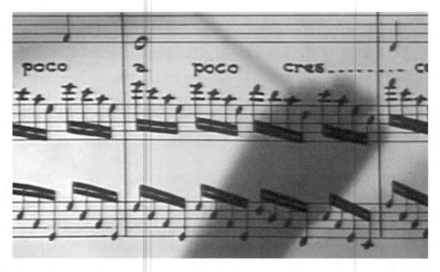

Figure 0.4

Sebastian's (Claude Rains) wine cellar. The sequence is rendered all the more suspenseful, for them and for us, by the knowledge that should the champagne at the party run out, Sebastian would have to go to the wine cellar for more champagne and find out that his wife had purloined the key. Every cut to champagne being poured or drunk—Hitchcock makes his cameo appearance by downing the first glass—and to Alicia pointedly refusing a refill—reminds us that time, like the champagne, is running out. Every cut to the bottles remaining on ice reveals that their number is dwindling, not only reminding us that the moment of decision is drawing closer, but quite literally enabling us to *see* the passage of time, making time itself visible.

In the 1956 version of *The Man Who Knew Too Much*, the Albert Hall sequence is a remarkable tour de force. Its stroke of genius is the shot in which the camera follows the score of the cantata the orchestra and singers are performing as the music leads inexorably to its climax, at which point, according to the villainous plan to which we are privy but Jo (Doris Day) is not, a cymbal crash will block out the sound of the assassin's gunshot. The music, conducted by no less than Bernard Herrmann, becomes identified with the film itself, the notes of the score standing in, as it were, for the words of the screenplay Hitchcock is "conducting." What is on view becomes a *vision*—a vision not only of time advancing like clockwork but of

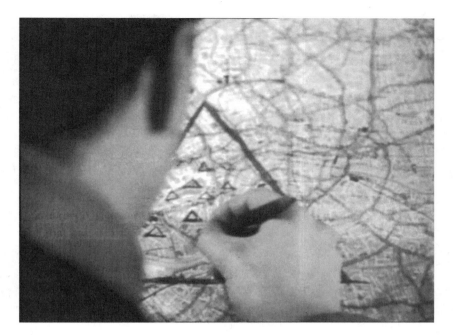

Figure 0.5

the very film we are viewing as it moves on toward its predestined ending. Ironically, Jo's scream derails the smoothly running machinery of the musical performance, disrupting both the composer's and villain's designs—but not Hitchcock's, which it is impossible for Jo to disrupt.

The Lodger, the film the director always called the first true Hitchcock picture, contains his earliest use of this device of rendering visible the passage of time both within the world of the film and within our world. I am thinking of the shots of the lodger (Ivor Novello) poring over a map of London on which triangles mark the locations of the Avenger's murders.

With each recurrence of this setup, we can *see* the pattern as it is emerging, the fact that (as an intertitle tells us) the triangles form a spiral zeroing in on Daisy's home. We can *see* that this progression has an end point. And time is of the essence, as it is in the Griffith-like chase that climaxes the film, in which what is at stake is whether Joe will arrive in time to keep the mob from tearing the lodger to pieces. The lodger's anguish reflects his knowledge that completing his project would make him a murderer. Divided between a past that haunts him and a future that holds hope only for the closing out of that past, he is in what Norman Bates, who knows whereof he

Figure 0.6

speaks, calls a "private trap," within which, no matter how much one "scrapes and claws" trying to escape, one never "budges an inch."

When the lodger, pursued by the mob, attempts to climb over a fence, his handcuffs catch on a spike. Unable to move, he hangs suspended, hands clutching at him from all sides. He is tormented by the mob, within which Hitchcock personally assumes a place. He cannot escape from these would be avengers, but neither can they get him in their clutches. This is a vision of eternity, of endless suffering.

In *The Murderous Gaze* I pondered this vision and posed the question, "Who brings the lodger to this moment of harrowing suspense?"[14] Here, I must respectfully part company with my young self. For the lodger, this is precisely *not* a moment of suspense. A man without hope for the future, like Scottie at the end of *Vertigo*, is not in suspense. In the lodger's mind the outcome is not uncertain. Being suspended *is* the outcome.

For himself, the lodger believes, no change is possible, no release, no dawning of a new day, no future. Or, rather, past, present, and future are one to him—as if he had awakened to the reality of his condition, the reality that he exists only in the world of a film, a projected world, a world that

Figure 0.7

does not really exist. The lodger, suspended, is untouched by the stream of time. Or, we might say, for him time itself is suspended—in something like the way the world is suspended when it is projected on a movie screen. If the shots of the lodger poring over his map declare the transience that is one aspect of the temporality of film, this shot declares the permanence that is the other aspect of film's temporality, the fact that in the projected world past, present, and future have the same kind and degree of reality, hence the same kind and degree of unreality. Time stands still for him in this vision of timelessness, of world—or worldlessness—without end. Suspended as if for all time, the lodger, like Scottie looking down from the ledge, is *beyond* suspense.

Hitchcock is called the "Master of Suspense." Does this mean that he had mastered suspense? Had Hitchcock, like the lodger and Scottie, reached a place beyond suspense? If so, was this a happier place than theirs? As I have said, Hitchcock never tired of quoting Oscar Wilde's line, "Each man kills the thing he loves." To believe that we are fated in such a way is to be beyond suspense. For it is to believe that in our lives, as in the lives of characters who exist only within a world on film, there are no accidents, that our future, no less than our past, is fixed, that it is not possible for us to write our own futures, to change, to *become*. It is to believe that our longing to realize what is human in our nature is doomed never to be fulfilled or that human nature itself condemns us to unfulfillment. It is to believe not only that "*Que sera, sera*, whatever will be, will be," as Jo puts it in *The Man Who Knew Too Much* when she sings to her son to pass on her mother's words of wisdom; it is also to believe that, no matter what Jo may sing

to her son, no matter what her mother may have sung to her, the future *is* "ours to see." And it is not a pretty picture, if it is our fate to kill the thing we love.

In Emerson's view it is within our power to take a step in the direction of the unattained but attainable self. "Intellect annuls fate," he writes in "Fate" (501). It is not that we hold our fate simply in our own hands, however. We must make our way in a world with other people in it. But it is not possible for us to walk in the direction of the unattained but attainable self unless we think for ourselves, rely on ourselves to take the next step; unless we open ourselves to change; unless we abandon our old settlements; unless we let our old self die, or acknowledge that it has already died, so that a new self can be born. Every step we take is a risk. We cannot be certain it will move us closer to our goal. But neither are we in suspense, in Emerson's view. We do not have the luxury of waiting in suspense to find out whether the step we have just taken has moved us forward. We have to take the next step before we know where the last step has left us.

To be unambiguously committed either to Wilde's worldview or to Emerson's is to be beyond suspense. But Hitchcock found himself suspended between them. Indeed, he found himself suspended between wishing to choose between these worldviews and wishing to deny the necessity of choosing. In *The Murderous Gaze* I characterized Hitchcock, whose films metaphorically equate artistic creation with murder, as uncertain about what his authorship made of him or revealed about him. The book's five original readings picture Hitchcock as *intending* his films to sustain incompatible interpretations, as if he were creating his films from a place beyond suspense. Is it that Hitchcock couldn't decide between two positions? I suggest in *The Murderous Gaze*, rather, that this irreducible undecidability *was* his position. When I wrote that book, I did not take Hitchcock's aspiration to be reconciling the irreconcilable, deciding the undecidable, bringing together the two halves of his artistic identity. Rather, I took it to be acknowledging, and embracing, the mysterious doubleness he took to be at the heart of the art of pure cinema. The entire trajectory of Hitchcock's authorship, as I traced it in *The Murderous Gaze*, calls forth the dark picture that, from *The Lodger* to *Psycho* and beyond, all Hitchcock did, in effect, was "scratch and claw without budging an inch" (xvi).

Extending and revising my thinking in *The Murderous Gaze, Must We Kill the Thing We Love?* offers a more affirmative interpretation of Hitch-

cock's authorship, which is that with each new film he thought a new thought, took a new step, drew a larger circle, always walking in the direction of the unattained but attainable self.

Drawing a New Circle

"The Moving Finger writes; and, having writ, moves on."[15] Our lives move inexorably on, every moment succeeded by the next, until our time runs out. At every moment our future becomes the present; our present, the past. Is our future, like Scottie's, already written? Are we fated, as he is? Or are our powers of thought capable, as Emerson believed, of freeing us—but also making it our responsibility—to write our own future, to realize our world? There are no accidents, no contingencies, within the world on film; nothing that is not real is possible. But our world abounds in unrealized possibilities. And our lives are woven of contingencies. I was not fated to write *The Murderous Gaze*. And I am not fated to be writing these words now. Yet I can now discern permanent marks that the writing of *The Murderous Gaze* left on me, and not only on my writing. Every moment of our lives is transient yet leaves permanent marks. Had I not written *The Murderous Gaze* then, my temperament would still be what it was, what it is. But I would not now be writing *Must We Kill the Thing We Love?* I would not have become the writer, the person, I am.

In this sense it becomes possible, looking back on our pasts, to discern a kind of necessity in the contingent moments of our lives. They could have been different. But if they had been different, we would now be different. Our futures are not yet written. And we do not have to let others write them for us. Nor do we have to write our futures in foolish consistency with our pasts. It is by acknowledging the past—acknowledging that it *is* past, abandoning it, yet mourning its passing—that we free ourselves to move on, to take a new step, to walk in the direction of the unattained but attainable self. This was Emerson's faith. It is a faith that Hitchcock was torn between embracing and resisting, between wishing to embrace and wishing to resist.

As I have said, at the time I was writing *The Murderous Gaze*, I was teaching film at Harvard and in almost daily conversation with Cavell, who only a few years before had been my doctoral adviser (and who, to me, has never stopped being my teacher, as well as my friend). But when I read *The Murderous Gaze* now, I can see clearly, as I could not when I was writing the

book, that I, like Hitchcock, was torn between embracing and resisting the philosophical outlook that Cavell's subsequent writings have taught me to call "Emersonian perfectionism." My own ambivalence manifested itself, in the five original chapters, in a conflict or tension between my practice of reading films—a practice that I passionately embraced, indeed single-handedly pioneered; a practice I now understand to be exemplary of Emersonian perfectionism—and certain of my assumptions and conclusions that resisted it. To be sure, I had reasons for drawing those conclusions. But I no longer wish to be the kind of person who is satisfied by such reasons. Thus I found myself moved, after many years, to publish an expanded edition of *The Murderous Gaze* and to write an altogether new book about Hitchcock.

Thirty years ago I was as drawn as Hitchcock was to the idea that "each man kills the thing he loves." Evidently, I botched it, though, when I wrote *The Murderous Gaze*. In writing *Must We Kill the Thing We Love?* I have been relieved to discover that Hitchcock's films have not stopped being alive for me and that I respect them as much as ever and love them even more. Of course, "killing" Hitchcock's cinema, or anyone's love for it, is not my goal—nor, I trust, the outcome—in writing this book. Neither is it my goal to "kill" *The Murderous Gaze*, which I also have not stopped loving. As I put it in the preface to the second edition, "No one had ever written such a book before, about Hitchcock or any other director. It does not say everything there is to say about Hitchcock's films. Far from it. But what it does say is said nowhere else. And it says it in a singular way and in a distinctive voice" (x). It is a voice, I am happy to say, I still recognize as my own.

In the three decades since the publication of *The Murderous Gaze*, Hitchcock's films have been the subject of dozens of substantial and illuminating books and essays. To name just a few of the writers from whose work on Hitchcock I, personally, have benefited (with apologies to those I have inadvertently omitted and others whose writings I have not yet discovered): Richard Allen, Dan Auiler, Charles Barr, Lesley Brill, Paula Marantz Cohen, Tom Cohen, Robert Corber, Sidney Gottlieb, Nicholas Haeffner, Sam Ishii-Gonzáles, Steven Jacobs, Robert Kapsis, Marian Keane, Bill Krohn, Leonard Leff, Thomas Leitch, Frank Meola, Tania Modleski, Tony Lee Moral, Christopher Morris, John Orr, Dennis Perry, Leland Poague, Murray Pomerance, Stefan Sharff, Irving Singer, Susan Smith, David Sterritt, George Toles, James Vest, Michael Walker, Robin Wood, Slavoj Žižek.

"Hitchcock studies" has become almost an academic field of its own. Thanks to this impressive and rapidly growing body of literature, we know far more about Hitchcock's working methods, the circumstances of the production of his films, their reception, and so on. We also have the benefit of illuminating insights into the films themselves gleaned by a wide range of critical approaches. Yet nothing scholars and critics have since discovered about Hitchcock's work seriously calls into question the significance and relevance of *The Murderous Gaze*, much less invalidates the practice of reading it exemplifies, or the Emersonian perfectionism that underwrites that practice. How could it?

Hitchcock critics can be loosely divided between writers who emphasize the "darker" side of his art (Slavoj Žižek, for example, and Robin Wood in his later writings) and those whose emphasis is on—what? I don't want to call it the "brighter" side; perhaps the "hopeful" or "redemptive" side (early Robin Wood, for one; also Lesley Brill, who sees Hitchcock's films as romances). In *Hitchcock's Romantic Irony* Richard Allen follows the lead of *The Murderous Gaze* in seeing both sides, and the tension or conflict between them, as equally essential to Hitchcock's artistic identity, although he understands the two positions somewhat differently than I do and places Hitchcock, quite fruitfully, in relationship to the aesthetic tradition of British romanticism rather than American transcendentalism, a late flowering of romanticism in the New World.[16]

Thinking through Hitchcock's relationship to *American* thought, and specifically to Emersonian perfectionism, has a crucial advantage, however, in that it is Emerson's worldview that underwrote not only the greatest achievements of nineteenth-century American literature (and to a large degree twentieth-century American literature as well) but also the equally great achievements of the classical American cinema. And part of the groundbreaking importance of Cavell's books about the comedy of remarriage and the melodrama of the unknown woman is that they envision these popular genres not as instruments of pernicious bourgeois, capitalist, or patriarchal "ideology"—ways of *not* thinking, ways of avoiding or suppressing thought—but as inheriting the serious way of thinking founded philosophically in America by the writings of Emerson and his great disciple Thoreau.

As excellent a critic as Robin Wood, whose pioneering early book *Hitchcock's Films* is filled with deep insights, and whose *Hitchcock's Films Revisited* is filled with even deeper insights, explicitly identifies American culture, in his last published essay on Hitchcock, with what he calls "fascism" (with a

small *f*, to distinguish it from Fascism).[17] Wood sees American culture's fascist tendencies as the inevitable product of American capitalism, which he regards as an institutionalized system of domination and violence. Wood applauds Hitchcock for subjecting America's "fascist tendencies" to a devastating critique all the more powerful for the fact that the director himself was anything but exempt from those tendencies. Wood fails to appreciate, however, that Hitchcock's critique of America's fascist tendencies is as deeply rooted *within* American culture as are those fascist tendencies themselves. For the Emersonian perfectionism that underwrites this critique has been a powerful force within American culture ever since Emerson made his living as a popular lecturer and Thoreau spent his time in jail—a force that has repeatedly been repressed yet repeatedly resurfaces (in the 1930s: in the New Deal and in Hollywood movies; in the 1950s and 1960s: in rock 'n' roll, the civil rights and antiwar movements, and the "counterculture"; in the 1970s and beyond: in the feminist and gay rights movements; and in our time: in the election of Barack Obama).

That it is illuminating to place Hitchcock's films within the American literary and philosophical tradition of which Emerson was the "founding father" is the guiding intuition of Frank Meola's erudite, nuanced, and eloquent essay "Hitchcock's Emersonian Edges," which I had the pleasure of reading only after completing the chapters that follow.[18] One element of my book's originality is its sustained demonstration that in his films Hitchcock is working out, thinking through, his ambivalence toward Emersonian perfectionism. Another is the book's argument that there is a dialectical progression in Hitchcock's thinking—as there has been in mine—that leads him ultimately, in *Marnie*, to overcome or transcend his ambivalence. Yet another is that the practice of reading that the book exemplifies—which is intimately responsive to (and reflects philosophically on) the ways Hitchcock's films are "written," cinematically—has deep affinities with Emerson's own ways of thinking, and writing, about thinking, writing, and reading.

In the chapters that follow, I write about films that many others have written about, but only occasionally do I pause to situate my claims in relation to other Hitchcock critics. More often, I relate my present thinking to my own published writings. Do I believe I'm the only important person, or the only person with important thoughts, who has written about Hitchcock? Of course not. But I am the only person who has had *my* thoughts, thoughts motivated by, and accountable to, my experience of the films I'm writing about. Only by taking a step beyond *these* thoughts can I draw a

new circle, in Emerson's sense. Is extending and revising one's own thoughts a legitimate mode of writing? I'm no Emerson, but that's how his essays are written. As I argue in this book, it's the way Hitchcock's films, cinematically, are "written" as well. Every Hitchcock film extends and revises the thinking in his earlier films, draws a larger circle around the circles they drew, shifting the center by expanding the periphery.

I have already had occasion to "part with my young self," as I put it, on the question of whether the lodger, impaled on the spiked fence, is in a state of suspense. There will be more than a few such occasions as we proceed. For example, the emotionally charged and densely argued reading of *Vertigo* that plays a pivotal role in *Must We Kill the Thing We Love?* hinges on two intuitions that had not yet dawned on me—or on any other commentator on the film, for that matter—when I wrote "*Vertigo*: The Unknown Woman in Hitchcock," an essay published several years after *The Murderous Gaze*.[19] How could I not have known what I now know about *Vertigo*? How could I have come to see what once I could not see?

In "Circles" Emerson writes, "People wish to be settled; only as far as they are unsettled is there any hope for them" (413). "I unsettle all things" (412), one more oft-quoted line from "Circles," along with a portrait of the square-jawed Sage of Concord, is emblazoned on one of my tee shirts, now more than a bit the worse for wear. (Another bears the cherubic, all but chinless, visage of the Master of Suspense.) Writing a long chapter on *Marnie*, as well as a new preface, for the second edition of *The Murderous Gaze*, unsettled my thinking about Hitchcock, or revealed to me how unsettled my thoughts had become in the years since I wrote *The Murderous Gaze*. "Our life is an apprenticeship to the truth, that around every circle another can be drawn" is yet another inspiring sentence in "Circles" (403), too long, unfortunately, for a tee shirt. In writing *Must We Kill the Thing We Love?* I have drawn a new circle.

When I was writing *The Murderous Gaze*, I believed I was giving equal weight to the two incompatible pictures of Hitchcock's authorship I discerned in the films I was studying and the two moral outlooks or worldviews between which I understood him to be suspended. I can see now, though, how much I favored the darker picture. In *The Murderous Gaze* dark moods predominate. And they keep getting darker, and intensifying, until the last pages of the *Psycho* chapter and the melancholy postscript I began writing when I heard the news that Hitchcock had died.

Dwelling mainly on films I passed over in *The Murderous Gaze*, *Must We Kill the Thing We Love?* retraces the trajectory of Hitchcock's career—with several detours along the way—in a manner intended to balance the scales. Happily, the Moving Finger, having writ, has tilted the scales in favor of the Emersonian perfectionism I find myself no longer resisting.

1

The Wilde-er Side of Life

In 1934 there was a seismic shift in American movies. It was the year of *The Thin Man*, *Twentieth Century* (Howard Hawks), and, above all, *It Happened One Night*, the unheralded film from Columbia Pictures that swept the major Academy Awards that year. This was also the year Hollywood imposed on itself the policy of strict adherence to the Production Code, a self-censorship the studios had accepted in principle in 1930 but did not rigorously enforce until four years later.

In Hollywood movies of the early 1930s, much was shown and said that violated both the letter and the spirit of the Code. So-called pre-Code films were never sexually explicit, but they were often explicitly sexy. And they kept getting sexier as the studios, hoping to increase ticket sales so as to remain financially solvent in the depths of the Great Depression, continued to push the envelope. For example, in the notorious *Baby Face* (Alfred E. Green, 1933), Lily (Barbara Stanwyck), pushed into prostitution by her father, sleeps her way to the top, taking pleasure in turning the tables on men eager to exploit the privileges granted them by a society both patriarchal and hypocritical. Viewers cheer her on as she plays her one trump card: her sexual magnetism. The narrative contrives for Lily to undergo a conversion to morality, however. She is redeemed, perhaps too late, by love for the man who helps awaken her to the error of her ways. But the sexy, untamed Lily, not the noble, tamed one, is the film's own trump card.

Viewing *Baby Face* today, our greatest source of pleasure is the gusto with which Stanwyck throws herself, body and soul, into portraying this woman, exploiting her own sexual magnetism in the process. We do not wish for Lily to sacrifice her happiness on the altar of a society that, as the film makes clear, lacks the moral authority to judge her. Nor does the man to whom she wishes to prove her worth subscribe to society's way of thinking about morality. He wants Lily to become moral, as we do. But he does not want her to become selfless; he wants her to awaken to her own humanity, as well as to the humanity of others, to walk in the direction of the unattained but attainable self. So do we. There is no way to prove it, but I have no doubt that most viewers at the time felt the same way. (Whether they would have admitted this, even to themselves, is an unanswerable question.) In any case, even though the film's ending asserts that Lily achieves such an awakening, society would have to change its moral outlook for it to become capable of acknowledging this woman's true worth. And *Baby Face* is entirely characteristic of pre-Code Hollywood movies in holding out no hope that society will change in such a way.

In their cynicism bred of despair, sexy pre-Code melodramas like *Baby Face* and *The Red-Headed Woman* (Jack Conway, 1932), and, for that matter, violent gangster films like *The Public Enemy* (William Wellman, 1931) and *Scarface* (Howard Hawks, 1932), were vivid expressions of America's mood as the Wall Street panic morphed into the Great Depression and the Hoover administration stood idly by. As I have said, *It Happened One Night* discovered both a new story to tell and a new way of telling its story that, like the New Deal itself, tapped into a reservoir of American thought that achieved its fullest philosophical expression in Emerson's writings. The film's astonishing popularity awakened Hollywood to the reality that Americans were hungering for films that acknowledged the darkness of the times yet overcame the temptation to give in to cynicism or despair— hungering for films that acknowledged and responded to the nation's longing for renewal. For the remainder of the decade the New Deal was in ascendancy in America, as Roosevelt was reelected in a landslide of unprecedented proportions. *It Happened One Night*'s Emersonian outlook was in ascendancy in Hollywood as well, above all in the romantic comedies that followed the path the film blazed.

The New Deal was also polarizing. Its enemies were in the minority, but they numbered millions of moviegoers whose patronage a film industry shaken by the Depression could not afford to lose. The studios, threatened with boycotts by the Catholic Legion of Decency and other groups that saw

Hollywood—and the New Deal itself—as a threat to America's moral values, agreed to enforce the Production Code. Filmmakers were compelled to conform to a censorship that severely restricted their freedom. Much that we value today in pre-Code films was lost as a consequence of this repression. That something of at least equal value was gained, however, is proved by the multitude of classics Hollywood produced between 1934 and America's entrance into World War II, their standard-bearers the romantic comedies that rank among the glories of America's cultural heritage. For the American cinema this all-too-brief period was, indeed, a "Golden Age." How could Hollywood's loss of freedom have been so liberating?

Pre-Code Hollywood had already anticipated an important element of *It Happened One Night*'s worldview when its leading directors, screenwriters, and performers collectively embraced the principle that the medium of talking pictures is best served when performers speak in their own voices. Playing characters who find themselves moved to give voice to their thoughts and feelings, to find their own words (and gestures) with which to express themselves, brought down to earth the gods and goddesses of the silent screen. Even Greta Garbo laughed. That dialogue should be written and spoken so as to sound like ordinary speech, not theatrical speech, is a principle that had already been established in the American theater, in large part because of the influence, direct and indirect, of George Pierce Baker's drama program, first at Harvard and then at Yale (direct, in the case of Donald Ogden Stewart, for example, a student in the Yale program who went on to adapt for the screen fellow-student Philip Barry's Broadway hits *Holiday* and *The Philadelphia Story*; indirect, in the case of George Cukor, whose years as a theater director helped, not hindered, him in directing both films).[1] Thus the migration of New York theater people to Hollywood in the early years of the talkies actually helped American movies to find their voice and avoid the trap of "staginess."

In Hollywood movies of the 1930s, stars were mortals, not gods or goddesses. They were fit to be loved or hated, not worshipped. Yet they were nonetheless stars. Projected on the silver screen, they have a godlike aspect, at least at times. When Ellie (Claudette Colbert) in *It Happened One Night*, framed in close-up, is thinking about the way a moment earlier Peter (Clark Gable) had almost kissed her as he was smoothing her haystack bed, her image is as radiant, mysterious, and deep as a sacred icon.

Even as such movies elevated their merely human stars to godlike heights, however, they brought them down to earth, acknowledging that these glorious beings were, like their viewers, creatures with human desires and

powers. Hence Hollywood movies of the 1930s, in an Emersonian spirit, revealed to viewers that they, too, were touched with divinity. James Harvey puts it eloquently:

> The stars, like the movies themselves, were both real and unreal. . . . Just like the best of their movies, they were about common life—or at least its possibilities. They stood for equality—but an equality without illusions. It wasn't their job (unlike the left-wing rhetoric of the time, with its sentimental populism) to flatter us and to tell us we were wonderful. But they made us feel wonderful, and they gave us hope. Because what they were, so to speak, in front of our eyes—in their different forms of toughness, commonness, openness, in their glamour and their final mystery and inviolability—testified to the possibility of American community.[2]

When the women in comedies of remarriage awaken to their humanity, the change they undergo is so traumatic that Cavell characterizes it as tantamount to death and rebirth. In his understanding, these films understand that metamorphosis to be equivalent, metaphorically, to the camera's transformation of flesh-and-blood women into stars. Hollywood movies of the 1930s envision the camera as endowed with the power to free its human subjects—or, rather, to reveal them already to be free—to embrace change, to be reborn on the screen as stars.

For the sake of humanity, how could Hitchcock not have wished his own films, too, to be on the side of freedom? But insofar as he believed that human beings are doomed to kill the thing they love, how could he not have thought of the camera as having the power to reveal, rather, the fatedness of its human subjects, to reveal their capacity to kill, their lack of the freedom to change, and their vulnerability to becoming a killer's victim? The language Norman Bates uses to describe his hobby of stuffing birds ("It's not as expensive as you might think. . . . The chemicals are the only things that cost anything") is one of *Psycho*'s ways of suggesting, not simply ironically, that Hitchcock's art of pure cinema is akin to taxidermy—as if the medium of film turns flesh-and-blood human beings into ghosts, or reveals them already to be ghosts, and breathes into these forms, these spirits, only a semblance of life. Like "facts in our life" when the intellect "raises" them, the world on film is "the past restored, but embalmed." The art of pure cinema, too, is "a better art than that of Egypt."

Hitchcock's *Rich and Strange* (1931), made three years before *It Happened One Night*, anticipated many of the defining features of the remar-

riage comedies Cavell celebrates. But Hitchcock's ambivalence is clearly in evidence. Early in the film, Fred (Henry Kendall) wishes for his life to change from merely existing to really living. Exercising his extraordinary powers as author, Hitchcock, as is his wont, "magically" grants this wish. An unexpected inheritance enables Fred and his wife, Emily (Joan Barry), to embark on an around-the-world voyage they both hope will transform their lives and renew their marriage. When the couple returns home, however, the film's ending implies that they have failed to discover anything about each other, or about themselves, capable of changing their marriage into the kind of relationship *It Happened One Night* envisions. A baby is on the way, but that only gives the couple new grounds for bickering, as Emily wants Fred to get a better job so they can move to a classier street, while he defends the status quo. The more things change, the more they stay the same—hardly an Emersonian (or Capraesque) sentiment. Unlike the Cary Grant character in *Bringing Up Baby*, Fred has not learned to embrace adventure. He has concluded that adventures are too risky.

Although during their journey Emily is more adventurous than her dullard husband, she, too, fails to be changed by her experiences; at least, that is what the film's ending asserts. But that assertion is far from convincing. Throughout the voyage, we have seen with our own eyes that this woman, as winningly played by Joan Barry, like the women of remarriage comedies, hungers for the education she seems indeed to be acquiring. For her, this around-the-world trip seems to be a true voyage of discovery. Thus *Rich and Strange* is akin to *Blackmail* (1929) and *Murder!* (1930), two Hitchcock thrillers that precede it, which likewise conclude with a woman trapped in a relationship with a man who is not her equal but who, with the complicity of a patriarchal society, unjustly wields power over her. Emily deserves better than marriage to a boorish, boring, overbearing man committed to remaining unchanged. Yet Hitchcock condemns her to that fate.

Hitchcock's unwillingness or inability to end his films of the early 1930s with a romantic union that acknowledges the possibility of rebirth derived in part, I take it, from a problem he perceived with British actors, an inadequacy that created a daunting obstacle to his creating male characters worthy of a spiritually (and sexually) awakened woman like Emily. A case in point is *The Man Who Knew Too Much* (1934), which pairs the fetching Edna Best with the kvetching Leslie Banks, a highly accomplished stage actor but too much of a conventional upper-class British stiff-upper-lip type to compel, or reward, the attention of Hitchcock's camera. It was not until Robert Donat's graceful, felicitous performance as Richard Hannay in *The*

39 Steps that a Hitchcock thriller decisively overcame this obstacle. (In the early 1930s, Hollywood had its own problems finding or creating male stars able to hold their own with women like Barbara Stanwyck and Katharine Hepburn, whose self-reliant spirit so perfectly prepared them to incarnate the heroines of comedies of remarriage. In their pre-Code films Stanwyck and Hepburn already projected the requisite spirit. But the macho screen persona of a star like Clark Gable had to change—it had to acknowledge, for one thing, what Cavell calls the feminine side of this man's nature.)

Secret Agent, Sabotage, Young and Innocent, and *The Lady Vanishes,* the brilliant thrillers Hitchcock made in the few years remaining before his departure for Hollywood, all conclude, as *The 39 Steps* does, with the union of a man and woman who can presumably look forward with hope to a relationship worth having. But even as they brought the Hitchcock thriller into alignment with the Hollywood comedy of remarriage, these films underscored their author's ambivalence toward the American genre's Emersonian worldview.

For one thing, the protagonists in these films are content with their lives as they are. They are not driven by a wish to change, to walk in the direction of the unattained but attainable self. In *It Happened One Night,* Ellie initiates the narrative when she declares her independence from her father by jumping overboard, and although Peter thinks he is motivated only by the need to win back his job, we learn late in the film that he has all along harbored a romantic dream that he would have let motivate his every action if only he believed there were any possibility of its being realized. In order to initiate the narrative of *The 39 Steps,* however, all Hannay has to do is buy his ticket to the music hall show, take a seat, and ask Mr. Memory the innocuous question, "How far is Winnipeg from Montreal?" Hitchcock takes over from there.

From Hannay's perspective it is simply an unlucky accident that Annabella Smith singles him out. But in the world of a Hitchcock film there are no such things as accidents. At least until Pamela (Madeleine Carroll) enters, or, rather, reenters the picture at the political rally, Hannay's project is only to escape from the trap into which he had unwittingly stepped. He is not walking in the direction of his unattained but attainable self when he travels, overcoming all obstacles, to the place in Scotland (a stone's throw from a town called "Killin"!) that Annabella Smith had circled on her map before she died. Once there, he unwittingly steps into another trap, one he escapes only because the prayer book in the pocket of his overcoat (the one that Margaret, the crofter's wife, gave him, without her hus-

Figure 1.1

band's knowledge, to help him blend into the bleak Scottish landscape) providentially stops Professor Jordan's (Godfrey Tearle) bullet—another "accident" that is really no accident.

When the crofter, suspecting Hannay of "making love behind me back" with Margaret, confronts Hannay as he is about to make his getaway, a muffled car horn signals the imminent arrival of the police. Hitchcock cuts to a shot taken through the slats of a chair—ironically, it is what is called a "Hitchcock chair"—and thereby marks the frame with parallel vertical lines unmistakably suggestive of prison bars.

This is an exemplary instance of what in *The Murderous Gaze* I call Hitchcock's "//// motif." Beneath the surface of Hitchcock's films—or, rather, on the surface; the movie screen is a surface—and hidden from us only by being in plain view, are recurring motifs or signatures, of which the //// is one, whose presence at significant junctures participates materially in the films' way of expressing their thoughts. Others that *The Murderous Gaze* identifies include circles, curtain raisings, eclipses, white flashes, frames-within-frames, profile shots, tunnel shots (shots composed in depth as if the camera were looking into a tunnel), and symbolically charged

colors, sounds, and objects, such as lamps, handbags, staircases, birds, and jewels. Each of these motifs, whenever it presents itself in a Hitchcock thriller, resonates with its other appearances in that film and in Hitchcock's earlier films as well. And the motifs resonate with each other. For example, *Vertigo* links flowers, jewels, and eyes, as we will see; in *The Birds* the horrifying image of Lydia's neighbor's bloody eye socket links eyes and birds. Taken together, these motifs, in successive films, create an ever denser, ever deeper, texture of interrelated echoes and associations that binds each Hitchcock thriller to those that preceded it, in a sense embedding the past in the present, the present in the future.

At one level Hitchcock employs these signature motifs to signify that this is a Hitchcock thriller; they are Hitchcock's personal marks on the frame, akin to his name in the credits or his cameo walk-ons. At another level these signature motifs serve as visible manifestations of the dark, erotically charged realm of unconscious fears and appetites that in Hitchcock's understanding, as in Freud's, underlies—and participates in shaping—our conscious experience. And at yet another level these motifs provide Hitchcock with a tool for acknowledging or declaring the very conditions of the existence of the projected world.

Each signature motif has its own way of accomplishing such declarations. Frames-within-frames, for example, are natural metaphors, as we might put it, for the film frame; circles for the camera's lens, its "eye"; and so on. The //// motif is unmistakably suggestive of prison bars. Hitchcock uses it here to express Hannay's feeling of entrapment. He knows he is caught in a trap from which he must find a way to escape. But the //// also declares—this is Hitchcock's declaration, not Hannay's—that Hannay is trapped in a way he does not know he is. He is trapped within a prison from which there is no escape: the projected world itself. The //// motif serves Hitchcock as a metaphor, or symbol, for the movie screen—the border separating the projected world from our world, which is also the place—or no place—where the two worlds meet. It is impossible for Hannay to cross this border. Nor is it possible for us to cross it. The screen marks a limit to our freedom, no less than Hannay's, the fact that we cannot escape from our mortal existence.

By the end of a comedy of remarriage, the couple has achieved a true marriage, a conversation of equals. They are committed to walking, together, in the direction of the unattained yet attainable self. To achieve this, they have to overcome obstacles that are internal to their relationship, obstacles they thus possess the freedom to overcome. At the end of *The* 39

Steps Hannay and Pamela take each other's hand. What moves them to perform this gesture is the death of the poignant Mr. Memory, juxtaposed in the frame with the high-kicking chorus line. Hannay and Pamela, too, have had to overcome obstacles. But even those obstacles that were internal to their relationship—her lack of trust, his lack of respect for her intelligence— were inextricably interwoven with obstacles placed in Hannay's path by external forces—clueless Scotland Yard, the villainous Professor Jordan and, last but not least, the film's author, Hitchcock, who casts himself as the divinity presiding over the "accidents" in this projected world.

Then again, although Hannay could not have overcome these obstacles if his courage or his gift for improvisation had failed him, his success also depended on a succession of happy "accidents" that were not really accidents. Luckily for Hannay, his relationship with Pamela has Hitchcock's blessing. And the film's ending suggests that the future of the relationship between Hannay and Pamela, like the chain of events that brought them to this point, does not rest solely in their own hands, as it does for the couples in remarriage comedies. One of Hannay's hands is still handcuffed, after all. Throughout the film, Hannay believes himself to be free in a way that Hitchcock declares him not to be. Hannay's freedom to write his own future (with a little help from his friends) is limited by the conditions of his existence within the film's world—and, Hitchcock reminds us, by the whims of the film's author. Does Hannay possess the freedom, then, to walk in the direction of the unattained yet attainable self? Does Hitchcock? Do we?

2

Accomplices in Murder

Secret Agent, Sabotage, Young and Innocent, and *The Lady Vanishes* follow the lead of *The 39 Steps*—as that film had taken the lead of earlier Hitchcock thrillers from *The Lodger* to *The Man Who Knew Too Much*—by revolving around murder. Indeed, it can be viewed as a defining feature of the Hitchcock thriller in its various forms—with exceptions that prove the rule, to be sure—that a villainous murderer dwells within the film's world.

As many other critics have noted, Hitchcock's villains are often the most interesting characters in their films—the most charming and, sometimes, even the most sympathetic. The Hitchcock villain represents a character type or set of types, like what in *The Murderous Gaze* I call "the girl-on-the-threshold-of-womanhood" (*The Lodger*'s Daisy is one) and the officer of the law (Daisy's frustrated suitor, Joe, for example) who uses his official powers for personal ends. Hitchcock often seems to *identify*—however exactly we understand this term—at least as much with his villains as with his protagonists. (As I argue in *The Murderous Gaze*, Hitchcock's identification with his female characters is at least equally strong.)

Many Hitchcock villains possess elegant manners and the sangfroid of an aesthete or gamesman. Among the examples that come to mind are the artist (Cyril Ritchard) in *Blackmail*, Sebastian (Claude Rains) in *Notorious*, Tony (Ray Milland) in *Dial "M" for Murder*, and, of course, Gavin Elster (Tom Helmore) in *Vertigo*. Just think of the moment in *The 39 Steps* when Professor Jordan (Godfrey Tearle), with a grin that invites an appreciative

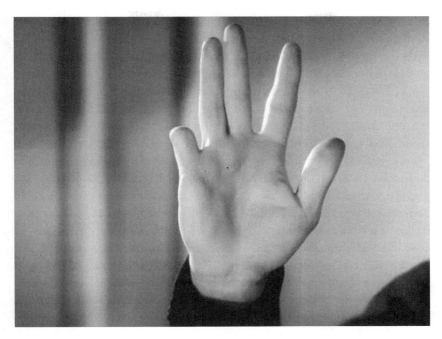

Figure 2.1

grin in return, holds up his hand, which is missing the top joint of its little finger, to disclose that he is the diabolical mastermind Annabella Smith warned Hannay about.

Villains are not the only Hitchcock characters who cultivate the style of a gamesman/aesthete, however. When at the end of *Frenzy* Chief Inspector Oxford (Alec McCowen) catches the serial killer with his pants down, he speaks the wonderful line, "Mr. Rusk, you're not wearing your tie," with exactly the same understated relish that we hear in James Mason's voice, at the end of *North by Northwest*, when Phillip Vandamm, now in custody, says to the Professor (Leo G. Carroll), who has just had a marksman shoot Vandamm's lieutenant, Leonard (Martin Landau), "Not very sporting, using real bullets."

With his cockney upbringing, Hitchcock no doubt found satisfaction in embracing the honorable, time-honored British tradition of associating villainy with the upper class. (But compare *Frenzy*, with its unapologetically working-class villain.) The effeteness projected by this style also gives some Hitchcock villains a hint of homosexuality. This enhances our sense,

in a number of Hitchcock films, most notably *Strangers on a Train* (1951), that the bond between male protagonist and villain is more passionate than the relationship either has, or desires, with whatever woman whose affections are ostensibly at issue.

There are other Hitchcock films, though, in which the villain loves a woman, or at least passionately desires her. We see this in *Notorious*, for example; hence Hitchcock's remark to Truffaut that Sebastian loves Alicia more deeply than Devlin does. We see it in *North by Northwest*, as well. Vandamm acts like a man who treats matters of life and death as games to be judged in aesthetic, not moral, terms—as if how well one plays the game, not whether one wins or loses (that is, lives or dies), is all that really counts. Yet when Leonard informs him that Eve has betrayed him, Vandamm loses his composure and punches him in the jaw. And in *Murder!* Handel Fane's (Esme Percy) sangfroid momentarily suffers a meltdown when Sir John (Herbert Marshall) has him audition for the murderer's role in his new play. Despite his disciplined efforts to keep his feelings hidden, Fane is tormented by seething emotions arising from his unrequited love for Diana, emotions he struggles to control and mask.

Having in mind the evocative question the state trooper asks the used-car dealer in *Psycho* ("Did she look like a wrong one to you?"), in *The Murderous Gaze* I call Hitchcock's tormented villains "Wrong Ones." Other examples that come to mind are the Avenger in *The Lodger*; the "bloke what twitches" (George Curzon), the real murderer whom the wrongly accused Robert Tisdall (Derrick de Marney) tries to track down in *Young and Innocent*; Uncle Charlie (Joseph Cotten) in *Shadow of a Doubt*; Dr. Murchison (Leo G. Carroll) in *Spellbound*; Phillip (Farley Granger) in *Rope*; Jonathan (John Dall) in *Stage Fright* (1950); Bruno (Robert Walker) in *Strangers on a Train*; and, most famously (but also most ambiguously), Norman Bates (Anthony Perkins) in *Psycho*.

In *The 39 Steps* we never see a crack in the villain's gamesman/aesthete facade wide enough to reveal what inner turmoil, if any, lies beneath. The only time he drops his mask at all, and then only for an instant, occurs when there is a knock on the door at just the moment he is waiting to see how Hannay will react to his theatrical master-stroke of unmasking himself by showing his hand. As Professor Jordan goes to unlock the door, he stops grinning and casts Hannay a look of frustration, as if he expects his intended victim to share his impatience with this untimely interruption. It's the professor's wife (Helen Haye), who tersely reminds him that lunch is ready. Her air of disapproval hints at the possibility that her husband

resents not only her intrusion but *her*, and expects Hannay to share his attitude. The look the professor casts Hannay invites him to acknowledge that the two men are members of an exclusive club, as it were—a club that excludes this woman, perhaps all women. By presenting this look, is Hitchcock inviting us to consider the possibility that the professor's work as a spy is his chief area of self-assertion in a sexless marriage, as if masterminding his traitorous scheme to wield power over the world by stabbing England in the back is a displacement of a wish to murder his wife, perhaps a wish to do violence to all women? Such an interpretation, which would make Professor Jordan a descendant of the Avenger, remains speculative at best, however, precisely because we never see the professor's sangfroid decisively melt down. Rather, Hitchcock chooses to leave it open whether Jordan is really a "Wrong One" tormented by all-too-human emotions he struggles to control, or mask, or an unfeeling, inhuman monster, utterly indifferent to the humanity of others, like Eric (Ivan Triesault), the most vicious of the Nazi conspirators in *Notorious*, and Willi (Walter Slezak), the shipwrecked Nazi in *Lifeboat* (1944).

By calling Hitchcock villains of this type "unfeeling," I don't mean that they feel nothing. Willi clearly feels pleasure, for example, in repeatedly demonstrating how superior he is in intelligence and physical prowess to the Americans in the lifeboat with him. That he also feels fear is evidenced by the beads of sweat that ultimately expose his villainous nature. And, as Robin Wood points out in his brilliant and detailed reading of *Lifeboat*, Willi feels such a strong desire to live that he struggles desperately to climb back into the boat after the American and British survivors throw him overboard. They have to keep beating him brutally until they know for certain that he is dead. What Willi seems to lack altogether is regard for the humanity of others. In *The Philadelphia Story* Dexter tells Tracy that she will "never be a first-class human being" until she learns to "have some regard for human frailty." It's an understatement to say that Willi, judged by this standard, falls short of being a first-class human being. Willi's contempt for human frailty is absolute. Is he a human being at all, or is he an inhuman monster?

In nineteenth-century theatrical melodramas, Peter Brooks argues in his seminal work, *The Melodramatic Imagination*, the villain embodies pure Evil, understood as an occult, supernatural force at eternal war with the powers of Good (likewise an occult, supernatural force).[1] In effect, such a villain is not human; he is an agent of the Devil or, indeed, the Devil himself. And the woman whose pure Goodness gives her the power to defeat the villain—of course, it doesn't hurt that God has her back—is more

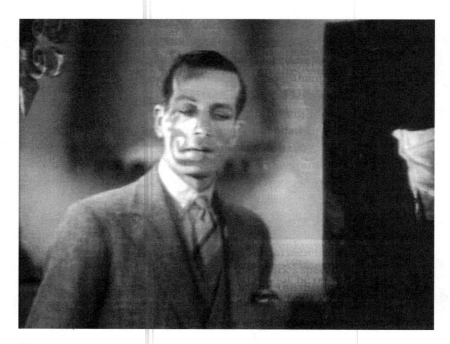

Figure 2.2

angel than flesh-and-blood human being. In melodramas of this kind a battle in the eternal war between Good and Evil is won when Goodness is publicly recognized in a "movement of astonishment," and Evil—with its own lesser power to astonish—is driven out. These plays are dramas of recognition, Brooks argues, in which acts of what he calls "self-nomination" are pivotal. "The villain at some point always bursts forth in a statement"— typically delivered as an aside directly to the audience—"of his evil nature and intentions," and at some point, too, the heroine announces her moral purity.[2]

There is a celebrated moment in *Blackmail* when the artist, having lured Alice (Anny Ondra) to his atelier, is waiting for her to finish dressing, and Hitchcock contrives for a shadow to be cast on his face that momentarily makes him appear to sport the curlicue mustache, eminently twirlable, of precisely the kind of villain who stalked the nineteenth-century stage and astonished the audience when he unmasked himself.

This man is unmasked here as a villain whose intentions toward Alice, judged by the standards of conventional morality, are anything but honor-

able. But this is not a moment of "self-nomination" in Brooks's sense. The declaration is performed by Hitchcock, not by the character. And Hitchcock is being ironic. Rather than declaring this man to possess the astonishing power that accrues to the villain of a nineteenth-century theatrical melodrama by virtue of his embodiment of pure Evil, Hitchcock's gesture underscores that the character is *not* the Devil; he has no supernatural powers, only human appetites and a human capacity for inhumanity. For that matter Alice is no angel, as the artist is about to learn the hard way. She possesses an all-too-human capacity to kill.

In Emerson's view human beings are always in the process of becoming. This means that our moral identities are never fixed, never pure. It follows that we do not have the power to declare our moral identity the way villains of nineteenth-century theatrical melodramas do. Characters in movies are always also the actors whom the camera filmed in the act of playing those characters. And these actors are mortal human beings like us, not embodiments of pure Evil or pure Goodness. How, then, is it possible— *is* it possible?—for human subjects of the camera to incarnate characters who possess the power to declare their moral identity?

When Professor Jordan holds up his hand, he presents to Hannay a view that astonishes his intended victim, as it is meant to do. By this gesture, the professor declares his identity. But does he declare his *moral* identity, in Brooks's sense? Hannay understands the gesture to mean that this man intends to kill him. But the professor goes on to explain to Hannay that killing him is something he has no choice but to do, not something he wishes to do. We may well suspect—no doubt Hannay does—that his adversary is putting on an act here, that he relishes killing, as villains are wont to do. But if the professor's good manners are a cover for his brutal nature, he is not unmasking himself, not openly declaring his Evil moral nature in the spirit of the villains of nineteenth-century theatrical melodramas. And there is a further crucial distinction to be drawn. When those villains perform acts of "self-nomination," they make their announcements to the theater audience. Professor Jordan, by contrast, addresses his announcement only to Hannay, who *is* his audience. Film is not theater. We are not the professor's audience. And in a theatrical melodrama, of course, there is no camera.

When Jordan holds up his hand, the view he presents to Hannay is the view Hitchcock presents to us. "When describing what happens in a film," I wrote in *The Murderous Gaze*, "we frequently find ourselves identifying with the camera, saying, for example, 'Now we see . . . ' But it is impossible

for us to identify with the agency that presents us with *this* view. The view of framed by Hitchcock's camera imposes itself on us here, disrupting and compelling our attention. Hitchcock, too, is showing his hand."[3]

Our view of the professor's hand, framed to represent Hannay's point of view, links Hitchcock with this villainous murderer (both are authors of views; both are authors of *this* view). And it links us with the murderer's intended victim. (Hannay views this hand, just as we do.) When Hannay arrives at the home of the man he believes will save him, he unwittingly walks into a trap. Hitchcock has set a trap for us as well. And at the moment the professor reveals to Hannay that he intends to kill him, not rescue him, Hitchcock unmasks himself to us. By the simple gesture of showing his hand, Professor Jordan means to open Hannay's eyes to the reality of his situation, the fact that trusting him was a fatal mistake. And by the simple gesture of presenting us the view that Jordan presents to Hannay, Hitchcock opens our eyes to the reality of our situation, as viewers: that it is a mistake for us to take for granted that we can trust this film's author. We trust Hitchcock at our peril.

When the professor goes on to shoot him, Hannay's startled eyes close, he slumps to the floor, and our view fades to black. Jordan has every reason to believe that he has killed Hannay. But Hitchcock is playing him for a sucker. The professor's fate is in the hands of the film's author as surely as Hannay's is. They are both subjects of Hitchcock's camera. The professor believes he has the power to write Hannay's future (or lack thereof), but he, too, dwells within a world whose real author is Hitchcock.

In passages such as this, Hitchcock asserts an affinity between a villain's murderous gesture and a gesture he performs with the camera. In other passages Hitchcock makes the camera assume a villain's point of view or frames the villain staring into the depths of the frame in a way that makes of him a veritable stand-in for the camera. In such cases Hitchcock associates the camera's passive aspect, not its agency, with villainy. Hence those passages are akin to the Hitchcock passages that portray guilty acts of viewing. When Norman Bates views Marion Crane (Janet Leigh) through his secret peephole, for example, this is not an instance of a villain's self-nomination. Unbeknownst to Norman, he is being "nominated" by Hitchcock, who performs a gesture with the camera that links Norman's villainous act of viewing with our own.

In *The Lodger* there is an astonishing sequence that begins with a shot of the lodger, with a trace of what appears to be the knowing smile of a villain, looking directly into the camera. The fact that the sequence begins

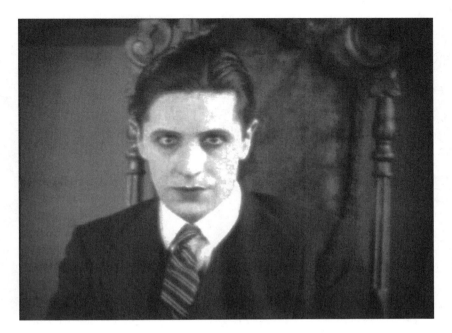

Figure 2.3

with this shot, which provides us with no way of knowing where he is located within the projected world or who or what he is looking at, enhances our unsettling impression that unlike Norman, who seems oblivious of our looking at him looking at Marion through his peephole, the lodger seems to be aware that we are looking at him; indeed, he seems to be returning our gaze, the way in the most chilling moment of *Rear Window* (1954) the murderer Thorwald (Raymond Burr), suddenly becoming aware that Jeff (James Stewart) is looking at him from his apartment across the courtyard, meets Jeff's gaze. If the lodger is capable of returning our gaze, must he not possess more than merely human powers, powers worthy of the villains of nineteenth-century theatrical melodramas, powers the all-too-trusting Daisy does not suspect he possesses?

The next shot, however, from the lodger's point of view, retroactively places him in the audience for Daisy's fashion show. For a moment we are reassured by the explanation this shot provides. Evidently, this character does not possess the power to overleap the barrier separating our world from his world. He is an ordinary spectator who takes pleasure in looking at Daisy, just as we do. Then it may well strike us that this ordinary viewer

might not be so innocent after all. Perhaps no viewer is. The passage does not declare the lodger to be an embodiment of pure Evil, but neither does it declare him to be innocent. Rather, it opens our eyes to the fact that we do not really know him. For all we know, these shots are saying, this subject of the camera—any subject of the camera—could be a murderer. In the face of the camera the lodger is only a human being, as we are, not the embodiment of an occult, supernatural force. But to be human is to be capable of murder.

3

"I Don't Like Murderers"

The failures of trust and acknowledgment around which remarriage comedies revolve are acts of violence. As Cavell puts it in *Cavell on Film*: "In our slights of one another, in an unexpressed or disguised meanness of thought, in a hardness of glance, a willful misconstrual, a shading of loyalty, a dismissal of intention, a casual indiscriminateness of praise or blame—in any of the countless signs of skepticism with respect to the reality, the separateness, of another—we run the risk of suffering, or dealing, little deaths every day" (340).

In comedies of remarriage the outcome of a failed marriage is divorce. In Hitchcock thrillers the worst case scenario is murder. Divorced couples can remarry, but murder—divorce Hitchcock style—is final. To transform their marriage into a relationship worth having, Lina (Joan Fontaine) and Johnnie (Cary Grant) in *Suspicion*, like the couples in remarriage comedies, have to overcome their failure to trust each other. But Lina also has to overcome a formidable obstacle, internal to her relationship with Johnnie, that the heroines of those comedies do not have to face—the all-consuming suspicion, which mounts throughout the film, that Johnnie is literally a murderer.

In *North by Northwest* Eve explains to Roger how she came to fall in with a murderer. She says that when she first met Phillip Vandamm she "saw only his charm." Vandamm is played by James Mason, so that charm is world-class. But Robert Donat in *The 39 Steps*, like Grant, is no less

charming. Henry Kendall and Leslie Banks play characters, in *Rich and Strange* and *The Man Who Knew Too Much* respectively, who are so charmless they appear self-evidently "what they seem," to borrow a phrase from the villainous Professor Jordan. (Both are so wooden that if Hitchcock had wanted them to give off sparks, he would only have had to rub them together.)

But Hannay is such a smooth talker, so adept at what the Cary Grant character in *North by Northwest* calls "expedient exaggeration," that it is almost imaginable that Hannay is the murderer Scotland Yard believes him to be, the murderer he jokingly pretends to be when he and Pamela, posing as a runaway couple, have no choice but to share a bed. Not that Pamela ever takes this possibility seriously enough to find herself actually imagining that he might murder her. When she half-jokingly calls him a "big bully," it is clear that she isn't afraid of him and never really was. What makes Hannay worthy of Pamela, what would have made Robert Donat as fit as Cary Grant to play the male lead in a Hollywood comedy of remarriage, cannot be separated from what it is about Hannay that makes Pamela more than willing to perform the leap of faith it takes for her to trust him.

If it is a defining feature of Hitchcock thrillers that their world contains a murderous villain who is a stand-in for the film's author, it is also a feature characteristic of Hitchcock thrillers—again, with exceptions that prove the rule—that before their protagonists can achieve a relationship worth having, they must prove themselves not to be guilty of murder. From "little deaths" rebirth is possible. Those who inflict "little deaths" can, in principle, be forgiven. But if Hannay were literally to murder Pamela, as at one point he pretends he might do, that act would literally be unforgivable. A murderer's victim is in no condition to forgive the murderer. Nor does any living person have the standing to forgive the murderer on the victim's behalf. (*Suspicion*'s previewed ending, in which Lina, believing Johnnie has poisoned her, forgives him for murdering her, is an exception that proves this rule.)

For the victim, murder terminates the cycles of death and rebirth that make it possible, in Emerson's view, for human beings to walk in the direction of the unattained but attainable self. Churchgoing Catholic that he was, Hitchcock may have believed that God can absolve even this mortal sin. But even though in his capacity as author Hitchcock wields a godlike power to punish or reward his films' characters, he does not have the power to grant absolution to murderers—even murderers who exist only

in the worlds of the films he authors. In *I Confess* (1953) Father Logan, in his capacity as a Catholic priest, receives a murderer's confession. But even if the actor who plays him had been a priest in "real life," as Montgomery Clift most certainly was not, the character he plays would not have the powers and authority that, in Catholicism, can be conferred only by the Church, which claims an apostolic succession that it traces back to Jesus, thus to God. In his role as author, Hitchcock casts himself as God, in effect, but—thank God!—that does not make him God. Within the world of a Hitchcock film—a world authored by a merely human artist, not by God (if there is a God)—no one—no individual, no institution—has the authority or power to act in God's name.

Within the world of a Hitchcock thriller, then, murder can never be absolved. Murder permanently fixes the identity of the murderer. Murderers are condemned never to become other than the murderers they are. By irrevocably denying another person the freedom to be reborn that, in Emerson's view, is a defining feature of being human, murderers forfeit their own freedom to change, hence their own humanity. If "each man kills the thing he loves," are we all murderers? Are we all condemned?

It is no wonder that Hitchcock thrillers, in which the protagonist's quest for selfhood often requires proving that she or he is not a murderer, raise age-old questions of moral philosophy. What, if anything, legitimizes taking the life of another human being? What, if anything, makes killing anything other than murder? How, if at all, does the act of killing change the person who performs that act? From the lodger, who is ready to kill the Avenger should he catch up with him, to Richard Blaney in *Frenzy*, who is kept from becoming a murderer only because it is a woman Bob Rusk has already murdered, not Rusk himself, whose body is hidden under those bedclothes, every Hitchcock thriller addresses such questions and meditates on their implications for the art of pure cinema as Hitchcock understood and practiced it.

For Hitchcock, the imperative of defeating the Nazis gave these questions about the morality of killing special urgency in the late 1930s and early 1940s, the way the imperative of abolishing slavery gave them special urgency for Emerson in the years leading to the Civil War (when he and Thoreau, apostles of nonviolence, found themselves defending John Brown's controversial and violent raid on Harper's Ferry). To defeat the Nazis, the Allies had to find it within themselves to kill. But if by killing we deny the humanity of our enemies, what, if anything, makes us superior, morally, to Nazis? Does killing murderers make us murderers?

In *Secret Agent*, made in 1936 but set during World War I, Richard Ashenden (John Gielgud)—a writer the British government falsely reports killed in order to employ him as a spy—watches through a telescope as the General (Peter Lorre), his sociopathic but strangely likable hit man associate, readies to kill the elderly man they believe to be the spy it is their mission to assassinate. Richard cries out, "Watch out, for God's sake!" But this is too little, too late, to stop the General from pushing the man over a cliff.

In the meantime Elsa (Madeleine Carroll), a newly hired agent whose assignment is to pretend to be Mrs. Ashenden, is having tea with the old man's wife. When she began her job, Elsa expected to find killing in real life even more thrilling than in books. But the sight of the man's cocker spaniel, inconsolable as if already mourning the master fated never to return, awakens Elsa to the true dimension of killing.

When he discovers that the General had mistakenly killed an innocent man, Richard muses bitterly to Elsa, "I was there, all right. A half-mile away, at the other end of a telescope. Just one of those long-range assassins. That doesn't make it any better, does it?" And does it "make it any better" that we watch the killing on film, from a place outside the projected world? Are we "long-range assassins," too? Is Hitchcock, watching from a place on the other side of the camera?

"I don't like murderers," Elsa says. "Can't we give it all up?" Richard responds. "Would that make any difference—to us?" Nodding, she kisses him, wordlessly imposing it as a condition of their continued relationship that they both give up their jobs and vow never again to be party to killing. Richard agrees, but later he insists on following a clue he hopes will lead him to the real spy so that this time the "right" man can be killed. True to her principles, Elsa walks out on Richard. She goes off with Robert (Robert Young), an American waiting in the wings. But then Richard discovers that Robert is the spy.

On a train passing through enemy territory, Richard and the General catch up with Elsa and Robert. Richard is about to kill Robert, but Elsa pulls a gun on Richard, saying, "I'd rather see you dead than do this." She is threatening to kill the man she loves to keep him from killing a spy, even though letting that spy live would likely cost thousands of British lives. By utilitarian standards, Richard would be doing a good thing by killing Robert, since stopping thousands of people from dying promises the greater good for the greater number than letting one man live. But Elsa isn't thinking like a utilitarian. To her way of thinking, it would be an act of murder for Richard to kill Robert, no matter how desirable the consequences. By

Kantian standards, the fact that thousands would otherwise die is irrelevant, morally speaking; killing another human being is always a violation of the Moral Law. For Kant it would be no less morally wrong, no less forbidden, for Elsa to kill Richard in order to keep him from killing, than for Richard to kill Robert. But Elsa isn't thinking like a Kantian, either. She is thinking like an Emersonian perfectionist. She would kill Richard to keep him from performing an act that in her eyes would make him a murderer, and thus would forever keep him from changing, keep him from becoming, keep him from walking in the direction of his unattained but attainable self.

Elsa doesn't like murderers. She doesn't want to be the kind of person who would let the man she loves become a murderer. Of course, she no more wishes to kill Richard than she wishes for him to kill Robert. She hopes that her threat, or vow, will provoke Richard to open his eyes to the true dimension of killing and thus keep both of these killings from happening. But if she does have to kill Richard—if she believes that killing Richard is a step she must take to continue walking in the direction of the unattained but attainable self—this act of killing would not, in her own eyes, be murder.

At this intractable impasse, Hitchcock makes an executive decision that renders these questions moot. Hearing bombers overhead, the General says, in Peter Lorre's inimitable manner, "Accidents. Most convenient coincidences." Rolling his eyes not so much heavenward as cameraward, he adds, "Heaven is always with a good cause. " "I think we can forgo the Thanksgiving service," Robert quips just before a heaven-sent—or, rather, Hitchcock-sent—bomb derails the train, pinning the American in the wreckage. Richard reaches out to strangle Robert but finds he cannot bring himself to perform the act that would make him a murderer in his own eyes, not only in Elsa's.

The General, who enjoys killing, doesn't think in moral terms at all. He picks up the gun and is more than willing to kill Robert. First, however, he puts down the weapon to light a cigarette for his intended victim, toward whom he feels no animosity. Although already mortally injured, Robert picks up the gun and gratuitously shoots the General to death. Utterly indifferent to this man's fate, Robert dies. But Robert's blood is on the hands of no one but the film's author, the "long-range assassin" who arranged for the bomb to drop. It is the film's author who kills Robert. In Hitchcock's eyes, is this murder? Does it make Hitchcock a murderer? And do these questions even make sense, given that this is a movie, not reality, hence that when Robert is killed, no one really dies?

Secret Agent ends with the Home Office receiving a postcard with the handwritten message "Never again" and signed "Mr. and Mrs. Ashenden," with the beaming couple, their sham marriage now transformed into a legal one, superimposed over the postcard. Evidently, Richard and Elsa are now walking together in the direction of their unattained but attainable selves. But to achieve a relationship worthy of a comedy of remarriage, they have found it necessary to repudiate the world of the Hitchcock thriller, a world that revolves around murder. "Never again," they've written on the postcard. They have exited that world, vowing never to return.

Not so Hitchcock.

Sabotage, too, revolves around murder, but it gives *Secret Agent* a dialectical twist in the sequence in which Mrs. Verloc (Sylvia Sydney), with our approval and Hitchcock's, stabs to death her husband (Oscar Homolka). Once he reaches for the knife, the die is cast, and she has no choice but to grab it first and stab him with it. Otherwise, he will kill her. We know this because Hitchcock's camera makes sure that we notice that her husband notices the way she looks at the knife just before picking it up.

The thought of killing first enters her mind, then jumps to his. And it enters her mind because she wishes for him to die. She wishes for him to die not simply because he made her little brother carry the bomb whose untimely explosion claimed his life. She wishes for him to die because his words and actions betray his utter indifference to the boy's death. All he wanted to talk about, when he sat down to dinner, was how he likes his cabbage to be cooked. So now his goose is cooked. His utter lack of regard for human frailty makes him so loathsome in his wife's eyes that she no longer sees him as a person. This frees her to pass judgment on him without violating the Emersonian principle that "the time to make up your mind about people is never." It also frees her to kill him without believing that this makes her a murderer. She does not want to be the kind of person who would let such a monster live.

Nonetheless, we do not know whether Mrs. Verloc would actually have killed her husband were it not for her recognition of his recognition of the way she looks at the knife. Hitchcock cuts to a shot of the knife a moment before she looks at it. The camera's gesture thus appears to cue, rather than simply register, her glance.

Does this shot then register her thought, not her action? But it is also as if by this cut Hitchcock calls the knife to her attention—as he calls it to our attention—and by this means provokes her to think of killing her husband. In Hitchcock's films the camera often seems to call forth a character's

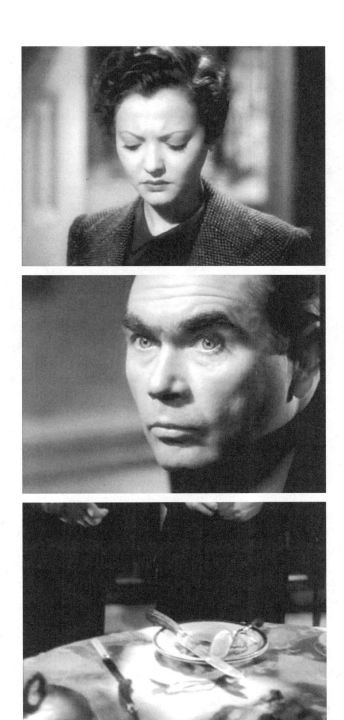

Figure 3.1

Figure 3.2

thought—to plant a thought in the character's mind, or to awaken a thought already there, below the threshold of consciousness.

As in *Secret Agent*, the film's author—that "long-range assassin," Hitchcock—makes a killing happen. In *Sabotage* Hitchcock intervenes, this time more subtly, by using the camera not to follow but to lead the exchange of glances that provokes Verloc to reach for the knife, giving his wife no choice but to grab it first. Hitchcock's intervention allows her to kill her husband, as she had wished to do, but to kill him in self-defense, thus without committing what the law deems to be the crime of murder. (Whether she really kills him to keep him from killing her or [also?] to satisfy her wish for him to die is a question that only God—not even Mrs. Verloc herself, and not even Hitchcock—has the ability to answer.)

Nonetheless, like young Charlie (Teresa Wright) at the end of *Shadow of a Doubt*, or Eve (Jane Wyman) at the end of *Stage Fright*, Mrs. Verloc is saddened and chastened. She is saddened by her brother's death and by the knowledge that there exist in the world monsters like her husband, human beings who forfeit their humanity by having no regard for the humanity of others. She is chastened by the knowledge that in repudiating her husband's

inhumanity, she found within herself the willingness, and the ability, to kill.

Hitchcock no more condemns Mrs. Verloc for thinking that she can kill her husband without becoming a murderer than he condemns Elsa for thinking that it would be murder for Richard to kill Robert. Both women think like Emersonian perfectionists, and Hitchcock respects them for this. In both films, however, he intervenes.

In *Secret Agent* Hitchcock's intervention frees Elsa from the need to kill, thus leaving it a pointedly unanswered question whether killing another human being is ever anything but murder. In *Sabotage* Hitchcock intervenes to force Mrs. Verloc's hand, to make her do what she wishes to do (what Hitchcock wishes her to do, what we wish her to do). His intervention leaves her no choice but to kill, at least if she values her own life.

4

Little Deaths

In suggesting that an Emersonian moral outlook was in ascendancy in Hollywood from 1934 to the eve of America's entrance into the Second World War, I don't mean to oversimplify the complex ideological currents that were then swirling around, and within, Hollywood. There are tensions or contradictions within many late-1930s Hollywood films. Not even all prewar comedies of remarriage are as consistently Emersonian as the films Cavell studies. And by 1938 a campaign could be mounted with some effectiveness that charged Katharine Hepburn with being "box-office poison." *Bringing Up Baby*, so beloved today, was a commercial flop. *The Philadelphia Story*, a box-office success for MGM, was made starring Katharine Hepburn and directed by George Cukor (whom David Selznick had fired from *Gone with the Wind* [1939] the year before) only because Hepburn (for whom Philip Barry, a student of George Pierce Baker, had written the Broadway hit) had bought the rights to the play and thus had leverage to force the studio to produce the film on her terms.

In any case, by 1940, the year Hitchcock made his first film in America, the period when Emersonian perfectionism was in ascendancy in Hollywood was ending. And the Second World War fundamentally changed American cinema. The Hitchcock thriller was a crucial catalyst—*Citizen Kane* (1941) and the rise of Billy Wilder were others—of the sea change that was to make most postwar Hollywood movies—Hitchcock's own films are among the exceptions that prove the rule—so much less rich, so

much more strange, and so much more stereotyped with regard to gender roles, than those of the 1930s.

Had Hitchcock arrived in America after making *Rich and Strange* and been handed Robert Riskin's script for *It Happened One Night*, he could not have made a Hitchcock thriller from it. (Where is the villain? Where is the stand-in for the film's author? Where is the protagonist who has to prove that he or she is not a murderer?) By the end of the decade, however, Selznick could lure Hitchcock with a hot property—Daphne Du Maurier's best seller *Rebecca*—from which the director could make (after an epic war of memos, to be sure) a Hollywood film that was also a Hitchcock thriller. Hollywood and Hitchcock could not have met each other halfway if both had not already changed, were not already changing, in ways that *Rebecca* at once reflected and helped provoke.

I am aware that the ending of *Rebecca* has been interpreted as the restoration, and affirmation, of patriarchal marriage. Yet in the end Manderley, symbol of patriarchal values, is burned to the ground, never to rise again—except in the Joan Fontaine character's dream, a dream represented, rhetorically, by Hitchcock's film. And that film ends with the explicit declaration that Manderley is gone. The burning of Manderley confirms that the protagonist's marriage can no longer be characterized as patriarchal. Once the cloud of suspicion that Maxim (Laurence Olivier) had murdered his first wife is lifted—in no small part because the "new Mrs. De Winter" keeps a level head during his trial—the film's ending asserts that the couple's marriage has been transformed into a relationship of equals in the spirit of remarriage comedies. Then again, as Hitchcock's camera moves from a long shot of the burning Manderley into Rebecca's room, to her bed, then to the *R* embroidered on her pillowcase, that *R*, even as it is being consumed by flames, fills the frame—like the "TONIGHT GOLDEN CURLS" sign at the end of *The Lodger*—casts doubt over this affirmative conclusion.

In their battles over *Rebecca*, Hitchcock was not simply the subverter, nor Selznick the upholder, of the Emersonian outlook the producer had once championed. After all, Selznick had recently removed the great George Cukor, Hollywood's renowned "woman's director," from the set of *Gone with the Wind*, and replaced him with Clark Gable's favorite director, Victor Fleming (who was, in all fairness, extraordinarily accomplished in his own right). Indeed, *Gone with the Wind*, whose phenomenal commercial success eclipsed even that of *It Happened One Night*, definitively signaled the turning of the tide.

Rhett Butler's refusal to forgive Scarlett O'Hara at the end of *Gone with the Wind* is based only on a misunderstanding. He believes that when she was delirious with fever, she never called for him and that this proves she didn't—and doesn't—love him. Since she was delirious at the time, even Scarlett doesn't realize that she did call for him but at an inopportune moment, when no one happened to be within earshot. For us, in any case, whether or not she called for him is a moot question, since we have no doubt that she really loves him now. Rhett's refusal to forgive Scarlett reflects an unwillingness or inability to acknowledge the truth about her—and about himself.

By the Emersonian moral standard of comedies of remarriage, Scarlett should only want to take Rhett back—we should only want her to want him back—if he changes, if he opens his eyes, awakens to the truth, as she has. The film's ending is a perfect example of having one's cake and eating it, too. Scarlett famously embraces the principle that "tomorrow is another day," that she can have faith in herself even if the man she loves has no faith in her, that his walking out on her doesn't mean that she can no longer walk in the direction of the unattained but attainable self. But what precipitates this realization is hearing the voice of her dead father, as Max Steiner's romantic "Tara" theme swells in the background, declaring that the land she owns, in its permanence, means more to her, and should mean more to her, than any mere human being, including Rhett—and including herself. This is a piece of claptrap that would have been anathema to Emerson, as it must have been to Cukor.

A year before *It Happened One Night*, Cukor, who had directed his first film in 1930 after earning a strong reputation as a stage director, directed Katharine Hepburn as Jo in Selznick's production of *Little Women* (1933). Arguably, it was in this film—whose narrative, anchored by Jo's uncompromising commitment to growing as a human being, concludes with her achieving a marriage to a man who desires to facilitate her education—that the Emersonian worldview exemplified by comedies of remarriage first emerged full-blown in the American cinema. Always respectful of literary texts, Cukor worked with the several screenwriters who had a hand in the adaptation to assure that *Little Women*'s screenplay was true to the spirit of Louisa May Alcott's enduringly popular and thoroughly Emersonian novel. Bronson Alcott, the novelist's father, was a member of the Concord circle of transcendentalists, and Emerson's way of thinking about morality, and about human relationships in general, infuses every scene of Cukor's film, as it infuses every page of Alcott's novel.

"Every art, every worthwhile human enterprise, has its poetry," Cavell writes, "ways of doing things that perfect the possibilities of the enterprise itself, make it the one it is."[1] (Or, as Emerson puts it, "There is always a best way of doing everything, if it be to boil an egg.")[2] Film is a worthwhile human enterprise that achieves its particular poetry when it achieves the perception of what Cavell calls the "poetry of the ordinary"—the perception that "every motion and station, in particular every human posture and gesture, however glancing, has its poetry, or you may say its lucidity."[3] Few directors were Cukor's peers in achieving such poetry or lucidity. Every moment Katharine Hepburn is on the screen in a Cukor film—or Greta Garbo, Cary Grant, Ingrid Bergman, Spencer Tracy, Judy Holliday, Judy Garland, or so many other stars he directed—the good of humanity, what Cukor called the "grace of dignity," shines through.[4]

Cukor understood such grace to be a function of respecting one's own humanity, and the humanity of others, by doing one's best to avoid committing those slights of others—ordinary ones, as well as extraordinary ones—by which we risk suffering, or dealing, "little deaths" every day. And yet Selznick had come to doubt the ability of the director—who remained true to his Emersonian faith throughout his illustrious Hollywood career—to create characters with whom the contemporary American viewers the producer was aiming to reach could identify.

After he read Hitchcock's initial treatment for *Rebecca*, Selznick began to doubt the ability of his highly regarded British import, too, to reach the audience the producer had taken to characterizing, patronizingly, as "shop girls." Selznick had become an apostle of a new Hollywood that was beating a hasty retreat from the Emersonian principle that "the time to make up one's mind about people is never." To pigeonhole women as "shop girls" is to make up one's mind that their identities are already known and fixed. Nothing could be more un-Emersonian. And nothing could be more un-Hitchcockian. Hitchcock does not look down on the women in his films. Nor does he look down on his films' viewers.

To be sure, even the definitive remarriage comedies Cavell singles out have moments that are difficult to align with the genre's Emersonian worldview. I am thinking, for example, of the moment in *The Philadelphia Story* when Seth (John Halliday), Tracy's father, says to his wife (Mary Nash), "That's very wise of you, Margaret," after she agrees that his dalliance with a young dancer is not really her concern. We can question whether she is wise to accept her husband's relationship with the dancer, especially because his tone is so paternalistic when he claims the authority to judge his

wife's wisdom, taking his own wisdom for granted. Two points, though, mitigate the film's evident approval of Seth's position. One is that Dexter, the Cary Grant character, is accepting of the mutual attraction between his ex-wife, Tracy (Katharine Hepburn), and Connor (James Stewart) and even the possibility that they had sex after the party. This suggests a line of defense against the charge that the film condones a double standard. Nonetheless, perhaps to appease the Hays Office, the screenwriter found it necessary—I wish he hadn't—to incorporate unchallenged assertions that both Tracy's fling with Connor and Seth's relationship with the dancer were chaste, or, at least, that both pairs stopped short of having sex. In Tracy's case this was not because she and Connor lacked the desire to make love but because she was under the influence of all those glasses of champagne she kept downing, and, as Connor puts it, "There are rules about such things." (Whether or not this is a line in Barry's play, in the film I hear it as incorporating a sly allusion to the Production Code.)

At a decisive moment in Jean Renoir's *The Rules of the Game* (1939), we are as disappointed as Christine is when André appeals to rules when she hoped he would run off with her, rules be damned. In Hollywood comedies of remarriage, Cavell argues, it is a "law of the genre" that the man must claim the woman, as Dexter does when he punches Connor in the jaw. When Connor later proposes to Tracy, however, Dexter is silent, acknowledging that it is up to her to decide whether to accept this proposal. To be sure, he knows that Tracy will turn Connor down if she has changed in the way he believes she has. If she accepts the proposal, Dexter will know that she is not the woman for him after all. This, too, is a "law of the genre." Such "laws" reflect the fact that in our culture marriage, unlike friendship, is an exclusive relationship. One can only be married to one person, a person to whom one vows fidelity. But what constitutes fidelity, given the genre's view that it is no concern of Dexter's whether Tracy and Connor had sex and that Seth's "philandering" is not a betrayal of his wife's trust?

This is a central question in *The Awful Truth*, a question Hitchcock's *Mr. and Mrs. Smith* expands upon. *Mr. and Mrs. Smith* provides another fascinating glimpse into the intricacies of Hitchcock's efforts to find common ground with a changing Hollywood. Generally dismissed as a failed venture into alien romantic comedy territory, it was, for all its weaknesses, a plausible, challenging experiment for Hitchcock to make a film that is explicitly a comedy of remarriage, not a Hitchcock thriller.

Norman Krasna's screenplay for *Mr. and Mrs. Smith*, closely modeled on *The Awful Truth*, revises Leo McCarey's classic remarriage comedy in

ways that shrewdly provide opportunities for Hitchcock's camera to take an active role, as in the nightclub sequence that mimics the one in *The Awful Truth*, and in the bedroom sequence that opens the film, which establishes that Ann and David Smith (Carole Lombard and Robert Montgomery) already have a marriage they define in terms explicitly drawn from remarriage comedies.

"Respect for each other as a person, that's our trick," Ann says as she is shaving her husband's throat with a straight razor. "I think we'd be friends if we were man or woman, don't you? Respect for each other as individuals, that's what counts. Always tell the truth no matter what the consequences. . . . If we told each other just one lie, we'd have to admit that we'd failed, wouldn't we?" "Uh huh," David answers dully, the first intimation that he has come to regard such a principle as a drag. "And what would we have left?" she goes on. "Marriage like other people's. Doubt. Distress. Going on with each other just because it's the easiest way."

Citing Rule Seven, and overriding his reluctance to follow this rule by saying, "If we give up one [rule], we're giving up that much of our wonderful relationship," she asks him, point blank: "If you had it all to do over again, would you have married me?" He responds: "Honestly? No. Not that I'd want to be married to anyone else, but I think when a man marries, he gives up a certain amount of freedom and independence. If I had it to do all over again, I think I would stay single. Forgive me. Say you forgive me. Now can I go to work?"

The Emersonian perfectionist moral outlook the couple embraces at the end of *The Awful Truth*, when they both claim to be—and are—different, and claim to be—and are—committed this time to a different kind of marriage, deserves to be mocked, *Mr. and Mrs. Smith* implies, when marriage is reduced to conforming to a set of rules. Why should a man give up his freedom, his power, only to be bound by rules?

Later that day, David learns that owing to a technicality he and his wife are not legally married. In the definitive remarriage comedies Cavell studies, the couple breaks up not because of a mere technicality but because both the man and the woman believe that a principle has been violated—a principle so important that even though they are married according to the laws of the state, their relationship does not constitute a true marriage. And they get back together when they begin to think in a new way about each other, about themselves, and about marriage. At stake is a way of thinking about marriage and about human relationships in general to which these films are committed. Is this true of *Mr. and Mrs. Smith* as well?

When Ann discovers that David had learned they weren't legally married without telling her what he had come to know, she doesn't tell him what she has come to know. Rather, she waits hopefully—or passive aggressively—for him to propose to her again that evening. As it becomes clear that he intends not to tell her they aren't legally married so he can enjoy the thrill of illicit sex with his own wife, she explodes, and they separate. Now that she is available, Jeff (Gene Raymond), David's office colleague, begins courting Ann, and David becomes jealous. When this rival for Ann's affections, to whom she is at first drawn because he has the manners of a gentleman, refuses to fight David to claim her, she rejects him.

A man who won't fight is not a real man, Ann and David agree, hence is unworthy of a real woman, which Carole Lombard certainly is. Yet being willing to fight, even loving a good fight, is as much in Ann's (and Lombard's) nature as in David's. It is not conversing together, as in *The Awful Truth*, but fighting together that makes the Smiths feel, in the end, that their relationship is a true marriage. They do not learn to forgo lies and deception. What they learn is to forgo making "Thou shalt not lie" a rule. Hence the final image of the film—Hitchcock gives his camera the last word—captures Ann's crossed skis suggestively rubbing together as the lovers engage in hanky-panky below the frame line. But they also form a cross, as if she were crossing her fingers to indicate that the real truth of their marriage is that it is based on lying.

In its nightclub sequence, closely modeled on the one in *The Awful Truth*, *Mr. and Mrs. Smith* commits a serious error, however, judged from the moral standpoint of the remarriage comedy genre. In *The Awful Truth*, Lucy Warriner (Irene Dunne), separated from her husband, Jerry (Cary Grant), observes that Dixie Belle Lee (Joyce Compton), with whom Jerry has been keeping company, "seems like a nice girl." (She seems nice to us, too.) Both Lucy and Jerry recognize that by society's standards it is embarrassing for him to be seen with a nightclub singer who specializes in a racy "wind effect." But Lucy and Jerry have never judged people that way. When Lucy later does her own comical rendition of Dixie Belle's signature number, she is acknowledging their kinship, not mocking her. She is mocking Jerry's intolerant fiancée and her family, the very personifications of puritanical, hypocritical society, and Jerry himself for imagining that this snobbish society woman is his equal, spiritually or morally.

In the corresponding scene in *Mr. and Mrs. Smith*, David himself feels embarrassed to be seen in the company of the blind date with whom his friend has fixed him up. He feels embarrassed not only because he believes

Figure 4.1

that Ann would look down on such a woman but because *he* looks down
on her. David's attitude reveals a streak in his character that makes him—
unlike Jerry in *The Awful Truth*—unworthy of our full sympathy. It is in-
ternal to the moral outlook of the remarriage comedy genre that in every
social class there are good people and bad. Amusing as this passage in *Mr.
and Mrs. Smith* is, it strikes a jarring note. Nor is this an isolated moment.
Throughout the film Robert Montgomery's David, like many characters
this prolific and gifted but not especially appealing actor played in the
1930s, is unlikably smug; he is more than satisfied with himself as he is and
has no wish to change. Nor do we particularly like Ann, his screwball wife,
as Carole Lombard plays her.

I find Robert Taylor in the generally weak *Remember?* (Norman Z.
McLeod, 1939) and Melvyn Douglas in the superior *Theodora Goes Wild*
(Richard Boleslawski, 1936) to be unpleasantly smug as well. In truth, very
few male actors of the period had what it takes to be a convincing remar-
riage comedy lead. Cary Grant was ideal. Henry Fonda, Gary Cooper, James
Stewart, and Clark Gable, too, proved capable. To this group I would
add Herbert Marshall, Joel McCrea, and, of course, William Powell, that

nonpareil among male stars of the 1930s. By contrast, virtually all the major female stars of the 1930s—even Greta Garbo—seemed to take naturally to their roles in such comedies. (Joan Crawford is a notable exception.) Among these women Carole Lombard is universally considered the quintessential "screwball comedy" heroine. It was, indeed, the great commercial and critical success of *My Man Godfrey* (Gregory La Cava, 1936) that brought the term *screwball comedy* into common parlance. In retrospect, however, the wholesale adoption of this term was a harbinger of the impending decline in Hollywood of the Emersonian worldview.

Screwballs are like curve balls, except they break in the opposite direction. Insofar as the term is applied in a way that suggests that screwball comedies are themselves screwballs, figuratively speaking, I have no problem with it. Typically, though, the implication is that screwball comedies revolve around at least one character who is a screwball, such as Susan, the Katharine Hepburn character in *Bringing Up Baby*. Screwballs are not merely eccentric; they have a "screwy" way of thinking. Chico Marx would be an exemplary screwball, except that the word is exclusively reserved for women. The implication is that women are incapable of rational thought; their inscrutable minds have their own illogical logic, but it is not to be confused with rationality. On the positive side, screwballs, like Shakespeare's Fools, are unrestricted by what men call "reason." Thus they can feel more deeply and intuit more clearly, not about matters of fact but about matters of the heart.

I admire Carole Lombard—who doesn't? Hitchcock surely did—but I find her screwball roles troubling. For one thing, I cannot believe it when this obviously highly intelligent—I mean, rational—woman speaks and acts in the "screwy" way she does in *My Man Godfrey*. Irene (the Lombard character) belongs to a dysfunctional family of wealthy misfits. Unlike the family of lovable eccentrics in Frank Capra's *You Can't Take It with You* (1938), the Bullock family appears to be so wealthy it is unaffected by the Depression. (The father knows that the family's finances are precarious, but he keeps this a secret from his wife and daughters.) Like Ellie in *It Happened One Night*, Irene can seem "spoiled." Yet, as Ellie asks, how can she be spoiled if she never gets what she really wants? Irene is genuinely spoiled, though. Eventually, she gets her way and gives Godfrey no choice but to marry her. But will their marriage be a relationship worth having? It is obvious why Lily loves Godfrey; he is William Powell. But although Lily is kindhearted and is graced with Carole Lombard's cheekbones and sparkling eyes, it is not believable that a character incarnated by William Powell

would—or could, or should—fall in love with a woman so "screwy" she cannot possibly hold her own in the kind of conversation the couples in remarriage comedies enjoy, a conversation of equals with the moral purpose of furthering mutual acknowledgment and self-knowledge.

Although Gracie Allen generally played herself (when I was growing up, I might easily have imagined that she was rather channeling my Aunt Ida), we never mistake the real Gracie Allen for the screwball she played so cleverly in movies, as well as on radio and television. Nor do we mistake the real Katharine Hepburn for Susan in *Bringing Up Baby*. Or, rather, insofar as we do recognize that Susan is Kate, we recognize as well that Susan is a performer, just as the actress who incarnates her is (and, we might add, we also recognize that Kate has a sense of the absurd, just as Susan does). The film's few close-ups of Susan (that is, of Hepburn) reveal that she is not really, or simply, the screwball she appears to be. Playing a screwball is internal to Susan's perfectly rational plan to keep David close by her side until he realizes that he has fallen in love with her.

When Carole Lombard plays screwballs, however, these characters really are "screwy." Ann, in *Mr. and Mrs. Smith*, all but entirely lacks the intelligence and depth revealed in the star's glamorous studio portraits, which project an unfathomable innerness, an unknownness, that rivals that of Greta Garbo and Marlene Dietrich.

Garbo and Dietrich project those same qualities in their films, as well as their still photographs, but only rarely is Lombard in her screwball roles empowered to acknowledge the innerness that shines through in her still photographs. One such moment occurs in *Twentieth Century*, when Lily, in the throes of a heated argument with Oscar, pulls back and, framed in close-up, simply marvels at his—Oscar's, John Barrymore's—stupendous theatricality. In the delicious smile that she is trying her best to suppress, we glimpse in Lily Garland the "real" Carole Lombard, glimpse what Oscar/Barrymore and director Howard Hawks saw in her.

At this moment we recognize that Lily, like Susan in *Bringing Up Baby*, is not really "screwy"; she possesses a self-awareness she only pretends to lack. *My Man Godfrey*, however, and the equally famous *Nothing Sacred* (William Wellman, 1937)—and, sadly, *Mr. and Mrs. Smith*—fail to grant Lombard a single moment of such innerness. Undermining the principle that the medium of talking pictures is best served when stars speak in their own ordinary voices, these films deny who this star really is. They give Lombard no choice but to lend herself to a pernicious view of women that clashes with the Emersonian outlook that underwrites the remarriage comedy genre.

This is precisely the view of women that Peter in *It Happened One Night* pretends is his own when he answers Ellie's "What are you thinking?" by all but spitting out the words, "I was wondering what makes dames like you so screwy!" Of course, at that moment it is Peter, not Ellie, whose thinking the film judges to be "screwy." The radiant close-up that follows, of Ellie pondering what underlies Peter's screwball logic, is *It Happened One Night*'s ultimate rebuttal to the view that women are incapable of rational thought. All the films Cavell considers to be definitive remarriage comedies similarly rebuke that view of women. So do the thrillers in which Hitchcock speaks fully in his own voice. *Mr. and Mrs. Smith* does not.

Mr. Deeds Goes to Town (Frank Capra, 1935) has a different word for "screwy" thinking. That word is *pixilated*. Crucially, the film contests the idea that some people are pixilated and others not. The film's point is that all people are pixilated; each is eccentric, individual, different from others in his or her own way. To be a human being is to be pixilated. To think is to be pixilated. The term *screwball comedy* suggests, patronizingly, that screwballs are aberrant (even if, like Native Americans when they are viewed as "noble savages," they are taken in certain limited respects to be superior, not inferior, to "normal" people). The term does not acknowledge the philosophical depth of the best romantic comedies of the 1930s, the radicalness of their Emersonian aspiration to "unsettle all things."

Saddled with such unlikable protagonists, *Mr. and Mrs. Smith* falls flat as a romantic comedy. Lacking magic, it fails to put us in a festive mood, as the best comedies of remarriage do. Does this mean that the film is an inferior comedy of remarriage? Or does it mean that the film does not earn, or does not seek, membership in the genre at all?

During the wartime and postwar years, the films Kathrina Glitre calls "career woman comedies"—for example, *Woman of the Year* (George Stevens, 1942), *Take a Letter, Darling* (Mitchell Leisen, 1942), *She Wouldn't Say Yes* (Alexander Hall, 1945), and *Without Reservations* (Mervyn LeRoy, 1946)—effectively supplanted comedies of remarriage on American movie screens.[5] Although the genres share many features, there is a glaring ideological difference between them. The "career woman," in learning to accept herself as a woman, embraces domesticity and motherhood as well. *Woman of the Year*, in many ways a wonderful film, genuinely seems to set out to humiliate its leading woman—she is Katharine Hepburn no less—and to do so not, as in *The Philadelphia Story*, in order to help her to awaken in the Emersonian sense, to open her eyes to her own wish to become more fully human, but, rather, to make her conform to an essentialist view as to which

forms of life are, and which are not, appropriate for women—as if for a woman to pursue a career, cultivate herself by learning nine languages, and appreciate her accomplished stepmother is for her to repress her feminine nature, to deny what makes a woman a woman. A woman's nature is best reflected, these films assert, by loving a man and by embracing the life of domesticity—literally in the kitchen—and motherhood that "naturally" follows marriage. In comedies of remarriage the narrative revolves around the creation of the woman, her quest to walk in the direction of the unattained but attainable self. In the career woman comedies of the wartime and postwar years, the woman's rebirth is aborted.

The Philadelphia Story may seem ideologically akin to such films, in that it revolves around Tracy's coming to acknowledge her sexuality, the fact that she is a flesh-and-blood woman and not a chaste goddess or a cold, unyielding statue. But Tracy is not tamed or broken when she learns to stop passing judgment on others for their frailties and learns to acknowledge her humanity and the humanity of others. There is no implication that Tracy comes to accept roles that are proper only to women. Her goal, and that of the men who lecture her (other than her fiancé, George Kittredge (John Howard), that is), is not to make her fit for domesticity and motherhood. It is her nature as a human being, not her special nature as a woman, that they want her to stop denying. Part of what she thereby acknowledges is what might be called the feminine side of her nature, but that does not set her apart from men. In comedies of remarriage, men as well as women, in their quest to become more fully human, find it necessary to acknowledge the feminine side, as well as the masculine side, of their natures.

The difference between a remarriage comedy and a 1940s career woman comedy is not like the difference between a comedy of remarriage and an unknown woman melodrama. The latter two genres share an Emersonian moral outlook. But career woman comedies fail to achieve—indeed, they reject or repress—that philosophical perspective. It is a mark of achievement for *Adam's Rib* that, uniquely among career woman comedies, it finds a way to affirm, in the uncongenial climate of the late 1940s, the Emersonian perspective that had been in ascendancy in prewar Hollywood.

As Cavell observes, in a comedy of remarriage the action characteristically moves, at a point when the couple's conflicts seem irreconcilable, to the place, or no place—in *A Midsummer Night's Dream* it is a moonlit forest outside Athens; in romantic comedies of the 1930s it is usually called "Connecticut"—where magic is real. In *Adam's Rib*, when the couple pays

off the mortgage on their summer home in Connecticut, making their shared dream come true, this ratifies their aspiration to make the Shakespearean "Green World" an everyday part of their lives. Postwar America spawned the growth of suburbia, as if by moving to the real Connecticut Americans could fulfill the utopian aspirations that underwrote, and were underwritten by, prewar Hollywood movies. But suburbia was a trap, as film noirs and Douglas Sirk melodramas were not alone in recognizing. Suburbia proved a cunning instrument not for marrying urban and small-town or rural America, day and night, men and women, as remarriage comedies envisioned, but dividing them. Rather than joining men and women in marriages that acknowledge their equality without denying their differences, suburbia locked women into the domestic realm while it accorded men—but not women—public identities. In these ways and more the reality of suburbia stood in opposition to Hollywood's Emersonian aspirations of the 1930s, which it precisely denied, that is, repressed.

Insofar as it is concerned with demonstrating that rules—vows, promises, moral laws—do not a true marriage make, *Mr. and Mrs. Smith* does align itself with the Emersonian outlook of the comedy of remarriage. Unlike the mismatched couple in *Rich and Strange*, Ann and David are worthy of each other. And they are walking together in the direction of the unattained but attainable self, although they are fighting every step of the way. Unlike career woman comedies, which retreated from, and repressed, the remarriage comedy's moral outlook, *Mr. and Mrs. Smith* respects the genre's Emersonian spirit by fighting it every step of the way.

Yet *Mr. and Mrs. Smith* is also ironic. The straight razor Ann holds poised at her husband's throat is one of the ways the film acknowledges, however jokingly, that their failures of trust aren't really funny. A slip of the hand, a sudden impulse, or an unexpected provocation can be all it would take to turn inflicting a "little death" into murder—all it would take to turn this comedy of remarriage—perhaps any comedy of remarriage—into a Hitchcock thriller. *Suspicion* takes this idea a step further by posing the question, which it ultimately leaves unanswered, of whether the film is a comedy of remarriage or a Hitchcock thriller.

Earlier, I observed that women like Barbara Stanwyck and Katharine Hepburn already projected in their pre-Code films the self-reliant spirit that equipped them to incarnate the heroines of remarriage comedies but that male stars like Clark Gable had to change. Cary Grant was exceptional in that he did not have to change his onscreen persona the way Gable did. Already in *Blonde Venus* (1932), in which he costarred with Marlene Diet-

rich under the inspired direction of Josef von Sternberg, Grant projected the distinctive kind of nonmacho masculinity that was to enable him to incarnate a man capable of being both a romantic hero and an "Emersonian sage," as Cavell describes Dexter, Grant's character, in *The Philadelphia Story*. He was *that* Cary Grant in *She Done Him Wrong* (1933) and *I'm No Angel* (1933) as well. That's what makes it so convincing when his costar, Mae West, expresses her desire for him to "come up and see" her sometime. This brave and brilliant woman from Brooklyn had made herself a star by re-creating herself as the "Statue of Libido" the public loved but the censors hated. No doubt she appreciated the fact that her costar, né Archibald Leach, a lower-middle-class English lad from Bristol, had re-created himself, just as she had. He had quite consciously endeavored to create "Cary Grant" out of the "stuff" of his own cockney self. Of course, Archie Leach could not have become Cary Grant, in his everyday life as well as in his films, had he not possessed matinee-idol looks. But neither could he have become Cary Grant had he not aspired to walk in the direction of the unattained but attainable self.

In *Pursuits of Happiness* Cavell demonstrates compellingly and in the old-fashioned way, that is, by exemplary acts of serious criticism, that a comedy of remarriage like *The Philadelphia Story* is, on one level, an allegory of the creation of a "new woman"—a woman worthy of marriage to a man like Cary Grant; on another level such a film is an allegory of the medium's own powers of creation, the camera's capacity to transform its subjects, to transform ordinary people into stars, and to reveal these stars to be representative human beings, such that beholding them we might be heartened, might find or refind the courage to pick ourselves up, dust ourselves off, and start all over again.

In Cavell's view *The Philadelphia Story* pointedly makes us recognize that the character Tracy is incarnated by a flesh-and-blood woman who really exists in the world; we see her do her own diving, for example. If the film is an allegory about Tracy's creation—about her metamorphosis from a statue or goddess into "a human, a human being," as she joyfully puts it at the end of the film—it is also an allegory about Katharine Hepburn's creation as a star, the metamorphosis effected by the camera.

Cavell does not understand *The Philadelphia Story* to be in the same way an allegory of the man's creation, which the film presents as happening offscreen, not accomplished by the camera. In comedies of remarriage there remains a mystery about such a man—about who he is, about how he comes to be who he is, about his creation. Was Archie Leach already a man

who "holds the holiday in his eye" and is "fit to stand the gaze of millions"—when he consciously set out to transform himself into Cary Grant? Did he ever stop being Archie Leach when he became the Cary Grant we know—or think we know—from his films? And do we really know Cary Grant? Do we know, for example, whether he is capable of murder? *Suspicion* is designed to pose, not to answer, these questions.

Does *Suspicion* "really" end with a murder, or does it end with a remarriage? Ultimately, the film is designed to leave this question pointedly unanswerable. Since it is a defining feature of the Hitchcock thriller that there is a murderer in its world, this means that Hitchcock also designs *Suspicion* to pose the question, which it likewise leaves unanswerable, whether the film itself is a Hitchcock thriller or a comedy of remarriage. *Suspicion* nurtures the doubt that *Mr. and Mrs. Smith* planted or unearthed within the comedy of remarriage, the suspicion that every member of the genre is, as it were, a closeted Hitchcock thriller. At the same time, *Suspicion* plants or unearths within the Hitchcock thriller the suspicion that within each member of that genre there is a remarriage comedy yearning to breathe free.

That it is impossible to decide whether *Suspicion* is a Hitchcock thriller or a comedy of remarriage does not mean there is no difference between the genres. Within the world of *Suspicion*, after all, Lina's life hinges on their difference. What real difference, if any, does that difference make? For Hitchcock, what hinges on this question is whether, in his role as author, he is fated always to kill the things he loves.

5

"The Time to Make Up Your Mind About People Is Never"

Several years ago, at a seminar at Columbia University, the ending of *Suspicion* was screened to a roomful of film studies scholars. At the moment Johnnie puts his arm around his wife, Lina, the audience snickered. They found it obvious, and delectable, that this gesture was a sinister prelude to murder.

In fact, nothing in Johnnie's gesture precludes our taking it at face value as affirming his renewed commitment to a marriage that had become poisoned by suspicion. Evidently, the audience wished to believe that Johnnie had murdered his lovable friend Beaky (Nigel Bruce) and intends his wife to be his next victim—as if it were cool of Hitchcock to unmask a Cary Grant character as a villainous murderer and cool of them to find this cool—one of the few perks of being a film studies professor, sad to say.

Johnnie's confession that he had been planning suicide offers a logical explanation for his increasingly suspicious behavior in the film. That this possibility had not even occurred to Lina highlights her failure to have enough faith in her husband to confide her suspicion to him. She stands in need of his forgiveness. He stands in need of her forgiveness, too, for failing to have enough faith in his wife to confide to her what was troubling him. Taken at face value, *Suspicion* has a happy ending, one that asserts that this man and woman finally attain the faith in the other and in themselves that Cary Grant characters achieve with the women they love in *The Awful Truth*, *Bringing Up Baby*, *The Philadelphia Story*, and (arguably) *His Girl Friday*—four films Cavell considers definitive comedies of remarriage.

Figure 5.1

But can we trust Hitchcock to trust us—and himself—enough to provide an ending we can trust? It is a Hitchcock practice that goes back to *The Lodger* to present a happy ending that intimates it is not the true ending. *Foreign Correspondent* (1940), for example, a film made a year before *Suspicion*, ends with the protagonist giving a radio speech in which he assures listeners that despite the Nazi conquests in Europe the light of liberty is still burning in America—even as the world on film fades to black.

If nothing precludes our taking Johnnie's gesture as reaffirming their marriage, nothing precludes our viewing it in a far more sinister light. Pointedly, *Suspicion* ultimately leaves unanswered whether Johnnie is a murderer or, rather, like the Cary Grant characters in *Notorious* and *North by Northwest*, overcomes his own dark impulses and becomes a man willing and able to commit himself to the kind of marriage that remarriage comedies envision.

Hitchcock shot at least two other endings for *Suspicion* and considered several additional alternatives as well. Diligent sleuthing, especially by Bill Krohn, has cleared away much of the confusion that has long surrounded these alternative endings.

In one early version Lina drinks the glass of milk she believes Johnnie has laced with poison. When she tells him she knows she is dying but wants him to know that she forgives him, he is shocked. He is not a murderer; the only thing harmful in that milk is cholesterol. But knowing that his wife thinks he is a murderer moves him to confess his many lies, both to her and to Beaky, and ultimately to acknowledge that he had been capable of murdering Beaky, whom he loved, and even capable of murdering Lina, whom he loves, as he puts it, "more than life itself." The scene fades out with Johnnie repeating, "You thought of me as your murderer!" and staring into the distance as Lina assures him that she knows now that he would have died for her, as she believed she was dying for him.

When the next scene fades in, Johnnie is gone, having left Lina a note saying that they will see each other again only if he finds a way to repay his debt to her. Lina has no luck tracking him down until, months later, a newspaper photo reveals that under an assumed name he has become a decorated Royal Air Force pilot. She visits him at his air base as he is about to depart on a bombing mission over Berlin. It is thanks to her, he tells Lina, that he has been able to be born anew. And he agrees to come to dinner if and when he returns from his dangerous mission. This ending asserts unambiguously that their marriage has been reborn, transformed into a relationship worthy of a remarriage comedy. To be sure, there is no guarantee that they will enjoy a happy future together. Remarriage comedies, too, never end with such a guarantee. But if Johnnie survives this mission, leg of lamb on Tuesday will certainly be an auspicious start (notwithstanding the episode of *Alfred Hitchcock Presents* titled "Lamb to the Slaughter," in which a leg of lamb provides the "heavy, blunt instrument" for a perfect murder).

Judged from the Emersonian moral standpoint of comedies of remarriage, however, this rejected ending is problematic. The problem resides in Lina's belief that her love for Johnnie requires that she let him murder her if that will make him happy, and in her willingness to forgive him on the ground that it is not because he hates her that he is murdering her. What she knows, or thinks she knows, is that Johnnie is incapable of hate—or love; he is a little boy who will never grow up, not a moral agent prepared to take responsibility for his actions. By making up her mind that he is incapable of changing, she violates the Emersonian principle that, as Tracy puts it in *The Philadelphia Story*, "The time to make up your mind about people is never." When Lina discovers that Johnnie is not a murderer, she pleads for forgiveness. And Johnnie undertakes to prove himself worthy of

her love by risking death to participate in the war against the Nazis. Lina and Johnnie both understand the measure of love to be the willingness to die. But in comedies of remarriage, the measure of love is the willingness to live—to embrace life together in a spirit of adventure.

In an interview published in the *New York Herald Tribune* (December 7, 1941—the ill-fated "day which will live in infamy"!) after *Suspicion*'s highly successful release, Hitchcock noted that some members of the initial preview audience "had laughed when Lina drank the milk, and that others complained about the long talky scene that followed." As Hitchcock observed at the time:

> Toward the end of the film Grant brings Miss Fontaine a glass of milk which she believes is poisoned. It seemed logical to me that she should drink it and put him to the test. If he wished to kill his devoted wife, then she might well want to die. If he didn't, fine and good; her suspicions would clear away and we'd have our happy ending. . . . She drained the glass and waited for death. Nothing happened, except for an unavoidable and dull exposition of her spouse's innocence. Trial audiences booed it, and I don't blame them. They pronounced the girl stupid to willfully drink her possible destruction. With that dictum I personally do not agree. But I did agree that the necessary half-reel of explanation following the wife's survival was really deadly[1].

And so Hitchcock filmed another ending. In Bill Krohn's words:

> A cutaway shows that the family dog is present in her bedroom when she starts to drink the glass of milk, and when she sets it down still not empty, Johnnie, with a remark about "waste," feeds it to the dog. Lina's horrified reaction reveals her suspicions, and a discussion ensues that ends with Johnnie swearing to reform, and Lina passionately telling him that she believes him. Johnnie: "Do you know—I'm beginning to believe it myself!" They both laugh. . . . "You believe that, don't you dear?" She [with his head resting on her shoulder]: "Yes darling—of course I do." Then: "As she says this, she looks out over his shoulder at the audience— she smiles very, very maternally and very understandingly, while she strokes his hair. But we know that she cannot believe him."[2]

This ambiguous ending also drew a discouraging response from members of a preview audience. They found it confusing. Many years later, Hitch-

cock told François Truffaut of yet another ending that he had contemplated but never shot (perhaps because RKO was loathe to make Cary Grant a murderer, as Hitchcock himself may have been; perhaps because it would have violated the Production Code to have the film's heroine commit suicide).[3] Again, Lina drinks the milk she believes is poisoned. But first she asks Johnnie to mail a letter to her mother that, unbeknownst to him, "spills the beans," assuring that he will not get away with murder. This ending, too, is unambiguous. But it unambiguously denies, rather than asserts, the possibility of a happy outcome.

Hitchcock wanted to make Johnnie a murderer. But he also wanted to find a way to end the film on a hopeful note without making nonsense of everything that leads up to it. He was drawn to the Emersonian moral outlook exemplified by Hollywood comedies of remarriage, in which the measure of love is a shared commitment to walking, together, in the direction of the unattained but attainable self, a commitment to living each day, and each night, in a spirit of adventure. But he was no less powerfully drawn to the idea that a truer measure of love is the willingness to die, not the willingness to live, an idea cognate to the principle, "Each man kills the thing he loves."

Hitchcock's vacillation over how to end *Suspicion*, and the fact that he had to settle for an ending that he found unsatisfying, reflects the depth of his ambivalence and the seriousness of the dilemma he faced as an artist.

6

"But May I Trust You?"

Made in America during World War II, *Lifeboat*—like its more celebrated companion piece, *Shadow of a Doubt*—gives *Secret Agent*, *Sabotage*, and *Suspicion* a further dialectical twist. Is there a difference, morally, between the murder of Gus (William Bendix)—in World War II movies, never bet that the guy from Brooklyn will live to see the final credits—by the German Willi and the killing of Willi by the American and British survivors? *Lifeboat* suggests that there is a difference, just as in *Shadow of a Doubt* there is a difference between Uncle Charlie's acts of strangling wealthy widows and Young Charlie's act of killing him by pushing him off a train. In both films Hitchcock's judgment is that one is murder, the other not. But *Lifeboat*, even more than *Shadow of a Doubt*, makes clear that the issue is complicated.

The United States and England are at war with Germany, but it is not the duty of the civilians on the lifeboat to kill Germans they rescue from drowning. Nor do they kill Willi in self-defense. Once they understand that they cannot trust him, he no longer threatens their survival. Other than the pleasure they take in doing violence to this man they have learned to hate, killing Willi doesn't benefit anyone. Thus it cannot be justified in utilitarian terms. And judged by Kantian standards, it is a violation of the Moral Law pure and simple. The others on the lifeboat also do not kill Willi simply as just punishment for what he has done. For one thing, they have not seen Willi, as we have, cold-bloodedly push Gus out of the boat to

drown. All they know is that this man made no move to save Gus and that he had deceived them by hiding his compass and water flask. But that is enough for them to see him, as Mrs. Verloc comes to see her husband, as so loathsome that they cannot bear to see him live. They don't kill him for what he has done. They kill him for what his actions reveal him to be. And don't we, too, feel that he deserves to die?

But the issue is complicated in the film, as I have said. Here is one complication.

When the others rise up as one and beat Willi into submission, throw him overboard, and continue to hit him with oars and whatever else they can get their hands on—including, a bit gruesomely, the boot Gus had worn on the leg Willi (a surgeon in civilian life) had amputated—Joe (Canada Lee), the lone African American, does not join in. We have no reason to believe that he condemns the others for killing Willi, but we are meant to understand, I take it, that he sees what they are doing as too close to a lynching for him to want to participate. If Elsa from *Secret Agent* were on this lifeboat, the fact that Willi is genuinely immoral, that he personifies the monstrous enemy that America and its allies are—and ought to be—fighting, would not in her eyes change the fact that killing him is murder. To Hitchcock, though, it makes enough of a difference to tip the balance.

Like Verloc in *Sabotage* and Robert in *Secret Agent*, Willi feels no emotion when an "inferior" person dies. He heinously violates the principle that "the time to make up one's mind about people is never." But don't the others on the lifeboat also violate that principle when they make up their minds that he doesn't deserve to live? Hitchcock's answer, I believe, is a qualified "no." Recognizing Willi's utter disregard for human frailty, repelled by his indifference to humanity, the others no longer see him as a human being. In their eyes he has forfeited his humanity. That is why killing him doesn't make them feel like murderers, and Hitchcock doesn't think of them as murderers either. Willi, in contrast, feels no guilt when he kills Gus, not because he sees Gus as having forfeited his humanity but because Willi sees himself as an exemplar of a master race and sees Gus, contemptible in his weakness, as representative of humanity. By killing Willi, the others are repudiating his contempt for humanity, his utter lack of regard for human frailty. They kill him in defense of humanity.

Here's another complication. Robin Wood, in his essay "Hitchcock and Fascism," argues persuasively that *Lifeboat* articulates with exceptional clarity the director's way of thinking about moral issues.[1] He points out, with characteristic insight, that each person who takes part in the killing

of Willi is in some way compromised, has impure motives, in doing so. Connie (Tallulah Bankhead), for example, like Rittenhouse (Henry Hull), had been taken in by the Nazi, so she attacks him with special ferocity because she feels personally betrayed. But feeling wounded by Willi, feeling that he had betrayed her by exploiting her vulnerability, her human frailty, means that she experienced firsthand the pain this man is utterly indifferent to causing when he inflicts "little deaths" on those he regards as his inferiors. That Connie feels personally hurt by Willi is a good reason, not a bad reason, for her to wish him expelled from the little human community on board the lifeboat. Her motives may be impure, but isn't that what makes her human? If she were an exemplar of purity, rather than a flawed human being, she wouldn't have the standing to kill in defense of humanity. In throwing herself, body and soul, into the killing of Willi, and doing so with impure motives, is she giving in to what Wood calls "fascist tendencies"? The demand for purity *is* a "fascist tendency."

When Alice (Mary Anderson), who earlier had said she didn't understand how people can be violent, attacks Willi even more ferociously than Connie does, it shows that she has now learned, from her own experience, what can make even good people wish to kill. But Wood is reluctant to acknowledge, even grudgingly, that any of Hitchcock's characters learn anything in the course of the film. I'm unabashedly partial to Connie, who is brought fabulously to life by Tallulah Bankhead's charisma and her inspired, pitch-perfect performance. Wood has little sympathy for Connie, though, and as a result underestimates her, in my judgment, by denying that her way of thinking is any different at the end of the film than at the beginning.

Connie is the character who berates the others for giving up after they kill Willi, as if they believe that they are powerless without him. As Wood observes, Willi makes a valid point when he justifies his own behavior by saying that the others should have saved water, as he did, but lacked his foresight, and that he had food because German U-boat commanders plan for emergencies. We know, however, that Willi is lying through his teeth when he claims to have endured unimaginable suffering watching Gus suffer. Connie's speech, meant to shame the others into embracing Emersonian self-reliance, does not deny the element of truth in the case Willi makes in his own defense. Her speech is one she could not have made, though, had her experience on the lifeboat not helped her achieve a new perspective.

And not only does she articulate the need for the survivors, individually and collectively, to achieve self-reliance; she practices the Emersonian

gospel she preaches by using her diamond necklace, her most prized possession, as bait to try to land a big fish. She willingly abandons it, or at least risks losing it, to help their collective chances of surviving until they can be rescued. And the fact that Connie hurriedly does remedial work on her hair and lipstick when she believes she is about to be rescued doesn't prove that she is as compromised at the end of the film as she is at the beginning. To walk in the direction of the unattained but attainable self, does she really have to let every day be a bad hair day?

Here's yet another complication. Willi and Gus are the only two who are awake late one night. Gus is slipping in and out of delirium that we take to be caused partly by the amputation of his gangrenous leg, partly by lack of drinking water. Gus is rambling on yet again about Rosie, the "girl he left behind" (and who was his sometime dance partner but never really "his girl"). It is not just Willi who finds Gus dim-witted and tiresome (as we suspect Rosie did, back in Brooklyn). We, too, find ourselves feeling superior to Gus, who was only marginally more coherent, only marginally less annoying, before he became delirious.

Of course, we believe we would never do anything as morally repugnant as what Willi does when he realizes that Gus has spotted him drinking from the flask of water he has been hiding. First, he tries to take advantage of Gus's confusion by manipulating him, *Gaslight* style, into believing that he didn't really see what he saw. But Gus's memory keeps stubbornly resurfacing. Realizing the threat this poses, Willi, adopting Plan B, manipulates him into believing, or half-believing, that his beloved Rosie is out there in the ocean, waiting for him, then pushes him into the water when Gus leans over the side of the boat to get a better look.

We don't have Willi's ulterior motive for wanting Gus to die. Gus poses no threat to us. And he offends us only aesthetically, not morally. But if we are honest with ourselves—I'm speaking for myself here—we have to admit that we wish we could be rid of him. We'd rather be watching, for example, Connie and the leftist blue-collar worker Kovac (John Hodiak) seducing each other. We are appalled by Willi's cold-bloodedness. Killing Gus is murder, pure and simple. And yet it holds a certain appeal for us. It feels, at least a little bit, as if he is performing "our" murder for us, the way Bruno performs Guy's murder for him in *Strangers on a Train*.

Willi is not an agent of the Devil or even the Devil himself, like the villain of a nineteenth-century theatrical melodrama. As his telltale beads of sweat ultimately prove, Willi is a mere mortal, not a supernatural embodiment of pure Evil. Thus he cannot know that we are watching. Or, rather, he

cannot know this unless he is Hitchcock's stand-in within the world of the film—the film's author incarnate, not the Devil incarnate. Indeed, Willi's brilliance in manipulating Gus matches Hitchcock's brilliance in manipulating us into identifying more with this Nazi murderer who has no regard for human frailties than with his pitiable, all-too-human victim.[2]

There are two moments in the film when Willi seems to be claiming quite explicitly that he is a stand-in for the film's author—a claim Hitchcock's camera appears to endorse. The first occurs when Kovac reluctantly agrees to allow the lifeboat to follow the German's course. At this moment Willi, who had been framed in the foreground, with his back to the camera, observing the others as if, like us, he is outside their world looking in, turns and moves closer to the camera and looks directly at it—at us—with a conspiratorial smile. A few moments earlier, as the others were complaining that there was no one on board who was good at handling emergencies, Hitchcock had presented us with a shot, from Willi's point of view, of the compass the German has been hiding. When he now furtively pulls out the compass again, Willi and the camera seem to be openly collaborating to underscore that we are in on his secret, which is also Hitchcock's secret.

The second occurs after the fury of the storm has passed. Hitchcock cuts to the single shot of the film, other than the opening, taken from a place at a remove from the lifeboat. It frames the lifeboat from a distance great enough for it to appear conspicuously small, surrounded by a limitless expanse of ocean. There is then a slow dissolve to Willi, framed frontally, rowing and singing, loudly, a German folksong.

The song's lyrics cast the singer as a man who knows he is good for his lover but whose lover doesn't know how good he is for her. "But may I trust you?" Willi sings, looking directly at the camera with an ironic smirk. He seems to be showing off, bragging to us, with Hitchcock's endorsement—or is it Hitchcock showing off, bragging to us, with Willi's endorsement?—that he—Willi? Hitchcock?—is the cock of the walk.

There is a third moment, though, in which Willi discovers, too late, how presumptuous he had been, in his hubris, to have taken for granted that he had a privileged relationship with the film's author. In this third moment Hitchcock's camera again frames Willi frontally, but this time in such an extreme close-up that we see only his eyes. Offscreen, the others are following a line of thought that leads them to the realization that if Willi can shed tears, or even if he can sweat, he cannot be as dehydrated as they are and must have a secret source of water that he has been withholding from them. The camera's relentless, unblinking gaze registers the intensity as

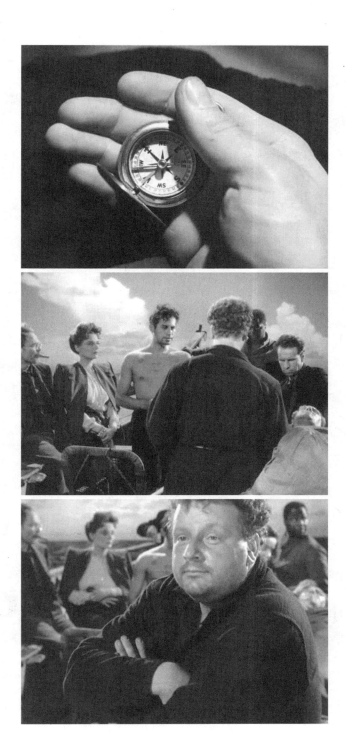

Figure 6.1

Figure 6.2

Figure 6.3

the others scrutinize Willi. The shot represents their collective point of view. When beads of sweat begin to appear on Willi's face, the camera not only "captures" this incriminating evidence; it is as if the camera's close attention, or Willi's awareness of it, is what causes him to sweat. (This shot is a variation of the celebrated moment in *Young and Innocent* at which the murderer the protagonist is desperately trying to find, who can be identified only by his twitching eyes, is stared down by the camera, whose close and unflinching gaze has the power to make the murderer's eyes twitch.)

Robin Wood sees no essential difference, morally speaking, but only a difference of degree, between the others' act of killing Willi and Willi's act of killing Gus. Then again, he sees only a difference of degree between capitalist America and Nazi Germany. Americans inevitably have strong fascist tendencies, in Wood's view, because America is a culture of domination, a culture of violence. But is this really what *Lifeboat* is saying?

Willi is a murderer. Killing him is not—not quite—murder. But in killing Willi, his killers lose their innocence. So must America, *Lifeboat* is saying, if it is to prevail against the Nazis—as America must, in Hitchcock's view. We have to be on guard, however, lest we, too, forfeit our humanity. As

Shadow of a Doubt asserts, and as Joe knows full well, Americans are no less capable of inhumanity than Germans are. Hitchcock makes the point explicitly when, at the end of *Lifeboat*, the German supply ship is bombed— shades of *Secret Agent!*—and those on the lifeboat rescue a young German sailor, as they had once rescued Willi. The frightened young man pulls a gun on his rescuers, although he is too weak to use it, and Rittenhouse, the capitalist, cites this fact as evidence that "these people" have to be exterminated, not treated as human beings.

The others repudiate this view, but the irony—it is not really a contradiction—isn't lost on us, or on them, that refusing to treat Willi as a human being—indeed, exterminating him—is precisely what they have just done. All of them, I take it, and not only Rittenhouse, feel the impulse to kill this young German to avenge those who died on board the lifeboat and those the Germans killed when they torpedoed their ship. But remembering those who died also makes the survivors mindful of the Allies' reasons for being at war with Germany. They not only let the German live; they minister to his wounds. When the young man is bewildered that they don't kill him, they pose the same question they posed when they killed Willi: "What are we going to do with people like that?" In the case of people like this frightened young German, *Lifeboat*'s answer is that we have to help them open their eyes to what it means to be human. In the case of people like Willi, though, the film's answer is that we must not treat them like human beings. Our humanity obligates us to kill them.

7

Silence and Stasis

In *Notorious*, made immediately after the war, Devlin, the Cary Grant character, comes perilously close to forfeiting his humanity. He is a "fat-headed guy full of pain," as he memorably describes himself, until he awakens to his responsibility to Alicia. At the moment of this awakening, which occurs off-camera (like Dexter's awakening in *The Philadelphia Story*), it dawns on Devlin that Alicia, who told him she had a hangover the last time they met, was really sick. He suspects the truth, that Sebastian, having discovered that she is an American agent, is poisoning her. He senses that she is in mortal danger. And he recognizes that she would not be in peril had he not failed, from the beginning of their relationship, to have regard for her frailties and to declare his feelings for her. If he now fails to rescue her and Sebastian (and his mother) succeed in their plot to murder her, he would feel that her blood was on his hands as surely as if he had murdered her himself. In awakening to the reality that a "fat-headed guy full of pain" is who he is, who he has been, a man concerned only with his own feelings and indifferent to Alicia's humanity, Devlin changes. That old self dies, and a new self is born.

When at the end of the film he leads the woman he loves to safety and (with her approval) locks a desperate Sebastian, reduced to groveling, out of the car, Devlin deliberately condemns Alicia's would-be murderer to death, delivering him into the hands of his Nazi executioners. To be sure, by conspiring with his mother to murder Alicia, Sebastian had forfeited

any claim on Devlin to show him mercy. But Sebastian is not Willi. He is far from indifferent to the fate of the woman he was poisoning; he was killing the thing he loved. Skillful actor that he was, Claude Rains conveys subtly but powerfully how much Sebastian, fallen back under his mother's sway, nonetheless enjoys administering the poison to the woman he loves and watching her weaken. But Sebastian takes pleasure in her suffering not because he has contempt for her but because he loves her—and because he knows that she loves Devlin.

Sebastian feels betrayed. Surely, though, he always knew that Alicia never loved him the way he loved her, that loving him was more than he could ask of her when he proposed to her. The most he could ask was that she not act, in public or private, in ways that would keep him from sustaining the illusion that they had a real marriage. But he must have known that even this was more than he had the right to ask. By imposing that condition, he was imprisoning Alicia, inflicting "little deaths" on her every day and certainly every night. Why did his wife marry him when she doesn't love him? He does not want to know. In keeping her from walking in the direction of the unattained but attainable self, he is at the same time denying reality and forgoing all hope of realizing his own dreams. For Sebastian loves Alicia no less deeply than Devlin does.

By his indifference to the fate to which he knowingly consigns Sebastian when he pushes down the car door lock, does Devlin forfeit his own humanity, then? Not in Alicia's eyes. And far from punishing Devlin, Hitchcock rewards him as he drives away with her, marriage presumably next on their agenda. But if Hitchcock doesn't condemn Devlin, neither does he share Devlin's indifference to Sebastian's fate. Rather than follow Devlin and Alicia as their car drives off, the camera remains with Sebastian, bearing respectful witness as he walks with dignity—no longer groveling but resolute now, like Stefan (Louis Jourdan) at the end of *Letter from an Unknown Woman*—toward the door that then closes behind him, sealing the fate whose necessity he no longer questions.

By the gravitas and formality of this framing, Hitchcock's camera at once acknowledges Sebastian's humanity and ratifies the death sentence that the Nazis in the house are ready to carry out. They will kill him not for poisoning his wife but for failing to succeed in killing her, not for loving unwisely but for loving at all, and not for crimes against humanity but for the crime of being human. Hitchcock is not ratifying their condemnation of Sebastian. He is ratifying the judgment Sebastian passes upon himself when he awakens, too late, to his own humanity.

Figure 7.1

And what of Devlin and Alicia? They are not murderers, but until the film's penultimate scene, when they achieve the mutual forgiveness that comedies of remarriage require for a true marriage, they are guilty of inflicting "little deaths" on each other, locked as they are in a perverse pattern they are unable, or unwilling, to break. They love each other but avoid acknowledging their love. With scrupulous attention Hitchcock's camera tracks the violence they do to each other, and to themselves, by their words and their silences.

In the racetrack sequence, as Alicia is dutifully reporting to Devlin, as per her assignment, the impressions gleaned from her dinner with Sebastian and his fellow Nazis, Hitchcock frames their conversation in a frontal two shot that underscores that they are in a public place and have to appear as if they just happened to have run into each other and are simply chatting. But when Alicia says, "You can add Sebastian's name to my list of playmates," the camera registers, and expresses, the jump in the emotional intensity of their conversation by cutting to a pair of shots that are closer and more intimate, but which also isolate Devlin and Alicia in separate frames. First, a shot of Devlin, in which he says, "Pretty fast work." Then a countershot of Alicia, who says, "That's what you wanted, isn't it?"

With these provocative words, Alicia reveals to Devlin for the first time her private understanding of his behavior in an earlier scene. Her revelation of how she really thinks, albeit offered in a mode of attack, constitutes a significant development within a closed, repetitive pattern that seemed to allow for no new developments. This revelation will turn out to be an important moment within *Notorious* as a whole, but its full significance will reveal itself to us only retroactively. It initiates a series of revelations by both parties, each a response to the preceding one—a series that is not completed until the end of the film, when Devlin finally confesses to Alicia not only that he loves her but that he has loved her from the beginning. To underscore both that this moment is meaningful and that its meaning as yet remains unknown (indeed, unknowable) by us, Hitchcock composes this shot so that we experience it as spatially disorienting.

As Alicia begins to speak, she turns her head screen left. But because she performs this gesture before we have a chance to grasp how this new camera angle relates, spatially, to the ones that preceded it, we literally cannot tell whether Alicia is turning her head toward Devlin or away from him.[1] The following close-up of Devlin, framed in profile, compounds our disorientation. Does the fact that we are viewing him from this angle mean that he has turned away from Alicia as she, perhaps, has turned away from him? Are we, perhaps, viewing him from her point of view? Or has only the camera changed position?

If Alicia and Devlin were characters in a stage play, these expressive effects would not be possible. Onstage, an actress either does or does not turn away from an actor. The actor either does or does not turn his profile to the actress. And if he should turn his profile to the audience, it is he who performs this gesture; the audience's position remains fixed. Again, it is not merely that such ambiguities need the camera to capture them; without the camera they cannot be. Classical movies regularly employ a number of expressive postures and gestures—including, but not limited to, turning away from the camera, almost facing the camera, looking "through" the camera, and meeting the camera's gaze—that in this way can only be real (it is not merely that they can only be captured) within the world of a film. Such postures and gestures, which are particular to film, affect the moods in which we perceive all the "faces and motions and settings" by which movies express themselves, thus the moods cast by entire sequences, entire films.

Wounded by Devlin's words—"You almost had me believing in that little miracle of yours. . . . Lucky for both of us I didn't. It wouldn't have

Figure 7.2

Figure 7.3

been pretty if I'd believed in you. . . ."—Alicia is pretending to be looking through her field glasses.

Phenomenologically, a film is a moving picture, not a succession of still frames. Every shot has a temporal as well as a spatial dimension. When a film moment is reduced to a frame enlargement printed on a page, its motions are stilled, its temporal dimension stripped away. The film stops being a film and turns into a still photograph. This particular frame enlargement of Alicia holding the field glasses to her face does a minimum of violence to the film moment I am using it to invoke only because up to this point in the shot her face has been motionless, as has the camera. Visually, this is a moment of stasis within the film, a moment in which the film has stopped in its tracks, as it were. Still photographs, like paintings, cannot but be static, of course. But few still photographs convey the sense of time itself standing still, as this frame enlargement must if it is to evoke this moment of stasis within the film.

If we are watching a DVD of *Notorious* and hit the pause button, we not only stop the film's motions; we also silence the film's voices. Frame enlargements on a page do not silence the film in the same way; the film is already silenced. A frame enlargement invites the reader to pause for a moment, to suspend his or her reading of the writer's words to contemplate this still im-

age. At best, a frame enlargement can evoke a moment of a film, not enable a reader to experience it. Yet in that moment of contemplation, the writer's voice—or, rather, the reader's "inner voice," speaking the writer's words (when they're printed on the page, can they be said to be the writer's own words?), falls silent. Or, perhaps, that voice has already achieved its own silence, has said all that the writer finds words to say about this moment of the film, so that the reader is already in the mood for the contemplation invited by the frame enlargement, which comes as if in response to a silent call. When reading resumes, the reader's "inner voice" breaks its silence.

Then how can I provide evidence to back up my impression that at this moment of the film Alicia does not wish for Devlin to finish his sentence, which she fears will wound her deeply—my sense that if she could make time stand still, she would? In any case she cannot stop time in its tracks. The camera remains on Alicia, framing her closely, as Devlin completes his thought. ". . . If I'd figured . . . " Alicia begins slowly lowering her field glasses, or lets them fall of their own weight. ". . . she'd never be able to go through with it—she's been made over by love."

The mesmerizingly slow lowering of her field glasses gradually unblocks Alicia's eyes from the camera's view, revealing them to be already downcast, turned inward, to avoid meeting Devlin's gaze and to keep him from seeing the tears—and the rage—welling up in them. No frame enlargement alone can capture the mood, or succession of moods, conveyed here, because Alicia's train of moods is expressed by movements within the frame, not by any static expression. Her face is anything but static. Her expressions paint as many hues as any string of beads Emerson could ever have seen or imagined. And like the earlier spatially disorienting shots of Alicia and Devlin, this close-up has an expressive impact impossible to achieve onstage. Eyes do not reveal their intimate expression to those who view them from a distance. If a stage actress were to hold a pair of field glasses to her face, the expression in her eyes would remain inaccessible to the audience, as it is at the beginning of this shot, but it could not be revealed to the audience when the glasses are lowered.

At this moment there seems an attunement, not a complicity, between Ingrid Bergman, behaving as if she were Alicia, and the camera, which is a presence in the actress's world but an absence in the character's world. It just seems to happen that when Alicia holds the field glasses to her face to hide her eyes from Devlin's gaze, this woman's eyes—that is, Bergman's eyes—are hidden from us as well, as it just seems to happen that as the glasses lower, her eyes become unveiled to our view, as well as to Devlin's. That these

things do happen, however, has a profound, traumatic impact on our experience of this shot and, indeed, the sequence—and the film—as a whole.

Emerson could be describing our experience of the moment Bergman's eyes are unveiled when he writes, "We look into the eyes to know if this other form is another self, and the eyes will not lie, but make a faithful confession what inhabitant is there."[2] If Devlin is looking into her eyes as we are at this moment, he will know her as we know her. He will know she loves him. He will know she is worthy of love. If he is not looking into her eyes, is unmoved by their confession, or fails to acknowledge how he is moved, he is inflicting upon her as grievous a "little death" as it is possible to imagine.

Up to this point, the focus of this close-up has been Alicia's silent reaction to Devlin's cruel words, which wound her as he means them to do. But there is something they pointedly leave unsaid. His " . . . she's been made over by love," for all its bitter sarcasm, belies his assertion that he had never believed in her. His implication is that he had never loved her. But then how could she have been made over by love? What Devlin is saying to Alicia without saying it—what his silence is saying—is that he now knows that she is unworthy of love but that he had once loved her. This leaves open the possibility, of course, that this "knowledge" has not stopped Devlin from loving Alicia, that he is silently revealing what his words are denying. In any case the motion of the field glasses continues the whole time he is speaking the hateful words that nonetheless reveal that he had once loved her.

Within this close framing, now devoid of motion, Alicia finally breaks her silence: "If you only once said that you loved me." In movies the poetry—the lucidity—of speech resides in the way just this person, framed just this way, speaks just these words in just this tone of voice, looking just this way, with just this expression at just this moment in just this situation in just this setting. (The camera's own gestures are performed, of course, in silence.) I hear Alicia's line, as Ingrid Bergman hauntingly speaks it, less as an accusation than as a sorrowful expression of a wish she knows cannot come true—the wish that she could change the past.

If only . . .

Alicia has heard in Devlin's hurtful words an acknowledgment—he had never admitted this before—that he had once loved her. If he only once had said he loved her, she is saying without saying it—said it one time, said it "once upon a time"—she would have acted differently, and they would have been happy all this time, would be happy now, and would live happily ever after. Heard this way, her words are also acknowledging something she had never admitted before, that her actions were no less responsible than

Figure 7.4

his for leading them to the present desperate impasse. At the same time, she is mindful, as never before, that the clock cannot be turned back, the past cannot be altered, the happy times they could have enjoyed together are forever lost.

Just as she is on the verge of speaking the words, "If you'd only once said that you loved me," Alicia turns her face slightly screen left. This time, her turning does not disorient us. She is turning toward Devlin, not away from him. She would be speaking these words directly to him were her eyes not still lowered, turned inward. I see her at this moment as suspended at the border between fantasy and reality, imagining she is speaking to a man who might, despite everything, still be moved to declare that he loves her, that he believes in her, even as she knows—or thinks she knows—that the man who is really in her presence is not the Devlin of her dreams. If only . . . And yet, in the end, the "real" Devlin will turn out to be—to become, or always to have been—her dream man.

Visually, this is another moment of stasis whose mood a frame enlargement is capable of evoking.

I am moved to say about this frame that when within it Alicia whispers longingly, and without visibly moving her lips, "Oh, Dev . . . ," she seems to be speaking entirely from within her fantasy, to be speaking only to the

man of her dreams, not to the man in her presence who has just inflicted upon her yet another "little death" and is poised, perhaps, to strike a fatal blow by saying that he no longer loves her.

I discern in Bergman's face both sadness and excitement. These are moods I am prepared to attribute to Alicia on the basis of what I see—what I believe anyone might see—in Bergman's expression at this moment. Why is she sad? Because she cannot change the past, cannot turn back the clock. Why excited? Because she is looking forward to, almost as much as she is dreading, what will come next. But sadness at the time that has irretrievably been lost, and excitement compounded of anticipation and dread of what might come next, are not in the same way simply visible in this woman's face. How could they be? They have to do with the way, for Alicia at this moment, the present is haunted by what might have been and by what might never come to be, both of which have no tangible reality and thus are out of reach (are they not?) of Hitchcock's camera.

In attributing to Alicia sadness for the time with her dream man that she has lost, and excitement compounded of anticipation and dread of what might come next, I am advancing an interpretation, one might say an explanation, not simply a description—a way of making sense of, a way of tracing the implications of, what I believe can be perceived in this woman's face at this moment of the film. Virtually all the claims I have been making for the past several pages attribute particular thoughts, feelings, and intentions to Alicia and Devlin, and particular thoughts, feelings, and intentions to Hitchcock in choosing to frame them the ways he does. On what grounds do I base such assertions? They can be based only on my perceptions, my experience of the film. But to perceive Alicia's sadness as sadness for the time that has been lost, and her excitement as compounded of anticipation and dread of what may come next, I have to be in a particular mood—a mood that this moment of the film has the power to cast over me, given the train of moods cast over me, the emotions awakened, by the succession of "moods of faces and motions and settings" that have led to this moment.

Only when sounds fall silent do we become aware of the reality of silence, and only when motions run their course do we become aware of the reality of stillness—as if when motion ceases, time itself is suspended, the way it is for Scottie at the end of *Vertigo*. For Scottie, as I have said, no change is possible, no dawning of a new day, no future, no becoming. Alicia, at this moment, is not in the same place as Scottie. She, too, finds herself suspended. But she is not beyond suspense the way he is. Alicia has not yet lost all hope for the future, as Scottie has. She has reason to believe,

now, that Devlin had once loved her. Her reaction to his words confirms that despite everything she has not stopped loving him.

I take Alicia, as blind to the future as we are in our own lives, to be feeling at this moment that all her hopes and dreams are staked on what Devlin now goes on to say and do. Hitchcock liked to distinguish between surprise (when a time bomb goes off that neither we nor the characters knew to be there) and suspense (when we know, but the characters do not, that there is a bomb set to go off any moment). Alicia knows, as we do, that Devlin might be about to detonate a bomb, figuratively speaking. If so, she is as powerless as we are to keep this from happening. For Alicia, as well as for us, this is suspense, Hitchcock style.

Like every moment of every film, this moment of *Notorious* has a double temporal existence. This moment is special, though, in that it precisely marks Alicia's own awakening. She now knows that every moment of her experience is both transient and permanent. She can see now that her own past actions and failures to act, her own words and silences as surely as Devlin's, have left permanent marks. Now she can trace their implications, discern necessity in the way her past has led her to this place—a place where she finds herself wishing for a future in which she might be saved, and at the same time wishing for time to stand still. We can say that what Alicia does not see at this moment is that it is not only impossible for her to undo her past actions; it was never possible for her to have acted differently. She does not see that in her world there are no accidents, that nothing that is not real is possible, that every moment of her life is scripted. We can also say that what she does not see is that there is a camera filming her— a camera that is always there, a camera that knows the script, because it is an instrument of that script's author. We can say, in other words, that the place where Alicia now finds herself is precisely the border that separates her world, the projected world, from our world, the one existing world. And, it seems to me, unless we say such things, we are not fully tracing the implications of this moment.

In *The "I" of the Camera* I wrote that films "speak to us in an intimate language of indirectness and silence. To speak seriously about a film, we must speak about that silence, its motivations and depths; we must speak about that to which the silence gives voice; we must give voice to that silence; we must let that silence speak for itself."[3] There may seem to be a conflict between the imperatives of giving voice to silence and letting the silence speak for itself. When one puts into words what a film consigns to silence, does one not drown out the film's silence? The point, though, is that it is not

one's words but rather the silence they achieve when they reach the limits of what words can say—a silence within which the film's own silence echoes—that gives voice to that which the film consigns to silence.

In writing about films, it is my experience that we always can find words to evoke their "moods of faces and motions and settings." This suggests that the border that separates words from film is also where the two touch, or at least come face-to-face. It is when it reaches this border that film achieves its poetry. For writing about film to acknowledge this border, the poetry of film—the perception that every human posture and gesture, however glancing, has its lucidity—must artfully be evoked by the writing itself, by its own voices and silences. Such writing perceives film—the medium limited to surfaces, to the outer, the visible—as also a medium of mysterious depths, of the inner, the invisible. The "inner voice" that "speaks" the words on the page expresses, and casts, moods of its own—moods that color the reader's perception, hence contemplation, of the frame enlargements, which in turn color the way the reader gives "inner voice" to the words on the page.

It has been a recurring theme of my writing that many great and influential films, Hitchcock's preeminent among them, meditate on the border, the barrier-that-is-no-real-barrier, that is the movie screen and that they envision themselves as possessing the power to pass back and forth across this border, a passage that "overleaps the wall," to borrow a metaphor Emerson invokes in "Intellect" to characterize the power of thought.[4]

Is this not a power that a film's moods of faces and motions and settings possess? Is it any wonder, then, that writing like mine, which envisions itself as passing back and forth between giving voice to movies and finding my own voice in saying what I have to say about them, is especially drawn to films like Hitchcock's? And to writing like Emerson's?

8

Talking vs. Living

Of Hitchcock's postwar films of the 1940s, *Rope* most fully articulates the issues concerning killing and murder that are addressed in *Lifeboat* and *Notorious*. When Rupert (James Stewart) opens the chest holding David's body, Brandon (John Dall), one of the young murderers, tells his former teacher that "Phillip and I have lived what you and I have talked." What they had "talked" involved Rupert's theory that "the lives of inferior beings are unimportant" and thus that "moral concepts of good and evil and right and wrong don't hold for the intellectually superior."

Rupert responds passionately: "You've thrown my own words right back in my face, Brandon. You were right to. If nothing else, a man should stand by his words. But you've given my words a meaning that I've never dreamed of. And you've tried to twist them into a cold, logical excuse for your ugly murder."

When in *Strangers on a Train*, Guy (Farley Granger) shouts that he could kill his scheming wife, and when he earlier patronized Bruno (Robert Walker) on the train by glibly agreeing with him about the desirability of each performing the other's murder, but without dreaming (or so it would seem) that Bruno would carry out his side of the bargain, Guy fails to live up to Rupert's principle that "a man should stand by his words." Is Guy's failure the moral equivalent of murder?

When Rupert insists that by twisting his words into an excuse for an "ugly murder"—are all murders, even artistically perfect ones, "ugly"?—Brandon

has given them a meaning he had "never dreamed of," he conspicuously fails to say what he did mean by his words, how he could have meant by them anything other than the meaning Brandon drew from them. Unable to defend his words, ashamed at having spoken them, Rupert is reduced to saying to Brandon that "there must have been something deep inside you from the very start that let you do this thing" and "something deep inside me that would never let me do it and would never let me be a party to it now." Rupert is not saying that Brandon forfeited his humanity by murdering David. He is saying that because of the mysterious "something" Brandon was born with "deep inside," he was never really human in the first place.

Surely Hitchcock is aware that Rupert is thinking like a Nazi when he claims to be superior to Brandon (even if he is claiming to be superior morally, not intellectually or physically). Hitchcock is not endorsing Rupert's view that ordinary Americans and murderers are born with different hidden "somethings." Even if Willi, say, has a "something" that allows him to kill Gus, the lack of that "something" doesn't stop the Americans from killing Willi. And, as we will see, Rupert, too, is capable of killing. Before he takes action, though, Rupert delivers an eloquent speech that articulates principles that up to a point Hitchcock—and we—can readily endorse:

> Tonight you've made me ashamed of every concept I ever had of superior or inferior beings. But I thank you for that shame. Because now I know that we're each of us a separate human being, Brandon, with the right to live and work and think as individuals but with an obligation to the society we live in. By what right do you *dare* say that there is a superior few to which you belong? By what right did you *dare* decide that that boy in there was inferior, and therefore could be killed? Did you think you were God, Brandon? . . . I don't know what you thought or what you are, but I know what you've done. You've *murdered*!

When Rupert moves closer to the window, Brandon nervously asks him what he is doing. Rupert's answer makes clear his intent to "stand by his words" this time, to transform "talking" into "living." "It's not what I'm going to do, Brandon, it's what society is going to do. I don't know what that will be, but I can guess. And I can help. You're going to die, Brandon." It is only to give society the chance to do whatever it decides to do, Rupert claims, that he now fires three shots through the open window. The shots provoke neighbors and passersby to gather, discuss the situation and call

the police, setting in motion the machinery of justice by which society will decide what to do about the two murderers. And yet Rupert knows— or thinks he knows—that by firing these shots, he is causing Brandon to die, the way Devlin knows he is causing Sebastian to die when he locks him out of the car. Indeed, it is with undisguised glee that Rupert repeats, before firing the shots, "You're going to *die!*" He is not merely "guessing" that this is the sentence society will decide to impose; he is taking it on himself to pass judgment. It is clear from his tone that it pleases him to be condemning Brandon to death. He wishes for Brandon to die, the way Mrs. Verloc wishes for her husband to die, the way the others wish for Willi to die, the way Devlin wishes for Sebastian to die.

When Rupert insists that he "never dreamed" that Brandon would transform his teacher's words from "talking" to "living," it is possible, of course, that he is simply lying. But even if he is not lying, he is not necessarily speaking the truth. It is a fact about being human, after all, that we do not always remember our dreams, as we are not always conscious of our intentions. And Rupert may have a motive as well as a reason for wishing to deny his own guilt (a motive he has in common with *Vertigo*'s Scottie, that other James Stewart character). Rupert wishes for Brandon to die for being utterly indifferent to the humanity of others. But perhaps Rupert also wishes this because he is unwilling, or unable, to face his unbearable sense of guilt for the consequences of his own words. If Rupert were simply to shoot him to death, he could not continue to believe in his own superiority to Brandon. But what if society were to take it upon itself to condemn Brandon to death? What I am suggesting, perhaps too obscurely, is that it is possible to view Rupert as twisting his own words, as Brandon had done, into a justification for his own "ugly murder." That is, it is possible to view Rupert's firing of the shots as a way of provoking society to perform "his" murder (the way Bruno performs Guy's murder in *Strangers on a Train*). To throw Rupert's words back at him: By what right does *he* "dare decide" that this "separate human being" must die? For that matter, what, if anything, gives "society" such a right?

Hitchcock films Rupert's speech in a singular way that underscores its ambiguity. On the words "we're each of us a separate human being," the camera begins to twist counterclockwise. The camera's turning meshes with Rupert's movement so that on his words "think as individuals" he is looking toward the camera. In eminently Hitchcockian fashion these movements cause Brandon, who looks perplexed by Rupert's words, to eclipse him in the frame.

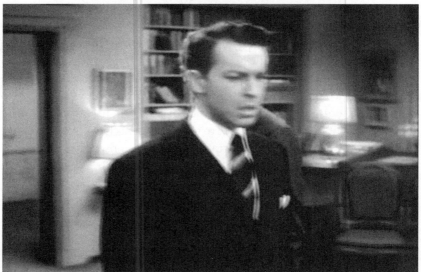

Figure 8.1

 As Rupert continues speaking, the camera reverses direction and starts twisting clockwise. Again, the camera's movement meshes with Rupert's to cause his figure to be eclipsed. Then the camera reverses direction again, and yet again, causing this eclipsing to occur two more times. Fi-

nally, the camera moves in until it isolates Rupert's arm, hand, and gun, framed by the window. He pulls the trigger and three shots go off.

It is impossible to view this passage without being cognizant of the role the camera plays both in its design and its execution. At least in part, it was to impress and please him, Rupert intuits, that Brandon conceived the plan to murder David and manipulated Phillip to carry it out the way he did. What goes without saying in the film is that Hitchcock made *Rope* the way he did—with complexly choreographed ten-minute shot sequences unbroken by edits—to impress and please us. Like Brandon, Hitchcock wished for somebody else to know how brilliant he is. Indeed, with the possible exception of *Psycho*, no Hitchcock thriller is more overt in asserting a metaphorical equivalence between Hitchcock's art in creating the film and the act of murder around which the film's narrative revolves.

No matter how compellingly *Rope* affirms Rupert's rebuke of Brandon's inhuman indifference, the film calls Rupert's moral authority into question as well. It also identifies its author's act of artistic creation with Brandon's attempt to perform the perfect murder. Thus it calls Hitchcock's own moral authority into question. It is this instability of identification, this oscillation between repudiating murder and enjoying its fruits, that the camera's gestures in this passage—and in *Rope* as a whole—so brilliantly

Figure 8.2

convey. By designing *Rope* to declare his own wish for "somebody else to know how brilliant he is," Hitchcock places himself in Brandon's position and the viewer in Rupert's. But by designing this film (like *Shadow of a Doubt* before it, as I argue in *The Murderous Gaze*) to teach us how to view a Hitchcock thriller in a way that acknowledges its author's brilliance, *Rope* also places Hitchcock in Rupert's position and the viewer in Brandon's.

As the camera now pulls back, we hear the voices of neighbors and passersby; collectively, they represent society. The camera continues pulling back to a tableau. Rupert is in the foreground, his back to the camera; Phillip, in the left background, begins to play the piano; and Brandon, in the right background, pours himself a drink and, with the sangfroid of the Ray Milland character at the end of *Dial "M" for Murder*, raises his glass, like a sportsman toasting his opponent's victory in what had been only a well-played game.

Hitchcock allows this framing, and the meditative mood it casts, to linger as the piano music mingles with the crescendo of a police car siren as the final credits roll. Until the police arrive, there is nothing for Rupert to do but reflect on the events that have transpired and the disturbingly ambiguous role he has played in them. This is a moment of meditation for Hitchcock, too. And for us.

9

Two Things to Ponder

"Breakdown" (1955), the seventh episode of the first season of *Alfred Hitchcock Presents*, was the one my fifth-grade classmates and I couldn't stop talking about on the P. S. 181 playground in Brooklyn. It has haunted me ever since. It begins, as each of the episodes in this series does, with Hitchcock's introduction. "I think you'll find it properly terrifying," he says, "but like the other plays of our series, it is more than mere entertainment. In each of our stories we strive to teach a lesson or point a little moral. Advice like mother used to give: You know, 'Walk softly but carry a big stick.' 'Strike first and ask questions later'—that sort of thing. Tonight's story tells about a business tycoon and will give you something to ponder. . . . You'll see it after the sponsor's story, which, like ours, also strives to teach a little lesson or point a little moral."

"Breakdown" is, indeed, a morality play. William Callew (Joseph Cotten), a businessman, scoffs at the weakness of others and pays dearly for it. He is paralyzed in an automobile accident. Taken for dead when the authorities find him, he is only able to reveal that he is alive when, on the coroner's slab, he gives up trying to control the situation and, breaking down, prays to God. His silent weeping produces a telltale tear.

This tear engenders a very different reaction than did Willi's telltale beads of sweat. When the coroner sees it, he leans over to assure Callew that everything will now be all right. End of story. Except that Hitchcock appears again onscreen and says, with that inimitable knowing,

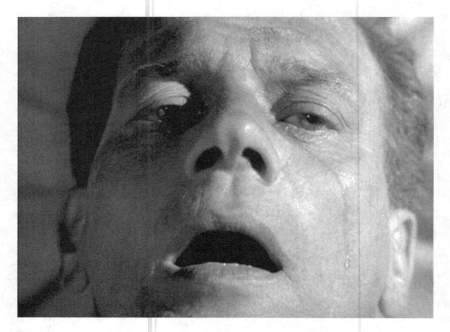

Figure 9.1

bored, disdainful look to the camera, "Well, that was a bit of a near thing."

There is such contempt in Hitchcock's voice! But is he sharing this contempt with us or directing it at us? And what, or whom, does Hitchcock hold in such contempt? Surely, his sponsors, who won't let him "tell it like it is" but insist on a happy ending, or at least a conventionally moral one, and those of his viewers whose eyes need to be opened to the gap between his sponsors' rosy picture of the world and the way things really were in America of the 1950s (and perhaps, in every place and every time). And what won't his sponsors let him tell? That the real world, unlike the world according to his sponsors, is not just or moral? (If it were, would Hitchcock have had to kowtow to "sponsors," impersonal corporations that profit from exploiting human frailty?)

Does Hitchcock really believe that "Walk softly but carry a big stick" and "Strike first and ask questions later" typify the kind of advice that mothers give, or should give, to their children? Or does a mother's love impart a different kind of lesson, the kind of lesson the Cotten character learns when he fails to acknowledge the humanity of others, hence his own

humanity, and finds himself subjected to a horrendous comeuppance? When the car crash leaves him totally paralyzed (except for one little finger) and mistaken for dead, he learns in a hard way, indeed, that his ability to control his world, or even his own emotions, has limits. When he stops trying to assert control, the "miracle" happens. He is saved—if he counts being condemned to total paralysis as salvation. Unless his tearful prayer signals a full-fledged Emersonian awakening, such a life would feel like a fate worse than death to him.

Yet even as "Breakdown" is pointing this little moral, its author is asserting his own control over Callew's fate. Hitchcock, not God, arranges the series of unlucky "accidents" that push this man to the breaking point. And when on the coroner's slab Callew finally breaks down, prays and weeps, it is Hitchcock who intervenes to spare his life. In arrogating to himself the godlike power to mete out retribution and rescue, does not Hitchcock become, or reveal himself to be, no different from Callew, hence no less deserving of punishment, no less in need of learning the very lesson he calls upon Callew to learn?

Here, as elsewhere, Hitchcock's reassuringly impish delivery masks his seriousness. Playing the jester gave him a license to speak truths that others on television consigned to silence. Yet for all his impishness, there is real vitriol in his voice, a palpable cruelty in his expression, as if it suits him just fine that the world is unjust and that he is the one opening our eyes to this reality. "Breakdown" points a little moral, which it also calls into question, even as it calls into question its own self-questioning. What could be more Hitchcockian?

Hitchcock returns after the final commercial break and prefaces his concluding remarks by saying, "There, now." His voice is soothing, as if he were a mother who has just administered medicine to her sick child and is now reassuring herself that the ordeal wasn't as bad as the little tyke had thought it would be. When Marnie's injured horse finally stops struggling after she shoots the poor animal in the head at point blank range, she says "There, now" with exactly the same intonation, as if she believes she has put her beloved Forio to sleep, not merely figuratively but literally, and is satisfied that the bullet to the brain she has just administered was not too bitter a pill to swallow. The distinct echo of Hitchcock's voice I hear in Tippi Hedren's delivery of her line brings home both the sincerity of Marnie's belief that her act of killing is an act of love and the mocking irony of Hitchcock's suggestion that the "medicine" his sponsors have just slipped down our throats does more than put us to sleep. It blows out our brains.

In his appearances on *Alfred Hitchcock Presents*, Hitchcock expressed his contempt for the Gospel According to 1950s Television, the world as Hitchcock's sponsors would have viewers believe it really was—a world in which father knows best that morality always pays and crime never does and that marrying, raising children in the suburbs, and buying products that may or may not be needed guarantee living happily ever after. Hitchcock's words and tone intimate that he knows better. And what he knows is that no one's motives—including our own—can be trusted to be pure and that in reality there is no guarantee that good will prevail or that trust will be rewarded.

Then did Hitchcock truly believe that the world is a "foul sty," as another Joseph Cotten character, Uncle Charlie in *Shadow of a Doubt*, rather hyperbolically puts it? Nowhere does Hitchcock present a darker vision than in "Revenge" (1955). This, the very first episode of *Alfred Hitchcock Presents*, brilliantly set the tone for the series and served as a kind of study for *The Wrong Man* (1956), one of his great masterpieces.

When in "Revenge" Carl (Ralph Meeker) comes home from his new job, he finds his wife, Elsa (Vera Miles), on the floor, evidently having been attacked by a brutal intruder who left her in an almost catatonic, trancelike state similar to that into which Rose Balestrero (another Vera Miles character), in *The Wrong Man*, withdraws after her breakdown. (We recognize this state from other Hitchcock films as well. Alice White in *Blackmail* is in such a state after she kills the artist who tries to rape her, as is Diana Baring in *Murder!* after she witnesses a murder she will be wrongly accused of committing. Scottie is in such a state after he sees, or so he thinks, Madeleine fall to her death in *Vertigo*. So is Melanie, in *The Birds*, after the attack in the attic.)

When the traumatized Elsa keeps repeating, in a flat, affectless voice, "He killed me, he killed me," Carl announces his intention—his wife emerges enough from her trance to say "Yes" and nod her approval—to track down and kill the brute who did this. Driving into town from their trailer park—unlike Hitchcock's movies of the 1950s other than *The Wrong Man*, episodes of *Alfred Hitchcock Presents* often have working-class protagonists; they are more "slices of life" than "pieces of cake," as Hitchcock liked to call his theatrical films—Carl and Elsa pass a man walking on the street. Elsa exclaims, "There he is! That's him. That's him!" So Carl follows the man to his hotel and, with a monkey wrench, bludgeons him to death. As they are driving home, however, Elsa spots another man on the street. "There he is! That's him. That's him!" she says of this man, too.

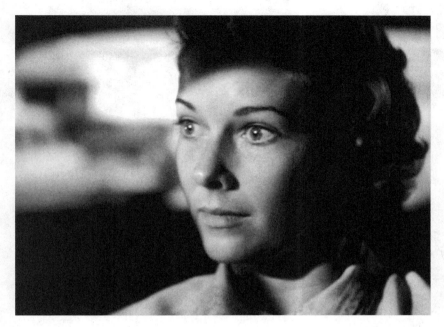

Figure 9.2

This time, Elsa speaks these words with the barest trace of a smile that chillingly intimates, or at least hints, that she really knows exactly what she has done to her husband—and that she has done it deliberately, in a spirit of revenge.

Echoing the ending of *Rope*, the sound of a distant siren grows ominously louder.

10

The Dark Side of the Moon

Vera Miles again has an enigmatic expression at the end of *The Wrong Man*, when Manny, Rose's husband (Henry Fonda), visits her in the mental institution to which she asked him to commit her after her breakdown, to tell her that their ordeal is over—he was on trial for a series of holdups the law-abiding Manny did not commit—because his case was dismissed after the police caught the real criminal. Rose repeats, flatly but perhaps not without hostility, "That's fine for you," before withdrawing into an impenetrable silence.

These words pierce Manny's heart, and Rose seems to mean for them to, as if they are her revenge. For what? What "little deaths" could this all but saintly man, who always tries to do right by his family, have inflicted on his wife, whether in reality or in her imagination? Manny is not violent like Carl. Nor does he lack regard for human frailty, like Willi, Rupert, or Callew. But there are ways of failing to acknowledge other human beings without beating them or holding their humanity in contempt. After Uncle Charlie announces that he will be leaving Santa Rosa in the morning, Emma (the great Patricia Collinge), Young Charlie's mother and Uncle Charlie's sister, breaks down. Her beloved brother's stay in her home had reminded her that she should not be treated simply as a satellite of her husband. Before her voice trails off into melancholy silence, she says quietly, to no one in particular, "You know how it is. You're your husband's wife . . . "

Figure 10.1

Manny is selfless to a fault, but he has been oblivious, as even good men can unthinkingly be, of his wife's right to feel that she is a person in her own right. For Manny the two children come first, his mother second, Rose third. And since his arrest he became so absorbed in his trial that it hadn't occurred to him that Rose could be undergoing a trial of her own. He hadn't even noticed that she was descending into madness until his lawyer called it to his attention. Is it madness for Rose to blame Manny for her madness?

In *Notorious*, as we have seen, Alicia experiences an epiphany at the racetrack. She awakens to the ways her own actions and failures to act, her own words and silences, as surely as Devlin's, are implicated in leading them to their present impasse. But she does not awaken to her real condition as a denizen of the world projected on the movie screen. She remains blind to the reality that her life is scripted, that we are viewing her now, that at this moment she finds herself at the border that separates our world from her world. To that reality Rose, too, once was blind, but there is a remarkable moment when she seems to see, or at least glimpse, what Alicia does not see. I am thinking of the moment when Rose, learning of the death of a man they were counting on as a witness who could verify her husband's alibi, bursts into hysterical laughter and says to Manny, who is stoically prepared to keep soldiering on, "Don't you get it?" She goes on to explain to her uncomprehending husband that he cannot win because "they" have stacked the deck against him.

This moment foreshadows Rose's madness. It also reveals an extraordinary power she possesses—a power I think of as clairvoyance. Rose's clairvoyance reflects Hitchcock's understanding of who Vera Miles was capable of being, or becoming, within the world of a film. He envisioned her as projecting a distinctive otherworldly quality, a quality he was seeking in an actress at this moment in his career when his films were becoming more openly—and more profoundly—metaphysical. After *The Wrong Man* Hitchcock wanted Vera Miles to star in *Vertigo*, but her pregnancy made that impossible. The fact that Kim Novak would be utterly miscast as Elsa or as Rose underscores how different *Vertigo* would have been had the otherworldly Vera Miles, not the carnal Kim Novak, been the object of Scottie's obsession. Would Vera Miles have been better than Kim Novak in *Vertigo*? No one could be. But in the very different *Vertigo* that might have been, no one could have been better than Vera Miles.

That Manny is utterly oblivious of the dark reality Rose is capable of glimpsing is part of the point of another of *The Wrong Man*'s most remarkable passages. Having been arrested late one night as he was returning home from his job as a bass player in the Stork Club band, Manny finds himself alone in a prison cell. A series of point-of-view and reaction shots makes all too clear that the cell is devoid of anything meaningful for him to rest his eyes on. Manny looks down at his hands, and Hitchcock cuts to a close-up that isolates them in the frame. As if they have a will of their own, they slowly tighten into fists—Manny's only physical gesture in the entire film that expresses the impulse to physical violence, an impulse that is only natural for a victim of injustice to feel but which Manny almost obsessively represses. Then, as if exhausted, he leans against the wall and looks in the direction of the camera.

In fiction films it is a familiar strategy for conveying that a character is turned inward to have that character look toward the camera without seeming to see it. We understand that when Manny, wrongfully imprisoned, alone with his nightmarish thoughts, stares into the middle distance, he is looking at nothing. Rather, his looking toward the camera conveys that he is absorbed by what he is thinking or imagining. To convey this, Henry Fonda has to act in a way that denies the reality of the camera in his presence. But Manny, the character the actor is playing, has no need to deny reality in order to act as if no camera were in his presence. In Fonda's world the camera is a presence—a presence that is also an absence, insofar as the views it is capturing are destined to be projected onto movie screens in the future so as to enable the likes of us, who are not in his presence, to view

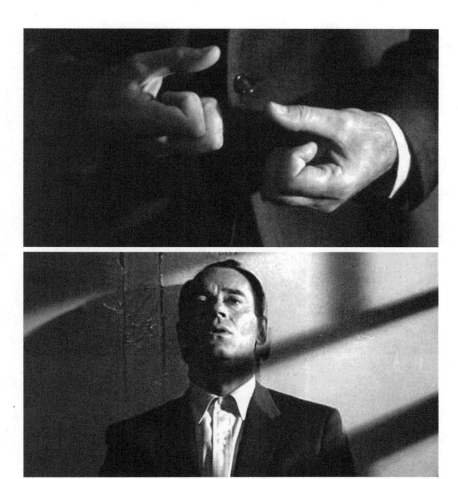

Figure 10.2

him. In Manny's world, by contrast, the camera is an absence. But it is an absence that is also a presence, insofar as the lens the actor is looking at is in effect transformed, within the character's world, into an imaginary screen on which what we might call his "inner reality" is projected. In Manny's world the camera's gaze becomes only a projection of his imagination, but it is no less real for that; it is no less real—and no less unreal—than his inner reality itself.

As if to shut out reality altogether, Manny now closes his eyes. At this very moment, the camera begins turning; not pivoting on its axis—it

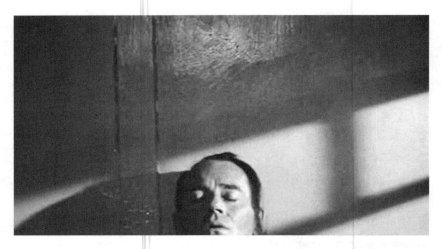

Figure 10.3

never stops facing Manny—but circling in space as if it were fixed to the side of a revolving wheel. The camera's circling causes our view of the projected world—and Manny within it—to circle. As the movement accelerates, so does the quietly rhythmic, repetitive, melody-less, almost Philip Glass–like music—dominated by Manny's own instrument, the double bass—that Bernard Herrmann composed for this passage. Soon, we can no longer tell—could we ever?—whether it is Manny's world that is circling while the position from which we are viewing it remains stationary; whether it is our position that is moving, while Manny's world remains in place; or both. This also means that we can no longer tell, as if we ever could, whether it is from a position inside Manny's world, or outside his world, that we are viewing him.

Self-evidently, no frame enlargement can convey the mood the camera captures, and casts, in this shot. Visually, this is anything but a moment of stasis, anything but a timeless moment. Indeed, the camera's gesture here precisely acknowledges, or declares, the transience that is one aspect of the temporality of film: the fact that we experience every film moment—as we experience every moment of our lives—within time, the suspense-inducing fact that, for us as well as for the characters, time moves on like clockwork—and that time is running out.

This passage perfectly exemplifies Hitchcock's understanding that the camera is more than a machine that passively takes in whatever happens in front of it. The camera also has the power to make things happen. Within

our reality, and within Manny's reality as well, the camera—that is, what the camera becomes within the film's world—is at this moment making the projected world turn, not to mention our stomachs. The dizziness this turning causes us to suffer engenders the uncanny impression that Manny would find relief from his vertigo, as we would, if only the camera would stop moving. It also engenders the uncanny impression that Manny has the power to make his world, the projected world, stop spinning—as if all it would take would be for him to open his eyes, to awaken to reality. This he is unwilling, or unable, to do.

Later in the film, Rose, in her madness that is also clairvoyance, provokes Manny to open his eyes, if only for a moment, to glimpse the uncanny reality that, as we might put it, the reality of his world is that it is not reality. This is the climax of one of the most profound—and disturbing—sequences in this or any Hitchcock film, a sequence that reverberates deeply within *Psycho*, *The Birds*, and *Marnie*.

Aware now that his wife is disturbed, Manny again comes home from work late at night and finds that Rose hasn't gone to bed. Solicitously, he says, "You should have been asleep a long time ago." "I can't sleep," she replies. This initiates a tense exchange that is presented, in characteristic Hitchcock fashion, by alternating between two camera setups. In "her" shots, Rose shares the frame—for Hitchcock, this, too, is a characteristic practice—with two symbolically charged objects: a large table lamp and their still-made double bed.

MANNY: Rose, this is the second night I've come home and found you awake. And you're not eating either. Honey, this isn't right. Don't you think you ought to see a doctor?

ROSE: There's nothing wrong with me. Why should I see a doctor?

MANNY: Well, when a person doesn't sleep and doesn't eat, and seems to lose interest in everything, maybe a doctor can think of something.

ROSE: We can't pay for things now. How could we pay for a doctor?

MANNY: I've been thinking about the trial, and who'll stay with the boys while we're away. I've called Mother and she'll come over and stay.

ROSE: If you want her to.

Clearly, Manny begins their conversation with an agenda, but he doesn't want Rose to know this. Clearly, too, Rose sees right through him. He doesn't want her to know the real reason he thinks she needs a doctor. Surely she understands, though, that it's because he thinks she's crazy.

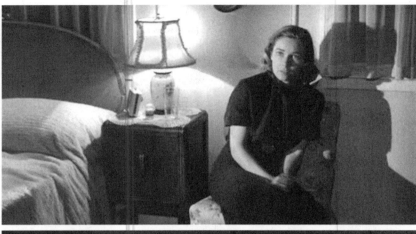

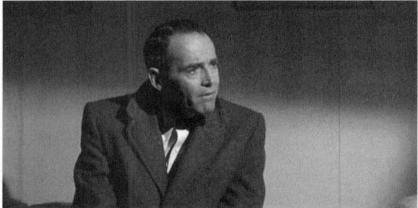

Figure 10.4

When she points out that they can't afford to pay for a doctor, we recognize this as a thinly veiled accusation. In the course of this conversation Rose will come to reveal—and perhaps discover for herself—how bitterly she resents Manny—and for good reason—for having repeatedly borrowed money and paid for things on time even though she told him not to. Indeed, if he had listened to her, he wouldn't have gone to the insurance company office to borrow money and would never have been arrested.

Furthermore, when Rose responds to Manny's statement that his mother will come over to stay with the boys by saying "If you want her to," the palpable hostility in her voice bespeaks what we may surmise to be a

long-standing resentment of Manny's mother for playing too intrusive a role in her son's relationship with his wife, and of Manny for letting his mother do so. As will momentarily become explicit, she also intuits that his real intention is to get the boys out of the house to protect them from their crazy mother.

Realizing that the conversation isn't going as he had planned, but perhaps not quite fully picking up on Rose's veiled and not so veiled accusations, Manny, saying only "Rose . . . ," cautiously moves closer to her. The camera, moving to follow his movement, reframes to a two-shot. Rose's pointed silence cues a cut to a new setup, then to its reversal, and Hitchcock now begins alternating these setups. Thus begins a new phase of this shot/reverse shot dialogue sequence, which so clearly was to serve Hitchcock as a model for shooting and editing the elaborate conversation between Marion and Norman in the Bates Motel parlor.

In an altered, more intimate, voice that reflects his closer physical proximity to his wife, Manny says, "The last few days, you haven't seemed to care what happens to me at the trial." As he speaks these words, Rose stares at him with an intense, scrutinizing gaze. I cannot imagine that it escapes her notice that his caring, solicitous tone is belied by his choice of words, their implication that what really concerns him is not what is happening to her, so much as her seeming lack of regard for what might happen to him.

No doubt, Manny expects Rose to respond by saying that she really does care how his trial is going. Heartbreakingly, she says instead, "Don't you see? It doesn't do any good to care." Rose is acknowledging, not denying, that she has stopped caring what happens to Manny at the trial, but her tone, too, is now solicitous, not angry or bitter. She recognizes that he simply does not see what she sees so clearly. She is certain that their future has already been scripted—which is true—and that, as she puts it, "No matter what you do, they've got it fixed so that it goes against you; no matter how innocent you are or how hard you try, they'll find you guilty"—which is, by contrast, a belief that seems, on the face of it, to be nothing but a paranoid fantasy, a symptom of her madness. In the end, after all, her prophecy will not come true. The case against Manny will be dismissed.

Rose sounds crazier and crazier—she also begins to sound as if she's living in the world of *The Birds*, not the world of *The Wrong Man*—as she goes on: "Well, we're not going to play into their hands. You're not going out. You're not going to the club and the boys aren't going to school. I've thought it all over sitting here. We're going to lock the doors and stay in the house. We'll lock them out and keep them out."

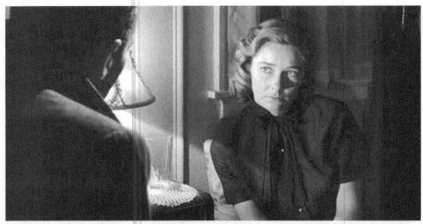

Figure 10.5

"Yes, that's the thing to do," Manny says in a voice even calmer than usual, not daring to confront her. But when he adds, pretending it's an afterthought, "There's one thing we must arrange, whether Mother comes here or the boys go and stay with her," he is clearly unaware how easily Rose sees through him. After a long pause, she rises, so that she is a looming figure in the frame as she says to him, forcefully, "You want to get them out of the house because you think I'm crazy, don't you?" Vehemently, she repeats the words, "Don't you?" She all but spits those words out. "Well you're not so perfect either. How do I know that you're not crazy? You don't tell me everything you do. How do I know you're not guilty? You could be. You *could* be!"

Saying "Rose" in a gentle voice, Manny, too, gets up. As the camera follows his movement, causing Rose to be excluded from the frame, Manny walks past two paintings and a mirror on the wall to the bedroom door and closes it. I take it that it is clear to Rose, as it is to us, that Manny wants to keep their young sons from hearing their mother sounding like this.

I don't imagine that Rose, even in her madness, actually believes that Manny may have committed the crimes for which he is on trial. But that doesn't mean she sees him as guiltless. Nor does it mean that he isn't crazy. The camera is on Rose as she goes on: "You went to the loan company to borrow money for a vacation. You did that when we couldn't afford it. You always want to buy things on time. I told you not to. I told you they'd pile up and pile up and we couldn't meet it all."

This is a serious charge Rose is leveling against Manny, and a devastating one. To be sure, it isn't fair for her to imply that because he visited the loan office, it's his fault that he was arrested. But it is fair for her to point out that it was crazy for him to keep borrowing money without having a plan for paying it back. And it is fair for her to charge Manny, no matter how well-intentioned he may be, with failing to listen to her, failing to take her ideas seriously—fair for her to charge that she is only her husband's wife to him, not a person in her own right.

"Rose," Manny again says gently, recognizing how upset she is, but not acknowledging the truth of what, in her disturbed state, she sees so lucidly. There is reason in her madness, in other words. There's also madness. Goaded, not relieved, by his attempt to calm her, she becomes unhinged. "And it did pile up," she shouts hysterically. "Honey," he interjects, again trying to calm her. But she's beyond calming. "And then they reached in from the outside! And they put this last thing on us!" She is shouting loudly now. "And it'll beat us! And you can't win!"

At this climax of Rose's explosion of fear and anger, Manny reaches his hand out to her shoulder. Recoiling with a loud intake of breath, she stares at his hand, as he had stared at it himself in his prison cell, evidently fearing its potential for violence. We hear the sound of an elevated subway train that passes close to their home—at once credible as a "real" sound, and an expressive objective correlative to her inner turmoil. The camera moves with her as she steps back from Manny, significantly leaving only his hands, doubled by their shadows, in the frame with her. The train sound grows louder and more agitating, and the camera moves in on Rose as she shouts, "They spoiled your alibi!" As she backs away further from Manny, the camera pulls in on Rose, removing him altogether from the frame.

Figure 10.6

Rose's shadow eclipses one picture on the wall, but not a portrait of Jesus that is in the background of this frame, as she shouts even more loudly, "They'll smash us down!"

There is a cut to Manny, doubled by his shadow. He moves toward Rose, hence toward the camera. His motion cues a cut to her, backing away from him in fright. Clearly, she has suddenly stopped believing that "they" are out to smash them both. At this moment she sees Manny as the embodiment of "them." She looks down again, and there is a cut to her own hand, not his this time, as it picks up a hairbrush and swiftly pulls it up and out of the frame; a quick cut to Rose with arm and hairbrush raised; to arm

and brush, framed from below; to Manny, watching wide-eyed; to the brush, slashing through the frame from top to bottom; and finally to a close-up of Manny, his eyes now tightly shut (as they were in his prison cell when the camera made the whole world, with Manny in it, begin to circle). When the hairbrush swiftly enters this frame and brutally hits Manny's left temple with an exaggeratedly loud, sickening thud, the effect is shockingly violent. Only then does he open his eyes and there is a cut, coinciding with a sound of breaking glass and a quite inexplicable but expressive sound as of tearing canvas, to a shot in which Manny is staring wide-eyed directly at the camera, a jagged fissure running the height of the frame and splitting his face into two ill-fitting pieces, one eye higher than the other.

What are we seeing in this remarkable shot? Are we seeing Manny staring at his own image in the cracked mirror we just heard breaking? Or is this a point-of-view shot that represents Manny's reflection, as he is seeing it in the mirror? Manny viewed and Manny viewing fuse with the camera's view to create an image—and self-image—of his shocked, split, transfixed face. Manny is shocked that his gentle, compliant, uncomplaining wife has such violence within her. If he didn't know this about his wife, he doesn't really know her. But it's Manny's own fractured image, not Rose's, that this shot shocks us by capturing, and expressing. There is something about himself that Manny is shocked to discover he doesn't know. He doesn't know what he has done, what he is, that makes it possible for Rose to see him as so hateful, and so terrifying, that she can believe he wants to "smash her down," and makes her wish to kill him.

In the shower murder sequence of *Psycho*, Hitchcock contrives to identify the shower curtain that Marion's killer tears open with the movie screen, as if the murderer also tears open the "safety curtain" that keeps us safe from murderers who dwell within the world on film, so that it is as if we, too, find ourselves face-to-face with our own murderer. I take this shot in *The Wrong Man*, too, to have a self-referential dimension. Like the surface of a mirror, the movie screen is a border between an image of reality and reality itself; it is also where the two touch. In this shot the mirror's frame is outside the film frame, so the mirror's surface fills the entire movie screen. Visually, there is nothing to distinguish one from the other. Thus the question of whether it is Manny we are viewing or his view of his own mirror image melds with other questions: From which side of the border separating his world from our world are we viewing Manny? On which side of this border is the camera? From which side comes the violent strike that fractures Manny's image or self-image and freezes his face, turning it to

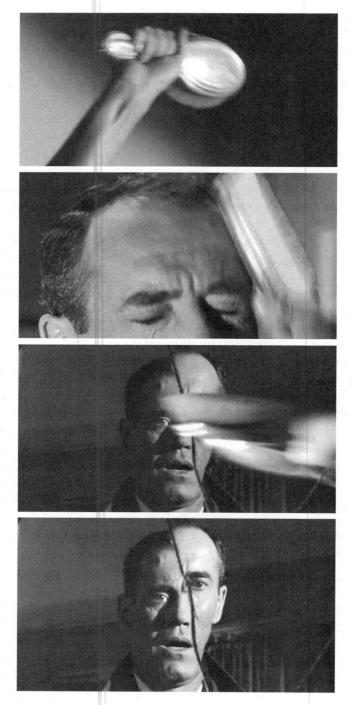

Figure 10.7

stone? Is it Manny whom Rose believes she is striking, or has Manny become the embodiment of "they" to her? Or is it really "they," reaching in from outside, who have possessed Rose, using her hand to wield a weapon to smash Manny down and make sure he cannot win?

That the "outside"—the other world to whose reality Rose's violent act forces Manny to open his eyes, a world so close to their own that she is afraid "they" will reach in from it to smash them down—could be our world, the one existing world, is underscored by yet another dimension of the shot's ambiguity. We cannot tell whether the fissure that splits Manny's image is a crack in the mirror, a crack in the lens of the camera or projector, or a tear in the movie screen (is that the otherwise inexplicable sound we heard of tearing canvas?). If the vertiginous spinning of Manny and his world declared the transience that is one aspect of film's temporality, the present disturbing vision of Manny's disturbing vision—visually, this is a moment of stasis—declares the timelessness that is film's other aspect—the fact that in the projected world past, present, and future, as well as "inner reality" and "outer reality," are equally real and unreal, and in the same way. It is as if for all time that Manny's face is frozen, his mismatched eyes staring at us, staring into the abyss.

The agitating train sound segues smoothly into Bernard Herrmann's now soothing music. Her passion spent, Rose goes over to Manny, her hands reaching toward his face in a supplicating gesture, as if begging his forgiveness for having forced his eyes open to see the reality of her madness—and see the *truth* in her madness. Tenderly, she pulls his face down to hers as if to kiss it, but thinks the better of it. She looks past him, as if it is fully sinking in that she is alone.

Then, staring at the hand that had held the hairbrush, Rose turns away from Manny, goes back to the chair between the bed and the lamp, the camera following her, and sits down again, her hands crossed, as if to keep them from once more betraying her innermost feelings. "It's true, Manny," she says sadly. "There is something wrong with me. You'll have to let them put me somewhere." Manny, who does not comprehend what has happened, is silent as the scene fades out.

When Marion Crane intimates to Norman Bates, as tactfully as she can, that it might be best if he put his sick old mother "some place," he replies with a flash of anger, "You mean an *institution*? A *madhouse*?" He characterizes such a place as one where there are always "cruel eyes studying you"—not coincidentally a description that could aptly be applied to the world of *Psycho*, the "place" they are in as they are conversing. Rose may well believe

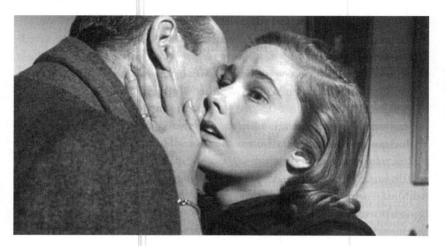

Figure 10.8

that at this moment "they" are looking at her from the "outside," as we actually are, but what she fears is not their "cruel eyes," or ours. She fears the things "they" have done, and threaten to do, when they "reach in" to her world—the power they possess, and their intention, to "smash her down."

Rose believes, I take it, that what has just happened—what she has just seen, what she has just done—has revealed two things to her. Manny's hand—even though it isn't missing the top joint of its little finger—has unmasked him as one of "them." And her own hand has revealed its capacity for violence. The "somewhere" Rose tells Manny he will have to let them put her is a place—a "private island"—where she believes she will be free, or at least freer, from the threat that "they" will smash her down. Specifically, it is a place where Manny can be locked out, except for brief visits, keeping Rose safe from him but also keeping him safe from her.

Before Manny agrees to let Rose be put in an institution, her doctor explains to him that his wife has suffered a mental breakdown resulting from her unbearable feelings of guilt, her belief that her inadequacies are the cause of all Manny's suffering. Now she is "living in another world" from theirs, the doctor tells Manny, a place that could just as well be "the dark side of the moon." In that world Manny is there, the doctor assures him, but only as a monstrous shadow of himself, not as he really is—a projection of Rose's inner reality, not reality itself. Of course, the doctor's words aptly describe the world of *The Wrong Man*, implicitly equating our perspective with that of Rose, not Manny.

In a Hitchcock film it is always a mistake, however, to assume the veracity of a psychiatrist's explanation. At the end of *Psycho*, for example, one assumes at one's peril that the psychiatrist gets it right, that it really is "Mother," not Norman, who has filled him in on the situation; thus, we err if we simply take for granted that it is "Mother" who is casting that villainous grin directly to the camera. Norman, who prides himself on being someone who can't be fooled ("not even by a woman"), would find it child's play to bamboozle this psychiatrist, who is such a slick, self-important know-it-all. Rose's doctor is more sympathetic, but it would likewise be a mistake simply to take his word for it that when Rose, in a "private island" that could be "the dark side of the moon," perceives Manny as saying "hateful things," she is not perceiving Manny as he is but only his "monstrous shadow," a projection of her own broken mind. Surely, the Manny that Rose perceives in her madness *is* real—the Manny who doesn't listen to his wife even when it is crazy for him not to; the Manny who borrows, borrows, borrows without a plan to pay the money back; the Manny who has secret fantasies of solving all his problems by winning big at the racetrack but who is afraid to take the risk of betting; the Manny who, for all his good intentions, perceives his wife as a satellite of himself.

Manny's response to the doctor is a testimonial to his love for his wife, to be sure, but his words also betray what Rose, in her madness, would have reason to find hateful. "I want only the best for her," he says (not, for example, "She deserves the best")—as if what *he* wants is what really matters to Manny. When he repeats, emphatically, "The *best*," it is obvious that he is giving no thought to how expensive "the best" will be, to the money they will have to borrow to pay for it, to how much deeper this will dig the hole out of which they already have no way to climb. Evidently, the reality he glimpsed in the cracked mirror failed to shock Manny sufficiently to provoke him to change. His eyes are again shut.

Rose does have to be paranoid—most Americans were, in the mid-1950s—to say, and believe, "They've got it fixed so that it goes against you," and "No matter how innocent you are or how hard you try, they'll find you guilty." Yet Manny would almost certainly have been found guilty were it not for a totally unexpected occurrence, the happy accident—happy for Manny, at least—that the real holdup man returns to the butcher shop that was the scene of one of the crimes the police believe Manny committed, is arrested after he tries to hold up the store a second time, and is brought to the police station at precisely the moment the younger (and more sympathetic) of the two detectives who had originally questioned Manny walks

by. His memory jogged, the detective puts two and two together. The result is that the case against Manny is dropped. A highly unlikely succession of accidents—a miracle, in effect—has to occur for Rose's dark prophecy to fail to come true. Or perhaps it does come true after all, since even when Manny's court case is thrown out, Rose does not let him win. Her hateful words, "That's fine for you," pronounce him guilty.

In the film's most celebrated passage, the camera not only enables us to bear witness to the "miracle" that leads to Manny's exoneration in the eyes of the Law; it is also instrumental in making the "miracle" happen. The passage begins when Manny's mother, sensing that her son's faith is faltering, asks him if he has prayed. He prayed for help, he tells her. Unhappy with this, his mother implores him to pray for strength. With a rare trace of anger—anger at his mother and, perhaps, at God—Manny replies that what he really needs is a little luck. Saying "I've got to go to work," he abruptly leaves the room. His mother silently prays.

Alone in the bedroom, Manny is putting on a dress shirt when something offscreen strikes his attention. Is he seeing his own reflection in the still-cracked mirror? When we do cut to his point of view, what we discover, rather, is that Manny is staring at the portrait of Jesus we had glimpsed on the wall just before Rose's violent breakdown. In this strikingly composed frame—a setup that Hitchcock first used in *The Lodger* and was to use again in *Vertigo* at the all-important moment Scottie recognizes the telltale necklace—Manny's shadow is in the left foreground, while in the right background Jesus, in the painting, seems to be meeting the gaze of Manny's shadow. That the camera is moving closer to the painting, all the while keeping Jesus's eyes centered in the frame, enhances our sense that the painted Jesus's gaze, like a magnet, is pulling Manny's gaze—and the camera's—toward it. This is a shot from Manny's point of view, yet it is not Manny's own gaze, but that of the painted Jesus, that presides over this frame. When the camera returns to Manny, he is framed differently from the way he had been. When we now view Manny, moving his lips in silent prayer, he is framed in a nearly frontal close-up. It is as if this shot represents not a conventional reaction shot but a shot from the painted Jesus's point of view. This shot is less striking, visually, than the preceding shot, which juxtaposed Manny's shadow and the painting, but it is no less mysterious. The sense of mystery the shot conveys is enhanced by the fact that Manny's face is framed by a curtain—always, in Hitchcock, an allusion to theater—whose folds form a perfect Hitchcockian ////.

Figure 10.9

Is Manny following his mother's advice and praying for the strength she believes he needs to carry the heavy cross God has chosen for him to bear? I imagine that Manny's mother is now praying for God to grant her son strength but that he is praying for the real holdup man to be arrested—the "good luck" he believes is the only thing that can help him. And that is what is about to occur, although Manny will not immediately be aware that his prayer has been answered. A long, slow dissolve now begins to superimpose Manny's face, his lips still moving in prayer, and a New York street at night, lined with brightly lit storefronts—one shot marked by the //// motif, the other forming a Hitchcockian tunnel shot.

At first a small figure in the depths of the frame, but growing ever larger as he strides directly toward the camera, is a man wearing a raincoat and a hat just like Manny's. (Marian Keane pointed out to me that it is probably no coincidence that the hat the Italian American Manny likes to wear looks so much like the protagonist's hat in Vittorio De Sica's Italian neo-realist classic *The Bicycle Thief* [1948].) As the man draws closer and closer to the camera, he looms ever larger until his face, superimposed over Manny's, or perhaps under it, rises in the frame until—this is a breathtaking moment—the contours of their faces coincide. For a moment their features do not quite fit together, and we may well be reminded of our earlier view of Manny's face—or of Manny's view of his own face—in the cracked mirror. At the precise moment their faces do perfectly meld into one, this man's eye-line matches Manny's, as if his gaze, like Manny's, is drawn by the power of Jesus's gaze, thus as if the camera is viewing him with Jesus's eyes.

When the man looks screen right, severing his gaze from Manny's, his expression is grave. He lowers his eyes, as if in shame. It is at this point that it fully sinks in that the camera, perhaps animated by Jesus's gaze, has transferred its attention, and ours, from Manny to this stranger. When he turns in the opposite direction and begins walking, he is grim-faced, having made the fateful decision, as we will momentarily discover, to pay a return visit to the butcher shop.

When Manny is exonerated, justice is served. Yet we may well find it troubling, if understandable, that in praying for his trial to end, Manny is praying for another man's trial to begin. No doubt, that man is a criminal who has a very different story from Manny's. But he *has* a story, as every person does, a story that remains unknown to Manny—and to us. We may well also find it troubling, if understandable, that when their paths "accidentally" cross in the hallway of the police station, Manny angrily con-

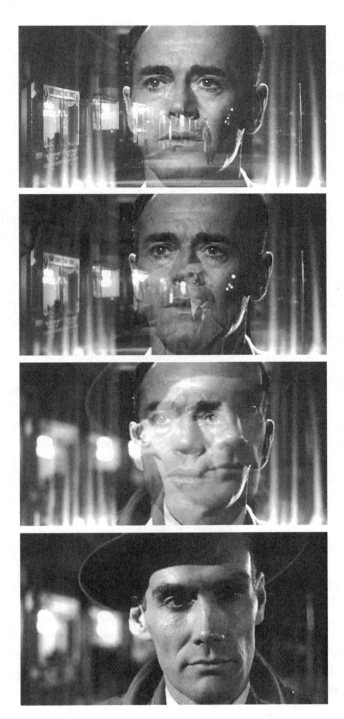

Figure 10.10

fronts the newly arrested man, saying, "Do you know what you've done to my wife?"—as if Manny himself bore no responsibility at all for her descent into madness. That is not how Rose, in her madness, sees it. But Manny's eyes are shut. And they will still be shut when he brings his wife the glad tidings that their nightmare is "all over," only to be rebuked with the words, "That's fine for you."

It takes an unlikely conjunction of "accidents"—a "miracle"—to cause Manny's court case to be dropped, just as it took an equally unlikely conjunction of "accidents"—another "miracle"—for him to have been arrested in the first place, and yet another for his alibi to have been "spoiled," as Rose put it. In the preceding chapters we have repeatedly observed that in the world of a Hitchcock film everything that happens only happens because Hitchcock makes it happen. In the films I've discussed, everything that happens within the film's world is a manifestation of Hitchcock's power as the film's author; in that sense, we can say that everything that happens is a miracle. From the outset, however, *The Wrong Man* claims to be different. It opens with Hitchcock himself, doubled by his shadow, speaking directly to us to testify that the story this film tells—"every word of it"—is *true*.

Although *Psycho* opens with titles that specify the time and place of the camera's entrance into the hotel room where Marion and Sam have just had illicit sex, that film's suggestion that the events actually happened is only a rhetorical device. In *The Wrong Man*, though, Hitchcock's personal appearance seems to lend his full authority to the claim that, as we might put it, reality itself is the real author of this film's script. And, indeed, the film's story does follow, at least in broad outline, events in the real lives of, among others, Emanuel Balestrero; his wife, Rose; and a young lawyer, Frank O'Connor, who was to go on to become a well known New York City district attorney. Their names aren't even "changed to protect the innocent" (or the guilty).

Near the end of *Lifeboat*, Connie lectures her fellow Americans, in an Emersonian spirit, on the need for self-reliance, then practices what she preaches by using her prized necklace as bait to try to land a fish. Just as a humongous fish, no less committed to self-reliance, seems about to risk a bite—an underwater shot adds a wonderfully absurd comic touch—Hitchcock cuts to Joe. A man of faith, like most black characters in Hollywood movies of the 1940s, he is looking toward the horizon with a prayerful expression. When his face lights up and he announces that he sees a ship, we understand that he perceives the ship's arrival as providential. A miracle.

This ship, it turns out, is the German supply ship toward which Willi had been secretly steering the lifeboat. By answering Joe's prayer, God, whether owing to cruelty or incompetence, seems only to have made things worse. Joe's faith isn't shaken, though. He knows that God works in mysterious ways. So does Hitchcock. In a twist reminiscent of *Secret Agent*, an American plane suddenly appears and sinks the German ship. Had Joe's prayer not been answered, the lifeboat wouldn't have been close enough to the German ship for the bomber pilot to spot it and rescue all on board—but not before they pull a young German survivor from the water and overcome the temptation to kill him.

Joe has no doubt that God has performed a miracle. We know better. We know that the film's author, not God, is the responsible party. But if we accept *The Wrong Man*'s claim, voiced by Hitchcock himself, that this film is different because everything that happens in its world actually happened in our world, how are we to account for all those unlikely conjunctions of accidents, those "miracles," around which the film's story revolves (as does every Hitchcock story)? In the world of *Lifeboat* there are no accidents, only "accidents"; no miracles, only "miracles." But every "miracle" in the world of *The Wrong Man*, Hitchcock tells us, represents an event that actually happened in our world. In the one existing world, those events must either have been coincidences pure and simple—true accidents, not "accidents"—or else they were acts of God—true miracles, not "miracles." Which were they?

For other Hitchcock films, such a question would be moot. In their worlds there are no accidents, only "accidents," and every "accident" bespeaks the power of the film's author and is a miracle, in that sense (but only in that sense). In our world such a question is not moot, but neither does it admit of a definitive answer, because we can never adduce tangible evidence that can definitively distinguish "accidents" from accidents or "miracles" from miracles (if there are such things as miracles). This would seem to be the case, as well, in the world of *The Wrong Man*, if we accept the film's claim that every event within its world has its counterpart—whether "accident" or accident, "miracle" or miracle—within the one existing world.

But what of those extraordinary moments in the film, major turning points in its allegedly true story, in which it is not even possible to describe what is happening within the film's world without taking into account what the camera is doing—especially the moments that manifest the camera's power to anticipate what is going to happen and even to make things happen. (Are these powers of the camera in principle separable?) Obviously,

no camera was in the presence of the "real" Emanuel Balestrero when the events represented in *The Wrong Man* took place. Awareness of that fact had always convinced me that what happens in this film's world at such moments couldn't possibly have actually happened, hence that we should not take at face value Hitchcock's claim that the film's story is literally true.

I now question that conviction. I now realize that I had been overlooking the implications of the crucial fact that, as I've put it, the camera that was in Henry Fonda's presence but not in the presence of the "real" Emanuel Balestrero, is not in the presence of the film's Manny, either—the character Fonda plays, and incarnates, within the world of *The Wrong Man*. Or rather, the camera *is* a presence in Manny's world but only as an absence. Manny lacks Rose's clairvoyance, but the God who is a reality to him is an "absence-that-is-also-a-presence" with powers comparable to the camera's in films Hitchcock unambiguously authors—the power to make miracles happen, to make his world go 'round, to split him in two, to answer his prayers.

Does our world have an author who presides over the world of His (or, more likely, Her) creation the way Hitchcock presides over the worlds of his films? I don't claim to know. Nor do I claim to know whether Hitchcock really believed in such a God, even though he was a Catholic who regularly attended Mass throughout his adult life. But I do know that *Manny* believes that God exists, however much his mother has to jog his faith when it is most tested. And if everything that happens in the world of *The Wrong Man* actually happened in our world, Emanuel Balestrero, Manny's "real" counterpart, prayed before a portrait of Jesus, just as Manny does, the night the "right" man was arrested.

Manny does not exist in the same world as Emanuel, but they pray to the same God. The thrilling slow dissolve by which the camera effects the transfer of its gaze and ours from Manny, praying, to the real holdup man manifests itself to us, but not to Manny, who doesn't see what the camera enables us to see as God answering Manny's prayer. In all his other films Hitchcock uses the camera to perform his own miracles. Here, he is using the camera to *represent* or *reenact* a miracle—a miracle originally performed by God, not by Hitchcock.

Earlier, I observed that in his role as author Hitchcock could play God without being God because the worlds of his creations, over which Hitchcock presides, do not really exist. Within those projected worlds, I argued, Hitchcock possesses godlike powers, but his powers have limits. He cannot make himself God. This means, for example, that he cannot grant him-

self the power to absolve murderers. After making the bus blow up in *Sabotage*, killing the protagonist's likable young brother and the lovable puppy he befriended, the intuition dawned on Hitchcock, or so he told Truffaut, that killing the boy and the puppy, for no reason other than that he wanted to, was wrong. It didn't make Hitchcock a murderer. Nonetheless, it troubled him.

The Wrong Man is an unusual Hitchcock film in that its story doesn't revolve around murder. But it is altogether unique, among Hitchcock films, in being a story of unrelieved suffering—unrelieved for the characters we care about and unrelieved for us by virtue of the total lack of the kinds of gratifications other Hitchcock films offer us. For example, it has none of the humorous moments he relies on in all his other films, with a mastery rivaling Shakespeare's, to vary the mood or our perspective on the action. In the Hitchcock films we've examined so far, and the ones we will examine in later chapters, sympathetic characters suffer at times, but also enjoy pleasurable moments. And almost without exception—*Rope* is an exception—they are ultimately rewarded (although, as we have seen, Hitchcock also undermines, or hedges, some of these "happy endings").

I am not suggesting that *The Wrong Man* rewards us with no pleasures at all. For one thing, it rewards us with great, and singular, beauty. If other Hitchcock films are trains of moods, dazzling strings of beads of different colors, this film's story of unrelieved suffering allows, or rather requires, the telling of its story to sustain a single mood, a darkly poetic mood that casts an ever-deepening hypnotic spell over us.

The fact that the protagonist is Manny, even though Rose is the heart and soul of *The Wrong Man*, is a key to the film's ability to keep us entranced. As played by Henry Fonda in an inspired and technically flawless performance, Manny seems to be sleepwalking through life. His behavior has an almost preternatural even-tempered calmness not because he is clairvoyant, like Rose, but because his eyes are shut to what Rose sees. Working in tandem with Bernard Herrmann's spellbinding score, cinematographer Robert Burks employs several strategies to attune the film visually, with exceptions that prove the rule, to Manny's subjectivity, not Rose's. As in those hypnotic passages in *Vertigo* in which Scottie, following Madeleine's car, drives what seems endlessly through the streets of San Francisco, throughout *The Wrong Man*, shot smoothly follows shot, and the camera moves, when it moves, in a slow, even tempo that lulls us into a trancelike state between sleep and wakefulness.

Figure 10.11

And Burks doesn't use black and white expressionistically, as John Russell does in *Alfred Hitchcock Presents* episodes and in *Psycho*, to project a world of stark melodramatic contrasts. *The Wrong Man* feels less like a black-and-white film à la *Psycho* than a color film in whose world shades of gray happen to be the only colors. To this end he employs a range of grays, the way he uses colors in other Hitchcock films of the 1950s, to divide the frame into regions, separated by distinct borders. The juxtapositions of these regions create satisfying two-dimensional compositions that make us register, consciously or not, the flatness of the screen that holds these projected images of a world in three dimensions. This strategy enhances our uncanny sense that we are dreaming this calm, gray, beautiful world rather than viewing it wide awake. It makes us all the more vulnerable to the brutality of those moments when Rose's subjectivity reaches into our dream and turns it into a nightmare.

Vertigo and *Psycho* are dark films, too. But only *The Wrong Man*, for all its beauty, is so unrelentingly harrowing that it irresistibly invites comparison with the book of Job. Job suffers for a reason, even if the reason is God's wish to teach his creations the painful lesson that they are not to question His reasons. God does not need a reason to make His creations suffer. But Hitchcock isn't God. The "mistake" he made in *Sabotage* helped bring home to him that *he* needs a reason to make *his* creations suffer—even though the characters in his films don't really exist, even though making them die doesn't make him a murderer, and even

though he is powerfully drawn to the idea that each man kills the thing he loves.

I can believe that Manny suffers for a reason, but I cannot believe that Rose does. Nor can I believe that Hitchcock believed there was a reason to make her suffer. Why does he make her suffer, then? The simple answer is that he doesn't. In his role as the author of *Notorious*, Hitchcock makes Alicia suffer, and he does so for a reason (a reason related to the fact that Devlin is an accomplice in making her suffer, as is Alicia herself). But if we accept his claim that *The Wrong Man* is different from his other films in that everything that happens in its world actually happened, it follows that Hitchcock is not responsible for Rose's suffering, the way he is for Alicia's. How could Hitchcock be responsible for the suffering of the film's Rose if her suffering only represents the actual suffering of the "real" Rose Balestrero?

Hitchcock's claim that the events in *The Wrong Man* actually happened constrained him, however, in at least two ways. One is that, if only for legal reasons, there are things the film cannot say. For example, it cannot say— I am not implying that this was really the case—that the two detectives who arrest and question Manny actually frame him, much less that framing suspects they believe to be guilty is standard procedure for New York's finest. The detectives dictate to Manny the words of the holdup note and make him write them on a slip of paper. Looking at the original, the copy, and each other with what seems feigned amazement, they hand him another slip of paper and dictate the words again. After another theatrical exchange of looks, the older detective says, in the most Kafkaesque moment of this Kafkaesque scene, "It looks bad for you Manny. It really looks bad for you." He then informs Manny that he had misspelled the word *drawer*, just as the holdup man had done. I always have the impression that the detectives are brazenly pulling a "three-card Monte" number on the gullible Manny, that both slips of paper with the misspelled word are the ones Manny wrote. As a consequence of his claim that everything that happens in the film's world actually happened, however, Hitchcock wasn't free to make the film unambiguously assert, even if he wanted to, that New York City detectives routinely break the law when they interrogate suspects.

A deeper consequence of Hitchcock's claim that this film tells a true story is that he cannot in good conscience end the film with Rose's devastating words to Manny, "That's fine for you." That would have made a powerful and meaningful ending. But it would have exposed these two characters so abjectly, so cruelly, without suggesting that there was even a hope for

their redemption or salvation, that the "real" Emanuel and Rose Balestrero would surely have perceived the film as hateful and would have been painfully wounded by it. This ending would have inflicted on these two vulnerable people "little deaths" of great magnitude.

It would have been less cruel for Hitchcock to have ended the film with the nurse's kind words to Manny, spoken as he is leaving, which hold out to him, and us, a ray of hope. "Miracles do happen," she says in a caring voice, "but they take time." Ending the film with this line, however, would have meant withholding from us the fact—surely, a telling feature of the "true" story—that such a "miracle" actually happened in the lives of the Balestreros, who moved to Florida after Rose's condition improved sufficiently for her to be released from the institution. Hence Hitchcock concludes the film with a shot of the skyline of Miami, then still a sleepy southern town, over which he superimposes a title informing us that this is where the family is now living happily, Rose having left the institution "completely cured."

This title may seem congruent with—even mandated by—the actual lives of the Balestreros, but it unmistakably smacks of that irony familiar from Hitchcock's appearances as host of his television show—as if *The Wrong Man* were an episode of *Alfred Hitchcock Presents*, and this is the "happy ending" his sponsors demand. Presumably, the "real" Rose Balestrero wouldn't have been released were her doctor not convinced that she was well enough to make the long journey to Miami from "the dark side of the moon." In *The Wrong Man*, though, as we have seen, there is reason, as well as madness, to Rose's madness. Does being "completely cured" imply that Rose no longer perceives, in Manny's words and actions, what it was not madness for her to have seen as hateful?

I'd like to think that in encouraging Manny to hope for a miracle, the nurse understands that any miracle that changed only Rose but left Manny unchanged would fail to cure what ails their marriage. To transform their troubled relationship into the kind of marriage that couples achieve in comedies of remarriage (and, as we will see, in *North By Northwest*), a further miracle would be required, one that moved Manny to open his eyes. It would take more than time to make that kind of miracle happen. Part of what Manny would see, if he opened his eyes, is that there is no such thing as a "complete cure" for his condition, or Rose's. This is true of our condition as well. That being human means being finite, having frailties, is an intuition that Hitchcock, as well as Emerson, shared with the Katharine Hepburn character in *The Philadelphia Story*. The human condition is ter-

Figure 10.12

minal. The only "complete cure" to being human is one that it is madness to prefer to the condition itself.

Hitchcock concludes *The Wrong Man* by asserting a claim—a claim about both the film's world and our world—that I don't believe he believed to be literally true, the claim that Rose is "completely cured" when she is released from the institution. Thus the film's ending calls into question the claim Hitchcock personally voices at the opening of the film, the claim that this film is different from his other thrillers in that it tells a story every word of which is true. The more I contemplate the film's opening, however, the more mysterious it reveals itself to be, and the more it appears also to be calling into question the very claim it is nonetheless seriously asserting. Again, what could be more Hitchcockian?

"This is Alfred Hitchcock speaking," we hear that familiar voice say, but in a tone devoid of its usual irony. "In the past," the voice goes on, "I have given you many kinds of suspense pictures. But this time, I would like you to see a different one. The difference lies in the fact that this is a true story—every word of it. And yet it contains elements that are stranger than in all the fictions that have gone into many of the thrillers that I've made before."

Hitchcock's voice, speaking these words, is accompanied by the same Philip Glass–like music that will be reprised when Manny, alone in his prison cell, finds his world vertiginously circling. And Hitchcock is filmed—he films himself—from afar within as weirdly composed a shot as he had ever created.

As he begins to speak, Hitchcock walks toward the camera, much as the "right" wrong man will later do. Or is this really Hitchcock? Rendered strangely small by the camera's distance, silhouetted against, and centered horizontally within, a triangle-shaped pool of light that pierces the darkness surrounding it—this triangle at once evokes the beam of light that is projecting this image onto the movie screen and turns the image into one of Hitchcock's signature tunnel shots—this figure could be anyone. Or no one. That this figure is doubled by its own monstrous shadow, twice as long as the figure is tall, might well remind us, in retrospect, of the language in which Rose's doctor describes "the dark side of the moon."

This association is enhanced by the fact that we may find ourselves wondering whether that familiar voice, sounding impossibly close, is emanating from the silhouetted figure we take to be Hitchcock "as he is," or from the monstrous shadow he casts within the frame. There are no villains in this film's world—unless we count the ones Rose calls "they," in which case there is no one we can be certain is *not* a villain, and that includes Manny, and it includes Rose herself. It also includes Hitchcock, the film's opening is telling us in its singular way.

When the court case against Manny is dropped, he believes his suffering is over and that, therefore, Rose's suffering will be over, too. But Rose, in her madness, is unable, or unwilling, to stop suffering. And she will not allow Manny to stop suffering, either. As usual, there is reason in Rose's madness. What justice would there be if Manny, whose eyes are closed to the guilt he bears, were allowed to stop suffering, while Rose still suffered?

I'm not suggesting that Hitchcock took pleasure in Rose's suffering. I feel that he empathized deeply with her. And I'm certainly not suggesting that Hitchcock saw Rose, or that Rose sees herself, as a victim to be pitied or as a damsel in distress to be rescued. Nor is Rose perverse, like Alicia, who participates actively in her own victimization by demanding—as Ingrid Bergman characters are wont to do, with *Spellbound* a glorious exception—that the man she loves do the thinking—or, at least, the speaking of words of love—for both of them. Manny's misfortunes, and her own, are in no way Rose's doing—except for the madness she suffers. And she brings her madness on herself by virtue of what I have called her clairvoyance.

In light of *The Wrong Man*'s claim that its story is true, hence that it is not Hitchcock who presides over the film's world but rather God, the author of our world, Rose's clairvoyance reveals her kinship with the heroines of Carl Dreyer films who sense God's presence in ways the films' other

characters do not. Since Rose envisions the divinity that holds sway over her world, and whose nearness she alone senses, as the terrifying "they" who have singled her out only because they want to smash her down, Rose's clairvoyance seems a curse, not a privilege or a blessing.

Job learned the old-fashioned way that God needs no reason, other than wanting to do so, to make his creations suffer. That we must not only accept, but also affirm, God's dominion over us is the little moral to which the book of Job points, the little lesson it teaches. Is this the lesson *The Wrong Man* teaches as well? Because in reality, as Rose sees it, "they" want to smash her down, she refuses to affirm the reality she sees, but she also will not, or cannot, close her eyes to it to become "a sleepwalker, blind," like Manny. Is it seeing that "they" really want her to suffer that causes her madness? Or is it her madness that causes her to see reality this way?

If Hitchcock believed in a God, the creator of our world, capable of wanting to smash down the likes of Rose Balestrero, it is no wonder he never chose to repeat the experiment of ceding his authorship to such a God. In any case, as great a film as I believe *The Wrong Man* to be, when Hitchcock uses the camera to represent or reenact miracles, rather than to perform miracles of its own, the Emersonian dimension of Hitchcock's art is inevitably submerged. Submerged, but not lost, I must add. For even if God wanted to make the "real" Rose Balestrero suffer, it would not be possible for the film's Rose to suffer the way she does in *The Wrong Man* if she kept her eyes closed to that reality. God cannot make Manny open his eyes. And God cannot make Rose open hers, either. Rose's suffering in the film, like Elsa's in "Revenge," is not a sign of weakness but rather a manifestation of a freedom she claims for herself, a power she possesses. This power intrigued as well as moved Hitchcock, perhaps not only because, like all masters of the art of pure cinema, he possessed that power himself. (How else could he have perceived it in Vera Miles?)

Rose is a mystery to Hitchcock in a way only Elsa, among his characters, had ever been before. If one of God's creations can claim the freedom to impose her will on God, is it possible for a character in a film Hitchcock truly authors—a character he creates rather than a character who represents a "real" person—to impose her will on the film's author, even make Hitchcock, against his will, kill the thing he loves? Pondering this question gives me vertigo. Pondering this question moved Hitchcock to give us *Vertigo*.

When I began writing this chapter, I had high hopes that when a movie was one day made of my life, it would end with a title announcing that I

had moved with my wife to Miami, not far from the happy home the Balesteros made for themselves after Rose was released from the institution, and that I was "completely cured" of the dark vision I had found to be at the heart of Hitchcock's work, and that was at the heart of my book as well, when I wrote *The Murderous Gaze*. As I am writing these words that are at long last bringing this chapter to a close, I'm not so sure. It is bleak midwinter in most of the country, but outside my window, birds are singing. Am I speaking to you, in this chapter, from sunny Miami? Or are these words coming to you from "the dark side of the moon?"

11

Scottie's Dream, Judy's Plan, Madeleine's Revenge

At the end of *Vertigo* Scottie, like Stefan at the end of *Letter to an Unknown Woman*, awakens too late to his failure to recognize the woman he loved. In "*Vertigo*: The Unknown Woman in Hitchcock," an essay I published several years after *The Murderous Gaze*, I reflected on the intimacy of *Vertigo*'s relationship to the Hollywood genre that Cavell, in *Contesting Tears*, calls the "melodrama of the unknown woman."[1] (In addition to *Letter from an Unknown Woman*, the other members of the genre Cavell's book studies are *Stella Dallas*, *Now Voyager* [Irving Rapper, 1943], and *Gaslight*.) *Vertigo*'s Judy, in her quest for existence, is close kin to the women in these melodramas. So are a number of other women in Hitchcock thrillers. And yet, as I argued in my essay, the role of the villainous Gavin Elster, and Judy's implication in his plot to murder his wife, sets *Vertigo* apart from an "unknown woman" melodrama like *Letter from an Unknown Woman*, a comedy of remarriage like *The Lady Eve*, or a member of an adjacent genre, like *Random Harvest* (Mervyn LeRoy, 1942)—all classic Hollywood films about a woman in love with a man who fails to recognize her.

In the years since I wrote "*Vertigo*: The Unknown Woman in Hitchcock," I have come to see Hitchcock's masterpiece with new eyes and have arrived at a new understanding of its crucial importance within his career as a whole. *Vertigo*, his one tragedy, is a turning point for Hitchcock.

The specific circumstance that provoked me to think about *Vertigo* in a new way was coming across on the Internet a brilliant if perverse essay on this, his favorite film, by the great French filmmaker Chris Marker. Marker offers an audacious twist on the idea that Hitchcock designed *Vertigo* to deceive us and that Gavin Elster is his stand-in. Marker's interpretation motivated me to look more closely at Scottie's dream sequence (if that is what it is) and at Judy's flashback. Then my eyes were opened.

Scottie's Dream

Marker interprets the last third of *Vertigo* as Scottie's wish-fulfillment dream or fantasy. According to his interpretation, our last glimpse of reality is a shot of Scottie sitting in his hospital room—or is he on "the dark side of the moon"?—as Midge (Barbara Bel Geddes) plays Mozart to "chase the cobwebs away" (although she knows he has an aversion to the composer) and assures him that (in her chilling words) "Mother is here."

In reality, Marker argues, Scottie never leaves his chair; he is absorbed in a fantasy designed to assuage his unbearable guilt for causing the woman he loved to die by denying that she really is dead. During the last third of the film, in Marker's view, nothing the camera presents is reality; everything—Elster's plot to murder his wife; Scottie's project of changing Judy into Madeleine; indeed, Judy herself—is a projection of Scottie's inner reality. Like Norman Bates's efforts to breathe life into the mother he murdered, Scottie's dream is a broken mind's way of denying a reality it finds intolerable. What begins as wish-fulfillment turns into nightmare. The repressed returns as Scottie, within his fantasy, again causes the woman he loves to die.

Marker's claim that *Vertigo* deceives us into mistaking Scottie's inner reality for reality itself has the virtue of recognizing a fundamental Hitchcockian principle: on film there is no inherent difference between what is objectively real and what is real only subjectively. That is what makes possible the signature Hitchcock practice of employing his powers as author to make the innermost wishes of his characters—wishes they are not even conscious of harboring—"magically" come true. In using his powers as author to make reality coincide with fantasy, his aim is not to deceive us into mistaking one for the other. As I argue in *The Murderous Gaze*, it is one of his strategies for declaring in a modernist spirit, as well as exploiting for emotional effect, the capacity of the art of pure cinema to overcome or tran-

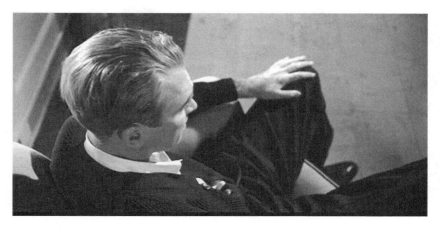

Figure 11.1

scend the opposition, which we ordinarily take for granted, between reality and fantasy.

Because on film there is no inherent difference between what is objectively real and what is real only subjectively, filmmakers instituted conventions (cueing the beginning and ending of a flashback by making the screen go wavy, for example) in order to assert, against the grain of the medium, as it were, a real separation between them and to provide viewers with criteria to distinguish one from the other. In segueing to Scottie's dream sequence, Hitchcock invokes one such convention by having Scottie look toward the camera as if a point-of-view shot (and, in turn, a reaction shot) were to follow. But Hitchcock complicates this transition between "outer" and "inner." Instead of asserting a clear division between objective and subjective, the sequence is awash in ambiguity and paradox.

Scottie's dream sequence begins with a dissolve to Scottie lying alone in bed, fitfully tossing and turning. Hitchcock cuts in to a closer shot, Scottie's head framed by his white pillowcase. Without warning, the image turns blue. The blueness gradually intensifies, then subsides. Next, the image turns purple. Then, in waves or pulses, the purple begins switching on and off.

We know, or think we know, that these color shifts aren't real. We take them to be conveying, expressionistically, the nightmarish quality of Scottie's dream. We are not seeing what he is dreaming, the reality that exists only in his imagination. But we do take the pulsing colors to stand in for what he is dreaming. Partly because they are anxiety-producing to view, they convey the sense that Scottie is being assaulted by them, as if they

originate from outside, not inside, his mind. Like the spiraling camera in *The Wrong Man* that at once expresses and causes Manny's vertigo, they seem to be causing Scottie's suffering, as if he would be able to dream peacefully, and be unafraid of waking, if only they ceased. (As we have seen, Hitchcock had experimented with pulsing colors in the ending of *Rope*, and this technique will of course be of great importance in *Marnie*.)

Scottie seems to be struggling to open his eyes, as if waking might make the pulsing colors stop. At the same time, he seems to be struggling to keep his eyes closed, as if he feared awakening to find that his nightmare was real. When he does open his eyes and looks searchingly toward the camera, he seems wide-awake. Yet the pulsing colors go on. Are they real, then? Or is it only in his dream that he is no longer dreaming?

When Hitchcock first cut to this close-up, wrinkles in Scottie's pillowcase visibly placed him as lying in bed. By the time he opens his eyes, the wrinkled pillowcase has morphed into a featureless background that offers no clue where he is. He could be anywhere. He could be lying in bed, or he could be sitting in a movie theater viewing *Vertigo*. And, as I have said, he could either be awake or only dreaming he is awake.

Common sense tells us that Scottie is either dreaming or not, that he cannot be both and cannot be neither. But in the world on film, which of these states really obtains at this moment is impossible to determine, even in principle. Like Wittgenstein's "duck/rabbit," we can see Scottie at this moment in two incompatible ways, either as awake or as dreaming. But we cannot see him both ways at the same time (except, perhaps, by splitting hares). Both possibilities are equally real. Both are equally unreal. The world on film is not reality. It is reality projected, reality transformed by the medium of film. Then what, in reality, is the world on film? This is a question Hitchcock ponders.

Although Scottie is looking at the camera, his gaze is unfocused, like Manny's in his prison cell. This cues us that the next shot represents not his literal point of view but what he is imagining. The image that materializes is a stylized representation of the nosegay Scottie saw Madeleine buy at the flower shop, a perfect replica of the one in the portrait of Carlotta Valdes. This cluster of flowers, each like the facet of a jewel, framed against a smooth background, is linked, visually, to the jeweled necklace that is fated to play a crucial role in the film.

Hitchcock does not cut directly from Scottie to this "flower/jewel," however. He fades out the former and fades in the latter. For a moment the screen is empty, withholding access both to objective reality and to Scottie's

Figure 11.2

inner reality. This vision of nothingness endures only a moment, but we have no standard for translating this moment of screen time, as we experience it, into its equivalent in "real time" within the world of the film (whether that be chronological time as a clock might measure it or time as Scottie subjectively experiences it). The moment of blankness, however brief, opens a temporal gulf that isolates Scottie, turned inward, from the "flower/ jewel" that appears before us, born out of nothingness, and thus calls into question whether this is what he literally sees or is specifically what he does not see, or even imagine.

A Freudian would interpret this "flower/jewel" as a symbol of female sexuality. I see it as (also) an eye staring unblinkingly at Scottie. Viewed this way, the image of the "flower/jewel/eye," which seems to represent Scottie's inner vision, retroactively reveals the shot of Scottie that preceded it to represent what this "eye" is seeing. I take this "flower/jewel/eye"—like the showerhead that oversees Marion's murder in *Psycho* (phallic when viewed in profile, a circle-within-a-circle when viewed frontally), the circular drain that receives her blood and then dissolves into her lifeless eye, the porthole that oversees what some take to be Mark's rape of Marnie, and the diamond that all but winks at us at the end of *Family Plot*—to be a stand-in for (the circular lens of) Hitchcock's camera. (I might add that the moment in *Vertigo* when Madeleine, standing beside Scottie in front of the cross section of a sequoia that had been cut down, points to the rings that correspond

Figure 11.3

Figure 11.4

to her birth and her death irresistibly brings to my mind the opening of Emerson's essay "Circles": "The eye is the first circle; the horizon which it forms is the second; and throughout nature this primary figure is repeated without end. It is the highest emblem in the cipher of the world" [403].)

Alluding at once to the woman fated to die and to the perfect jewel, the "cold and lonely work of art" (to invoke the lyrics of "Mona Lisa," the song "Miss Lonelyhearts" plays on her phonograph in *Rear Window*) that is *Vertigo*, the "flower/jewel/eye/circle" invokes the mystery at the film's core—a mystery the film takes to be inseparable from the mystery of its own creation. It thus resonates with the film's opening title sequence, which takes the form of a meditation on the birth of the projected world. *Vertigo* initiates what becomes a signature Hitchcock practice of incorporating such a meditation within each film's opening title sequence, as we will see in our discussions of *North by Northwest, Psycho,* and *Marnie.* (My concluding chapter reflects on this practice, which is one of the surprising affinities between Hitchcock and Emerson, whose great essay "Experience" envisions itself, precisely as *North by Northwest* does, as pregnant with itself, as giving birth to itself. And Emerson's essay ends, as Hitchcock's film does, by returning us to its beginning.)

In *Vertigo*'s title sequence, "IN ALFRED HITCHCOCK's" is superimposed over an extreme close-up of a woman's eye, looking at Hitchcock's invisible camera, which is looking at her looking at it. Inside the circle-within-a-circle that is this eye's black pupil, precisely centered in the frame, the title "VERTIGO" appears, a pinpoint of light that expands until it spans the width of the eye. Then this title is replaced by a spiral, shaped like a galaxy, that emerges from the circle of the eye's pupil and expands until it fills the frame. Elaborating on the circling of Manny's world, with him within it, in *The Wrong Man*, the spiral's circular movement, like a whirlpool, pulls our gaze into the blackness of the circle at its center, from within which a new spiral is born, and so on.

It is as if the chase sequence that ensues (which ends with Scottie suspended over an abyss with no conceivable way of being rescued) and, indeed, the entire film for which this chase sequence serves impossibly as a prologue, is envisioned, or conjured, by this eye, or as if the world of *Vertigo* is born out of the mysterious black circle at its center.

In Scottie's "dream" sequence, no sooner does the "flower/jewel/eye/circle" materialize out of the blank frame than it is subjected to, or subjects us to, the pulsing colors. It is at this point that Hitchcock begins to animate the image. To me, the Disneyesque animation isn't effective; in my experi-

Figure 11.5

ence it undercuts, rather than enhances, the gravity and mysteriousness of the sequence. (I am no fan of *Spellbound*'s dream sequence, either.) But whether or not the animation "works," it is important to grasp the thinking that underlies it. First, the outer fringe disappears. Then the petals drop away, causing the image to fragment. I had never noticed this before, but there is a moment when at the center of this jumble there appears a form, at once a circle and a spiral, that is like a miniature "flower/jewel/ eye/circle" and at the same time seems to resonate with the spiral "galaxy/ eye" of the opening credits.

Both associations are confirmed, I take it, when the petals part, opening a yawning hole that draws the camera into it, engulfing the frame in blackness. From this blackness emerges the most enigmatic shot in the film. It duplicates the framing in which Gavin Elster, after the inquest, has the chutzpah to say to Scottie, "Only you and I know who really killed Madeleine." What makes the present shot different is the woman standing next to Elster. Silhouetted against the window, more shadow than flesh and blood, looking at neither man, she is turned inward, like the ghost at the end of Mizoguchi's *Ugetsu* (1953), mindful that she must return to the dead as soon as she completes her unfinished business on earth. Then a color shift reveals this woman to be, or seem, real. Plainer than Kim Novak (who isn't?), she is a woman we have never seen before. As she turns her head to cast an accusing gaze at Scottie, we see that she is dressed like Carlotta in her portrait.

Figure 11.6

The shot that follows presents a painted image of this woman, viewed from Scottie's perspective, looking toward the camera out of the corner of her eye. Like the cracked mirror in *The Wrong Man*, this painted image has no visible frame. Thus it seems to be the gaze of the "real" woman, not the painted one, that solicits the camera, which still seems to represent Scottie's point of view, to move in on and center her jeweled necklace. Like the "flower/jewel/eye/circle," this necklace seems to have a gaze of its own, one the camera's movement links with the power of this mysterious woman's gaze—an elaboration of the strategy Hitchcock had employed in *The Wrong Man* to imply that the painted Jesus has a gaze with comparable power. Thus the shot of Scottie that follows, which seems to present Scottie's reaction (or nonreaction) to what he is seeing, seems at the same time to represent what this "necklace/eye" is seeing, or conjuring. As Scottie walks, zombielike, toward the camera (but without coming any closer), it is as if this woman's gaze, relayed by the "necklace/eye," is drawing him by its hypnotic power, even when the black background is replaced by one that places him in Carlotta's graveyard. Hitchcock cuts to a shot in which the camera moves toward an open grave. The darkness within the grave looms larger and larger until the frame is again engulfed by blackness.

In this shot the dream alone commands the camera's attention. But whose dream is it? I am moved to ask this question because the preceding shot of Scottie, which cued us to take the present shot as being from his point of view, began as a representation of the "necklace/eye"'s vision. Our view of the open grave seems to have its source or origin in the mysterious

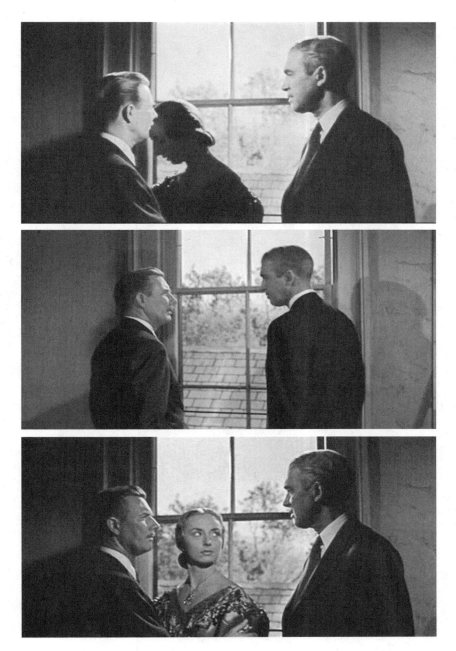

Figure 11.7

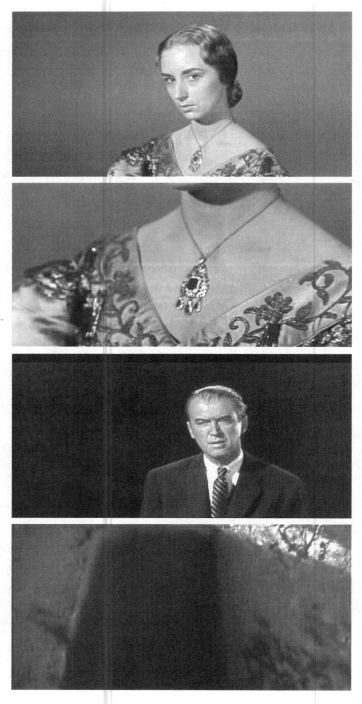

Figure 11.8

Figure 11.9

woman's gaze. Has she by some unnatural art planted her own vision in-
side Scottie's dream or raised it from the darkest depths of his soul? Does
such a question even make sense? Who or what would this woman have to
be to possess such power? I am persuaded that she is the "real" Madeleine
Elster. But this is not who Scottie thinks Madeleine Elster is. How could a
dead woman Scottie never knew gain entrance into his dream? He cannot
have invited her in, since he doesn't know she ever existed. Unlike vam-
pires, though, ghosts don't have to wait for an invitation. If this is Madeleine
Elster, it is her ghost. Why would this ghost haunt Scottie? Is it because he
took no notice of her, failed to keep her safe, did not prevent her from be-
ing murdered?

The shot of the open grave also aligns Scottie's dream with the scene the
woman he knew as "Madeleine" described when he pressed her to say what
she remembered after awakening from one of her trances. We will soon
come to know—or think we know—that "Madeleine" was only acting when
she told Scottie she remembered standing before her own freshly dug grave.
In the present view of the open grave, Scottie's dream fuses with that scene
he will then believe she believed she remembered.

The moment the camera descends into the open grave, there emerges from
the blackness an image that is vertigo-inducing to view. The shot frames Scot-
tie's disembodied face, staring at the camera, against a receding spiral.

This surrealistic frame strikes me as a kind of inversion of the image in
the title sequence of the spiral emerging from the black circle at the center
of a woman's eye. Its ambiguity again elaborates on the ambiguity of the

shot in *The Wrong Man* of Manny's fractured image in the mirror. Are we seeing what Scottie's imagination is conjuring, or are we only seeing Scottie in the act of seeing whatever he is seeing in his dream? Is the camera inside, or outside, the dream? And how can Scottie be dreaming, since his eyes are wide open? Is he dreaming of himself dreaming? Is he dreaming of himself dreaming of himself dreaming?

Scottie's face now disappears, leaving only the vertiginous background. Then the face reappears yet again—this time, it almost fills the screen. The shot that follows begins with the screen yet again engulfed by blackness, as if this emblem of nothingness is what Scottie was envisioning as represented in the previous shot. That Scottie *is* this blackness is revealed as his stylized, silhouetted figure falls from the region of the camera, whose view he had totally eclipsed, casting the world in shadow. Visually, this figure, which is its own shadow, seems at once inside the world on film and outside looking in, as we are. This effect is underscored by the fact that the lines of the roof form a perfect instance of Hitchcock's signature //// motif. In Scottie's nightmare self-image of his body falling, the background marked by the //// abruptly vanishes, giving way not to blackness but to whiteness. Scottie's shrinking figure is no longer in the world. Is it suspended in infinite space? Or is it a mere shadow, or a black paper cutout, on the flat white surface of the movie screen? His figure's posture, at once scarecrow-like and Christlike, anticipates Scottie's posture in the film's final shot (see fig. 0.7). In that shot Scottie, looking down from the tower from which Judy has just fallen, or jumped, to her death, finds himself suspended as if for all time, as if time itself were suspended. And it is this uncanny premonition of his own fate that makes Scottie sit bolt upright in his bed and stare in terror at the camera. We cannot tell from this shot whether his awakening is real or whether he is only dreaming that he is not still dreaming. The sequence has come full circle.

It is the extraordinary way Hitchcock designs Scottie's dream sequence (if that is what it is), and *Vertigo* as a whole, for that matter, that makes possible Chris Marker's interpretation of the film. It *is* possible to interpret everything we view from this point on as a continuation of Scottie's dream. Marker errs only by claiming that in *reality* Scottie is dreaming everything that happens in the last third of the film. Hitchcock has gone to extraordinary lengths to make this sequence demonstrate that in the world on film there is no reality—at least, if the criterion of reality is that it stands opposed to unreality. In the world on film, all possibilities are equally real

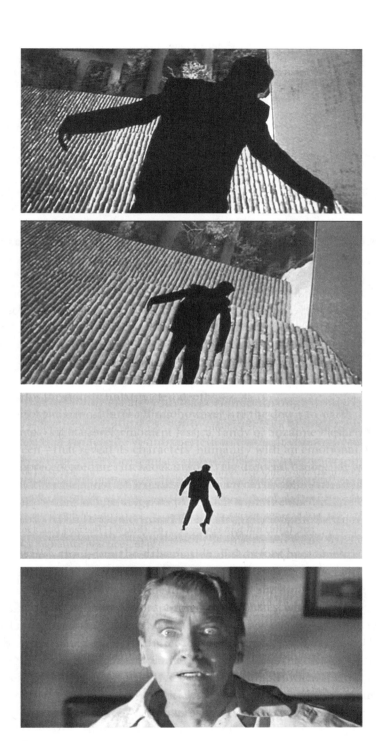

Figure 11.10

and equally unreal. Everything that is, in the projected world, also is not. Everything the projected world is, it also is not.

Judy's Plan

Scottie, like Manny, is an open book to Hitchcock's camera. His thoughts are legible even when we find ourselves increasingly reluctant to endorse them. The mystery at the core of *Vertigo*, the mystery that attracts Scottie himself, is not a mystery *about* him. It is a mystery *to* him. But it is a mystery the "hard-headed Scot" does everything in his power to explain away. Scottie himself is a mystery to Hitchcock only insofar as he illustrates the fact about being human that it is possible for others to know us better than we know ourselves. The camera's relationship to the woman projected on the movie screen, in her various guises, is more ambiguous but also more intimate. She is an object of desire to Scottie, to us, and to Hitchcock. Yet she and Hitchcock's camera are also mysteriously attuned.

I drew the conclusion in "*Vertigo*: The Unknown Woman in Hitchcock" that this mysterious woman is no less a stand-in for the film's author than is Gavin Elster, the film's murderous villain. Hence the title I gave my essay. Yet I had no doubt that this "unknown woman" was known to me. ("I was so much older then," sang the young Bob Dylan, one of Emerson's greatest disciples. "I'm younger than that now.")

I seem always to have known that it cannot be a simple mistake when Judy—saying, "Can't you see?"—asks Scottie to help her put on her necklace. (Freud was a genius, after all.) I said as much in "The Unknown Woman in Hitchcock." "The deepest interpretation of Judy's motivation for 'staying and lying,'" I wrote, "is that she wishes for Scottie to bring Madeleine back (which means that it is no accident when she puts on the incriminating necklace). Judy wishes for Scottie to lead her to the point at which she can reveal that she is Madeleine—but without losing his love" (230). I understood that "deep down" Judy wished for Scottie to "change" her. But I still assumed, as has every commentator on *Vertigo*, that in the last third of the film it is Scottie who is leading Judy, not the other way around, hence that putting on the necklace is at most a slip. At least I recognized it as a Freudian slip, one that revealed an unconscious wish for Scottie to know the truth about her.

The thought had not yet dawned on me, however, that Judy might be *conscious* of harboring such a wish, hence that putting on the necklace

might be a deliberate gesture, a step in a plan calculated to make that wish come true. Nor had it dawned on me to ask myself why I resisted questioning the assumption—an assumption, and a resistance, common to all who have written about the film—that Judy could not be conscious of wishing for Scottie to know the truth. Evidently, I believed I knew this woman better than she knows herself. Evidently, I *wished* to believe this. How could I not have known this about myself? What made me awaken to this truth?

It is vertigo-inducing even to contemplate the possibility that Judy consciously plans for Scottie to discover the necklace. One reason I find this idea so dizzying is that it calls for me to recognize that Hitchcock had deceived me. I trusted him to reveal the border separating what is real from what is not, but he betrayed my trust. Why would Hitchcock do this to me?

"Why me?" is a question Scottie poses (to Judy? to Madeleine? to himself? to whatever God there may be?) on top of the tower after he accuses her of being Gavin Elster's "very apt pupil" (the pun surely intended by Hitchcock but not by Scottie). "I was the made-to-order witness, wasn't I?" is his answer to his own question. In my wish to believe that I knew what I really did not know about Judy, about *Vertigo*, and in my wish to believe that I did not know what I really knew, I was Hitchcock's made-to-order witness. I was no different from Scottie in Hitchcock's eyes. I did not wish to believe that of myself—or to believe that of Hitchcock. As the postscript of *The Murderous Gaze* confesses, I wished to believe—and I did believe— that I was Hitchcock's "very apt pupil." As I am writing these words, I wish to believe—and I do believe—that I was blind, but now I see.

It is also vertigo-inducing to contemplate the possibility that in *Shadow of a Doubt* Uncle Charlie's plan is not to kill Young Charlie but for her to kill him. Or that it is Norman, not the mother who is her son's creation, as the smug psychiatrist believes, who grins at the camera at the end of *Psycho*. Yet in *The Murderous Gaze* I took those possibilities seriously, just as in *Contesting Tears* Cavell took seriously the vertigo-inducing possibility that Stella Dallas deliberately makes a spectacle of herself at the soda fountain, that she is already carrying out a plan to free her daughter—and herself—to accept the necessity of their separation. And yet, until now I did not even consider the possibility that the woman in *Vertigo* knows herself better than I knew her—and better than I knew myself. Like Scottie, I loved this woman and wished to go on loving her. I did not wish to think that I was *her* made-to-order witness.

It is Judy's letter to Scottie, together with the flashback that shows us the "true story," à la *The Wrong Man*, that sets us up to believe, wrongly, that

Figure 11.11

we always know what Judy is thinking. The passage is prefaced by the moment when Scottie, who has just walked back into her life, exits her room in the Empire Hotel and Hitchcock's camera pans to Judy and then holds on her, framed from behind, staring at the closed door, precisely the way King Vidor's camera holds on Stella Dallas after Stephen departs with their daughter, Laurel.

In this framing, the woman and Hitchcock's camera are in complicity, as they were that night at Ernie's when Scottie, believing she was Gavin Elster's wife, Madeleine, whom he had been hired to follow, fell in love with her at first sight. Deliberately, but pretending it was only by chance, "Madeleine" had "happened" to pass close to him, "happened" to pause, and "happened" to present her profile for him to view, enabling him to drink in her intoxicating beauty. The present shot so emphatically hits us over the

Figure 11.12

head with the fact that Judy's hair is different from "Madeleine"'s that it distracts us from registering its deeper revelation, which is that we are being refused access to what this woman is feeling or thinking.

A few moments later, the flashback proper is initiated by another close-up of Judy, this time staring toward the camera, a signal that the views to follow will grant us access to her inner reality.

Scottie, in his dream, seemed unaware of the source of the images assaulting him. Judy, by contrast, seems to be marshaling the images the camera presents to us, authorizing the camera's presentation, in effect. This flashback is designed to secure our trust in Judy—and in Hitchcock's camera. We trust that Judy's letter, which she reads out loud in voice-over as she is writing it, proves that she loved Scottie, that she still loves him, and that if she "had the nerve," she would "stay and lie" in the hope of making him "forget the other, forget the past" and love her, as she puts it, "as I am, for myself." And we are moved when she admits to herself—by now, she has stopped writing; what began as a letter to Scottie has become an interior monologue—that she does not know whether she has the nerve to try.

Having confessed this self-doubt, still in close-up, Judy, expressionless, stares again in the direction of the camera, this time without the suggestion of meeting its gaze. Still facing the camera, her gaze still averted, she rises solemnly, her movement synchronized with the camera's as it pulls back. Momentarily, she is eclipsed by a table lamp, before she is framed by the lamp on the left of the screen and a mirror on the right.

Figure 11.13

Now steadfastly meeting the camera's gaze, acknowledging its power to bear witness, she purposefully—perhaps there is a trace of violence in her gesture—tears the letter to pieces. Like the "right" wrong man, she has come to a decision. Whatever the risk, she will "stay and lie" and prove she has the nerve to make Scottie love her "as she is, for herself." We silently applaud her.

This passage sets us up to think that we know what Judy is thinking. We have her own testimony as evidence. Yet at the decisive moment, she is silent, absorbed in her private thoughts. The camera, which moments before had revealed Judy's vision of the past, now refrains from revealing her vision of the future. Lacking her clairvoyance, we have no access to her thoughts at this all-important moment. And yet we *think* we know what she is thinking. We think we know what she means by "staying and lying"; what she thinks it means for Scottie to love her "as she is, for herself"; and what she thinks her "self" is—what it is "for herself."

In "*Vertigo*: The Unknown Woman in Hitchcock," I wrote, "When Judy writes the note she never sends to Scottie . . . she contemplates 'staying and lying' and making him love her 'for herself.' . . . She may think that the Judy persona—Judy's way of dressing, making herself up, carrying herself, speaking—is her self. . . . Yet . . . once she is transfigured into Madeleine, there is no bringing Judy back. She can act the part of Judy only by repressing the Madeleine within her, only by theatricalizing herself" (230).

I understood that "Judy," no less than "Madeleine," is a role this woman is playing (just as this woman herself, in both guises, is a role played by the

actress we know as "Kim Novak"). I also understood that the fact she has made these roles her own means that both "Judy" and "Madeleine," at once her creations and her incarnations, are expressions of who she is. But I assumed that these were facts I knew about her that she didn't know about herself. I continued to cling to the assumption—as all critics have done, as Hitchcock sets us up to do—that in wishing for Scottie to love her "as she is, for herself," she was wishing for him to love "Judy," that slightly slutty dark-haired hard-luck story who wears too much makeup and speaks not in Madeleine's near-British English but rather pronounces "Salinas, Kansas" with a whiny, exaggeratedly lower-class midwestern twang. (In her voice-over Kim Novak reads Judy's letter in a voice more neutral, more natural, than either of those voices.)

The thought had not yet dawned on me that this woman wishes for Scottie to love her as the actress she is, not the "Judy" who is one of her roles—a role that so perfectly denies her "inner Madeleine" that she must have created it for that purpose. I am not claiming that in the world of *Vertigo* the *reality* is that Judy is always acting. My claim is that Hitchcock designs the film so that every moment sustains this as a *possibility*. Again, it is Hitchcock's understanding that in the world on film there is no reality as opposed to unreality. All possibilities are equally real, all equally unreal. I might add that we don't even know that "Judy" and "Madeleine" are this woman's only identities. She keeps as many suits and dresses in her closet as Marnie. For all we know, each is a costume, a memento of one of her roles. We don't even know that "Judy Barton" is her real name. That is what it says on her Kansas drivers license, but for all we know she has as many phony licenses as Marnie, or as, in *North by Northwest*, Vandamm's cohort Leonard assumes that George Kaplan has when he contemptuously says to Roger, believing him to be that nonexistent decoy agent, "They provide you with such good ones."

It would seem that Judy (as I will continue to call her) has set herself an impossible goal. How, by lying, can she possibly make Scottie love her "as she is, for herself"? Then again, insofar as she is an actress whose identity cannot be separated from the characters whose roles she has made her own, how can she make Scottie love her "as she is, for herself" except by "lying"? Insofar as she knows that, as an actress, there is nothing she is "for herself," she possesses the knowledge possessed by the heroines of such "unknown woman" melodramas as *Stella Dallas*, *Now Voyager*, and *Letter from an Unknown Woman* (all films intimately related to *Vertigo*). It is the knowledge, the self-knowledge, that, as Cavell puts it, their identities are

ironic. Judy knows, as those women do, that her "self" is not fixed; that everything she is, she is capable of not being; that in the condition in which she finds herself—Emerson thinks of this as the human condition—she stands in need of creation.

Terrified of death, longing to become someone "for herself," she stakes her quest for selfhood on winning Scottie's love. Why Scottie? Both as "Judy" and as "Madeleine," she loves this man. As she writes in her letter, she wants him to find "peace of mind." Unless she saves him, she cannot be saved. If she lets him "change" her so he can love her as "Madeleine" again, or, for that matter, if he falls in love with "Judy" and falls out of love with "Madeleine," she would not win his forgiveness, apart from which she cannot be saved. She cannot tell him the truth without making him stop loving her, but his love cannot save her unless he learns the truth. Neither of them are saved if Scottie loves "Madeleine" but not "Judy," or "Judy" but not "Madeleine," or even if he loves both but without recognizing that they are "positively the same dame," as Muggsy (William Demarest) puts it in *The Lady Eve*. Only if Scottie finds "Madeleine" in "Judy" and "Judy" in "Madeleine" can his love heal the rift in her soul and enable her to be reborn, to take a step in the direction of her unattained but attainable self. How can she make this happen?

Judy's unfinished letter to Scottie began, "And so you've found me." Scottie's finding her is one of those "accidents" Hitchcock is wont to arrange to bring reality and fantasy into alignment. But I view this "accident" as also arranged by Judy. It is the first step in her plan.

Scottie is standing in front of the flower shop where he saw "Madeleine" buy the nosegay—he haunts all the places "Madeleine" used to frequent—when Judy "happens" to walk by, chatting with friends. She "happens" to pause in full view of Scottie, "happens" not to see him; "happens" to turn her face so that he views her in profile, exactly as "Madeleine" had pretended she hadn't deliberately done that fateful evening at Ernie's. After Scottie follows her to the Empire Hotel, the camera slowly tilts to an upper-floor window she "happens" to open. Then she "happens" to stand framed in that window. Scottie now "happens" to know exactly where to find her.

Even if we think it *is* only by chance that Scottie finds her, Judy—like Félicie in Eric Rohmer's *A Tale of Winter*—gives the man she loves every chance of finding her by chance. Unlike Rohmer's heroine, but very much like Paula (Greer Garson) in *Random Harvest* (which I suspect provided the inspiration for *Vertigo*'s telltale necklace), Judy knows all along where to find the man she loves. But her plan is to let herself be found.

Figure 11.14

Judy's next step is to lead Scottie to believe that changing her is his idea, not hers. When she finally gives in, as Scottie thinks of it, and allows herself to become "Madeleine" in his eyes, they kiss. Hitchcock expresses Scottie's rapture by that celebrated camera movement in which the background changes from Judy's hotel room to the livery stable where they had kissed before. The camera is registering a change in Scottie's subjective experience, we take it, but one he has not (yet) consciously registered. He does not literally see or even imagine the change in his surroundings the camera presents to us. We know, or think we know, that Scottie hasn't really gone anywhere. He has been transported only metaphorically. What has transported him is this woman's kiss. (He is not a necrophiliac, as some commentators have suggested. Chris Marker is on target when he insists

Figure 11.15

that in this kiss Judy is anything but dead to Scottie; she is "Madeleine" very much alive.)

But then Scottie opens his eyes and turns his face almost to the camera, so we see his perplexed expression. We also see that he is hiding his perplexity from the woman in his arms.

Our impression is that Scottie is seeing the change in his surroundings that we are seeing, and is at a loss to explain it, just as he is at a loss to explain how it can be that this woman not only looks like "Madeleine" but also kisses like her. But what causes the background to change? Scottie's perplexity makes clear that it is not his doing. Of course, we can say that it is Hitchcock's camera that effects the change. But it does so by way of registering a change in Scottie's subjective experience, the fact that he has been transported. And it is Judy who makes that happen—deliberately, I am suggesting—by the magic of her kiss.

Like a man awakening from a pleasurable dream and willing himself back to sleep, perchance to continue the dream, Scottie abandons himself to Judy's embrace, choosing not to question the miracle, or black magic, that has brought his love back from the dead. I view Scottie's fateful decision, too, as internal to Judy's plan. Although the kiss resumes, it is not the same as before. The camera's continuing circling has led it to frame Judy from behind. We no longer see her face, only the spiral twist of her hair, an image that will be echoed, uncannily, in *Psycho*.

Figure 11.16

Judy is no longer the kisser but the kissee. Neither resisting nor re-sponding, like Marnie in Mark's arms on their honeymoon cruise from hell, she has become, visually, a lifeless body. And this change in the image does not register a change in Scottie's subjective experience. That he does not feel he is kissing a corpse is confirmed, I take it, when after the fadeout that signifies that they have sex, Scottie relates to Judy—who expresses the wish for a "big, juicy steak"—in a way that makes clear he sees her as full of life. If Hitchcock's camera registers anyone's subjec-tivity, it is Judy's, when it intimates that Scottie's kiss drains her of life. Understandably, she feels deadened in Scottie's arms, for he hasn't yet come to see her as she is, "for herself." This kiss takes her closer to her

goal, but it does not get her there. She has yet to take the most danger-
ous step. She takes it when she asks Scottie, seemingly in all innocence,
to help her put on her necklace—Carlotta's necklace, "Madeleine"'s
necklace. The necklace moves him to open his eyes, as it had in his
dream.

Once Scottie knows—or can no longer deny to himself that he knows—
that this woman is "Madeleine" or, rather, that the "Madeleine" he loved
never existed, Judy "lets" him return her to the scene of the crime and drag
her to the top of the tower, enraged enough to kill her. All this is part of her
plan. When she declares her love for him, falls into his arms and pleads
with him to keep her safe, he says, "It's too late, there's no bringing her
back," but does not resist her embrace. And he responds to her "Please . . . "
by kissing her with overwhelming passion. And this kiss completes Judy's
plan, I take it. Everything has unfolded as she had scripted it. All is ful-
filled. She has led Scottie to this point at which he forgives her, and him-
self, and loves her unconditionally. For Scottie this kiss is forever. Then
why is it the kiss of death for Judy?

When in *The Wrong Man* Manny visits Rose in the hospital to bring the
glad tidings that the police have caught the man who committed the
crimes of which he was accused and that their nightmare is over, she says,
"That's fine for you," rebuking him for assuming that her life revolved around
his. In "The Unknown Woman in Hitchcock" I viewed the ending of *Ver-
tigo* as such a rebuke to Scottie. Yes, holding this woman in his arms is his
dream come true. But how can it be a step in the direction of her unat-
tained but attainable self for her to find herself in the embrace of a man for
whom it makes no difference who or what she is, whether she is "Judy," a
human being of flesh and blood; "Madeleine," a woman who never existed;
or even the ghost of "Carlotta," a madwoman who took her own life?

I now have a more compassionate view of Scottie. When Judy declares
her love and pleads with him to keep her safe, he rebukes himself for
having been, like Devlin in *Notorious*, a "fat-headed guy full of pain"
who had been so absorbed in his own feelings that he had failed, until
this moment, to recognize who she is, "for herself." For Scottie this kiss
is not like the kiss in Judy's hotel room. His vertigo is gone. He holds in
his arms the key to the mystery. It is not, as I had thought, a matter of
indifference to him who or what she is. Judy is now Madeleine, and
Madeleine Judy, in his eyes. He forgives her for the suffering she caused
him. What more is there for Judy to ask of Scottie? Nothing more, as
there is nothing more for him to ask of her. Like the couple at the end of

a remarriage comedy, he has forgiven her, she has forgiven him, and they have both forgiven themselves. And if they have forgiven each other, what standing have we—or Hitchcock—to rebuke one on the other's behalf?

Then why does Judy have to die?

Madeleine's Revenge

When I wrote "The Unknown Woman in Hitchcock," I believed that Judy chooses to die when she recognizes that Scottie's kiss has changed nothing, that in his eyes she is still nothing "for herself." If with this kiss Scottie does acknowledge her, as I now believe, who, or what, kills her? Why does she pull away from Scottie's kiss, as she had at the livery stable, her gaze drawn in the direction of the camera? That what provokes this is not something Judy literally sees when she looks toward the camera is made clear when Hitchcock cuts to a shot, from her point of view, that is devoid of human figures. Only after a moment does a shadowy figure emerge, barely perceptible, out of the blackness.

Judy seems to know what she will see before she literally sees it, as if she imagines this specter before her gaze and the camera, in concert, conjure it into being. When she does see this shadow, her eyes widen. The fact that what she had imagined is real takes her by surprise. That this is not something she has planned is significant, because it implies that if she sees this shadow as Death coming to claim her, as I do not doubt she does, Death is not coming at her bidding. And yet she immediately knows, or thinks she knows, who or what this apparition is. She *recognizes* it. But how can she recognize this specter unless it had appeared to her before? While in character as "Madeleine," Judy had described to Scottie a scene she said she remembered in which she stood before what she knew was her freshly dug grave. She now knows in the same way, I take it, what this shadow is—that it is, in effect, her own freshly dug grave. Is it, then, that she really did dream the scene she had only pretended to remember, that she is only now remembering that dream, which has returned to haunt her?

Scottie, not granted her vision (although it is one that he might well have recognized from his own dream), remains absorbed in embracing Judy until with a heartbreaking, "Oh no, no!" she steps back in terror and awe and slips silently out of the frame. Only when it is too late does Scottie turn, and we hear a woman's offscreen voice say, "I heard voices." There is

Figure 11.17

a chilling scream and Scottie wheels around in horror. As Hitchcock films this scene, we do not know whether in her terror Judy accidentally steps over the edge or whether she deliberately jumps. Does she scream as she is falling because she wants to live or because she has chosen to die but finds herself terrified as the void is about to engulf her?

Judy's scream still reverberating, the silhouetted figure steps into the light. It is a nun. And she is looking straight into the camera.

Crossing herself, the nun intones, "God have mercy," and begins tugging on the bell rope, ringing down the final curtain on Hitchcock's most disturbing film.

In discussing the shot of the open grave in the dream sequence, I was motivated to ask whose dream this really was. The vision of the open grave seems to have its source, or origin, in the gaze of the woman I took to be the ghost of Madeleine Elster. And I found myself wondering whether Madeleine's ghost, with the complicity of Hitchcock's camera, was the author of that vision. I now find myself wondering whether Madeleine's ghost— again with the complicity of Hitchcock's camera—is the author, as well, of the vision that kills Judy.

It hardly seems just for Madeleine's ghost to make Judy die screaming while letting her deceitful husband get away with murder. But Judy is vulnerable to being haunted, as Gavin Elster is not, because she is already haunted, as Scottie is. I am not suggesting that Judy sees the shadow that frightens her *as* the ghost of Madeleine Elster. Judy sees it as a vision of her own death, the way Scottie sees his death in his vision of the open

grave. If the vision of her death Judy sees when she looks toward Hitchcock's camera emerges from the depths of her soul, how did it get there in the first place? Has the dead Madeleine somehow conjured it into wakefulness, or planted that vision—perhaps Madeleine's vision of her own death—in Judy's soul? That this death-dealing vision metamorphoses into a flesh-and-blood nun suggests that if it is an unnatural art that raises the specter that kills Judy, it is also divine justice that she die. The nun herself is powerless. She can only bear witness, in her faith, that God's will has been done.

Judy's lies to Scottie, like the psychic violence of his efforts to change her, are venial sins. If there is such a thing as a mortal sin, Gavin Elster surely commits one when he murders his wife. As I have argued, in the world on film murder is not forgivable. No living person has the power to forgive the murder of another person. Scottie can forgive Judy for the suffering she caused him, but he has no standing to forgive her for the part she played in the murder of Madeleine Elster.

Do we believe that her complicity in Gavin Elster's diabolical plot to murder his wife makes Judy guilty of a sin morally equivalent to his? We do not wish to think that she is a murderer. But our judgment must hinge on whether we believe that when she breaks away from Scottie's kiss at the livery stable, tells him there is something she must do, and runs up the tower, she is sincerely trying to keep the murder from happening, or is still playing her assigned role in Elster's script. It is internal to Hitchcock's design of Judy's flashback, I take it, that it does not settle this question. Nor is it settled by her later telling Scottie that she tried to stop it. No matter how well she knows herself, even she does not know the answer to the question. That is something only God can know.

A few pages ago I was moved to ask myself, as I often have, why Judy has to die. But that is a prejudicial question. It presupposes that Judy's death *is* necessary, that Hitchcock has no choice but to kill her, that it is not in his power to keep her safe. If her death has no necessity to it, it would mean that Hitchcock chose to kill her, that like the arch misogynist some mistakenly take him to be, he wished for Judy to die. Would that make the creation of *Vertigo* the moral equivalent of murder?

What, if anything, legitimizes killing? How, if at all, does the act of killing change the person who performs that act? As we have seen, these are questions to which the Nazi menace gave special urgency in Hitchcock's British films of the late 1930s, such as *Secret Agent*, *Sabotage*, and *The Lady Vanishes*, and the films he made in America during the Second World War,

such as *Shadow of a Doubt* and *Lifeboat,* and in the war's immediate aftermath, such as *Notorious* and *Rope.* But every Hitchcock thriller has its own way of posing and addressing these questions, and of thinking through their implications for the art of pure cinema of which Hitchcock was both master and slave.

If there were no Gavin Elster in the world of *Vertigo,* Judy would not have to die. But if there were no Gavin Elster, there would be no *Vertigo.* Elster is Hitchcock's accomplice in artistic creation. But Hitchcock is Elster's accomplice in murder. Madeleine has to be murdered for *Vertigo* to be created. Judy, too, has to die.

And what of Madeleine Elster? There would be no *Vertigo* unless she were murdered. Yet except for her appearance in those two pivotal shots in Scottie's dream sequence, Hitchcock's camera takes no notice of her. The film's author seems as indifferent to Madeleine's fate as her murderer is, as Judy is, as Scottie is, as we are. When Judy looks toward Hitchcock's camera and sees the figure of Death come to claim her, it has finally dawned on me, this death-dealing vision is the murdered woman's revenge. If Hitchcock is Gavin Elster's accomplice in Madeleine's murder, he is no less an accomplice in Madeleine's revenge against Judy. But Judy's death is Madeleine's revenge against Hitchcock as well. Judy's fall forces the film's author to recognize the limits of his own power—the dark fact that he could not keep Judy safe even though he loved her—and the murderousness of his unnatural art—the even darker fact that Hitchcock killed Judy not only because he had to but because he wished to. Hitchcock wished for this woman he loved to die so that his most perfect work of art could be born.

I am aware, of course, that Madeleine Elster—not to mention her ghost—has no real existence apart from the world of *Vertigo.* But what kind of existence is that? In the world on film, the opposition between the natural and the supernatural breaks down. The camera represents a supernatural agency to the denizens of a film's world. For them, the film's author and viewers alike are ghosts. And the camera's subjects, fixed and projected onto the screen, are suspended between death and life.

I am also aware that Alfred Hitchcock was a human being of (more than ample) flesh and blood, that unlike Madeleine or Judy, this man really existed. But even during his lifetime his existence was a double one. Viewed from the perspective of the world on film, he was—is—a ghost. Now that he is dead, it is only as a ghost that he is real to us, only through the medium of film that he speaks to us. In reality, of course, no human being

dies when Judy jumps or falls from the tower. In reality, Hitchcock was no murderer. Then again, in Hitchcock's understanding, the medium of film, by its very nature, mysteriously overcomes or transcends the opposition between what is objectively real and what is real only subjectively. The world on film is real, but it is not reality. It is reality transformed by the medium of film.

An Awakening for Hitchcock

In *Rope*, as we have seen, Brandon makes a distinction between "talking"—mere words—and "living." When Guy, in *Strangers on a Train*, says—and means—that he could kill his scheming wife, that is "talking." When Bruno murders her, that is "living." Does morality have to do only with "living" and not also with "talking"? When Herb and Joe, in *Shadow of a Doubt*, "relax" by talking about murdering people, does that have nothing to do with living?

In authoring his films, Hitchcock envisions characters who commit murder. But he also envisions killings he performs himself in his capacity as author. Again, in reality Hitchcock is no murderer. Yet on film there is no intrinsic difference between what is objectively real and what is real only subjectively. As I have said, that is what makes possible Hitchcock's signature practice of employing his powers as author to make his characters' innermost wishes—wishes they are not even conscious of harboring—"magically" come true. Indeed, it is Hitchcock's practice to throw back at his characters not only the words they speak but also their thoughts and their dreams. Are we responsible for our dreams? Are we free to dream what we wish? If Freud is right, we are free *only* to dream what we wish. If the world on film overcomes or transcends the opposition between fantasy and reality, does it also overcome or transcend the opposition between "talking" and "living"?

I wish to believe—and I do believe—that there is a difference, morally, between Gavin Elster and Hitchcock. I wish to believe—and I do believe—that Hitchcock was not indifferent to Judy's fate, that he loved her as much as Scottie does. *Vertigo* is a tragedy because Scottie's love fails to keep Judy safe. The tragedy is also Hitchcock's. Not only does he fail to keep this woman safe, but he takes it upon himself to kill her.

As we have seen, Hitchcock's lifelong attraction to Oscar Wilde's principle that each man kills the thing he loves, which in its negation of all

hope for change is not only un-Emersonian but anti-Emersonian, coexisted tensely and uneasily with his attraction to the Emersonian moral outlook embraced by the comedy of remarriage. After *Vertigo*, how can he continue to author Hitchcock thrillers, if doing so requires him to kill the things he loves—and to love the things he kills? Is that the kind of person, the kind of artist, Hitchcock wishes to be? Taking to heart the tragedy of *Vertigo*, Hitchcock acknowledges the need to change.

12

Never Again?

North by Northwest, the comedic follow-up to the tragedy of *Vertigo*, is a monumental landmark in Hitchcock's career. It is the first of his American films to end, like a comedy of remarriage, with a romantic couple joined in marriage and unambiguously joyful to be married to each other. Evidently, it took the major part of his career for Hitchcock to achieve—or reconcile himself to—such an ending. When *North by Northwest* concludes with Roger and Eve about to indulge in the pleasantest perk of connubial life, they have no guarantee that they will live "happily ever after." This they have in common with the couples of remarriage comedies. Roger and Eve also have in common with these other couples a shared commitment to their ongoing—and witty—conversation and to living each day, and each night, in a spirit of adventure.

It is illuminating to reflect on the path by which Roger and Eve arrive at this perspective. As I have said, in a Hollywood comedy of remarriage, the woman has to undergo a metamorphosis tantamount to dying and being reborn in order for the couple to transform their failed marriage into a relationship worth having. The man may or may not also have to change, but he does not have to undergo so traumatic a metamorphosis. In *The Philadelphia Story* the man has already changed when he shows up at his ex-wife's home on the eve of her wedding; arguably, in *His Girl Friday* and *The Lady Eve*, the man never really changes. As this asymmetry suggests, there is a measure of inequality in all these "comedies of equality," as

Cavell sometimes calls them. This is one reason, I take it, that he thinks of the genre as exemplifying a stage in the development of the consciousness of women. It is as if the marriage of equals that remarriage comedies envision calls for a kind of man that already exists but a new kind of woman that stands in need of creation—and this despite the fact that in the early 1930s, before *It Happened One Night* inaugurated the genre, the great stars who were to play the female leads in remarriage comedies were already "new women" in their films. It was the "new man," worthy of such a woman, who remained to be created (with Cary Grant an exception that proves the rule).

As we have argued, in his films of the early 1930s, Hitchcock, too, was able to bring "new women" to the screen, but it was not until *The 39 Steps* that a Hitchcock film paired such a woman with a man who was worthy of her. For Hitchcock, too, it was the "new man," not the "new woman," who stood in need of creation. But the Hitchcock thriller does not mask this, the way the comedy of remarriage does. Thus a crucial feature that distinguishes *North by Northwest* from the remarriage comedies Cavell studies is the fact that, as he observes in an essay titled simply "*North by Northwest*," in this film it is the man, not the woman, who undergoes a metamorphosis so traumatic as to be tantamount to death and rebirth. In *North by Northwest* the man's rebirth requires, symbolically, not only a death but a murder. (He also has to break with his best friend, his mother [Jessie Royce Landis]. This is something the Ralph Bellamy characters in both *The Awful Truth* and *His Girl Friday* cannot bring themselves to do.)

In remarriage comedies the threat to marriage is divorce. In the Hitchcock thriller, as we have seen, divorce, which is always provisional, is replaced by murder, which is always permanent—although *The Trouble with Harry* (1955), in which Harry, the Shirley MacLaine character's ne'er-do-well husband, keeps popping up like a weed even after he is dead and (repeatedly) buried, casts doubt even on the efficacy of death in terminating a worthless marriage. At the same time, Harry's corpse seems to fertilize the several romances that spring up after his death.

In *North by Northwest* Roger's rebirth is marked by the piece of theater he and Eve perform together, under the Professor's direction, in which Eve pretends to kill Roger, and he plays dead. Staging a theatrical scene in which she murders him is apt, symbolically. It enables them to put behind them her complicity in sending him to his encounter with the crop-dusting plane that was "dusting crops where there ain't no crops." He escaped with his life thanks only to an "accident"—that is, an intervention by Hitch-

cock—that spared Eve from becoming a "long-range assassin" and finding herself with Roger's blood on her hands.

To be sure, Vandamm had forced Eve's hand; not to go along with his plan would have meant blowing her cover as a double agent. But that doesn't mean there wasn't a part of her that wished for Roger to die—not for being a man, exactly, like Elsa's husband in "Revenge," but for being, as Eve puts it, the kind of man—his two ex-wives being Exhibits A and B—who "doesn't believe in marriage." The couples in remarriage comedies don't believe in marriage, either, if that means believing in the institution of marriage as it existed in society at the time—believing that what society accepts as marriages are necessarily relationships worth having. Whether there is, or can be, any other kind of man, and any other kind of marriage, are questions *North by Northwest* poses and then answers in the affirmative.

After Roger learns that Eve had knowingly sent him to what she thought would be his death, he finds himself unable to forgive her. At the art auction, he deliberately, vengefully, arouses Vandamm's jealousy and places Eve's life in jeopardy. If Vandamm were to kill her, her blood would be on Roger's hands as well. He wanted her to die. Roger stands in need of Eve's forgiveness no less than she stands in need of his, in other words. By the end of the film they forgive one another for the darkness in them that makes them capable of killing, as all human beings are—the darkness whose existence the sponsors of *Alfred Hitchcock Presents* would have the show deny.

At the end of *North by Northwest* the Professor—one of Hitchcock's stand-ins in the film—has no choice but to order a subordinate to shoot Leonard, Vandamm's henchman. Leonard has responded to Roger's desperate plea for help—delivered directly at the camera—by sadistically grinding down hard with his shoe on Roger's hand as he is desperately holding on, with his other hand, to the hand of Eve, who dangles precariously from the sheer face of Mount Rushmore. If the Professor does not intervene, Eve will die, and her blood will be on his hands—and on Hitchcock's. Through a surrogate "long-range assassin" the film's author intervenes, not to kill Eve but to rescue her.

Spiritually or morally, there is little to choose between Leonard and the Professor. Poetic justice demands a violent death for Leonard, whereas Hitchcock devises a very different punishment for the Professor. His punishment is to be forced to authorize the shot that kills Leonard, thereby aborting the plot he had so brilliantly scripted. The Professor's scenario is shattered, like the little African statue that slips out of the dying Leonard's clutches. The statue breaks into pieces when it falls, releasing the roll of

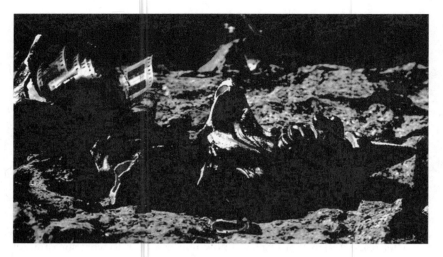

Figure 12.1

microfilm that had been hidden within its belly, as if the statue had been pregnant with it. This is an ironic, comic, yet elegant image of birth. Allegorically, this is the birth of *North by Northwest* itself. From the "death" of this statue the film's ending is born.

The Professor had lied to Roger when he promised him that once Vandamm was out of the country, his courtship of Eve would have his blessing. Hitchcock turns the Professor's lying words against him. As I wrote in "*North by Northwest*: Hitchcock's Monument to the Hitchcock Film": "The shot that kills Leonard and ends the Professor's game is the means by which Hitchcock declares his authority and confers his blessing on this couple. The Professor proves to be only an unwitting agent of the film's author, the decoy of the real 'Professor,' Hitchcock."[1]

Hitchcock refuses to show the Professor or Vandamm the respect he accorded Sebastian at the end of *Notorious*. After Vandamm chides the Professor for using real bullets ("Not very sporting of you . . . "), Hitchcock has his camera abandon them both, choosing instead to return to Roger and Eve, still in their desperate straits on the sheer face of Mount Rushmore. For Eve to be saved, the killing of Leonard is obviously necessary. Equally obviously, saving Eve will still require another intervention by the film's author, another "miracle." In *Vertigo*, as we have seen, the opening chase ends with Scottie dangling from the edge of a rooftop, holding on for dear life, with no imaginable way of surviving the incident. It is equally

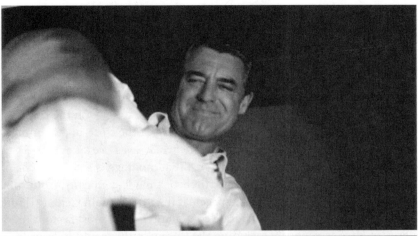

Figure 12.2

unimaginable that Roger can actually pull Eve to safety; if Cary Grant were holding Eva Marie Saint this way, she would be a goner. The camera frames Eve's anguished face in close-up as she cries out, "I can't make it!" When we cut to the reverse shot, Roger says, "Yes you can."

With the camera framing Eve in an even tighter close-up, she says to Roger, "Liar!" She knows that he is lying. She knows that Roger cannot really save her and that Roger knows this, too. And yet, we hear him say, off-screen, and in a changed voice, "Come along . . . " And when we cut back to Roger as he completes his sentence (" . . . Mrs. Thornhill") and succeeds in

pulling her up to his side, we realize that the two are no longer on the face of Mount Rushmore; they are in a cozy Pullman compartment. Roger has pulled Eve up to join him in the upper berth so that they can make love.

Retroactively, we can recognize that in the preceding shot of Eve, when her death seemed imminent, the camera framed her so tightly that we could not see whether she was still wearing her orange sweater or was already in the white pajamas she is now wearing—not for long!—on the train. At some indeterminate point within the duration of the close-up, the impossible happens. The "miracle" by which Hitchcock saves Eve takes more than a bullet. It takes the magic of montage. (That montage is a cornerstone of the art of pure cinema is the point Hitchcock made comically, ironically, yet elegantly in the one-sentence speech at the 1976 Lincoln Center tribute to his career. Following an elaborate compilation of his most famous murder scenes, conspicuously including the killing of the would-be murderer in *Dial "M" for Murder*—the Grace Kelly character, his intended victim, stabs him in the back with a pair of scissors—Hitchcock rose slowly and simply said, "As you can see, scissors are the best way.")

Equally comically, ironically, yet elegantly, Hitchcock's camera makes clear the couple's amorous intent by the famous cut from their passionate embrace to the film's final image, daringly signifying the consummation of their marriage, of a locomotive penetrating the black hole of a tunnel entrance. The title "THE END / NORTH BY NORTHWEST" is briefly superimposed, before the image fades to black.

This is the ending of the film, but for Hitchcock it heralds a new beginning. That it implies a new beginning for *North by Northwest*, too, is suggested by the strategies Hitchcock employs to link the film's ending with its opening title sequence. The film begins—or almost begins, to be more accurate—with the logo of the MGM studio, *North by Northwest*'s "sponsor." We are presented with the familiar roaring lion—this is the lion named Tanner, I believe, one of a long line of distinguished felines that goes back at least to the early 1920s, when the employer was Goldwyn, before the merger that created MGM. Within the MGM logo, the lion appears inside a circular frame-within-the-frame made from a strip of film. This circular frame is itself integral to an elaborate, pleasingly old-fashioned design, itself almost entirely made from a film strip, that incorporates the Latin words "ARS GRATIA ARTIS" (art for art's sake) and "TRADE MARK" (reminders that as far as MGM is concerned, "art for profit's sake" would be an apter motto).

North by Northwest's incarnation of the MGM logo has two unfamiliar features, however. One is that the film does not begin with the logo. Rather,

Figure 12.3

it begins the way it ends, with the frame completely black. That the logo emerges out of blackness links this opening with *Vertigo*'s title sequence. And it links it doubly with *North by Northwest*'s ending, in which, as we have seen, the fade to black is preceded by the image of the train, carrying the lovers, penetrating the black hole of a tunnel, signifying the consummation of their marriage, upon which the image—abruptly, swiftly, and with the closing chords of Bernard Herrmann's music decisively underscoring finality as the image of the projected world fades to black. It is as if what comes after the final moment of *North by Northwest*, when the projected world is engulfed by blackness, is the film's first moment, the moment the projected world is conjured out of nothingness—as if *North by Northwest* follows an image of its birth (the microfilm released from the belly of the statue) with an evocation of the moment of its conception.

The other unfamiliar feature of the MGM logo, in its *North by Northwest* incarnation, is that it appears against a green background rather than the customary black one. "For Hitchcock," as I wrote in *The Murderous Gaze*, green is "the color of dreams, fantasies, and memories. The perfect love not attainable in today's world is infused with green in its imagining. When Judy turns into Madeleine before Scottie's eyes in *Vertigo*, she is bathed in a soft green light."[2] Even in Hitchcock's black-and-white films, the color green already possessed such associations. In *Shadow of a Doubt*, for example, we cannot actually see the green of the emerald in the ring that is Charles's gift to Young Charlie, but when he speaks of emeralds as

the most beautiful things in the world, we imagine the deep, rich green so vividly we all but see it; and it is no accident that Vernon Street was the location of Charles and Emma's childhood home, the past they both long for with profound nostalgia. Even in the silent *Downhill* (1927), Hitchcock had the fantasy and memory sequences tinted green.

When the MGM logo fades out, nothing but green fills the frame. Then straight lines begin crisscrossing the screen. First are parallel diagonal lines that mark the green frame with a perfect Hitchcockian ////. Vertical lines begin intersecting with these diagonals. Soon the entire frame becomes a grid. By the principles of linear perspective, the convergence of the lines implies that what is at the right of the frame is more distant than what is at the left, but the evenness of the green background underscores our sense that this is a flat, two-dimensional image—a schematic representation of a three-dimensional space, not a real space with depth.

When the opening credits begin to appear in the frame—some entering from above and some from below—their white letters are parallel to the diagonal. A split second before each credit appears, a white rectangle passes in the opposite direction through the frame, as if it were a counterweight pulling a scaffolding platform into place. This clever touch provides the first inkling of the metamorphosis that the image is about to undergo: a slow dissolve that transforms the grid of black lines on a flat green background into the glass facade of an office building, its surface marked by the same grid. In this mirror are reflected cars and taxis on a heavily trafficked Manhattan avenue. What Heidegger calls "the worldhood of the world" has announced itself. Or has it? After all, this is the world's mirror image, not the world itself. And the parade of credits continues, until there is finally a slow dissolve to the ground floor of an office building; men and women pouring into the street (from the blackness of the frames-within-the-frame of the building's doors, yet another linkage with the film's ending) where they join the hordes of office workers—they might all just as well be wearing the proverbial gray flannel suits—leaving work at the end of the business day.

For a long moment the //// of the grid lingers. At first, we take what we are viewing to be another reflection, as if it were superimposed over the grid, projected onto this simulacrum of the movie screen. By the time the grid vanishes, it seems to have morphed from a mirror into a window through which we are looking into a world on the other side of the grid/screen, a world that has risen up from beneath it, as it were. It is at this moment that *North by Northwest* "realizes its world," to invoke an Emerson term, by a

Figure 12.4

Figure 12.5

transition that is as mysterious, as magical, as the one that transports Roger and Eve—and us—from the face of Mount Rushmore to a cozy Pullman compartment love nest. And it is at this moment that a title card makes the announcement—not really needed, in this case, to avoid libel suits—that the events of the film are "fictitious" and that "any similarity to actual persons, living or dead is purely coincidental." Oscar Jaffe, the John Barrymore character in *Twentieth Century*, would call this "the final irony."

 At the end of *North by Northwest*'s "fiction," Roger and Eve have achieved a marriage of equals worthy of a comedy of remarriage. Not coinciden-

tally, Eve, her mission accomplished, has washed her hands of the job that called for her to take marching orders from the likes of the Professor. When Roger escaped from the hospital and set out on his own to claim the woman he loves, he, too, declared his independence from the Professor. Never again will Roger or Eve take part in the murderous games that (today, no less than at the height of the Cold War) threaten America's soul.

When the Professor informs Roger that Eve is a double agent (in the scene at the airport we considered in the introduction), this onset of knowledge, which is also self-knowledge, engenders a true Emersonian awakening. As we have seen, this awakening, unlike the comparable ones Cary Grant characters achieve in *The Philadelphia Story* and *Notorious*, happens onscreen, before our very eyes. Roger opens his eyes to who he is, that is, who he has been, who he no longer wishes to be. He knows why, and how, he must change. And to come into such self-knowledge is to change.

When Leonard tells him of Eve's duplicity, Vandamm, too, is anguished, as is Sebastian in *Notorious* when he discovers, as his mother says to him, the "enormity of your stupidity" in marrying Alicia. But Vandamm never awakens to his humanity, as Sebastian does. Vandamm does not feel anguish for Eve. It is only his pride of possession that is wounded. When he cold-bloodedly plots her murder, he is indifferent to her fate. He simply does not care. Roger does. When the Professor informs him that Eve is a double agent, what Roger learns is not that she loves him (for all he knows, he may still be to her just one more of those men in her life who do not believe in marriage). What he learns is that he loves her. He also learns that in his failure to declare his love, he had been, like Devlin, a "fat-headed guy full of pain." That is not the kind of person he wishes to be. Overcoming or transcending his resistance to change, Roger changes.

Unlike Scottie, whose change comes too late to undo what cannot be undone, Roger, like Devlin, is given—and gives himself—a second chance to free himself from the "private trap" into which he had stepped. And this Cary Grant character—like the Grant characters in *The Awful Truth*, *Bringing Up Baby*, *His Girl Friday*, and *The Philadelphia Story*, as well as *Notorious*—rises heroically to the challenge (with the timely help, to be sure, of the "long-range assassin" who kills Leonard). Roger declares his now unconditional commitment, which Eve shares, to their walking together in the direction of the unattained but attainable self.

The ending of *North by Northwest* reprises the ending of *Secret Agent* but with a difference. In *Secret Agent* the Home Office receives a postcard from Richard and Elsa declaring, in effect, that they have exited the world

of the Hitchcock thriller and vowing never again to be party to the killing that is one of its defining features. Hitchcock applauds them, but it is from within the world they have repudiated that the camera presents their post-card to us. At the end of *North by Northwest*, by contrast, Hitchcock's cam-era abandons both Vandamm and the Professor—abandons the world of the Hitchcock thriller, I want to say—to mark the consummation of the marriage of this man and woman who—with Hitchcock's help, and with the help of montage—have escaped that world, never to return.

13

A Loveless World

With an ending that appears unqualifiedly hopeful, *North by Northwest* suggests that Hitchcock has changed, that he has at last overcome or transcended his ambivalence and embraced the Emersonian moral outlook that in the 1930s had been in ascendancy in the American cinema but that by 1959 had become, within Hollywood, all but completely repressed. And yet, wherever Roger and Eve are going, the camera does not follow them. Where does the camera find itself? Back at the beginning of the film. And if, in effect, Hitchcock concludes *North by Northwest* by vowing "Never again"—never again will he make films that equate their own art with murder—why did he have to make *Psycho*, a film that revolves around vicious murders, a film whose ending denies all hope, whose world is utterly devoid of love?

Or is the question "Why did Hitchcock have to make *Psycho*?" as prejudicial as the question "Why does Judy have to die?" The question rules out the possibility that Hitchcock made *Psycho* not because he felt he had to but because he wished to. Perhaps one motivation for making *Psycho* was to disclose that his fingers had been crossed when he had declared his commitment (as I understand him to have done by the ending of *North by Northwest*) to leaving killing behind him. I would be tempted to suggest that *Psycho*, even more than *Vertigo*, is Hitchcock's ultimate illustration of the idea that each man kills the thing he loves, except that I don't believe that Hitchcock loved anyone within the world of *Psycho* the way he loved

Rose and Judy and Eve; nor is there anyone he hated the way he hated Verloc and Willi. If Hitchcock neither loved nor hated Marion Crane, why would he have wished to kill her or, for that matter, to save her? If *Vertigo* is really a turning point, and *North by Northwest* really marks an Emersonian awakening for Hitchcock, why would he have wished his next work to be a loveless film, a film that even its creator could not love?

Just before forcing Judy to climb to the top of the tower, Scottie mockingly parrots Madeleine's words, "There's something I must do and then I'll be free of the past." Was making *Psycho* the "something" Hitchcock felt he had to do to be "free of the past"? My long, intricate, and passionately argued chapter on *Psycho* in *The Murderous Gaze* fleshes out the idea that after *North by Northwest* Hitchcock authored *Psycho* to bring the cycle of Hitchcock thrillers to a definitive end.[1]

As a result of her conversation with Norman in the parlor, Marion has already decided to extricate herself from her own private trap when she steps into that fateful shower. As I put it in *The Murderous Gaze*: "Marion feels beholden to this hopeless case, edified by this example of the resilience of the human spirit. She does not regard Norman as her equal. For example, she does not view Norman as a man she could desire or who could desire her. Even as she thanks him for imparting a lesson in humanity, she summarily dismisses him" (294).

Marion is oblivious of the fact—Norman, I take it, is not—that by finding her own salvation in this lost soul's damnation, she is committing one of those everyday acts of violence, inflicting one of those "little deaths" around which comedies of remarriage revolve. As "little deaths" go, this is a big one. But surely she has not thereby forfeited her humanity. Killing Marion is murder; to think otherwise is madness. But then Norman has no hope of receiving any compensation for the slight he has suffered at her hands. Where is the justice in that? In the world of *Psycho* there is no justice.

In *Vertigo*, as we have seen, Judy's plan comes to fruition when Scottie, holding her in his arms, realizes that whoever or whatever she may be, she is the woman he has always loved and always will love. But then Judy, like Rose, opens her eyes. When she does, she sees the figure of Death come to claim her. And this death-dealing vision appears to Judy first in her inner reality, so that when she opens her eyes, she knows what she will see even before she literally sees it. At the moment the murderous intruder pulls open the shower curtain, Marion's face is turned away. Our uncanny impression is that if she were never to turn around, her killer would never

attack. It is Marion's turning—and, quite remarkably, she turns a full 270 degrees—to face this phantom that brings it to life. What Marion then sees, I take it, is what Judy sees: the figure of Death come to claim her. And the death-dealing vision first appears to Marion, as to Judy, in her inner reality. She, too, knows what she will see before she literally sees it. As I wrote in *The Murderous Gaze*:

> This is the being she conjured in her ecstasy as she received the shower head's stream, the being whose reality and power she denied. Now this being has violated the "inviolable" shower curtain, the barrier between outside and inside, and stands before her demanding acknowledgment. The visitation demonstrates to Marion that her wish to keep outside and inside separate—this is also her wish to find a private island where she may author her own salvation—will not come true. . . . First, she is compelled to acknowledge this apparition as a projection of her own subjectivity. Second, she is compelled to acknowledge this nightmare figure also as real, beyond her control. It is not within Marion's power to make the apparition go away. The curtain has really been torn. (307)

If this were a scene in one of the slasher films that we think of, not altogether wrongly, as following in *Psycho*'s footsteps, we would expect the vulnerable woman's first view of her monstrous attacker to be simultaneous with our own so that our moments of terror would coincide. In *Vertigo* Judy already knows what she will see before she opens her eyes, but we see the shadowy figure at the same moment she does. But the fact that Marion does not become aware when we do that someone (or something) has entered the bathroom—we see the intruder's silhouette diffused by the translucent shower curtain—marks this sequence as significantly different from its counterpart in *Vertigo*.

If all this intruder wished was to kill Marion, there would be no reason to wait for her to turn around. Like Handel Fane in *Murder!* and Uncle Charlie in *Shadow of a Doubt*, this killer is also undertaking an act of instruction. It is a theatrical demonstration performed for Marion as audience. Presumably, Marion's killer wants her to know that she is face-to-face with her own murderer. And this piece of theater is also addressed to us. The shower murder sequence is composed precisely to equate the shower curtain with the movie screen. When the frame-within-the-frame of the featureless, translucent shower curtain comes to engulf the film's frame by virtue of the simultaneous movement of Marion and the camera, it is as if

nothing separates this curtain from the screen on which our view is projected. In this shower curtain, the gesture Hitchcock performs with his camera declares, the world of *Psycho* and our world, the one existing world, "magically" come together. Or perhaps this gesture declares that there was never a real barrier separating them. Thus when Marion's murderer theatrically pulls open the shower curtain, it is as if this "torn curtain" reveals that we, like Marion, find ourselves face-to-face with our own murderer (if we can be said to be face-to-face with a being whose face has not yet been revealed to us).

When the shower curtain is suddenly pulled open, and Marion turns 270 degrees to face her murderer, she presumably sees the killer's face. For Marion, but not for us, this is a moment of recognition; a villain performs an act of "self-nomination" for her as audience, and she is, to say the least, astonished. In this sequence we never do see what Marion sees—the closest we come is seeing the murderer's backlit silhouette, a mere shadow projected on the screen, which is what all film images are, of course. Who or what, then, is this monstrous murderer?

At the end of *Psycho* the psychiatrist's explanation sets us up to believe that we know the definitive answer to this question. The murderer, he is sure, is the "mother half" of Norman, who was driven by the guilt and shame of matricide to create from himself, within himself, a semblance of the mother who had given birth to him, the mother he had murdered, the mother who is his own creation and who has now taken revenge by possessing, or dispossessing, the "self" of her own creator.

But just as in *The Murderous Gaze* I reflected on the vertigo-inducing possibility that in *Shadow of a Doubt* Uncle Charlie's plan is for Young Charlie to kill him, not the other way around, I also reflected on the possibility that the psychiatrist has been taken in, that at the end of *Psycho* it is really Norman who is grinning at us, challenging us to acknowledge the truth, rather than the mother who is only her son's creation, one of his "stuffed birds."

This means, I would now add, that insofar as we think of Marion's murderer as an allegorical stand-in for the film's author, *Psycho* posits two incompatible ways of understanding who or what the film's author is—and gives us no way of rationally deciding between them. Who or what stands before Marion, and us, as a veritable figure of Death? Is it the flesh-and-blood Alfred Hitchcock, now long dead—the artist whose lifelong dedication to the art of pure cinema gave birth to *Psycho*? Or is this murderous figure, like the mother half of Norman, only the creation of this artist's

Figure 13.1

creations? And who are we, allegorically, that when viewing *Psycho* we feel that we are face-to-face with our own murderer?

When she turns to face her murderer, we see Marion from the killer's point of view. It is as if we are viewing her with the eyes of her murderer. *Psycho* pointedly denies us the ability to dissociate ourselves from the monstrous being that reveals its identity to Marion. We wait with her murderer for Marion to awaken to the full dimension of the reality of this moment. And as we are waiting for Marion to recognize that she is about to die, it is as if it is we who are poised to unleash the violent attack on her—and on ourselves—that is about to take place.

To view the world on film as a "private island" wherein we can escape the real conditions of our existence is to make the world on film a self-contained universe. This is to make the real world—the one existing world, the world into which we have been born, the world in which we are fated to die—only an image, not the real world at all. It is to be condemned to a condition of death-in-life, as if we, too, were mere shadows on a screen, not human beings of flesh and blood. *Psycho* is an allegory about the death of the art of film as Hitchcock has known and mastered it—the art of creating self-contained universes on film, private islands, to which viewers can imagine themselves escaping from the real conditions of their existence.

When Norman raises his eyes directly to the camera and grins, the shot conveys the impression that he is returning our gaze. It is thus akin to the shot of the lodger who is only retroactively revealed to be in the audience at Daisy's fashion show. Hitchcock does not follow this shot of Norman, though, with a reverse shot that would disavow the implication that this subject of the camera has the power to see us.

Like Professor Jordan when he shows his hand, Norman authors a view. But the view whose authorship Norman claims is a view of him. And he presents it to us. Like all the views that make up *Psycho*, however, this is also a view framed by Hitchcock's camera. Even as Norman fixes the camera in his gaze, the camera gazes at Norman, as it cannot but do with its subjects. Presenting this view to us is at once a gesture Hitchcock performs with the camera, and a gesture performed by Norman, the camera's subject. These gestures are not only linked; they are one and the same. At this moment Hitchcock and Norman Bates—can we also say "Hitchcock and Anthony Perkins"?—appear to be conspirators of such intimate complicity that we cannot draw a distinction between them. The film's author has become one with his camera's subject. Norman/Perkins has become a mask

Figure 13.2

for Hitchcock, one of Hitchcock's stuffed birds. In turn, the grinning Norman/Perkins has become impressed indelibly on our idea of who Hitchcock is.[2]

This villain is not the Devil incarnate. He is the film's author incarnate. This passage is thus an exception that proves the rule that a Hitchcock villain cannot nominate himself, that Hitchcock has to second the nomination, as it were. For Norman nominates himself by being nominated by Hitchcock. Furthermore, by nominating Norman as a villain, Hitchcock nominates himself as a villain as well. When Norman grins directly into the camera, a villain is unmasking himself, and Hitchcock is declaring his own camera to be an instrument of villainy. But then, most astonishingly, Norman's mother's mummified face becomes superimposed over, or surfaces from beneath, the face of the camera's living human subject.

In *The Murderous Gaze* I interpreted this composite figure, at once alive and dead, as emblematic of the condition of all who dwell within the world on film. The camera "fixes its human subjects, possesses their life. They are reborn on the screen, creatures of the film's author. . . . But life is not fully breathed back into them. They are immortal, but they are always already dead" (347).

Psycho is Hitchcock's darkest meditation on the sea change the medium of film makes the world undergo, his fullest statement of his understanding of the camera as an instrument of taxidermy. When living human

beings are captured by the camera and their images projected onto the movie screen, they are turned into shadows of themselves. In Emerson's view human beings, always in the process of becoming, are free to participate actively in writing their own futures. Characters in movies do not possess such freedom. Their futures have already been written. But with exceptions that prove the rule—Rose in *The Wrong Man* is one such exception—they do not know this about themselves. They do not know that their identities are fixed, that they are condemned to a condition of death-in-life.

I understand *Psycho* to be declaring that the art of pure cinema it exemplifies is the art of creating, from the camera's living human subjects, beings that are immortal but already dead. And that the act of creating *Psycho* fixes the identity of its author as well, condemns Hitchcock, too, to Norman's condition of death-in-life. And if Norman Bates is Hitchcock incarnate within the world of *Psycho*, within our world, the one existing world, must not Hitchcock be Norman Bates incarnate? Is Norman's grin Hitchcock's way of saying to us, to paraphrase the dying Annabella Smith, "I'll get you next!"? Norman is the figure of Death come to claim us.

"Marion Crane's dead eye and Norman/mother's final grin prophesy the end of the era of film whose achievement *Psycho* also sums up, and the death of the Hitchcock film," I claimed in *The Murderous Gaze*. "In *Psycho*, Hitchcock's camera singles out a human subject as if for the last time, then presides over her murder. Marion Crane's death in the shower, mythically, is also our death—the death of the movie viewer" (255). In *Psycho* Hitchcock envisions, in the medium of film, that the movie screen has magically been breached. Like Norman Bates himself, *Psycho* envisions no possibility of liberation. In *Psycho* the breaching of the movie screen barrier does not spell freedom. It spells death. That is, it changes nothing. We are already fated to die. And to kill. In *Psycho*'s dark vision we are all condemned to a condition of death-in-life. We are all born and die in private traps within which we "scratch and claw but never budge an inch."

And yet, as much as *Psycho* revolves around death, around killing, it opens and closes with evocations of birth. The film's opening title credits, designed by Saul Bass, are dominated by graphics that—underscored by Bernard Herrmann's music—play tensely and rhythmically on Hitchcock's signature ///// motif. The white parallel lines, standing out against a featureless black background, give way to an aerial view of a large city, enabling what Heidegger calls "the worldhood of the world" to announce itself, as in the title credit sequence of *North by Northwest*. The camera begins to move right and the words "PHOENIX, ARIZONA" appear, superimposed over

the image. The camera continues its movement, hesitates, as if having second thoughts, then resumes moving. There is a dissolve to a less lofty perspective, the movement continuing, as "FRIDAY, DECEMBER THE ELEVENTH" appears; to a yet less lofty shot, the camera zooming in and panning right; then to the nondescript wall of a building, over which the words "TWO FORTY-THREE P.M." appear as the camera moves in toward a bank of windows. There is an "invisible" cut to one of these windows, the venetian blinds almost completely closed. The camera moves in toward this window until the blackness of the opening below the blinds fills the frame. Then the camera, now inside the drab room, moves in to frame a double bed, its headboard forming a perfect Hitchcockian ////, and a half-dressed couple.

It is the real city of Phoenix spread out below the camera and, for all we know, it really was Friday, December 11, 2:43 p.m., when these shots were taken. *Psycho*'s prevailing fiction is that the world of the film is real. In dramatizing its choice of subject, the camera at the same time is declaring itself. In asserting, rhetorically, that the film's world is reality, *Psycho*'s opening is also asserting the reality of the camera's gesture of singling out this room and entering it. "In order to enter the room," I wrote in *The Murderous Gaze*, "the camera must descend from the great height at which it soars freely like a bird—*Psycho*'s myth is that the phoenix is the kind of bird the camera is—and plunge through this narrow opening, where it is immersed in blackness." The passage goes on in language that, as I read it thirty years after I wrote it, reverberates as deeply in me as if I had written it (in the dead of night) only yesterday:

The lodger enters Daisy's world possessed of the camera's powers and animated by its spirit. The camera magically possesses him, cloaks itself in his human form. In *Psycho*, however, the camera itself is called upon to suffer incarnation. Passing through this narrow opening, the camera is engulfed in blackness, suffers a symbolic death, before it emerges "on the other side," born into *Psycho*'s world. But this is at the same time the birth of that world to us. By imaging the creation of its world as a birth, *Psycho*'s opening revises and outdoes that of *North by Northwest*, the Hitchcock film immediately preceding it, which begins by imaging a magical conjuring of its world out of nothingness. Mythically giving birth to the world of *Psycho*, the camera is its mother, its gaze a mother's gaze. But the passage of the camera through the window is also its penetration of a world that, as the titles announce, already exists. This penetration

Figure 13.3

reveals the masculine aspect of the camera's mythic identity; if the camera gives birth to Marion Crane's private world, it is born into it as a son. (260)

Hence the phoenix as the camera's totem: rising from its own ashes, alive and dead, mother to itself and its own son. Hence, too, the camera as harbinger of the monstrous being known to this world as "Norman Bates," who is at the same time living and dead, son and mother, male and female, murderer and victim, artist and work of art, creator and creation.

What impels the camera to suspend its majestic soaring to descend to earth to undergo death and rebirth, penetrating and giving birth to Marion Crane's world? The opening of *Psycho* does not attempt to explain, or explain away, this mystery. Nor does the film's ending, in which the death's head grin of Norman's mother's mummified face is momentarily superimposed over Anthony Perkins's grinning face (is this Norman's mother, or is it Norman?), before this composite dissolves into an image of Marion's car being pulled by a clanking chain, trunk first, out of the swamp to which Norman had consigned it. Then the graphic pattern of the opening titles is very briefly reprised and the film ends with abrupt finality as the image quickly fades out and with a few stern chords the music plays over an empty black frame.

The slow dissolve momentarily superimposes the umbilical cord–like chain over Norman's/"Mother's" throat, imaging a hanging and thus signifying that this "composite" is damned. But "Mother" also dissolves into the black muddy waters of the swamp, as if Marion's car emerges from within this monstrous being. The film's final image, then, echoes the equally cryptic last shot of the shower murder sequence, when the camera moves in on the water mixed with blood spiraling into the blackness of the circular drain, which then dissolves into Marion's lifeless eye, staring unblinkingly at the camera, which slowly pulls away from it.

"One myth of art," I wrote in *The Murderous Gaze*, is that the artist

who lives for his creations gives a part of his life to each of his works. Through a lifetime of creation he dies many deaths and is reborn by stages until he is finally created as his works' creator. As artist, he is immortal. . . . But in his acts of creation, the human artist is also brought back to the inevitability of his own death. In the creation of a work of art, the artist takes his own death upon himself. And his art has a murderous aspect as well. How could his impulse to create be separated

Figure 13.4

from his desire to avenge himself on those who, beholding his creations, draw sustenance from them? Norman Bates stands in for every artist whose life is circumscribed by acts singularly composed of murder and creation. (346)

After *Vertigo* Hitchcock no longer wished to be such an artist. By making *North by Northwest*, he had vowed, in effect, that he would never again create a Hitchcock thriller that equated its own art with murder. Perhaps he created *Psycho* in the hope that a film that made us feel the brunt of murderous violence, and at the same time made us feel implicated in that

Figure 13.5

violence, responsible for it, would spoil our appetite for such art. By authoring *Psycho* Hitchcock killed, symbolically, the thing he loved most in the world: the art of pure cinema itself as he had mastered it (or as it had mastered him).

Marion's dead body, hidden in the trunk of her car (the way in *North by Northwest* the microfilm is hidden in the belly of the statue), is returned to the world from the mud of the swamp. She is born, or reborn, already dead. We can also say that it is Norman, or "Mother," who is stillborn. But it is also as if the birth or rebirth with which *Psycho* ends is that of *Psycho* itself. To say the least, this is a far darker self-image of the film's birth than we encountered at the end of *North by Northwest*. Nonetheless, I like to think that in creating *Psycho*, Hitchcock's hope was that when the art of pure cinema was reborn, it would be transfigured into something full of life, not something stillborn; something beautiful, not something monstrous.

This was what indeed came to pass when Hitchcock created *The Birds* and *Marnie*. These are his last two masterpieces. And yet, ironically, viewers at the time were disappointed—many still are—that these films did not "out-*Psycho Psycho*."

14

Birds of a Feather

After *North by Northwest* and *Psycho* Hitchcock was riding high, artistically and commercially. He planned to follow up these successes by wooing Grace Kelly out of retirement and pairing her with Cary Grant in an adaptation of Winston Graham's novel *Marnie*. When the people of Monaco, in a referendum, expressed the wish that their Princess Grace not return to the screen (and certainly not as a psychologically disturbed kleptomaniac), Hitchcock signed Tippi Hedren, a model his wife had noticed in a television commercial, to an exclusive contract. Thanks to his friend Lew Wasserman, Hitchcock was offered an ownership share in Universal, and it seemed an ideal setup for the last chapter of his career. Deferring *Marnie*, he chose as his first film at his new studio home *The Birds*, based on a Daphne Du Maurier story (as was *Rebecca*, his first film in what was to become his new home, America).

Production of *The Birds* was challenging—perhaps too challenging. "Not enough story, too many birds," Hitchcock summed up the film, too harshly but not entirely inaccurately.[1] On the whole I find the bird attacks, heavily reliant on special effects, to be extraordinary technical achievements on the part of his gifted and dedicated collaborators but less effective than some of the less spectacular sequences; for example, the quietly understated passage in which Melanie (Tippi Hedren) sits smoking on a schoolyard bench while waiting for the children to be sent out for recess. We see, as she does not, that crows, one by one, are gathering on the monkey bars

Figure 14.1

behind her back. But when her eyes follow a single bird and the camera follows her gaze to a framing that reveals crows occupying every possible perch on the once bare monkey bars, we are as shocked as she is. We are struck by their sheer number but also by their eerie stillness, which continues until they fly off as one, in a sonic burst of beating wings, just as the children leave the schoolroom. The immediate attack on the schoolchildren—an impressive montage that was far more difficult, technically—is almost an anticlimax.

Yet the single greatest shot in *The Birds* is the one that posed perhaps the greatest technical challenge: the "bird's eye" view of the gas station in

Figure 14.2

flames, the camera occupying an impossible position alongside the soar-
ing seagulls, as if a bird of their feather.

Ordinarily, when the camera calls attention to itself in a Hitchcock thriller,
the film's author is showing his hand, declaring that he is the deity who
presides over the world of the film. This shot is different. Here, the camera,
surveying its domain from a great height, unafraid of falling, seems be-
yond the control, or ken, of a merely human author. But it is not God's in-
strument, either, as in *The Wrong Man*. The birds that oversee this world
are just birds, this shot implies. Creatures of their appetites, they exist
within nature. This condition they have in common with human beings.
But they are not human.

No doubt emboldened and challenged by the films of Truffaut, Godard,
Chabrol, Rohmer, and the other young French critics-turned-directors who
were fervent in their admiration of his films, Hitchcock experiments in
The Birds with cinematic devices that at times give it a bit of the feel of a
nouvelle vague film. He uses jump cuts, for example, to convey the discov-
ery, by Lydia, Mitch's widowed mother (Jessica Tandy), at the neighboring
Fawcett farm, of the body of her friend, his eyes pecked out.

The Birds' narrative, too, has something of the feel of a European art
film. I am thinking, for example, of the film's refusal to attribute to the
birds a clear motive for their violent attacks on Bodega Bay's human in-
habitants (although the film repeatedly intimates that, like the camera, the
birds have a special bond with Melanie); its refusal to provide a "scientific"

Figure 14.3

explanation (on the order of the radioactive fallout science fiction films of the 1950s were wont to cite as causing the strange metamorphoses of ants, mantises, and the like into humongous monsters) for the birds' changed behavior (although the film keeps reminding us of the outrages against nature that humans unthinkingly perform every day); and, especially, its unresolved conclusion, from which the conventional "The End" is pointedly withheld.

This ending offers us no assurance that Melanie, in shock after the birds' mass assault on her, will ever be herself again. Mitch (Rod Taylor) does all

he can, but no man has the power to rescue this woman. Nor are we given any assurance that the birds, having ravaged Melanie, have had their fill of violence, that the cluster of attacks was a localized occurrence, or that humans can safely go on, as before, eating fried chicken and having little regard for our fine-feathered friends—or for each other.

All Hitchcock's films are open to allegorical interpretation, but *The Birds* is unique in openly presenting itself as an allegory. How can we not ask ourselves what those birds represent and what they really want (a variant of Freud's famous question about what women want)? And the question "What do the birds want?" takes on special urgency because the ending precludes our taking the projected world to be a "private island," a place separated from our world by the safety curtain of the movie screen, a place where we can escape from the real conditions of our existence. Like Michelangelo Antonioni's *L'avventura* (1960), *The Birds* implies that it means more than it literally says. In the film's overt claim to profundity, too, I sense that Hitchcock was emboldened and challenged by New Wave films like *Jules et Jim* (François Truffaut, 1962) and *Vivre sa vie* (Jean-Luc Godard, 1962), made by the young French cineastes who first began to plumb his work's previously unsuspected depths.

What I value most in *The Birds*, however, are the down-to-earth, human moments—such as every moment Jessica Tandy or Suzanne Pleshette is on the screen—that reveal its characters' humanity with an emotional directness unprecedented in Hitchcock's work. The camera, caucusing with the birds, not the humans, achieves a separation from the film's merely human author by means of a strategy very different from the one he employed in *The Wrong Man*. Detached from Hitchcock's ego, at least rhetorically, the camera is freed from the rancor that afflicts all human beings. Acknowledging that he is the servant, not the master, of the art of pure cinema, in this film Hitchcock does not claim personal possession of the camera, does not strive to impose his will over the film's world. In *The Birds* the camera goes a little crazy sometimes (to paraphrase Norman Bates, who, as usual, knows whereof he speaks). But it is also freed, as never before in Hitchcock's work, to allow its human subjects the freedom to reveal their own humanity.

I am not suggesting that in earlier Hitchcock films the camera's subjects are never movingly revealed. In *Rebecca*, for example, when the Joan Fontaine character descends Manderley's grand staircase in that gown and preposterous hat, her face reveals to us what she is trying to hide from her husband, Maxim, her desperate longing for his acceptance. Or in *Shadow of a Doubt*, when Young Charlie's mother breaks down, in full view of

family and friends, after her brother, Charles, announces that he is leaving town. Or in *Vertigo*, when Scottie points out to Midge that she is the one who had broken off their engagement, and a cut to an uncomfortably close high-angle shot reveals to us the pain she is trying to hide. At those moments, however, the camera exposes the vulnerability of subjects who are trying to mask their thoughts and feelings. But when Mitch's ex-girlfriend Annie (Suzanne Pleshette) offers friendly advice to Melanie, her rival, or when Lydia, Mitch's mother, confides her fears to Melanie, what the camera captures is what these characters openly reveal of themselves.

Lydia revises humanely the stereotype of the monstrous mother that plays a central (if ambiguous) role in *Psycho* (and nowhere else in Hitchcock's work). Annie characterizes Lydia, not unsympathetically, as fearing that Melanie will give her son the love she has never given him. No woman played by Jessica Tandy can be a monster, but Annie understands Lydia's fear to be a source of Mitch's resistance to committing himself to another woman. Annie's characterization rings true, and she offers it as a friendly gesture. Lydia is so different from her own mother that Melanie is genuinely interested in understanding her. Melanie and Lydia both recognize that they are in competition for Mitch's love. Yet they develop respect, even affection, for each other.

In the course of *The Birds* we come to appreciate Mitch for his honorable efforts to balance his career and his responsibilities toward his family, which require him to help raise his younger sister and minister to the emotional needs of a mother who sees him as a sorry substitute for her dead husband. As the family braces for the birds' attack on their home, Lydia makes it all too clear to Mitch that she doesn't see him as his father's equal when she blurts out, "If only your father were here!" Rod Taylor isn't Cary Grant's equal, either. Who is? However, Taylor's rugged features, physical strength, and thoughtful demeanor make him a plausible romantic hero, if a somewhat wooden and humorless one.

In *Notorious* and *North by Northwest* a character played by Cary Grant rescues the woman he loves but only after his actions have placed her in jeopardy. In the world of *The Birds* no man has the power to rescue Melanie, if only because no man places her in danger. Mitch does everything that can reasonably be asked of a man to keep his mother and young sister— and Melanie—safe. Nonetheless, when a rustling awakens Melanie, she sees that Mitch is asleep, exhausted by his labors. Whether in reality or in her dream, the birds are calling Melanie. As if entranced, she walks quietly

Figure 14.4

to the stairs, lighting her way with a lantern, ignoring the warning sig-
naled by the //// motif formed by the banister of the staircase.

Melanie ascends the stairs to the attic, even as everyone in the theater
is silently screaming, "No! Don't go up there!" Melanie must sense, as we do,
that the birds are waiting for her. Why else would they have called to her?
But why have they singled her out? Why does only she hear their call? Why
does she answer it? At the top of the stairs Melanie's hand reaches slowly
for the doorknob but hesitates. A cut to her face conveys that she senses
that she is faced with a momentous decision.

Evan Hunter, the film's screenwriter, has expressed his understanding
that when Melanie enters the attic, it is an act of self-sacrifice. Hitchcock's
understanding, I believe, is deeper and more disquieting. At the end of
F. W. Murnau's *Nosferatu* (1922), a woman characterized by an intertitle as
"pure of heart" offers her life's blood to the vampire, putting an end to the
contagion of death. Without denying the nobility of her gesture, Murnau's
camera reveals that this woman, for all her "purity," desires the vampire
no less than the vampire desires her. In responding to the birds' call—in
ascending the stairs, entering the attic, and even offering her body to the
birds to do with as they desire—Melanie, too, however pure of heart, is
driven by desire—a desire she believes, not wrongly, that no man can sat-
isfy. What does she desire of the birds? What does she believe they desire
of her?

Whether it resides inside her world or outside it, Melanie senses, I take it, the presence of a mysterious "something" that rules the roost. Something that is not human—something uncannily linked to the camera—had called seductively to her, knowing she would be drawn by this call, the way in *Vertigo* Madeleine, or, rather, Judy, is drawn to the ghostly spirit of Carlotta Valdes, forever searching for the daughter cruelly taken from her. But whatever Melanie may be imagining, she is utterly unprepared for the sustained ferocity of the birds' attack—as Tippi Hedren was unprepared for the ordeal of filming this sequence (no one had informed her that for days on end live birds were going to be thrown at her from the region behind the camera).

It is only from a scene that Hitchcock took the unusual step of writing himself—he inserted it into Evan Hunter's screenplay although Hunter thought it was stupid and added nothing to the film—that we learn that Melanie's mother had deserted the family when her daughter was a young girl. In Hitchcock's mind, but evidently not in Hunter's, it is one of the defining features of Melanie's character that she is a woman who has never known a mother's love. In the scene Hitchcock wrote, Melanie asks Mitch, in light of his difficult relationship with his own mother, whether it might be better not to know a mother's love. He answers thoughtfully, but only after a pause almost as long as Jack Benny's when a mugger says to him "Your money or your life," that it is better to be loved.

The Birds dwells more on Mitch's fatherless family than Melanie's motherless one, but Hitchcock's interest in Melanie is deeper than his interest in Mitch, his films' interest in mothers deeper than their interest in fathers. Her knowledge that her mother abandoned her gives Melanie a personal interest in learning something about a mother's love that her own experience has not taught her. The scene Hitchcock scripted illuminates Melanie's otherwise inexplicable decision to walk into that attic. Perhaps she hears, in the birds' quiet call, the call of Mother Nature herself, the voice of the mother whose love she has never known.

The scene also underscores the thought-provoking, emotionally resonant connections between *Vertigo* and *The Birds*, and between *The Birds* and *Marnie*. Carlotta Valdes does not abandon her daughter; in a bygone world in which men had the power and freedom to do such things, her daughter was taken from her. Marnie's mother (Louise Latham), too, never abandons her daughter. Indeed, she loves Marnie so much that she sacrifices mightily for her sake. Yet Marnie grows to adulthood not knowing that her mother loves her, hence not knowing from her own experience

whether a mother's love, for which she longs, is worth knowing. *The Birds* and especially *Marnie* are Hitchcock's most heartfelt films, and this question helps bind them together.

When Hitchcock released *The Birds*, many viewers were disappointed, as I have said, that the film did not out-*Psycho Psycho*. The world of *The Birds* is not loveless, like the world of *Psycho*. Nor does love fall victim, as in *Vertigo*, to a villain's sinister machinations. In *The Birds* there are no villains. All the human characters earn our sympathy. The birds kill, but they are not murderers. Far more than earlier Hitchcock films, *The Birds* conveys a profound sense that it is human nature to hunger for love but that love is so painful, our appetite for it so voracious, that it is also human nature to avoid loving.

In *North by Northwest* Hitchcock grants Roger and Eve their wishes; Roger rescues Eve, their romantic dreams come true, and love triumphs. In *The Birds* all the adult characters we care about are too scarred by life, too wounded, for their romantic dreams to have survived intact. The only character who still believes that dreams can come true is Cathy (Veronica Cartwright), Mitch's young sister, who insists, when the little family group is about to drive off into an unknown, perilous future, that they not abandon the pair of lovebirds that were Melanie's birthday gift to her. In his capacity as author, Hitchcock still possesses the power he has always had to preside over "accidents" within the projected world. He still possesses the power to grant wishes, to make characters' dreams (and nightmares) "magically" come true. But in a world in which human beings have turned against nature, have turned nature against itself, a world in which we no longer harbor romantic dreams or believe in them, no longer know how to wish or what we really wish for, Hitchcock's powers as author no longer guarantee that he can reward with love characters he loves and who are worthy of love.

15

A Mother's Love

In *The Murderous Gaze* I attended to five Hitchcock films, and to the experience of viewing them, with an unprecedented degree and kind of attention. I said then, and I am saying now: Hitchcock films are designed to teach us how to think about the way they think. And this, as I now understand, is a feature they share with Emerson's essays. Hitchcock's films, like Emerson's essays, have something to offer everyone—they were meant to be, and were, *popular.* And yet the more closely we attend to them, the deeper they reveal themselves to be. They were designed to teach us how, as films, they express their thoughts by their "moods of faces and motions and settings, in their double existence as transient and as permanent."[1]

It is because Hitchcock's films and Emerson's essays have such a pedagogical and self-reflective dimension that what Cavell calls "self-images" are everywhere to be found in them. As we have seen, Hitchcock's signature motifs, which declare his authorship, serve as invocations of the movie screen, the film frame, the camera lens, and so on. They are precisely analogous to what Cavell calls Emerson's "master tones,"[2] the philosophically charged words, which at one level refer to the writing itself, and which recur in Emerson's writings within each essay and from essay to essay, their occurrences meant to resonate meaningfully with each other.

Writing about the final paragraph of "Experience," for example, Cavell singles out a number of such words, *realize* and *world* among them. When Emerson concludes his essay by noting the discrepancy between the world

he "thinks" and the everyday world with which he converses "in the city and in the farms," he poses the question, "Why not realize your world?"[3] It is precisely the aspiration of "Experience," as Cavell reads it, to "realize" the "world" its author "thinks." (This is the aspiration of Cavell's philosophical writings as well.)

At the end of his own essay about Emerson's essay, Cavell revisits the question with which "Experience" begins: "Where do we find ourselves?" Having followed the essay's thinking from beginning to end, Cavell finds that the experience of reading "Experience" has taught him to understand that this question is addressed specifically to the situation in which we, readers of "Experience," find ourselves. So, too, is the answer that follows: we find ourselves "in a series of which we do not know the extremes, and believe that it has none. We wake, and find ourselves on a stair; there are stairs below us, which we seem to have ascended; there are stairs above us, many a one, which go upward and out of sight."[4]

An Emerson essay is a series, a series of sentences, a series of "stairs," that is, steps—steps that move us in the direction of "realizing" the world we "think." We do not "know" the "extremes" of this series, insofar as this essay as a whole, the second in *Essays: Second Series*, is itself a step in such a series. The essay's end returns us to its beginning, indicating that after we take the last step, our next step is to take the first step. To "realize" the world we "think" requires that we acknowledge that our world stands in need of "realizing." It requires acknowledging the passing of a world, and a self, that had seemed real to us. Haunted by the death of its author's young son, "Experience" is at one level about—at one level *is*—a process of mourning. Yet images of pregnancy and birth are ubiquitous within the essay. They are among the essay's "self-images." There is a particular birth that the writing seems to be expecting: the birth of the essay itself—as if by envisioning its writing as pregnant with itself, "Experience" gives birth to itself, as we must give birth to ourselves if we are to walk in the direction of the unattained but attainable self.

Giving birth to itself, to the thinking its writing expresses, Emerson's essay aspires to "realize"—to make real, to give birth to—the new world, the new America, its writing "thinks." As we have seen, *Vertigo* begins and ends by envisioning its own birth or creation. As we have also seen, *North by Northwest* envisions itself, precisely as "Experience" does, as giving birth to itself. And it ends, as Emerson's essay does, by returning us to its beginning. To be sure, *North by Northwest*'s prevailing mood, comic and at times ironic, is a far cry from the profound sense of loss that haunts Emerson's

Figure 15.1

essay. *Psycho* is more open in meditating thoughtfully, even somberly, on the unsettling, vertigo-inducing way that the world on film gives birth to itself.

Marnie's opening credit sequence, ostensibly modest and even old-fashioned, together with the shot that follows it, takes a further step in Hitchcock's ongoing meditation on the creation or birth of the projected world. The credits are presented as if they were pages of an old-fashioned photo album or, perhaps, a guest book. The first "page" contains the words "UNIVERSAL PRESENTS," together with the studio logo.

Universal's globe, less endearing but no less familiar than MGM's roaring lion, has evolved over the years, but it has always looked three-dimensional, with the continents outlined as realistically as possible, and it has always been spinning. The globe conveys both that the studio's movies are seen around the world and that the stories they tell likewise span the globe; wherever Universal movies are shown, the world is projected on the screen. In *Marnie*, "UNIVERSAL PICTURES RESENTS" is not set apart from the opening title sequence; it appears as if printed on the first page of a book, a page no different, in principle, from the pages that follow. And the globe is reduced to a circle with the continents crudely sketched inside it. It is not an image of a world spinning in infinite space; it is an image only of an image of the world—a picture on a flat page that is itself a picture projected onto a flat screen.

The transition to the last title, "Directed by ALFRED HITCHCOCK," like all the "page turnings," is effected by a slow wipe. But from this title to the

Figure 15.2

first "real" shot of the film, there is a direct cut, rather than another wipe or a conventional fade-out / fade-in. We are taken abruptly, without any conventional transition, from the pages of a book that is not real, in either our world or the film's world, to our first view of what is, within the projected world, reality. The abruptness is reinforced by the fact that just before the cut, Bernard Herrmann's swelling music—I believe that Herrmann's score for *Marnie* is his greatest achievement—concludes with a forceful chord but without resolving harmonically. The abrupt shift to "natural" sound feels like the sudden emergence of silence—all we hear are footfalls that echo unnaturally in the silence from which they emerge. The combined effect of these devices is to make a subliminal yet strong connection between the name "Alfred Hitchcock," credited on the last "page" as the film's director, and the solitary object that materializes within the frame: a bright yellow handbag, shot end-on. (Readers of *The Murderous Gaze* might recognize the resemblance of this object, thus framed, to the black bag, emblematic of the lodger's mysterious project, which *The Lodger* associates with Hitchcock's own mysterious "project," the first of a series of acts of artistic creation that link *Marnie* with all the Hitchcock thrillers that precede it.)

Viewed end-on, this object, which stands out within an otherwise almost completely black frame, forms a circle that precisely matches the circle to which the Universal globe is reduced on the first "page." It is as if

the globe *becomes* this handbag, as if the handbag *is*, or *contains*, the world as a whole, the way a mother's womb is, or contains, the unborn child. The folds within this circle endow the object with a suggestive aspect that reinforces, visually, the conventional Freudian association, which Hitchcock films have often jokingly exploited, between women's handbags and what to Freud were the twin mysteries of female sexuality and motherhood.

The sound of footfalls and the bobbing movements of the yellow handbag enable us to know, before we actually see, that in reality this object is held by a woman who is walking away from a camera that is keeping pace with her movement. I would add "as she walks into the depths of the frame," except that up to this point within the shot, the woman, the handbag, and the surrounding blackness eclipse all else, keeping the frame from having, or appearing to have, any depth at all. It is as if the camera and this object that holds its complete attention, as circular as the camera lens itself, have not yet become separate. We know that what we are seeing is an object in the world, but it appears before us as if it were in no real space, like Scottie's falling body at the climax of the dream sequence (if that is what it is) in *Vertigo*, which is suspended between reality and unreality—as, indeed, the projected world always is. After a moment, however, the camera slows. No longer keeping pace with the woman, it enables the world on film, and this woman within it, to be revealed, to reveal itself. Then the camera stops altogether as the woman, a brunette dressed in gray and carrying a large gray suitcase as well as her yellow handbag, her footfalls still echoing, recedes into the depths of this frame—depths that her movement, combined with the camera's cessation of movement, causes to open up, visually, transforming the depthless frame into a signature Hitchcock tunnel shot and opening a bracket that will be closed near the end of the film. What this frame contains is reality, but it is a reality that bears an unreal, dreamlike aspect, an unreal reality "signed" with a Hitchcock signature.

Film images are *of* the world. Reality is re-created, re-creates itself, in its own image, when it is captured by the camera and projected onto the movie screen. The world on film is reality itself, albeit reality transformed by being thus captured and projected. It is a defining feature of the medium of film that the reality of the camera's presence is also the reality of its absence. Indeed, as we have seen, it is one of Hitchcock's guiding intuitions that the medium of film overcomes or transcends our commonsense distinctions between the real and the unreal, between presence and absence, between reality itself and inner reality.

Figure 15.3

"If I have described life as a flux of moods," Emerson writes in "Experience," "I must now add, that there is that in us which changes not, and which ranks [i.e., outranks] all sensations and states of mind." The passage goes on in language that is as precise as it is poetic: "The baffled intellect must still kneel before this cause, which refuses to be named. . . .—Suffice it for the joy of the universe, that we have not arrived at a wall, but at interminable oceans. Our life seems not present, so much as prospective; not for the affairs on which it is wasted, but as a hint of this vast-flowing vigor" (485–86). The world our eyes see, which our particular mood paints in its hue, is a world in which "souls never touch their objects." Objects "slip

through our fingers . . . when we clutch hardest at them," as Emerson vividly puts it. "I take this evanescence and lubricity of all objects, which lets them slip through our fingers then when we clutch hardest, to be the most unhandsome part of our condition."[5]

Cavell understands Emerson to mean that what is "unhandsome" in our human condition is not that "objects for us, to which we seek attachment, are, as it were, in themselves evanescent and lubricious." Rather, the "unhandsome" part of our condition is "what happens when we seek to deny the standoffishness of objects by clutching at them, which is to say, when we conceive thinking, say the application of concepts in judgments, as grasping something, say synthesizing."[6] What is "unhandsome" about us is not that we are finite, limited in our powers, that our concepts and judgments lack unity, that we are creatures of moods. What is "unhandsome" is our "clutching at things" in our human effort to escape our humanness.

Hitchcock was powerfully drawn to the idea that we live our lives in private traps within which, in the words of Norman Bates, "For all we scratch and claw, we never budge an inch." Norman Bates is no Emersonian. Nor was Emerson a Batesian. Yet Emerson could write, in "Intellect," that "every man beholds his human condition with a degree of melancholy. As a ship aground is battered by the waves, so man, imprisoned in mortal life, lies open to the mercy of coming events" (418). Our "unhandsome" efforts to escape our humanness are doomed to fail. But if being "imprisoned in mortal life" is the human condition, as in melancholy moods we take it to be, how different is Emerson's vision from Norman's? If we are imprisoned in our mortal lives, is not our humanness a trap in which we were born—a trap we can never escape for all we "scratch and claw," as Norman puts it, or for all we "clutch at things," to use Emerson's virtually identical metaphor?

"Clutching" is one of Emerson's "master tones." In Cavell's view the idea that what is "unhandsome" is our "clutching at things" in our human effort to escape our humanness is central to the philosophical enterprise Emerson took himself to be founding, which in the New World was to replace the European edifice of philosophy. It is a striking coincidence—is it simply a coincidence?—that images of hands clutching, clutching at, holding things in their clutches, and so on, are among the signature motifs that appear at crucial moments in every Hitchcock thriller. Think of Alicia, in *Notorious*, clutching the key to the wine cellar. Or Bruno, in *Strangers on a Train*, desperately reaching through the grating for the lighter that seems just beyond his reach. Or the dying Bruno involuntarily unclenching his

hand, revealing to the police the telltale lighter he had been holding in his clutches. Or Manny, in *The Wrong Man*, alone in his prison cell, staring at his own hands, clutching at nothing. Or Scottie, in the opening of *Vertigo*, losing his grip on the policeman's hand and watching in horror as the man falls to his death. Or Roger, in *North by Northwest*, desperately clutching Eve's hand as she dangles precariously from the sheer face of Mount Rushmore. Or Babs in *Frenzy*, clutching her murderer's incriminating tie pin so tightly, even in death, that he has to break her fingers, one by one, to pry it from her grip. Or Marion, in *Psycho*'s shower murder sequence, her body slowly sliding down the wall, looking with glazed eyes in the direction of the camera as her hand reaches out to something she cannot see, something whose presence she senses—as if she were trying to reach the camera, or reach the screen, or, rather, to reach through the screen to our world on the "other side."

At this moment in *Psycho* the camera pulls slowly away, precisely reversing the movement by which it had earlier allowed the shower curtain to engulf the movie screen—as if the "safety curtain" that separates us from the projected world, and the shower curtain Marion's murderer tears asunder, were one and the same. Then Marion's hand, framed in extreme close-up, continues its movement until it grasps the shower curtain in the foreground. She is clutching it for dear life. But her grip is so strong, so fierce, that it bears an aspect of violence, as if she were struggling less to hold herself up than to pull the curtain down with her as she falls, her life's blood draining away.

As this haunting shot makes explicit, Hitchcock's recurring images of hands clutching, clutching at, holding things in their clutches, and so on, have a self-referential dimension, as do all his signature motifs. Like Emerson's "master tones," they are self-images in Cavell's sense. That is, they participate in the films' thinking—at one level, their thinking about their own way of thinking, about *film's* way of thinking. Cavell characterizes Emerson's philosophical enterprise—which he takes his own writing to be inheriting—as the "overcoming of thinking as clutching."[7] Hitchcock's art of pure cinema can be characterized the same way. His films invite—or provoke—us to open our eyes to the fact that films do not think by "clutching at things."

Had Hitchcock consciously sought a way to express, cinematically, Emerson's guiding intuition that what is most "unhandsome" about us is our effort to escape our real condition by "clutching at things," he could not have come up with a more perfect illustration than the moment—a crucial

Figure 15.4

turning point—when Marnie, having unlocked the office safe, reaches out toward the stacks of twenty-dollar bills inside, but finds her hand unable, or unwilling, to grasp the money, however desperately she clutches at it.

All her adult life Marnie, a thief, has "clutched at things," not wisely but too well. But it is at the moment Marnie recognizes the futility of her efforts to reach the money in the Rutland office safe that she first knows in her heart, if not yet consciously, that her real wish is to change, to abandon the way of thinking that has for so long imprisoned her, a way of thinking that Hitchcock envisions, metaphorically, as "clutching at things."

Figure 15.5

Marnie's mood at this moment is very different from Marion's. In taking a step, not yet fully consciously, toward the unattained but attainable self, Marnie is, to paraphrase Bob Dylan, busy being born, not busy dying. By visually equating Marnie's clutching at the money with the gesture of reaching toward the camera, the close, frontal framing of her clutching hand conveys the impression that what makes the money unreachable by her is what makes the camera unreachable by her, what makes the screen unreachable by her, what makes our world unreachable by her, what makes her world unreachable by us.

Few viewers at the time appreciated the sympathetic consideration *The Birds* accords the relationship of Melanie and Mitch, Annie's moving death, or the haunting, haunted figure of Mitch's mother. Fewer still were prepared for *Marnie*'s emotional intensity and the unbearable sadness unmitigated by its "happy ending." In *Marnie*, as in *The Birds*, there are no murderous villains, although mean-spirited Strutt (Martin Gable) and jealous Lil (Diane Baker), who are unkind to Marnie, come close. And Bernice, Marnie's mother, whose inability to express her love causes her daughter inestimable suffering, is a tragic figure.

Bernice's most poignant moment comes at the end, when her daughter finally acknowledges that her mother has always loved her, and Bernice responds by saying, "You were the only thing in this world I ever did love."

Figure 15.6

Still, she holds back from fully expressing her love, first, by referring to Marnie not as a person but a thing (a "thing" she acquired when she let a boy have sex with her in exchange for his sweater, the beginning of her career as a prostitute); second, by not even now caressing Marnie, although her hand is poised just above the golden hair her daughter had always longed for her to caress; third, by forcing Marnie to pull back from physical contact by saying, as she had several times in the film, "Get up, Marnie, you're aching my leg."

After tenderly brushing Marnie's hair back with his hands (a gesture that Robin Wood convincingly takes to be the emotional climax of the film),[8] Mark (Sean Connery) leads Marnie out of her mother's house, promising to return her someday soon. Marnie looks back at Bernice, sitting alone with her thoughts and memories in the gathering darkness, and says, "Good-bye." "Good-bye," her mother answers. Not holding back from expressing his compassion for this woman who is incapable of expressing the love she feels, Hitchcock's camera stays with Bernice as Mark and Marnie exit. Only then, when Marnie is gone, does she add, in a loving voice her daughter will never hear, " . . . Sugarpop."

I find it natural again to refer to the camera here as "Hitchcock's" because *Marnie* breaks with *The Birds'* rhetorical strategy of identifying the camera with the awesome, mysterious "something" *The Birds* represent, a "something" that is specifically not human. Nor does it revert to *The Wrong Man's* strategy of ceding control of the camera to God. *Marnie* is not a re-

turn, however, to Hitchcock's earlier practice of using the camera to declare that he is the God who holds sway over the world of the film. It is Hitchcock's own humanity—what he has in common with these characters—no less than theirs, that shines through here. But this means that Hitchcock does not try to keep the camera in his own clutches. He acknowledges, at least rhetorically, that there are limits to his power and that the camera has its own nature, its own instincts and powers, that no merely human author can claim for his or her own.

When Mark first takes Marnie to Wykwyn, his family's estate, to meet his father, jealous Lil, who had feigned a sprained wrist so as to make Marnie serve the tea, hoping she didn't know how to do it properly, and not wanting the two lovebirds to be alone, tries to contrive to accompany them to the stables, where Mr. Rutland keeps his horses. Mark says to Lil, "I'm sure your sturdy young wrist has recovered sufficiently to pour Dad another cup of tea." Holding up her wrist, she protests "I can't!" Rubbing it in, Mark replies, quoting Emerson, "When Duty whispers low, *Thou must*, / Then youth replies, *I can*."[9] "Ratfink!" Lil shouts, lowering the level of discourse a notch, as Mr. Rutland (Alan Napier) reaches for another slice of his favorite Horn & Hardart butter cake. "And you misquoted!"

Emerson's line is actually "The youth replies, *I can*," not "Then youth replies, *I can*." But even though Mark misquotes Emerson, he seems to have read him and to have taken his philosophy to heart. This is clear from a little scene sandwiched between the passage, during their honeymoon cruise from hell, in which Mark promises Marnie that he will be kind to her and will not touch her again, and the controversial passage often referred to as the "rape scene."

Mark, trained as a zoologist, is sitting with Marnie at a table in the ship's lounge, he with a tall cocktail, she a glass of orange juice. He is telling her about a phenomenon of nature he thinks will be of special interest to her: "In Africa, in Kenya, there's quite a beautiful flower. It's coral colored with little green-tipped blossoms, rather like a hyacinth. If you reach out to touch it, you'd discover that the flower was not a flower at all, but a design made up of hundreds of tiny insects called fattid bugs. [This should be spelled "flatid," but out of deference to Jay Presson Allen, the film's screenwriter, I will continue to spell the word the way she does in her shooting script.] They escape the eyes of hungry birds by living and dying in the shape of a flower."

In his highly informative book *The Making of "Marnie,"* Tony Lee Moral sees this speech as "the crux of the film." He quotes Allen, who articulated

its point this way: "In any aspect of beauty, there may be extremely ugly elements, but the overall thing is beautiful. Marnie has terrible problems, but [Mark] sees her as a beautiful thing."[10] (I have no doubt that, if the screenwriter had been pressed and had been in the mood to be more expansive, there is much more she could have said about it.)

In the shooting script, Mark prefaces his little speech with "There is no such thing as 'the norm'; we're all singular," and ends it by adding that the bugs seem to have invented the flower they imitate, "as there is none other like it in nature. . . . Even the flower the bugs imitate is singular." And when Marnie does not look up, "he kills the rest of his drink" and all but barks, "As singular as I am, Marnie—as singular even as you." The film omits these lines—perhaps because they make their point so obviously and directly, as opposed to the evocativeness of the central part of the speech they bookend. Omitted in the film, too, is Marnie's overt lack of interest, which risks conveying the impression that Mark's speech simply goes over her head. Tippi Hedren's Marnie is as smart as Sean Connery's Mark. Nothing either says goes over the other's head.

"Lady animals figure very largely as predators," Mark had pointedly remarked to Marnie earlier in the film, when he had arranged for her to be alone with him in his office and asked her to type an article he wrote titled "Arboreal Predators of the Brazilian Rain Forest." Significantly, he is now no longer characterizing her as a predator but as a vulnerable animal instinctively hiding behind a mask designed to be a defense against predators. The beautiful mask that it is the fattid bugs' collective instinct to create enables them to survive in a bird-eat-bug world that revolves around killing. Mark is saying to Marnie, without saying it in so many words, that he has come to understand that she is not really the predator he had thought she was; that he, too, is not a predator; and that she can trust him, can safely reveal herself to him as she is, "for herself," as *Vertigo*'s Judy would put it, because he knows he will find her true self just as singular, just as beautiful, as her mask.

But the beauty of the fattid bugs' mask serves only to deceive hungry birds into mistaking it for a real flower, which they have no interest in eating, whereas the beauty of Marnie's mask is seductive. Were its only purpose to hide her vulnerability from predatory men who would otherwise desire to devour her, figuratively speaking, why has she created for herself a mask those predators find irresistibly attractive? Mark does not yet know— nor do we, nor does Marnie herself, at least consciously—what happened to her when she was a child, or, rather, what she did, that motivated her to

create this mask. Did Marnie create this beautiful, seductive mask because, unconsciously, she wishes for revenge against men, like Elsa in "Revenge" and Rose at the end of *The Wrong Man*? Or did she do so to keep from awakening to the truth about herself that she had killed a man? Is she torn between a longing to open her eyes and the fear that if she were to awaken, she would discover that she is a killer by nature?

Predators burn bright with beauty, too, of course. The beauty of nature masks the ugliness of killing. But the ugliness nature's beauty masks is also a mask. What it masks is the singularity of everything in nature— even predators, and even creatures whose instinct is to protect themselves from predators by appearing other than what they are. The Emersonian point of Mark's fable is that everything in nature is beautiful, because everything in nature strives instinctively to exist, to become its unique self— including Marnie.

And including *Marnie*.

Mark, who understands human behavior to be rooted in instincts inherited from animal ancestors, wants Marnie to take to heart the fattid bug "flower" as a metaphor for herself. But Hitchcock wants us also to understand it as a metaphor for the film we are viewing. A clue that *Marnie* posits the fattid bug "flower" as one of its own "self-images" is the fact that when Mark says that fattid bugs "escape the eyes of hungry birds by living and dying in the shape of a flower," virtually every word—escape, eyes, hungry, birds, living, dying, flower—resonates with ideas and images that recur in every Hitchcock film. Flowers, eyes, and birds, in particular, are quintessential Hitchcock motifs or signatures. And they resonate with each other; for example, *Vertigo* links flowers and eyes, as we have seen; in *The Birds*, the horrifying image of Lydia's neighbor's bloody eye socket links eyes and birds.

Taken as a metaphor for *Marnie*, the fattid bug "flower" suggests that if we look closely at the film—as we are doing—we will find its hundreds of "petals" to be shots representing individual moments, each a vulnerable creature, metaphorically speaking, a being that strives to exist, to become what it is capable of being. Each is possessed of the universal instinct to protect itself. And each is possessed of the more specialized instinct to protect itself by joining with others of its kind to mask its nature by collectively taking on the look of a beautiful flower. When we first encounter *Marnie*, we see it from a "bird's eye" perspective, as it were. Those viewers who see the film with the eyes of "hungry birds" are deceived; having no appetite for flowers, they see no reason to look any closer. Only those who find this

flower-that-is-no-real-flower irresistibly attractive are moved to look more closely. What *Marnie* is designed to mask, it is also designed to move us to unmask. To what end?

If *Marnie* were a whodunit, the climactic revelation that Marnie's mother had been a prostitute, and that as a child Marnie had killed one of her johns, would be the solution to the mystery that was the film's raison d'être. To be sure, *Marnie*'s flashback is a profound and moving sequence, brilliantly conceived and executed, but it is not privileged over other sequences. If *Marnie* is a train of "moods of faces and motions and settings," every moment captures and casts a singular mood. Every moment of *Marnie* is singular. Every moment is beautiful. Film achieves its particular poetry, as Cavell suggests, when it achieves the perception that "every motion and station, in particular every human posture and gesture, however glancing, has its poetry, or you may say its lucidity." Emerson writes in "The Poet" that "it is not metres, but a metre-making argument, that makes a poem— a thought so passionate and alive, that, like the spirit of a plant or an animal, it has an architecture of its own, and adorns nature with a new thing" (450). In *Marnie* Hitchcock's art of pure cinema becomes an art of pure poetry.

No less than an Emerson essay, *Marnie* is designed to call forth, in those moved to respond to its call, an experience in which we "find the journey's end in every step of the road."[11] It would be only a slight exaggeration to say that the events that unfold in the "flashback" are the film's MacGuffin. Its revelation of what happened to Marnie in the past is central to making the screenplay's Marnie the character she is. But it is not in the same way central to making the film's Marnie, at every moment the camera relates to her, the beautiful creation of the art of pure cinema that she is. In Hitchcock's film, as opposed to Jay Presson Allen's screenplay, Marnie's past only participates in creating or revealing Marnie's singularity when the camera makes it present, when it is present to the camera. The "flashback" does not explain what "caused" Marnie to act in the singular ways we witness throughout the film. For it offers no explanation as to what causes her child self to act in the singular ways she does in *this* sequence.

As a child, the "flashback" reveals, Marnie's instinct was already to find herself repelled by the sailor's closeness, to call out in her distress to her mother, to respond to her mother's own call for help by killing the man Marnie believed, wrongly, was killing her mother, to take pleasure in her own act of violence, and to scream in horror and revulsion at the sight of the blood of the man she had killed. The self-knowledge Marnie achieves by reliving this unbearably painful childhood experience is not a matter of

learning what caused her to become the way she is. It is a matter of awakening to the reality that this *is* her past, is *her* past, and that she has now put it past her.

To a degree unprecedented in a Hitchcock film, *Marnie* pays privileged attention to the thoughts and moods of its characters, not to the author's fate or the conditions of Hitchcock's authorship. Or perhaps it is more accurate to say that what is unprecedented in *Marnie* is its commitment to breaking down or transcending that opposition. At every moment, the camera does something to call our attention to the characters' thoughts and feelings and moods. In *Marnie* the camera's relationship to the characters is at every moment so intimate—even, or perhaps especially, when their motivations are inscrutable to us—that all of its revelations of their thoughts and feelings and moods are also revelations about the camera itself.

The camera declares itself at every moment in *Marnie*, declares itself in everything it does, not only when it performs spectacular gestures. This has always been true of Hitchcock thrillers, as the original five readings of *The Murderous Gaze* demonstrate. But in the long new chapter on *Marnie* I wrote for the book's second edition, I demonstrate that in this film it is this fact or condition that is precisely what the camera is declaring whenever it declares itself. One way to put this is to say that to an unprecedented degree Hitchcock identifies with the characters in *Marnie*; their reality is a reflection of his own "inner reality." Paradoxically, another way to put the point is to say that in *Marnie*, again to an unprecedented degree, Hitchcock acknowledges his characters' separateness from him. This is what frees him to love them, and to express his love for them, to a degree that is new for Hitchcock. Does it free him from the fate of killing the things he loves?

Marnie is not a story of unrelieved suffering like *The Wrong Man*. Nor is it a tragedy like *Vertigo*. Indeed, it rivals *North by Northwest* in the pleasures with which the film generously rewards us. Chief among these pleasures are found in the many conversations between Marnie and Mark, or, rather, their one conversation, with many interruptions, that runs the length of the film. In this ongoing conversation Marnie fully holds her own with Mark—and, miraculously, the inexperienced Tippi Hedren fully holds her own with the charming and charismatic Sean Connery. Indeed, Marnie gets more than her share of the wittiest lines. For example, when Mark, his voice dripping sarcasm, asks her where she learned to speak and behave as if she were born into wealth and privilege, as he was, Marnie replies, with perfect comic timing, but also genuine anger at society's unjustness, "From my betters." Marnie's wittiest line in the film occurs when at the beginning

of the free association "game" she cuts him short by saying, "You Freud, me Jane?"

Regrettably, Hitchcock went along with Truffaut, in their book-length interview, by speaking mockingly of dialogue sequences, disparaging "talking heads" as uncinematic. In truth, though, as *Marnie* demonstrates as convincingly as *Psycho*, no director has ever known better than Hitchcock how to turn great conversation into great cinema. When heads talk like Mark and Marnie (that is, like Sean Connery and Tippi Hedren, speaking lines written by Jay Presson Allen, as directed by Alfred Hitchcock, photographed by Robert Burks, edited by George Tomasini, and accompanied by music composed by Bernard Herrmann), and when the camera attends to their conversation with the kind and degree of attention necessary to follow their thoughts and capture their moods, the result is a triumph of "pure cinema." Without this triumph the film would not fully earn its ending, which is worthy of the great remarriage comedies Cavell writes about. For we have no doubt, from the quality of the conversation each can have with no one else, that however grave her problems, or the conflicts between them, Mark has met his match in Marnie, and Marnie has met her match in Mark.

Marnie has become a touchstone. I find Robin Wood's judgment to be only slightly hyperbolic when he says, in the documentary on the making of the film that is included with the DVD release, "If you don't like *Marnie*, you don't really like Hitchcock. I would go further than that and say if you don't love *Marnie*, you don't really love cinema." *Marnie* is, for reasons Wood understood, one of Hitchcock's greatest achievements (as Wood's two essays on *Marnie*, written almost forty years apart, are among his greatest achievements as a film critic).[12] But I would slightly revise his formulation to say that if you don't really love cinema, you cannot love *Marnie*; you cannot know what makes the film so singular, so beautiful. But even if you do love cinema, *Marnie* can be difficult to like, much less love. Even more than *The Birds*, *Marnie* is infused with a deep sense of loss, an urgency, an emotional directness, but ultimately an affirmation, that sets it apart from other Hitchcock films. To fully appreciate the film's beauty, we have to open ourselves to the pain, as well as the pleasure, it calls upon us to feel. We have to trust the film, as I have learned to do—as *Marnie* has taught me to do.

These days, unfortunately, even lovers of cinema find themselves aggressively prodded to distrust the film. *Marnie*'s reputation has been tarnished by the oft-repeated assertion that the film contains an offensive

rape sequence that definitively exposes Hitchcock as an arch misogynist and by Donald Spoto's claim, which many take to be proof positive that Hitchcock was an egregious sexist, that near the end of production there was an incident in Tippi Hedren's trailer in which the director said or did something inappropriate to his star.[13] We will never really know what—if anything—actually happened in that trailer between director and star. And it is none of our business.[14] According to Spoto, this incident, and the anger and bitterness it caused, led Hitchcock to lose interest in the film, and this—along with the supposed fact that his once advanced techniques had become antiquated—led to the unreal-looking process shots and painted backdrop that many take to be grievous flaws. Production and postproduction records make clear, however, that Hitchcock never stopped being actively engaged in the film.[15] In any case close attention to the film itself makes clear that *Marnie* set new standards even for Hitchcock in its precise and masterful use of a wide range of cinematic techniques, including devices new to him, such as the handheld camera he used in the climactic "flashback" sequence. Furthermore, the much-maligned process shots and backdrops can plausibly be seen as strengths, not weaknesses, of the film.

In the fox hunt, for example, there are traveling matte shots in which there is a noticeable disjunction between foreground and background, as if they were separate worlds.

Did Hitchcock intend this as a means of conveying, expressively, that Marnie is more dreaming this ride than living it—the sense that her inner reality, the ecstasy of freedom expressed by her face, is more real to her than what philosophers call the "external world"? I don't know a good reason to doubt this, especially because Hitchcock's use of this strategy culminates, in this section of the film, with the shot of Marnie's gun firing, in sharp focus in the foreground, and Forio, her beloved horse, out of focus in the background, suddenly convulsing and then lying still.

I do not believe, however, that Hitchcock intended for us to be conscious that the visual disjunction between foreground and background is caused by a special effect. If the juxtaposition of "inner" and "outer" realities simply appears fake, a mere contrivance, that would be a flaw in the film. These shots don't strike me that way. Evidently, for some viewers they do. But why judge this to be a flaw so grievous that it justifies denigrating or dismissing *Marnie* as a whole, rather than a rare failed experiment in a film that features so many daring experiments that succeed beyond expectation—unless one were looking for an excuse, a cover story, to rationalize not being open to the disturbing emotions *Marnie* calls upon us to feel?

Figure 15.7

Figure 15.8

The so-called rape sequence, one of the most disturbing in *Marnie*, is preceded by a passage, painful in its own right, that takes place the first night of the cruise. When Mark finally goads Marnie into emerging from the bathroom, he strokes her face, ready to kiss it, when she suddenly pulls away, shouting, "I can't! I can't! I can't!" Mark responds to her earnest "If you touch me again, I'll die!"—a line altered from the screenplay's "If you touch me again, I'll kill you!"—by promising not to touch her. "I'll feel the

Figure 15.9

same way tomorrow, and the day after tomorrow, and the day after that," she says, her gesture of turning her face away from Mark underscoring the ambiguity as to whether this is a prediction or a vow.

"Let's try at least to be kind to each other," says Mark. "Kind!" she retorts, almost choking on the word. "If that's too much, I'll be kind to you, and you'll be polite to me." "You won't!" "I won't," he echoes her, as she had echoed him. Without irony, he adds, "I give you my word." Marking his words, she looks at him in silence. "Well, let's try and get some rest. How about it? You, in your little bed over there. Me, light years away, in mine here." Recognizing that this sarcasm is not a disavowal of his promise, she says, "Thank you." Mark quietly goes to his room, and there is a cut to an eloquent long shot of Marnie, melancholy in her solitude, then a slow fade to black.

The alleged rape scene takes place after three brief sequences—the third contains the "fattid bug" speech—that serve to indicate that Mark and Marnie have been on the ship for so many days—and nights—that their tempers are frayed.

Evan Hunter, who had written the screenplay for *The Birds* and whom Hitchcock had hired to adapt Winston Graham's novel, felt that this scene, as Hitchcock wanted him to write it, was offensive. When he wrote an alternative scene for Hitchcock's consideration, he found himself peremptorily fired and replaced (thank God!) by Jay Presson Allen. The scene she wrote in accordance with Hitchcock's wishes proves Hunter wrong. But

the fact that so many critics believe that Mark's behavior is unforgivable reveals the magnitude of the risk that Hitchcock felt compelled to take for the sake of his art.

The sequence begins with Mark peering over the top of a book (*Animals of the Seashore*) he is ostensibly reading (just as Marnie had ostensibly been typing when she was really watching Susan at the safe), looking through the open door to the bedroom. Marnie, in a nightgown, appears at the doorway. She says "I'll close the door, if you don't mind. The light bothers me."

Robin Wood, with his customary insightfulness, points out that if Marnie simply wanted the door closed, she would have closed it herself without saying anything to Mark.[16] By saying "if you don't mind," while knowing full well that he does mind, she is provoking him to respond the way she must know, at least unconsciously, that he will. "Hm, what's that, dear?" Mark replies with mock politeness, picking up but not drinking from what seems to be a tall glass of whiskey and water on the table beside him. "The light? Oh, yes, of course. You've been an absolute darling about my sitting up reading so late. I'm boning up"—the pun intended?—"on marine life since entomology doesn't seem to be your subject, and I'm eager to find a subject, Marnie, any subject."

No doubt Mark is frustrated sexually. But he is also frustrated by Marnie's continuing rejection of his efforts to engage her in conversation. We might assume that it is only a particular conversation, a conversation about a particular subject—the subject of her rejection of him sexually—that he really desires. But what he says is that he is eager for a conversation on any subject. Does he say this only because he believes that any conversation would be a step in the direction of their having the particular conversation he desires, a conversation that might lead to overcoming the obstacle of whatever it was that had "happened" to her to cause her to resist him? Or is conversation, like sex, something he desires in and of itself?

In any case, when Marnie responds to Mark's sarcastic words, her conscious intent is to thwart, not satisfy, his desire for conversation. Again, she provokes him. "All right. Here's a subject. How long? How long do we have to stay on this boat, this trip? How long before we can go back?" Mark responds to this provocation with an anger and bitterness beyond anything we have witnessed before. "Why, Mrs. Rutland, can you be suggesting that these halcyon honeymoon days and nights, just the two of us alone together . . . should ever end?" To this, Marnie responds by turning her back, withdrawing into the bedroom, and slamming the door behind her. For a moment Mark stares at the closed door. Then he leaps to his feet and barges in.

That Marnie is deliberately frustrating Mark's desire for conversation doesn't mean she has no desire for it. In the years between his first take on *Marnie* and his second, Wood—goaded, he tells us in *Hitchcock's Films Revisited*, by V. F. Perkins's provocative question "Does Mark cure Marnie?"—had come to believe, as I believe, that throughout the film Marnie wishes, albeit unconsciously, to be "cured" and gradually becomes conscious of harboring such a wish.[17] Like Dexter in *The Philadelphia Story*, Mark plays an essential role in the transformation of the woman he loves, but the impetus has to come—and does come—from Marnie. At crucial moments, Mark believes he is leading Marnie, when she is really—if unconsciously—leading him. In the pivotal "free association" scene, for example, it is Marnie, not Mark, who takes the initiative. It is she who provokes him to play the "game" in the first place, then provokes him to push her to the point of breaking down and crying out to God for somebody to help her. She is too smart not to have known, unconsciously, that the "game" would inevitably end this way. The question of consciousness aside, there are thus exact parallels between Marnie's (unconscious) plan and Judy's (conscious) plan, as I have come to understand it. The chapter on *Marnie* in the second edition of *The Murderous Gaze* shows in detail how the film tracks the stages by which Marnie's unconscious wish to be cured emerges into consciousness, preparing her for the momentous step of letting her old self die so that a new self can be born. As I also show, *Marnie* tracks the stages by which Mark comes to recognize, and accept, that he is not—cannot be—in control of this process, that his powers are limited.

Once inside the bedroom, Mark stands at a distance from Marnie, his half of the frame in shadow.

"If you don't mind, I'd like to go to bed," Marnie says, her choice of words (perhaps unconsciously) provocative. "I've told you the light from the sitting room bothers me." "We certainly can't have anything bothering you, can we?" Saying this, Mark angrily slams the door, casting the entire frame in shadow. With a calm forcefulness that belies her inner turmoil, Marnie says, "If you don't want to go to bed, please get out." The camera begins moving in, excluding her from the frame, until it isolates Mark in a medium close-up as he says, menacingly, "But I do want to go to bed, Marnie. I very much want to go to bed." Framed in eminently Hitchcockian fashion with a lamp beside her, Marnie cries out "No!" (in what the flashback will reveal, in retrospect, to be her "little girl" voice). She is still staring at Mark, unhinged by what she sees in his eyes, when we cut to her point of view of his grimly determined face. Mark's face jerks slightly toward the

Figure 15.10

camera, and we cut back to Marnie. His hands intrude into her frame and pull her nightgown down. There is a cut from her shocked face to her gown falling to the floor past her now bare legs. We cut back to Marnie's face, wide-eyed and expressionless, then back to Mark.

Because the camera is on Marnie, not on Mark, when her naked body is exposed to his gaze, what this last shot discloses is not his immediate reaction. By the time the camera returns to him, he is looking into her eyes, not at her body. He is mortified by the shattered look his action has caused. For Mark this is a moment of awakening comparable to Roger's when he learns that Eve is a double agent. He says, "I'm sorry, Marnie," acknowledging that he has broken his promise to be kind, as she had predicted he would. Never again will he be unkind to her. Never again will she say no to him—until he demands, out of kindness, that she confront her mother.

We cut to a shot that frames Mark and Marnie in profile. Within this frame, Tippi Hedren's profile is haloed, as we might put it, by the circular porthole through which we see the blackness of the night. Between Mark and Marnie, in this frame, is a curtain that forms a Hitchcockian ////. Mark takes off his robe and gently covers Marnie's bare shoulders. Cradling her head in his hands, he brings her face closer to his, as the camera moves in. His lips meet hers in a kiss. Marnie does not resist. And yet a cut reveals— a revelation hidden from Mark—that her eyes are wide open and staring fixedly in the direction of the camera.

Figure 15.11

Surely, if at any point Marnie were again to say, "No," Mark would not go on. That she offers no resistance gives him grounds for believing that after his sincere apology she now trusts him, and gives us grounds for believing, as he does, that he is making love to her, not raping her. As Hitchcock films this moment, Marnie even seems to move on her own accord to the bed, although backward, as if in a trance. Mark pulls away from her enough for a shot from his point of view of Marnie's face, never more beautiful, to fill the frame—except for the background, which is out of focus, but legible enough for us to understand that he is gently laying her down

Figure 15.12

on the bed. We cut to an extreme close-up of Mark, his face half in shadow so dark we see only one of his staring eyes.

This shot of Mark's hypnotic stare is taken from Marnie's perspective, but because in the previous shot she had appeared entranced, turned inward, it feels as if what we are now viewing is what she is imagining, not what she is literally seeing. When we cut back to Marnie, her face, too, is half in shadow. As Allen's shooting script puts it, "Her face is a blank, staring blindly at the ceiling above her. It is completely exposed to us, and on it is written . . . nothing. There is no flicker of expression, of emotion."

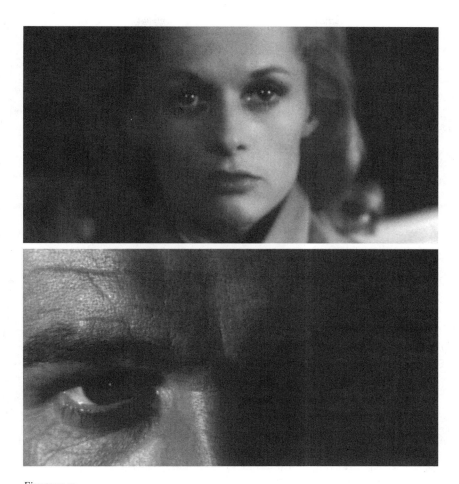

Figure 15.13

This language makes clear that Allen believed, as I do, that Mark thinks he is making love to Marnie, not raping her. At the same time, Allen believed that Marnie thinks she is being raped, as her shooting script implies in its assertion that "fear and revulsion" are "manifest in her frozen face." Surely, however, if "nothing" is "written" on Marnie's frozen face, her face does not "manifest" anything. It is possible to view her face as frozen with fear—that is, to project fear onto its blankness. But revulsion implies an impulse to recoil. We can project revulsion onto a blank, frozen face only if we interpret its immobility as a symptom of an inner conflict, a standoff between repulsion and attraction.

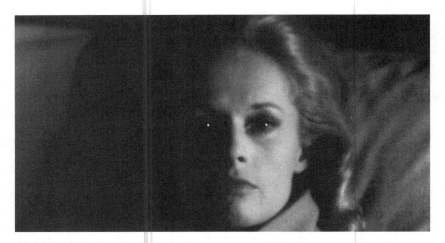

Figure 15.14

One might think a screenwriter's view is definitive on a matter like this, but that is not the case. Allen intended Marnie's state of mind to be un-ambiguous. But her intention—and even Hitchcock's—only matters inso-far as the film itself realizes it. All that really counts in this case is what the camera reveals in Marnie's—that is, Tippi Hedren's—face at this moment. And her face, like Mark's, is half in light, half in shadow. At every moment of her relationship with the camera, the film's Marnie, divided against her-self, is deeper and more ambiguous than the woman the screenplay char-acterizes so insightfully. The screenwriter's conviction that Tippi Hedren was miscast—too old, too icy, not vulnerable enough—is proof positive that the film's Marnie and the screenplay's Marnie are positively not the same dame.[18]

The sequence ends, mysteriously, with the camera panning from Mar-nie's face, past a curtain that fills the frame with the //// that in Hitchcock films is associated with the movie screen, to a porthole as circular as the camera lens. This circular porthole forms a frame-within-the-frame within which we see the sky and the calm sea—a vision as still and timeless as the sleep of death. The camera holds on this symbolically charged framing as the image fades out.

Why am I defending Mark? Because I take him at his word when he says, just before proposing to Marnie, "It seems to be my misfortune to have fallen in love with a thief and a liar." He is declaring his love. To be sure, he is declaring his love in Sean Connery's insouciant, almost sarcastic, manner.

Figure 15.15

But Marnie acknowledges that he means what he says when she responds, "Oh Mark, if you love me you'll let me go." When she adds, "I'm not like other people. I know what I am," he replies, "I doubt that you do, Marnie. In any event, we'll just have to deal with whatever it is that you are." Then he adds, "Whatever you are, I love you. It's horrible, I know, but I do love you." "You don't love me," she retorts with rising anger, not so much doubting his sincerity as frustrated by his lack of self-knowledge: "I'm just something you've caught."

Mark may seem to be pleading guilty to Marnie's charge when he replies, at once amused by the absurd situation and moved by the depth of

Marnie's feeling and his own, "That's right. You are. And I've caught something really wild this time, haven't I? I've trapped you and caught you, and by God I'm going to keep you!" But with these words Mark is reaffirming, not disavowing, his love, I believe. He is "taking on the responsibility" for her, as he puts it, because he loves her. The film asks us to believe that Mark already knows he loves Marnie when he proposes marriage in the least conventionally romantic proposal scene in the history of cinema (if not of the human race). But Mark's understanding of what his love for Marnie entails—what "love" means, what the responsibility is that he is taking on, and what its limits are—deepens as *Marnie* unfolds. It will ultimately bring Mark to the point at which, by knocking on the wall of her mother's living room, he opens the floodgates that release the memory Marnie had been repressing at a terrible psychic cost. Once Marnie's memory begins to flood in, Mark understands, and accepts, that all he should do, all he can do, is to act as a midwife, to direct by "indirection," by asking questions whenever needed to prod her to describe what she is seeing and hearing. Over that scene, which takes place at once in the past and the present, at once inside and outside Marnie's mind, Mark has no control.

"By the time you go into that trauma in Baltimore," Hitchcock said to his crew, "I don't want any normality to intrude anywhere."[19] At critical moments throughout the film, Marnie's experience uncannily foreshadows the climactic flashback. Thus it is perfectly natural that the flashback's "nonnormality" should be foreshadowed, visually, as it is in the film's remarkable opening and, as I show in the new *Murderous Gaze* chapter, at many other points in the film. And this brings us to the much-maligned backdrop. Both the first and last times we see it, the view is expansive, and the camera is shooting from an elevated position.

Did Hitchcock intend this backdrop to appear real? I believe so. Did he intend it also to appear unreal? I believe that as well. That does not mean he intended for us to be conscious that the backdrop is a backdrop. Surely, he didn't want it simply to look fake. When the footage came back from the laboratory, Robert Boyle, Hitchcock's production designer for *North by Northwest* and *The Birds* as well as for *Marnie*, was concerned that the painted backdrop didn't look real. When he assured Hitchcock that it could be fixed by being textured, Hitchcock responded that he thought that wasn't necessary. Boyle's understanding of this response, as expressed many years later, is that if the backdrop looked like a backdrop, that was a trivial problem of little importance to Hitchcock, who was concerned with "deeper matters."[20] Boyle's interpretation seems eminently reasonable.

Figure 15.16

Figure 15.17

And yet, to Hitchcock, the relationship of reality and unreality is one of those "deeper matters."

When Mark drags a reluctant Marnie to her mother's house in Baltimore, we cut directly from the two in the car riding on the open highway to the front of the house. Rain is falling. Then we cut to the street, with the freighter looming large at the end of it. Here, the view is anything but expansive.

Lit intermittently by flashes of lightning, the street now looks even more unreal. More precisely, there is a disjunction, visually, between the real-looking street in the foreground and the looming freighter, harbor, and threatening sky in the background, which do not look as if they exist within real space. To me the background looks less like the painted backdrop it really is than like reality reduced to an image projected on a flat screen—which it also really is. The fact that this is another Hitchcock tunnel shot, that it is designed to draw our eyes into the depth of the frame, underscores our impression that in this frame depth is an illusion.

Its play with depth and flatness, with presence and absence, with reality and unreality, links this shot to the film's opening shot of Marnie on the platform. The two shots are bookends between which the body of the film is contained. In the opening shot we see only Marnie. In the present shot we see no one; the disjunction between foreground and background is not a projection of Marnie's "inner reality." No one within the projected world is dreaming this moment. This is our dream, or Hitchcock's dream, or the camera's dream. In the opening shot Marnie's act of walking away from the stationary camera enables the worldhood of the world to be revealed, to reveal itself. In the present shot, there is no one to perform such an act. The camera itself, moving of its own accord, transforms a semblance of unreality into a semblance of reality by tilting down to reveal Mark's car in front of the steps leading up to Bernice's front door. He is trying to drag a reluctant Marnie, not yet visible, out of the front seat.

When Mark demands that Bernice tell Marnie the truth—which he believes he knows—about her "bad accident," she rebukes him by saying that she is the only person who knows what really happened. When he insists that Bernice has to help her daughter remember the past so that she can stop being haunted by it, Bernice becomes hysterical. Screeching, "You get out of my house!" she rushes at Mark with flailing fists. "You get out!" He has no choice but to forcefully hold her off. Over her mother's screams we cut to Marnie, who, as the script puts it, "watches this grotesque struggle with widening eyes that suddenly become fixed, dilated." In the child's voice we have heard before, Marnie cries out, "You let my mama go! You hear? You let my mama go! You're hurting my mama!"

At the sound of her voice, Bernice and Mark cease their struggle and stare at Marnie. Mark asks her directly, "Who am I, Marnie? Why should I want to hurt your mama?" "You' re one of them. One of them in the white suits." Framed in close-up, Bernice steps forward and shouts, "Shut up, Marnie!" Mark, in close-up, cuts her off. "No! Remember, Marnie . . . " We

Figure 15.18

cut again to Bernice, her face an anguished mask, as Mark continues excitedly, " . . . how it all was . . . " We cut back to Mark. " . . . The white suits! Remember?"

Mark looks at Marnie with an expectant smile. When we cut to her, she seems about to speak. Then she loses the thread. The camera returns to Mark. His face falls. But disappointment gives way to determination. When we cut back to Marnie, she is staring vacantly. And Mark's hand, closed in a fist, is present with her in the frame. The hand taps three times on the wall.

The camera is on Mark as he asks, "What does the tapping mean, Marnie? . . . " We cut back to Marnie. " . . . Why does it make you cry?" The camera moves in to a very tight close-up as she says, "It means they want in." Still not looking at Mark, her gaze turned inward, she continues: "Them in their white suits. Mama comes and gets me out of bed. I don't like to get out of bed."

Who is speaking these words? Although we have on occasion heard this child's voice emanating from Marnie, it is not her "normal" voice. Ordinarily, she speaks in an adult woman's voice—a cultivated voice wiped clean of all traces of her mother's "poor white trash" southern accent, a voice Marnie must have cultivated with precisely that intention. Who is the "she" who re-created herself, at least outwardly, as the woman who speaks in this cultivated voice? This "she" is the little girl Marnie has never stopped being—the child who seems to recognize no difference between Mark and "them in their white suits" yet who answers the questions he poses to her,

and thus really does see him as other than one of "them." Insofar as Marnie is this little girl, her "normal" voice is not really normal; it is the voice of a character the child has created, a role she has made her own, a role she plays virtually all her waking hours, a role she isn't conscious of being a role. Until Marnie acknowledges that she is—that she has become—the woman she has only been pretending to be, until this woman becomes real, her "normal" voice isn't Marnie's real voice. It is closer to the truth to say that her real voice, her voice when she isn't acting, is that little girl's voice.

In *Vertigo*, as we have seen, when "Judy" in her voice-over expresses the wish for Scottie to love her "as she is, for herself," she cannot be wishing for him to love the "Judy" who is only one of her roles, a role that so perfectly denies her "inner Madeleine" that she had to have created it for that purpose. Her wish must be for him to love the actress she really is. The woman we know as "Judy" is always playing a character, always playing a role she has made her own. We never see her "as she is, for herself," because there is nothing she is "for herself." But when Marnie speaks in her little girl voice, she is not acting. The child who doesn't like to get out of bed, who wishes to go back to sleep, perchance to dream, is who Marnie is "for herself." We can thus say that if she is to walk in the direction of her unattained but attainable self, it is not the adult Marnie who must change; that woman does not yet really exist. She who must change is the child Marnie still is. This little girl must awaken—awaken to the reality that she has become the woman she outwardly appears to be. Only then can this woman—Marnie's new self—really exist within the world.

For a long moment, Marnie falls silent as her eyes become fixed. When we cut to Marnie's point of view, we see nothing special—only a corner of the living room. Against the wall is a green sofa, one of its throw pillows centered in the frame. There is a lamp and a radiator to the right of the sofa. As the camera continues to stare fixedly, this nondescript view begins to change. This new view is, first of all, yet another tunnel shot. The walls on both sides, the ceiling, and the rug on the floor of an almost bare living room all converge in an exaggerated way toward the vanishing point to create what the shooting script calls a "long perspective"—a space that seems at once exaggeratedly deep, like all tunnel shots, but also exaggeratedly flat. In the center of the frame, where the pillow had been, is a region, the shape of an old-fashioned cameo picture frame, in which everything is slightly—but noticeably—lighter in color than what is outside it. The entire image is faded and almost monochrome, like an old sepia-tinted photograph, an association that enhances our sense that we are looking into the past.

Figure 15.19

Near the far end of the room, framed in the "cameo," are a young, attractive Bernice, her back to the camera, and (this comes as no surprise) a man dressed in white, evidently a sailor (Bruce Dern, a veteran of *Alfred Hitchcock Presents*, in his first movie role), who is standing in front of an open door, blocking our view of the room behind him. As the sailor moves to the edge of the "cameo," we see, in the room beyond the door, the foot of

a bed. Young Bernice goes into that room and, saying, "Come on, Marnie, get up," drags the child out of bed.

All this time, the shot's perspective has been continuously shifting. Using a variant of the technique developed for *Vertigo* of simultaneously zooming in, thus changing the focal length, and moving the camera out, the background looms larger, the "cameo" expanding almost to the edges of the frame. The space appears to flatten, to lose its depth—making the foreground appear as distant as the background, not making the background seem closer. We do not have the sense of a disjunction between foreground and background, as in the shots of the Baltimore street, with its painted backdrop, or the traveling matte shots of Marnie riding. The effect here is the opposite: foreground and background virtually fuse. We do sense a disjunction, but it is between ourselves and the projected world, the world we are viewing through the eye of a camera that remains fixed in place. Or in no place.

Our impression, indeed, is that the camera cannot move within the world it is framing, because no matter how close what we are viewing may appear, the camera is looking in from outside that world. It is as if there can be no place for the camera within this flattened, depthless frame, because the frame contains no real space, is no real space. What we are viewing morphs from a shot that presents Marnie's literal point of view, as she is staring in the present in the direction of her mother's sofa, with the camera in her real position, into a shot that presents—what? Is this a scene she is only conjuring in her imagination? Or is it somewhere, somehow, really taking place? To Marnie, surely, it is really happening. It is happening now. But how can this be, if this is the past, not the present? And how can this be reality to Marnie if she is viewing it from the outside, where the camera is? Then again, is reality ever fully real to Marnie, who lives her life as if she were only dreaming it?

Can we say that the projected world here is not a reality the camera is capturing but a reality the camera (in league with the projector) is creating—making it real by projecting it, that is, by projecting Marnie's inner reality, rendering the invisible visible? Marnie stared at the sofa in her mother's living room for what seemed an eternity before what is "really" present began morphing into the past. Has she conjured this past into being? (Strutt called her a "little witch." Is she one?) Does she will the past to appear in the present, or does she find herself subjected to a will not her own? We cannot say. It is clear, though, that once the metamorphosis happens—once it becomes the past that is present within the frame—the

genie cannot be put back in the bottle. Marnie has no more power than we do—than we ever do when we are viewing a film, or when we are remembering the past—to alter the events that are unfolding. It is also clear that once Mark sets the machinery in motion by tapping three times on the wall, he has no role to play within these events. And it is clear, as I have said, that he accepts this condition, which in any case he is powerless to change. Mark's powers are limited. So are ours. So are Hitchcock's.

Bernice pulls little Marnie into the living room, lays her on a sofa, tucks her in, and, saying, "You go on back to sleep, Sugarpop," kisses her. While we are viewing this, the sailor is beginning to undress. "Bernice," he calls to her impatiently. She leaves her child's side, leads him into the bedroom, and closes the door behind them. All this the camera has framed from its fixed position.

A split second before the door completely shuts, we cut to Marnie in the "present." I put the word in quotes here, because this sequence calls into question whether in the medium of film there is a clear distinction between past and present. As the sequence develops, both the "past" and the "present" become equally present to Marnie, present in the same way (and also absent in the same way). Evidently, Marnie has been deeply absorbed in the scene we have been watching. Just when we expect to hear the closing door hit the jamb, we hear, instead, a deafening clap of thunder. Marnie's eyes widen in terror, and she recoils violently, flattening herself against the wall. Is her terror caused by the thunder in the "present" or by the thunder in the "past," its deafening sound coinciding with the "missing" sound of the closing door, which to the little girl signifies her mother's abandoning her for the man in the white suit? We cannot say.

Astonishingly, we now cut to little Marnie, her golden hair facing the camera. With a scream, little Marnie, who had been sitting up in bed, buries her face in the pillow. As the camera reframes to follow her abrupt movement, then on its own pans jerkily to the left until it excludes her altogether and frames nothing but a section of the closed bedroom door, it becomes clear that it has broken away from its fixed position. The camera has breached the barrier separating it from the world of the "past" and now finds itself inside that world, like the projectionist Buster Keaton plays in *Sherlock Jr.*, who jumps "through" the screen into the world of the movie he is projecting. The terrifying thunderclap straddles the two shots, the two spaces, the two times, the two worlds. The camera is now not only located within the little girl's world but is also handheld and fitted with a telephoto lens that narrows its field of vision.

That the camera is now inside the "past" world, free to move within it and attuned, responsive, to the experience of the terrified child, suggests that Marnie in the "present" is no longer merely imagining this scene or viewing it from the outside, as we are. She is living it. This is no memory. This is no dream. Marnie in the "present" is the little girl living this scene. Is the presentness of the past an illusion? On film the "past" is no less real—and no less unreal—than the "present."

For Marnie, the "past" had literally been a dreamworld—a "private island," if one she longed to escape from, not escape to. Now, this "private island" has become reality to her. As long as the camera was filming this "private island" from Marnie's literal point of view outside it, her perspective coincided with ours. Now that her experience coincides with that of the little girl within that world, our perspectives no longer coincide. We are viewing Marnie. Marnie is not viewing herself. She is living within the world we are viewing. This means that the camera no longer affords us direct access to Marnie's experience. It also means that Marnie no longer has access to the views the camera presents to us. Who or what, then, is the source of these views? Can they be trusted?

When this flashback culminates in little Marnie's killing the sailor by hitting him repeatedly with a poker, Marnie, in the "present," tilts her head and says, exactly as she had after she shot her beloved Forio to put an end to the injured animal's suffering (and exactly as Hitchcock did when he returned to the screen at the end of "Breakdown" after we had suffered the sponsor's message), "There, now" in a voice the shooting script describes as "dreamy, soft, satisfied." When Marnie says this to her dead horse, to his departing soul, her voice is "dreamy, soft, satisfied" because she has succeeded in ending Forio's suffering and sending him off to greener pastures. After Marnie kills the sailor, by contrast, she is satisfied because she wanted to kill this man—this man she didn't like, this man she didn't want to kiss her, who smelled funny, who she believed was hurting her mother. The only way I can make sense of this moment in the film is to hear Marnie as speaking to her own departing soul—as if when she killed the sailor, her own self also died, and she is reassuring herself that death is for the best. When Marnie relives this act of killing, experiences it as if for the first time, and acknowledges it as her own, her innocence dies, the way in *Lifeboat* the Americans' innocence dies when they kill Willi. Marnie says, "There, now," in the voice of the child she no longer is. She says it in a "dreamy, soft, satisfied" voice. But that dreamy mood survives only a moment longer. Then she sees the blood.

Figure 15.20

We cut to young Bernice, emitting the scream she had been stifling; to the child Marnie, who screams as well; to the bloody face of the dead sailor; then to his shirt, with dark red lines, forming a *////*, running up and down the larger red stain, glistening with fresh blood. The camera tilts up until the frame is filled with the red of the blood. Finally, there is a slow dissolve to Marnie in the "present," her scream mingling with the others until they all subside into silence.

When the frame, awash with blood, dissolves into Marnie's face staring with horror in the direction of the camera, is she seeing what Judy sees at the end of *Vertigo* when the shadowy figure, emerging from the blackness,

so frightens her that she steps back and falls, or jumps, to her death? Is she seeing what Lydia's friend sees before his eyes are pecked out? Is she seeing what we see, at the end of *Psycho*, when the death's head appears superimposed over Norman Bates's grinning face?

Mark says to Marnie, "It's all over. You're all right." But he has not seen what she has seen. When she emerges from her trancelike state, she is changed. Having looked death in the face—the sailor's and her own—Marnie awakens to the true dimension of killing. And it is a woman, not a child, who awakens. A new self is born.

Mark sums up the moral, as he understands it, by saying, "It's time to have a little compassion for yourself." Not a bad moral, as morals go. He adds, "When a child, a child of any age, Marnie, can't get love, it takes what it can get any way it can get it."

After Marnie's final, deeply moving conversation with her mother, we cut to the front of the house. Mark and Marnie are on the stoop outside the door they have just exited. Mark turns on the narrow top step to shut the door. To give him room, Marnie moves a little to her left. These are small movements, but their combined effect is to remove Mark from the frame and replace him with his shadow.

Marnie has moved only a few inches, enough for her position in the frame to change by just a small fraction of its width, but her motion is so quick she seems to scoot across the frame. She stops on a dime the instant we hear the closing door hit the door jamb—the very sound that coincided, in the "flashback," with the deafening thunderclap that precipitated the camera's transition from outside to inside the world of Marnie's past. The way Marnie abruptly halts her movement here that gives this shot a jolting impact. This kinesthetic effect reinforces our impression of the abruptness with which Marnie's attention is drawn to a sight—or vision—that has intruded into her awareness.

The next shot seems to represent Marnie's point of view. Because at the moment of the cut she is framed more in profile than full face, however, it is ambiguous whether what follows represents a reality she is literally seeing or an "inner reality"—no less real, no less unreal—that she is envisioning, or conjuring, in her imagination.

We see four children in the street. Two boys, facing away from the camera, standing motionless, like sentinels, and two girls, facing the camera and looking in its direction. The girl on the left is wearing a white coat. Both girls have their arms and hands outstretched, as if in a posture of supplication or surrender, an association underscored by the fact that the

Figure 15.21

girl on the right is on her knees. The girl on the left, who has been jumping rope, takes one last quick jump and then stands stock still, staring directly at the camera. At the same time, a third girl, with golden hair and a yellow sweater the color of Marnie's handbag from the film's opening shot, enters the center of the frame from below, enhancing the air of unreality. The effect is uncanny, as if she were crossing the barrier separating the projected world from our world. The blond girl bounces a ball to the girl on the right, who catches it in her outstretched hands and then also just stands there, staring at the camera. The blonde, as if sensing that she is being watched, turns and confronts the camera with her gaze. She, too,

Figure 15.22

stands motionless, continuing to stare at the camera—at Marnie. And at us.

Her gaze, like that of the other girls, is certainly not friendly. Nor is it threatening, exactly—as long as its injunction is obeyed to keep out. It is as if Marnie sees these girls as ghosts from her past, not real children in the present—as if they are in their own world, vigilant to keep Marnie—and us—out. On film their world is a "private island" as real, and as unreal, as "reality" itself. Even if she wanted in, Marnie could not enter that world any longer. Nor is their world our world.

Surprisingly, we do not cut to Marnie to witness her reaction but to Mark. At the head of this shot, the camera frames him more in profile than full face, precisely as it had framed Marnie a moment earlier. He has just seen the children we have seen. That they are real does not mean that they are not also projections of Marnie's imagination. Mark now knows Marnie well enough to see them the way she sees them. He slowly turns counterclockwise, the camera panning and moving out in smooth synchronization with his motion until it includes Marnie with Mark in the frame (and with his shadow between them).

Marnie says to Mark, "I don't want to go to jail. I'd rather stay with you." These words may remind us of the epitaph W. C. Fields proposed for his own gravestone: "I would rather be living in Philadelphia." But I hear Marnie's line as ironic, as comic understatement, even though she says it soberly, in full seriousness. She is not really saying to Mark that staying

Figure 15.23

with him in Philadelphia is the lesser of two evils. What she is saying, without literally saying it, is that she wishes to stay with him. Her choice of the word *stay* is significant in that it acknowledges that she already is with him. "I'd rather stay with you" is Marnie's declaration of love, her vow of marriage or remarriage. "Had you, love?"—said with a warm smile as he puts his arm around her—is Mark's.

This is not a real question that Mark is asking but an acknowledgment that Marnie has already given her answer—an answer she now wordlessly confirms, showing that she trusts him to understand what her silence is saying. They both know they have no guarantee that they will live together "happily

Figure 15.24

ever after." But they have achieved the mutual trust and forgiveness, the conversation of equals, apart from which their marriage could not be a relationship worth having. They have given themselves as good a shot at happiness as human beings damaged by life, as in Hitchcock's view we all are, can hope for. Happiness is to be sought here on earth, where night always follows day, but where, in the words of the old bluegrass song, "the darkest hour is just before dawn." (Emerson put the point only slightly differently.)

At this moment we hear the girls chanting the same chant we heard when Marnie first arrived at her mother's house, except that "Mother, mother, I am ill" has become "Send for the doctor, I am ill":

Figure 15.25

> Send for the doctor, I am ill.
> Send for the doctor over the hill.
> Call for the doctor. Call for the nurse.
> Call for the lady with the alligator purse.
> Mumps said the doctor . . .

The chanting continues as Mark and Marnie descend the few steps to the car. The camera, shooting from a position more elevated than theirs, tilts down and pulls back to accommodate their movements. Mark opens the car door. Getting into the car, Marnie drops below the bottom frame line, her golden hair the last we see of her. We hear the car door close as Mark walks around to the driver's side. Just before he, too, slips out of the frame, he briefly looks back in the direction of the girls. Once Mark does pass out of the camera's field of vision, nothing remains in the frame except the closed front door of the house, centered and viewed frontally. The cut to the film's last shot abruptly silences the chanting. All we hear is Bernard Herrmann's sweepingly romantic theme. What we see is a reprise of our first view of the street, the freighter, the harbor, the sky.

The storm has ended. The sky is clear of all but a few wispy gray clouds. This is an expansive view. But this sky is only a painted backdrop. There is an air of unreality to the shot, an unreal flatness, as if we were viewing this world from the outside, the way we had viewed the world of Marnie's past

Figure 15.26

until, with a single clap of thunder, that "past" became the "present," its unreality, reality.

Viewed from this height and distance, the car is tiny as it drives away from the camera toward the end of the street. The girls, even tinier, run into the middle of the street and, with their backs to the camera, watch the couple's car drive off, the way the couples drive off at the end of *Suspicion*, *Notorious*, and *The Birds*. There are no ominous birds in this frame. But neither is there any heartening human presence. The image simply fades to black. Like *The Birds*, *Marnie* dispenses with the conventional "THE END" title. The ending of *The Birds* denies us closure. It implies that nothing

separates the world of Melanie and Mitch from our world, hence that when the film ends, the world—their world, which is our world—goes on. Marnie ends, by contrast, with the sound of a car door closing, Marnie and Mark having already exited the frame and leaving us only with the image of a closed door; and then this final image that insists on the separateness of the film's world from our world. When the image fades to black, it conveys a sense of finality augmented, not diminished, by the absence of a title announcing "THE END." From what place could such an announcement come? Our world goes on. We will not forget the events we viewed within the world of Marnie. But the portal to this "private island" is now closed to us.

Is this a happy ending?

Mark has said to Marnie, "It's all over. You're all right." This is no guarantee that she has been "cured." There is no assertion that Marnie's sleep will never again be troubled by the old nightmare or that she is now willing and able to enjoy passionate sex with Mark the moment they are alone and unobserved. Perhaps she never will. Marnie now knows, as we do, that she once killed another human being, a man who did not deserve to die (although at the time she was a child who thought he did). She knows that she had taken pleasure in killing him. She also knows that this act was her way of heeding her mother's cry for help, as her mother had heeded hers. She knows that she killed because she loved and because she was loved.

I wish to believe—and I do believe—that Marnie has found compassion for herself. I wish to believe—and I do believe—that she knows she is capable of loving Mark; knows she is worthy of his love; knows her mother loves her, and always has. But Marnie also knows that her mother is still unable to express her love. It is beyond Marnie's power to rescue her mother from her private trap. Was Bernice born in hers, the way Norman Bates says he was? Or did she step into it, the way Marion Crane believes she did? Did Bernice walk into her private trap by letting that boy have sex with her in exchange for his sweater? Had she not made that bargain, Marnie wouldn't have been born. And Marnie wouldn't have been reborn had Mark not undertaken to trap her and keep her and train her to trust him.

We come away from *Marnie* feeling that there is no hope for men like Strutt, and little hope for Bernice, for Lil, perhaps for the chanting girls. But we also come away from *Marnie* feeling that there is hope for us. Whether there is hope for our world is another question. Marnie does not need the girls chanting, "Call for the doctor, call for the nurse," to make her mindful of the fact that, although she and Mark can now face a difficult future

together in a hopeful spirit, they live in a world that suffers from a sickness they are powerless to cure.

Hitchcock is a moral artist. At the core of his moral vision is the sad truth that to keep faith with the better angels of our nature, we have to be willing to kill. But we also have to be willing to love. Is this a happier truth? Not if it is also a truth—as Hitchcock was torn for most of his career between wishing to believe, for his art's sake, and wishing to deny, for the sake of humanity—that "each man kills the thing he loves." Along with *Vertigo*'s Scottie, Bernice Edgar is Hitchcock's most devastating example of the element of truth in Oscar Wilde's maxim. But Mark Rutland is Hitchcock's ultimate counterexample—an exception that disproves the rule. At the conclusion of *Marnie*, the film's protagonist, thanks to Mark's help, is changed. Trapped since childhood by her fear that she was fated always to kill the thing she loves, Marnie has finally freed herself from her "private trap," her compulsive need to "clutch at things." She has not escaped from her mortal life, her humanness. At last, she feels, as Tracy Lord puts it at the end of *The Philadelphia Story*, "like a human, like a human being."

I wish to believe that by making *Marnie*, Hitchcock, too, found compassion for himself, that he freed himself from his own private trap—his belief that his art of pure cinema was murderous. I wish to believe that the creation of Marnie made Hitchcock, too, feel like a human being. Hitchcock, too, was changed. And there was no going back.

For Hitchcock personally, however, this proved a pyrrhic victory. *Marnie*'s critical and commercial failure was a catastrophe from which his career never recovered. *Marnie* was to be Hitchcock's last masterpiece.

16

Every Story Has an Ending

Reviewers savaged *Marnie*. As an artist, Hitchcock was never the same again. Never again would he probe so deeply the mysteries of love and the avoidance of love. Never again would he marshal the courage to bring to the screen a woman with whom he identified so profoundly—a woman whose belief that she was not like other people, that she was different in a way that made it impossible for her longing for love ever to be satisfied, touched a raw nerve in Hitchcock himself.

Professionally, *Marnie*'s poor showing at the box office, following the disappointing reception of *The Birds*, put Hitchcock behind the eight ball. "Mary Rose," which he commissioned Jay Presson Allen to adapt from the J. M. Barrie play that had haunted Hitchcock since he saw it as a young man on the London stage, was a project in which he passionately believed. Its theme of a "private island" where we can escape our existence with others in the world resonates deeply with all of Hitchcock's cinema. The world on film lures us with the prospect of being such a place. Had Hitchcock filmed "Mary Rose," it would have been one of his profoundest meditations on the seductive lure of the projected world, on what we hope to gain and what we risk losing by heeding its call. Since her mother, Maureen O'Sullivan, would have been thirty years too old for the part, I fantasize the young Mia Farrow as the childlike Mary Rose, who never visibly ages as everyone in her world grows old. Sadly, however, Universal vetoed the

project, concerned that such a melancholy film would further diminish the box-office value of the Hitchcock brand. No doubt, it would have.

With *Torn Curtain* and *Topaz* the bottom dropped out.

Hitchcock had done some of his most successful work under the aegis of David O. Selznick. It was by at once conforming to and subverting Selznick's dictates that Hitchcock found his own American voice after immigrating to Hollywood from England. That he thrived on that kind of tension is clear from the personal appearances that bookended episodes of *Alfred Hitchcock Presents* in the 1950s. He relished reminding the public that his "sponsors" were tying his hands. At Universal his hands were still tied. But his stake in the company meant that he was now in bed with his "sponsors." Wearing two hats, he couldn't simply dismiss, much less simply mock, Universal's growing worry that Hitchcock's "art of pure cinema," as he had mastered it, was no longer universal (to stoop to the irresistible pun), that he had become incapable of connecting with a changed, and changing, audience.

Hitchcock was becoming an old man. And this was happening at the very moment the youth culture was in ascendancy, the sexual revolution gaining steam, the generation gap widening, the Production Code losing its grip. In the 1950s, *Alfred Hitchcock Presents* was almost alone among network television programs in appealing to the sensibilities of those alienated young people who were marching to rock 'n' roll's different drummers. At a time when a thirtieth birthday meant one was on the wrong side of the generation gap and thus as "out of it" as the Mr. Jones of Bob Dylan's "Ballad of a Thin Man," who had no clue as to what was "happening here," how was Hitchcock, in his mid-sixties, to stay ahead of the curve, or even stay relevant? He must have realized that there was a real and growing gulf separating him even from the new generation of filmmakers who admired his art and aspired to emulate his work.

The stars with whom Hitchcock had collaborated so fruitfully had aged, too. Rod Taylor was fine in *The Birds*, but he was no James Stewart or Cary Grant. Sean Connery was—and is—a great star, and I have belatedly come to recognize that in *Marnie* Tippi Hedren, artistically, fully rewarded the risk Hitchcock took in casting her a second time, even though the making of the film precipitated a rupture in their relationship that was traumatic for both. How different would the last chapter of Hitchcock's career have been if fate—and the citizens of Monaco—had allowed him to make *Marnie* with Grace Kelly and Cary Grant?

Compounding Hitchcock's problems in this period, he lost key members of his creative team. Four months after *Marnie*'s release, his longtime editor George Tomasini died. Robert Burks, who had been director of photography for all of Hitchcock's films, with the exception of *Psycho*, from *Strangers on a Train* to *Marnie*, turned down *Torn Curtain* (according to Robert Boyle, it was because his nerves were shot and he didn't want to let his friend down by not being at his best).[1] Before *Topaz* was shot, Burks, too, was dead. (He and his wife were killed in a fire at their home.) Particularly devastating—Hitchcock had a falling out with Bernard Herrmann during the production of *Torn Curtain* that was as traumatic as his falling out with Tippi Hedren. Years earlier, Herrmann had composed music for *Psycho*'s shower murder, going against Hitchcock's explicit instruction that he wanted only natural sound. When Hitchcock heard those screeching violins, he couldn't help but recognize how greatly they enhanced the murder's impact. And yet he had not simply been wrong to have wanted no music for the sequence. He wished the shower murder to be his ultimate demonstration of the power of the art of pure cinema. But that was not the art to which Herrmann was dedicated. Herrmann swore allegiance to the art he called "melodrama," which restored to music what he felt was its rightful primacy. In the case of *Psycho* Hitchcock allowed Herrmann to prevail, but the incident must have opened his eyes to the fact that his friend, whose genius was as undeniable as his own, did not share his faith in the art to which he had dedicated his life.

Ignoring Universal's galling insistence that *Torn Curtain*'s music be in a style appealing to the youth audience and that it include a potential hit song, Herrmann composed a score in his usual idiom. As if spoiling for a showdown, he again wrote music for a sequence—the killing of the oddly likable Gromek (Wolfgang Kieling) to keep him from informing East German authorities of his discovery that defector Michael Armstrong (Paul Newman) is a Western spy—that Hitchcock wanted accompanied only by natural sound. Hitchcock must have felt that Herrmann had betrayed him. Or perhaps Hitchcock felt compelled to interpret his friend's principled action as a betrayal in order to keep from admitting to himself that by siding with the studio he was betraying his own art. Breaking Herrmann's heart, Hitchcock jettisoned his score and commissioned John Addison—an accomplished composer but hardly Herrmann's equal—to write a new one. With Herrmann's score instead of Addison's, *Torn Curtain* would surely have been a film Hitchcock would have found more satisfying. But

no score could have made the deeply flawed film the critical and commercial success Hitchcock needed.

Torn Curtain's failure was inevitable, if only because Paul Newman and Julie Andrews, cast as scientists, have little chemistry with each other or with Hitchcock's camera. Hitchcock has quipped that he should have paired Andrews—fresh from *The Sound of Music* and *Mary Poppins*—with a "singing scientist."[2] Instead, he had Newman, a gifted actor at an early peak of his stardom, performing as if a sour stomach, not America's security, were paramount in his character's thoughts. Both were major stars who could not possibly have been better at what they did well. That Hitchcock was unwilling or unable to take advantage of the singular qualities that made them stars, or to solve the script problems that Newman in particular felt were impediments to his inhabiting his character, reveals the magnitude of Hitchcock's crisis of confidence.

Topaz has a strong opening, vivid performances in supporting roles by Roscoe Lee Browne and others, and one shot that ranks among Hitchcock's greatest. When Rico Parra (John Vernon), a Castro lieutenant, discovers that Juanita (Karin Dor), his lover, is having an affair with a French agent, he shoots her to death, knowing that she would otherwise be tortured. Cinematographer Jack Hildyard captures Juanita's death in a ravishing overhead shot in which as she falls, her purple dress billows out like a spreading pool of blood, or like a rosebud opening.

But *Topaz* suffers from uncharismatic stars and an unfocused screenplay with an anticlimactic ending. Furthermore, the film's cold war theme was an impediment to winning the hearts and minds of the millions of antiwar youth inclined to view capitalist America as a greater threat to world peace than communist Cuba.

His confidence at a low ebb, Hitchcock sent Truffaut a detailed treatment for a new film he was contemplating, evidently seeking reassurance that it would be worth making. Truffaut couched his comments in respectful language, but Hitchcock must have sensed that his friend was less than enthusiastic. Although it may have been Universal that pulled the plug, I suspect that it was Truffaut's lukewarm response that caused Hitchcock to lose faith in the project.

The treatment was for a film, alternately called "Kaleidoscope" and "Frenzy" (not to be confused with the *Frenzy* that Hitchcock did go on to make), that would have been filled with shocking violence, its impact enhanced by the handheld camera Hitchcock intended to use to create a greater sense of immediacy, and by the daring device of having the film's

Figure 16.1

protagonist be a serial rapist/killer—on the surface, an attractive, confi-
dent man but really "just a little boy who can't cope with life," to quote
Benn Levy, who collaborated closely with Hitchcock on the treatment.[3]
I am not sad that Hitchcock or Universal got cold feet and abandoned the
project. It might have been taken, erroneously, as proof that he was a mi-
sogynist obsessed with violence to women, that he was a vile monster, or—
perhaps worse for his reputation as an artist—that he was himself "just
a little boy who couldn't cope with life."

Hitchcock returned to London, his hometown, to film *Frenzy*. Thanks
to his cast of accomplished British actors and actresses, the film has highly

polished performances. And its screenplay (by Anthony Shaffer, who wrote the hit play *Sleuth* and adapted it for the Joseph Mankiewicz film, released the same year as *Frenzy*) was better written than that of *Torn Curtain* or *Topaz*. For all its humorous touches, however, *Frenzy* preserves much of the shocking brutality of "Kaleidoscope" / "Frenzy." It asserts its contemporaneousness by "pushing the envelope." At the same time, self-conscious echoes of *The Lodger* are ubiquitous in *Frenzy*. It seems to have been Hitchcock's intention to create a film that declares, as we might put it, that it can recognize itself in *The Lodger*. The point wasn't to show that no distance really separated the two films—as if in his lifetime of filmmaking he had merely "scratched and clawed" without "budging an inch." From the place where Hitchcock now found himself, he could discern the path he had blazed, the long road he had walked, on the journey that began with *The Lodger*. His intention was to show that the distance he had traveled was, in part, a difference of perspective. A measure of that distance is the fact that *Frenzy* can recognize itself in *The Lodger*, but *The Lodger* cannot recognize itself in *Frenzy*. Hitchcock's hope, I take it, was that by looking back, *Frenzy* would take a step forward; by closing a circle, it would draw a larger circle.

It didn't work out that way. I have no problem recognizing *Frenzy* in *The Lodger*. But I have a problem recognizing *The Lodger* in *Frenzy*. Most of the time, *Frenzy* feels like an imitation Hitchcock thriller, not a genuine one, because it simply doesn't have the look of a Hitchcock film. Like *Torn Curtain* and *Topaz*, it suffers from the absence of Bernard Herrmann's music. More than *Torn Curtain* or *Topaz*, though, it is diminished by the absence of Robert Burks behind the camera. *Torn Curtain*'s director of photography, John Warren, a veteran of forty-eight episodes of *Alfred Hitchcock Presents* and thirty-three of *The Alfred Hitchcock Hour*, worked closely with Hitchcock to achieve a subdued color scheme that gives the film a distinctive—and effective—look of its own. Jack Hildyard, Hitchcock's cinematographer for *Topaz*, an Englishman with a long and impressive list of credits, proved willing and able to make that film look much as it might have if Robert Burks had shot it. And both *Torn Curtain* and *Topaz* abound in the visual motifs that have always served Hitchcock, at one level, as authorial signatures. But *Frenzy* is virtually devoid of those motifs. And the film's cinematographer—Gilbert Taylor, another Englishman with impressive credits—failed to give the film a distinctive visual style. Shot by shot, most sequences, visually, do not resonate meaningfully with Hitchcock's other films.

There are exceptions. Apart from the darkly hilarious exchanges between Chief Inspector Oxford (Alec McCowen) and his wife (Vivien Merchant), which are played with exquisite comic timing, the strongest—and most Hitchcockian—passages revolve around violence against women. In *Frenzy*'s most grueling sequence Bob Rusk (Barry Foster), another serial rapist/killer, visits Brenda Blaney (Barbara Leigh-Hunt), the ex-wife of the film's protagonist, Richard Blaney (Jon Foster), in the office of the matrimonial agency she runs. She coldly informs him that her agency will not serve a man with his repulsive sexual appetites. He discloses to her that he wants *her*, that she is his kind of woman. Repelled, she becomes frightened as he increasingly loses control. He begins to rape her. When he comes too quickly, he is so angry and frustrated that his voice becomes strangely slurred. To borrow a term from Norman Bates, he is transformed before her eyes—and ours—into a "raving thing." As I wrote in *The Murderous Gaze*:

> In *The Lodger*, murder is invoked but not shown; in *Blackmail*, it takes place behind a curtain; in *Murder!*, *The 39 Steps*, and *Stage Fright*, it is still not shown; in *Psycho*, the murder in the shower is presented in a montage that withholds all views of the knife penetrating flesh; in *Torn Curtain*, with the killing of Gromek, *Blackmail*'s curtain is opened, but murder is still a theatrical scene; in *Topaz*, it is treated poetically (a dying woman's dress, viewed from overhead, billows out like petals as she falls). Only in *Frenzy* is there a full revelation. We see the murder of Mrs. Blaney, in all its horror, from beginning to end, its presentation stripped of theater and poetry, and it is one of the most heartbreaking passages in Hitchcock's work.[4]

Brenda believes that the man who is raping her is not a monster but a pathetic man driven mad by his sexual perversion and impotence. We, too, believe that Rusk cannot help doing this terrible thing, that he, too, is "just a little boy who can't cope with life." Even when he strangles Brenda, we continue to believe this—until he walks to the dead woman's desk, stands for a moment with his back to the camera, picks up the apple that was to be his victim's frugal lunchtime dessert, out of which he had already taken a bite. He takes another hearty bite. When he now turns toward the camera, he seems changed. As he puts the rest of the apple in his pocket and, with a jaunty bounce to his step, walks coolly out of the office, he no longer has the air of a tormented "Wrong One" who is almost as

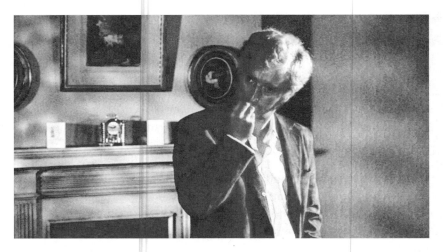

Figure 16.2

much a victim as his victim is. Now he has the insouciance of one of those heartless Hitchcock villains who lack regard for human frailties—a Serpent, not an Adam. Which is Rusk's true face? Which is a mask? We do not know the answer to this question because the camera refrains from unmasking him. At the moment he bites into the apple, his back is to the camera. The camera, perhaps with this villain's complicity, hides his face from us.

In another passage that strikes me as fully Hitchcockian, Rusk leads barmaid Babs Milligan—played by the immensely likable Anna Massey, who was so memorable in a similar role in Michael Powell's *Peeping Tom* (1960)—upstairs to his apartment. As he closes the door behind them, all background sounds fade out. His voice breaks the unnatural silence as he speaks the words that spell her doom: "You're my kind of woman." When the camera slowly pulls back from the door and down the stairs to the street below, the sounds of the city slowly fade back in. London's life goes on, oblivious of Babs's cruel fate. This camera movement, its elegiac mood enhanced by the soundtrack's invocation of silence, is a tour de force. It is also a haunting and eloquent acknowledgment of the unbearable sadness of this woman's death, the utter senselessness of her murderer's cruel act. And it is an acknowledgment of the unbearable sadness of being human, the sadness inherent in the fact that we are mortals born into the world and fated to die, the sadness apart from which the art of pure cinema would not be possible. We do not witness this horrific scene but can imagine it all

too well, for we know Babs's death scene will be a repetition of Brenda Blaney's. We are not indifferent to Babs's fate. But our lives, too, go on. The camera inexorably moves on, as is its fate, to the next scene, and then the next, drawing ever closer, as it must, to the film's inevitable ending.

Why do Brenda Blaney and, even more heartbreakingly, Babs Milligan have to die, or rather, why do their lives have to be senselessly cut short? Their fate is in Hitchcock's hands. Why does he sign their death warrant? Not because he hates them. Brenda is an admirable woman—so admirable that it is hard to feel a special affinity with her. When Rusk kills her, it is murder, plain and simple, and Hitchcock hates murderers. Babs, by contrast, is a warm, caring woman. I cannot imagine Hitchcock taking pleasure in her fate. Violence against women, in Hitchcock's films, is rarely, if ever, viewed as just. Babs has done nothing to make us, or Hitchcock, wish for her death. Then why, in a world on film over which he presides, does he at least tacitly endorse her murder? Perhaps there is no other answer than that Brenda and Babs have to die to enable *Frenzy* to be born. After *Vertigo*, *North by Northwest*, *Psycho*, *The Birds*, and *Marnie*, such an answer is no longer good enough to justify the film's creation. A work of art, it is often said, is of value in and of itself. What is *Frenzy*'s value? Is there a moral purpose its creation serves? Does it move Hitchcock, or us, in the direction of the unattained but attainable self, the way the creation of *The Birds* and *Marnie* did? I wish I believed that to be the case.

In David Freeman's screenplay for "The Short Night," the film Hitchcock was preparing for production when failing health forced him to announce his retirement (as perhaps he knew all along that it would), there is yet another scene that depicts an act of brutal violence against a woman. It takes place early in the story. Rosemary, a young communist described as "studious looking," finds herself alone in a small apartment with Gavin Brand, thirty-nine, who has just escaped from prison after having been locked up for five years for spying for the Soviet Union.[5] Brennan (who had helped Brand escape) and Rosemary's husband are due to return soon with a truck to spirit Brand away, ultimately to be reunited with his wife, who is living with their two young boys on a secluded island off the coast of Finland. (Again, the "private island" theme.)

When she tells Brand—with a "hint of coquettishness," the screenplay specifies—that she is glad to have him to herself for a moment, he looks her up and down. She explains that she wants him to tell her about the amazing things he did for the Communist Party in East Berlin. Although she is described as "studious looking," Hitchcock would surely have filmed

Rosemary so that she would appear sexually alluring in a way that Brenda and Babs (and even Melanie and Marnie) do not. When she goes to the sink to make tea (this is England, after all), she can feel Brand's eyes on her back. Growing increasingly uncomfortable, she starts chattering nervously as she prepares the tea. He draws her to him and kisses her. She doesn't kiss back, but she doesn't push him away, either. She says, "Please . . . Don't . . . They'll be back very soon. . . . You know I respect you so much. We all do." "You know how long I've been in prison?" "You'll be seeing your wife soon. . . . She'll be so happy. . . . " Brand strokes her breasts. "Don't. Please don't do that. They'll be back any time now." "So soft," Brand says. "It's been five years since I felt anything so soft." "Don't do that. . . . Please stop. . . . I'll yell out; really I will."[6]

The screenplay communicates, clearly, that it is possible that Brand, who has not been with a woman for five years, interprets Rosemary's every "no" as a "yes." She repeatedly tells him to stop, but the reasons she gives—that the others will soon be back, that he is a married man—do not rule out the possibility that, although she thinks he should stop, thinks she should want him to stop, she really wants him to go on. She keeps saying "please," keeps saying how much she respects him, keeps appealing to the better angels of his nature. Even when she says, "I'll yell out; really I will," she does not "yell out," leaving open the possibility that she has no real wish to do so.

As if he were waiting for an excuse, the moment Rosemary threatens to "yell out," Brand squeezes her cheeks to silence her. This is the moment he reveals his murderousness—to her and to us. The violence of his gesture forces her now to try desperately to "yell out." Angrily telling her to stop "babbling," he "pushes his mouth at hers, kissing her and running his hands along her body." We watch in horror as everything he does to stifle her voice forces her to react in ways that arouse him more, provoking him to more violent efforts to silence her. At the same time, his words become abusive. He calls her a "stupid cow" and demands that she do what he says. But we sense that what he really wants is for her to struggle, not submit. Her struggles to keep him at bay are what turn him on. She throws scalding tea at him; scratches his face, drawing blood; bites deep into the flesh of the hand covering her mouth. Caught up in a cycle of escalating violence, his words, too, escalate, from "Stupid cow, you'll do as I say" to "You stupid bitch, shut up" to "What do you think of that?" to "Oh damn you to hell" when her body goes limp in his arms. He forcibly stops her from speaking, then punishes her for "babbling." He commands her to do what he says but gives her no choice but to struggle. He squeezes the life out of

her for not shutting up, then, as she is dying, mocks her for her silence, rebuking her for not telling him what she thinks of what he has done to her. And when he realizes she is dead, he curses her for his own frustration and calls upon God to damn her to hell for what he, himself, has done.

There can be no doubt that the screenplay is condemning Brand, damning him to hell, reminding us that we must never take even the smallest step in the direction of forfeiting our humanity, the way this misogynistic rapist and murderer does. Yet this scene as written, had Hitchcock filmed it, would have had a powerful erotic impact by conveying viscerally the escalating intensity of Brand's arousal and of Rosemary's, too, as her romantic dream turns into a nightmare from which she never awakens. Our view of this man squeezing the life out of this woman would surely have been the scene's climax, its "money shot," in which our horror at what we are witnessing, and our arousal by it, would have been inextricably intertwined. That human beings have an appetite for violence, that killing can give us pleasure, is a dark truth about our nature. And it is a dark truth about the art of pure cinema, although not the deepest truth, that this sequence would have acknowledged, more starkly than any other in Hitchcock's cinema, even as it was arousing us.

Within the screenplay as a whole, though, this scene has a crucial function. The film's protagonist, Joe Bailey, is the aggrieved brother of an American CIA agent killed in the line of duty by Brand. Encouraged by the CIA to seek revenge, Bailey follows the trail of Brand's wife and children from London to Finland in the hope of intercepting the traitor before he can reach the Soviet Union. As the narrative unfolds, Joe falls in love with Carla Brand. Because we know the kind of brute she is married to, we are entirely on Joe's side when he declares his love for her even as he seeks to avenge his brother at her husband's expense.

The final showdown between Joe and Brand—unlike the more ambiguous showdowns between Young Charlie and her uncle in *Shadow of a Doubt* and between the Americans and the German in *Lifeboat*—is that rarity in Hitchcock's cinema: a Manichean conflict between absolutely opposed moral forces. Hitchcock wants us to feel no ambivalence, to wish with all our heart for Joe to prevail. The film needs the scene in which Brand murders Rosemary so that we will judge, not wrongly, that Brand has forfeited his humanity, that if Joe were to kill him, it would not be murder, morally speaking.

In Hitchcock's films evil is not an occult supernatural force. Brand is not an agent of the Devil. He is a human being, not fundamentally different

from Joe, from Hitchcock, or from us. Joe knows that Brand is human, just as he is, and that he himself is capable of forfeiting his humanity the way Brand has. This knowledge motivates Joe to wish to kill Brand and gives him the power to do so. It does not make Hitchcock immoral that he finds it possible, and necessary, to show us a monstrous act of violence through the eyes of the murderer. If *Marnie*'s Mark Rutland is a definitive counterexample to the idea that each man kills the thing he loves, Joe Bailey is another. Although Joe is prepared to kill Brand if that is necessary to keep Carla safe, in the end he is spared the need to kill. Brand escapes, but only after Joe rescues Carla's sons at gunpoint just before their train reaches the Russian border. Nonetheless, "The Short Night" dwells on killing, not loving. That is why it does not make me unhappy that Hitchcock never filmed the screenplay. It makes me happy—I like to think that it made Hitchcock happy—that *Family Plot*, not "The Short Night," turned out to be his swan song.

Family Plot is a playful twist on *Psycho*, its plot set in motion when elderly Julia Rainbird (Cathleen Nesbitt) tries belatedly to wipe the slate clean by granting her nephew—whom she had forced her sister to abandon when he was a child—his rightful inheritance. What she does not know is that this child murdered his adoptive parents and has grown up to be a scheming crook (William Devane) who is anything but Mr. Nice Guy. Blanche Tyler (Barbara Harris), a fake (or perhaps not so fake) medium, sets out with George Lumley, her boyfriend (Bruce Dern), to locate the wayward nephew.

With a beauty and wackiness reminiscent of Shirley MacLaine (who had made her movie debut in Hitchcock's *The Trouble with Harry*), Barbara Harris is the most delightful Hitchcock "leading lady" since Grace Kelly. She has real chemistry with Dern, whose George is as likable as her Blanche. Both are unglamorous, unpretentious, well-meaning, only slightly larcenous characters with whom we can readily identify. They are not legally married, but theirs is a true marriage, a marriage worthy of the couples in comedies of remarriage. For all their bickering, they love each other. Theirs is a relationship worth having. Is it a relationship of equals? That's a judgment call. He comes to her rescue and helps keep her safe. But she possesses powers he lacks.

After they have locked the villains safely away, George points out to Blanche how much more reward money they would earn if they somehow found the stolen diamond that is the film's MacGuffin. Suddenly, Blanche seems to go into a trance, as if this were one of her fake séances. But this trance, George believes, is real. Intrigued, he follows her up the stairs. When

Figure 16.3

she pauses and slowly raises her finger to point at something, the camera
follows her cue and moves in the direction she is pointing. Lo and behold,
there is the stolen diamond hidden in full view in a crystal chandelier!
Seeming to awaken from her trance, Blanche acts as surprised as George
that she has found the diamond. He beams with pride that the woman he
loved even when he believed she was a fake psychic has turned out to be
a real one. The moment this man she loves leaves her side, Blanche looks
directly at the camera—at us, it seems—and her face lights up in a great
big grin. Then she winks.

Is the secret Blanche shares with us, the secret she withholds from George, that she was only faking her trance, that she possesses no magical or supernatural powers at all? (She could have overheard the kidnappers say where the diamond was hidden.) But that discounts the extraordinary powers she has to possess to be able to reveal her secret directly to the camera—directly to us.

Who is this woman? She is the proverbial enigma wrapped in a mystery. She is Blanche Tyler. But how can a fictional character, a woman who has no real existence, wink at us? She is Barbara Harris. But how can an actress who is, as I am writing these words, almost as old as Hitchcock was when he made *Family Plot* be this vibrant young woman who, like Mary Rose, has not aged with the passage of time? She is a medium through whom Hitchcock, the film's author, communicates directly to us from beyond the grave. But how can Hitchcock wink at us if he has been dead and buried for thirty-plus years?

To us, the flickering shadows projected on the movie screen are insubstantial phantoms possessing only the illusion of life. But to the denizens of the projected world, we have no more tangible reality than ghostly spirits. In our world "Mary Rose" and "The Short Night" are films that might have been. In our world not everything that is possible is real. But there are no "might have beens" in Blanche's world. She cannot but wink at the camera every time *Family Plot* is screened. In Blanche's world nothing is possible that is not real. But Blanche's world does not really exist.

The world on film, a world in which all possibilities are real, and all are unreal, is itself at once real and unreal. The ending of *Family Plot* brings us back one last time to the thought that the art of pure cinema overcomes or transcends our distinction between the real and the unreal, between the real and the possible, between reality and fantasy. Such is the nature of the world on film. Its nature is also its magic. Or, rather, our distinction between nature and magic, between the natural and the unnatural or the supernatural, is yet another distinction the medium of film overcomes or transcends.

When Blanche grins and winks at the camera, she seems to be bridging the great divide between her world and ours. Her wink seems to cue the film's closing shot, over which the final credits roll, that frames head-on the priceless stolen diamond. Yet this shot of the diamond is not taken from Blanche's literal point of view. She was winking at us, not at the diamond. That the diamond is no mere object located on her side of the divide is a secret that Hitchcock, not Blanche, is sharing with us.

This twinkling diamond is a multifaceted jewel, just as every Hitchcock film is. As this shot frames it, the diamond appears strikingly like an eye—an eye looking directly at the camera. Thus the shot suggests, retroactively, that the preceding shot—of Blanche winking at the camera—represented the diamond's point of view. It is as if this "jewel/eye" is the camera that captured her wink or the projector that is at this moment beaming onto the screen the very image we are viewing. Viewer becomes viewed; viewed becomes viewer; Blanche's wink becomes the diamond's twinkle; the past becomes the present; the projected world—the private island that keeps this woman safe from the ravages of time even as the film that grants her eternal youth moves inexorably toward its inevitable ending—becomes the world into which we have been born and in which we are fated to die. The ending of *Family Plot* shares with us the secret, or, rather, the mystery, of Hitchcock's art of pure cinema: the two worlds are one. There is no such thing as a private island. If we live our lives, as Hitchcock's villains do, in such a way as to try to make the world our private island, we forfeit our humanity.

Psycho also ends with a grin at the camera. But Norman's (or is it his mother's?) grin is murderous. It announces that we are the butt of the film's cruel joke. Blanche's wink—or is it Barbara Harris's? or Hitchcock's?—intimates that the ending of *Family Plot*, too, may be a joke. If so, it is not a joke at our expense. And the joke is anything but cruel. Whoever or whatever this woman is, she wishes us well as we walk in the direction of the unattained but attainable self. Her heartening, life-affirming wink at the camera—a medium's salute to a medium—is the most Emersonian gesture in all of Hitchcock's cinema. Whatever else it may be, it is Hitchcock's acknowledgment of our love for him, of his love for us, and of his gratitude to the art of pure cinema for having made possible this relationship worth having.

It is better to be loved.

Conclusion

Emerson, Film, Hitchcock

In "Self-Reliance" Emerson writes, "Primary wisdom [is] Intuition, whilst all later teachings are tuitions."[1] Thus Emerson is called a philosopher of intuition, Cavell remarks, adding that he is at the same time a teacher of "tuition." "I read him as teaching that the occurrence to us of intuition places a demand upon us, namely for tuition; call this wording, the willingness to subject oneself to words, to make oneself intelligible. (Tuition so conceived is what I understand criticism to be.)"[2] The pages that follow are motivated by the confluence of two intuitions. One is that, *as authors*, Hitchcock and Emerson, for all their obvious differences, have profound affinities. The other is that my own practice of reading films, as exemplified especially by the chapters on *Notorious, Rope, The Wrong Man, Vertigo, North by Northwest, The Birds*, and *Marnie*, is itself underwritten, philosophically, by Emerson's essays. In this concluding chapter my intention is to "pay the tuition" for these intuitions.

"It is remarkable that involuntarily we always read as superior beings," Emerson writes in "History." "All that is said of the wise man by Stoic, or oriental or modern essayist, describes to each reader his own idea, describes his unattained but attainable self" (238–39). As is so often the case, unless one attends carefully to Emerson's words, it is easy to misread him. He is not saying that unless we will ourselves to do otherwise, we read as if we were superior to what we are reading. He is not saying that we look down on works rather than acknowledge that their thoughts correspond

to something in our own character, thereby denying ourselves the possibility of learning, growing from our reading, gaining a new perspective on our own thoughts. He is saying the opposite of this. When we read "involuntarily"—that is, when we do *not* "will otherwise"—when we do not, for example, let some theory or other run interference—we become "superior beings"—the word *superior* is used here without irony. If we do "will otherwise" and look down on what we read, we avoid, or try to defeat, another's thoughts as if we fear they are threats to our own. Then our timidity, masked by a pretense of superiority, reveals our lack of self-reliance; we are ashamed to stand by our own thoughts, to claim them as our own, to express them, to make them available —even to ourselves.

A famous passage from "Self-Reliance" begins: "In every work of genius"—that is, every work, in whatever form or medium, in which an individual, paying the tuition for each intuition, expresses and *publishes* his or her own thinking—"we recognize our own rejected thoughts: they come back to us with a certain alienated majesty." The passage goes on: "Great works of art have no more affecting lesson than this. They teach us to abide by our spontaneous impression with good-humored inflexibility, most when the whole cry of voices is on the other side. Else, tomorrow a stranger will say with masterly good sense precisely what we have thought and felt all the time, and we shall be forced to take with shame our own opinion from another" (259).

Although I was unaware when I was writing *The Murderous Gaze* that my practice of reading exemplified Emersonian perfectionism and was, indeed, underwritten, philosophically, by Emerson's writings, I was fortunate to have a philosophical basis, thanks above all to having been Stanley Cavell's student, upon which to reject the view, which was then dogma within the field of film studies, that the concept of authorship had been discredited, on theoretical grounds, as nothing but an instrument of pernicious ideology. And I had a philosophical basis on which to reject the broader view, itself dogma within the field, that by applying some theory or other we could know with certainty that classical Hollywood movies were in the repressive grip of ideology, that we could know, without performing the work I call "reading," the cornerstone of serious film criticism, that they could not be "works of genius" in Emerson's sense.

I remarked in the introduction that the idea that films express their thoughts by their successions of moods (moods the camera captures; moods its projected images cast) brings to my mind this oft-quoted sentence from "Experience": "Life is a train of moods like a string of beads, and as we

pass through them they prove to be many-colored lenses which paint the world their own hue, and each shows only what lies in its focus" (473). Although every mood brings *something* into focus—the region or aspect that "lies in its focus"—it is only by seeing at every moment through one lens or another, hence partially, colored by our mood at that moment, that we see a world at all. And even our particular temperament—the "iron wire on which the beads are strung," the iron rail that makes our "train of moods" run along a single track—"enters fully into the system of illusions, and shuts us in a prison of glass which we cannot see." ("There is an optical illusion about every person we meet," Emerson writes. "In truth, they are all creatures of given temperament, which will appear in a given character, whose boundaries they will never pass: but we look at them, they seem alive, and we presume there is impulse in them. In the moment it seems impulse; in the year, in the lifetime, it turns out to be a certain uniform tune which the revolving barrel of the music-box must play" [474].)

In a charming passage, Emerson evokes the possibility that our subjectivity actually creates our world in the same strokes by which it paints it a particular hue—the possibility that life's "train of moods" is nothing but a train of illusions, dreams from which we only dream we awaken, only awaken into other dreams (like *Vertigo*'s Scottie, as we have seen, in what is usually called his "dream sequence").

> Do you see that kitten chasing so prettily her own tail? If you could look with her eyes, you might see her surrounded with hundreds of figures performing complex dramas, with tragic and comic issues, long conversations, many characters, many ups and downs of fate,—and meantime it is only puss and her tail. How long before our masquerade will end its noise of tambourines, laughter, and shouting, and we shall find it was a solitary performance? . . . What imports it whether it is Kepler and the sphere; Columbus and America; a reader and his book; or puss with her tail? (489)

For all its lightness of tone, this passage deepens Emerson's essay's immersion in the problematic of philosophical skepticism—both what philosophers call "skepticism about the existence of the external world" and "skepticism about the existence of other minds." "Experience" does not mount an argument to *defeat* skepticism. But the essay does settle the matter of skeptical doubt to Emerson's satisfaction in a way that enables him to move on, to put it behind him, so that later essays have no need to revisit it.

"We live amid surfaces," "Experience" acknowledges. "The true art of life is to skate well on them." In the spirit of Pascal's wager, "Experience" offers Emerson's readers—and himself—this sage advice: "Let us treat the men and women well: treat them as if they were real: perhaps they are." We have no proof that "other selves" are real. Neither have we proof that they are *not*. If they are not "other selves," what is lost by treating them as if they were? If they are real selves and we treat them as if they are not, we deny their humanity—and our own. Why not treat them as if they are real, then? "Without any shadow of doubt, amidst this vertigo of shows and politics," Emerson writes (his words seeming to have been chosen for him by Hitchcock's publicist), "I settle myself ever the firmer in the creed, that we should . . . do broad justice where we are, by whomsoever we deal with, accepting our actual companions and circumstances, however humble or odious, as the mystic officials to whom the universe has delegated its whole pleasure for us" (478–79).

Coming to terms with the truth of skepticism, as we might put it, is the task "Experience" sets itself. "The new statement"—the new way of thinking philosophically that the essay takes its writing to be helping to found—"will comprise the skepticisms, as well as the faiths of society, and out of unbeliefs a creed shall be formed. For, skepticisms are not gratuitous or lawless, but are limitations of the affirmative statement, and the new philosophy must take them in" (487).

When Emerson composed "Experience," his writings had already contested Kant's belief in the necessity of synthesis, of "putting experiences together into a unity in knowing a world of objects," and had arrived at the position that there is no such thing as an objective view that anchors our relationship to the world, as Cavell puts it. Our world is many worlds. As Cavell reads "Experience," a main thrust of the essay is that "the existence of any one of these worlds depends on our finding ourselves within that world. They have no foundation otherwise."[3] As the opening of "Experience" asserts, when we awaken to our condition, we do *not* find ourselves *within* a world. Again, we find ourselves "in a series of which we do not know the extremes, and believe it has none. We wake and find ourselves on a stair; there are stairs below us, which we seem to have ascended; there are stairs above us, many a one, which go upward and out of sight." That is, when we awaken to our condition, we are in no place we know. We find ourselves lost. "Ghostlike we glide through nature," Emerson writes, "and should not know our place again" (471). As Uncle Charlie puts it in *Shadow of a Doubt*, we are "sleepwalkers, blind."

How are we ever again to find ourselves within a world, in light of what Emerson calls the "Fall of Man": the "discovery we have made"—the discovery Emerson's essays have conveyed to their readers—that our flux of moods only "plays about the surface" and never "introduces [us] into the reality, for contact with which we would even pay the costly price of sons and lovers"? (472–73).

> It is very unhappy, but too late to be helped, the discovery we have made, that we exist. That discovery is called the Fall of Man. Ever afterwards, we suspect our instruments. We have learned that we do not see directly, but mediately, and that we have no means of correcting these colored and distorting lenses which we are, or of computing the amount of their errors. Perhaps these subject-lenses have a creative power; perhaps there are no objects. Once we lived in what we saw; now, the rapaciousness of this new power, which threatens to absorb all things, engages us. Nature, art, persons, letters, religions,—objects, successively tumble in, and God is but one of its ideas. Nature and literature are subjective phenomena; every evil and every good thing is a shadow which we cast. (487)

What Emerson calls the "Fall of Man" is precisely what Cavell calls the "fall into skepticism" when he argues that "film could not have impressed itself so immediately and pervasively on the Western mind unless that mind had at once recognized in film a manifestation of something that had already happened to itself." This "something" was a cultural trauma that has produced "a sense of distance from the world," a "terrifying recognition that reason as such, language as such, can no longer be assured of its relation to a world apart from us or to the reality of the passions within us."[4]

In *The World Viewed* Cavell describes this crisis, at once of knowledge and of expression, as the "unhinging of our consciousness from the world." Our subjectivity became interposed between us and our presentness to the world. "Our subjectivity became what is present to us; individuality became isolation." The wish that prompted the creation of film as an artistic medium, he argues, was the wish to overcome this "unhinging of our consciousness from the world," the wish to "reach this world," to escape the metaphysical isolation to which our subjectivity condemns us.[5]

"Our condition," Cavell writes, "has become one in which our natural mode of perception is to view, feeling unseen. We do not so much look at the world as look *out* at it, as if from behind the self" (102). When we view

films, "our sense of invisibility is an expression of modern privacy or ano-
nymity, as though the world's projection explains our forms of unknown-
ness and of our inability to know." He adds, "The explanation is not so
much that the world is passing us by, as that we are displaced from our
natural habitation within it, placed at a distance from it. The screen . . .
makes displacement appear as our natural condition" (40–41).

Cavell's compelling picture of the modern human being looking out at
the world as if from behind a camera envisions our subjectivity as inter-
posed, as interposing itself, between ourselves and the world. *The World
Viewed* understands the entire history of movies to be bound up with their
origin as an expression of the wish to overcome the metaphysical isolation
that is the condition of human existence in the modern period. What we
crave is to "reach this world" and "attain selfhood," which Cavell under-
stands to require "the always simultaneous acknowledgment of others" (22)
(our acknowledgment of them, and theirs of us). Movies thus originate, in
Cavell's view, as a response to the condition Emerson so accurately diag-
noses—the condition that we find ourselves outside our world, not within
it, as if we, and our world, do not really exist but stand in need of being
"realized."

Every mood brings *something* into focus—the region or aspect of the
world that "lies in its focus." And yet, as Emerson puts it in "Experience,"
"Dream delivers us to dream, and there is no end to illusion." It is only by
seeing at every moment through one lens or another, hence partially and
colored by our mood at that moment, that our eyes are capable of seeing a
world at all. "Thus inevitably does the universe wear our color" (473), Em-
erson adds, meaning both that we inevitably paint our world in a particu-
lar hue and that we inevitably see the world as on our side, as championing
us. "As I am, so I see; use what language we will, we can never say anything
but what we are" (489.

As I have said, the idea that what is "unhandsome" in our condition, in
Cavell's view, our "clutching at things" in our human effort to escape our
humanness," is central to the philosophical enterprise Emerson took him-
self to be founding, which in the New World was to replace the European
edifice of philosophy. Indeed, Cavell characterizes Emerson's enterprise—
which Cavell takes himself to be inheriting—as the "overcoming of think-
ing as clutching."[6]

In favor of what?

Wittgenstein asks himself, in *Philosophical Investigations*, "What is your
aim in philosophy?" His answer: "To show the fly the way out of the

fly-bottle."[7] To be sure, the fly would then find itself within a world, not a prison. But the fly would still be a fly, poor thing. Emerson aims higher. In his view, as in Wittgenstein's, becoming free is a necessity if philosophy is to achieve its aim. And Emerson, too, believes that thinking, which has the power to imprison us, can also free us. Thus the passage I have just considered is preceded by these sentences: "The making a fact the subject of thought raises it. All that mass of mental and moral phenomena, which we do not make objects of voluntary thought, come within the power of fortune; they constitute the circumstance of daily life; they are subject to change, to fear, and hope." And the sentence that follows the passage asserts that "a truth, separated by the intellect, is no longer a subject of destiny." In "Fate" Emerson writes: "Intellect annuls fate. So far as a man thinks, he is free" (953).Freedom does not mean escaping from our human condition. Freedom is a possibility *within* our humanness. Emerson's aim in philosophy is to help us to become more fully human, to help us to walk in the direction of the unattained but attainable self, or, as he more or less puts it in "Experience," to help us to master the "true art of life." For Emerson, philosophy's goal is to help us to "realize" the world we "think."

Our lives in the world are such, Emerson remarks, that we possess everything we require for thinking. But when, in "Intellect," he poses the question, "What is the hardest task in the world?," his answer is, "To think" (420).He writes, "I would put myself in the attitude to look in the eye an abstract truth, and I cannot. We all but apprehend, we dimly forebode the truth. . . . Then, in a moment, and unannounced, the truth appears. A certain, wandering light appears"—"certain" meaning, I take it, both "particular" and "possessed of certainty"—"and is the distinction, the principle, we wanted. But the oracle comes, because we had previously laid siege to the shrine" (419). The mind's vision is capable of "raising" every rude "fact in our life" into a "truth"—but only when that "certain, wandering light" appears to illuminate it, to reveal it, to enable it to be seen, to be read. We cannot *will* this light to appear. It takes a revelation. We *receive* our thoughts.

Cavell invokes Emerson's term *indirection* to name something that "Experience" refrains from naming: "the direction of reception, of being approached, the handsome, attractive part of our condition." He writes, "The idea of indirection is not to invite us to strike glancingly, as if to take a sideswipe; it is instead to invite us, where called for, to be struck, impressed." The opposite of "clutching," then, that which would be the "most handsome part of our condition," is "the specifically human form of attractive-

ness—attraction naming the rightful call we have upon one another, and that I and the world make upon one another. . . . (Heidegger's term for the opposite of grasping the world is that of being *drawn* to things.)"[8]

How "unhandsome" is the notion, for so long dogma within the field of film studies, that to think seriously about films, we must break our attachments to them, stop letting them move us, so we can fix them firmly in our grasp! For if we keep ourselves from being struck by films, keep them from making impressions on us, we cannot think about their value, why we seek our attachments to them, why they attract us and draw us to them, what rightful call they make upon us. In that way we cannot think seriously about films at all.

No less unhandsome is the notion, once sacrosanct within film studies as well, that in classical movies the camera is an instrument of "the male gaze," as if there were one and only one thing the eyes of men are forever doing, and as if the camera, too, is forever doing this same one thing—namely, "clutching at" women, treating female subjects as objects to be seized, held, kept, interrogated, controlled. To be sure, Laura Mulvey's massively influential 1975 essay "Visual Pleasure and Narrative Cinema" asserts that in classical movies there are two things, not one, that the camera's "male gaze" is forever doing, that the camera oscillates between sadistically "clutching at" women (not Mulvey's term, but it might as well be) and *fetishizing* them.[9] The latter, her essay claims, is the alternative way by which movies objectify female subjects: by reducing women to images, at the same time manipulating those images so as to cause them, as we might put it, to disavow the flesh-and-blood women they are images of.[10] But it is not possible for film images to separate themselves from what they are images of. To do so, film images would have to be something other than what they are. If film images were really "fetishized," it would be impossible for them to capture "the moods of faces and motions and settings" the way they do. Thus Cavell hits the nail on the head when he asserts that "the details of Freud's description of fetishization do not account for what becomes of things and persons on film, say for the relation between a photographic image and what it is an image of."[11]

And if the camera's way of capturing "faces and motions and settings" were really by "clutching at" them, their moods—paradigms of what Emerson calls "evanescence" and "lubricity"—would simply slip through the camera's fingers, figuratively speaking. If that were the case, film images would not be able to attract us, strike us, make impressions on us. Then movies would not be what they are, would be unable to express themselves

the way they do. In our everyday lives we feel displaced, as if our subjectivity were interposed between our true being and the world we long to reach. But the world on film does not feel lost to us. Our displacement feels natural. And it feels natural because it is not *possible* for us to reach the projected world, hence not possible to *fail* to reach it.

In truth, there *is* only one thing that movie cameras do: they film whatever is in front of them. Cameras are machines. They have no subjectivity, no moods in whose hues they paint the world. They are not capable of "clutching at" people. But they have no need to do so in order to capture, on film, the moods that human faces and bodies express. This is because human beings possess what Emerson calls "wonderful expressiveness." As he puts it in his late essay "Behavior": "If [the human body] were made of glass, or of air, and the thoughts were written on steel tablets within, it could not publish more truly its meaning than now. The whole economy of nature is bent on expression. The tell-tale body is all tongues" (1041). And this leads to an extended aria about the eye as exemplary of the "wonderful expressiveness" of the human body. "Man cannot fix his eye on the sun, and so far thus seems imperfect," the passage begins, with a gloss on the Bible, as well as on Kant. The allusion to "Let us fix our eyes on Jesus [the Son], the author and perfecter of our faith" (Hebrews 12:2) adumbrates the essay's heretical claim that what we must seek to perfect is not our faith in God but our ability to "read" the "secrets" Nature is forever revealing. But the human eye *can* do, and express, an amazing variety of things:

> An eye can threaten like a loaded and leveled gun, or can insult like hissing or kicking, or, in its altered mood, by beams of kindness, it can make the heart dance with joy. . . .
>
> Eyes are bold as lions,—roving, running, leaping, here and there, far and near. They speak all languages. They wait for no introduction; they are no Englishmen; ask no leave of age, or rank; they respect neither poverty nor riches, neither learning nor power, nor virtue, nor sex, but intrude, and come again, and go through and through you, in a moment of time. What inundation of life and thought is discharged from one soul into another, through them! The glance is natural magic. The mysterious communication established across a house between two entire strangers, moves all the springs of wonder. The communication by the glance is in the greatest part not subject to the control of the will. It is the bodily symbol of identity of nature. (1043)

And so on.

Our eyes, and our faces and bodies in general, express our moods, make us readable by others, as they make others readable by us. "Men are like Geneva watches with crystal faces which expose the whole movement. They carry the liquor of life flowing up and down in these beautiful bottles, and announcing to the curious how it is with them" (1043). These "announcements" *can* be read. They *will* be read, Emerson's wording implies, only by those curious to know "how it is with us." But his wording also implies something beyond this. What our bodies express is not limited to our "flux of moods," which only "plays about the surface." Human bodies disclose not only particular moods but also that "wonderful expressiveness" itself, which reveals to the beholder that these "beautiful bottles" carry the "liquor of life."

"We look into the eyes," Emerson writes, "to know if this other form is another self, and the eyes will not lie, but make a faithful confession what inhabitant is there" (1042). When we look into another's eyes, both our own eyes and the eyes we behold testify, faithfully, that this "other form" *is* "another self," that the "liquor of life," which is in us, is in the other as well. He adds, "'Tis remarkable, too, that the spirit that appears at the windows of the house does at once invest himself in a new form of his own to the mind of the beholder," reiterating that this "spirit that appears in the windows of the house" (1042) reveals itself to be a separate being with a mind of its own. We are not alone. But if, as Emerson asserts, "communication by the glance" is the "bodily symbol of identity of nature," this "other self" is identical to us *in nature*. There is in the other, too, "that which changes not." Hence there is no real "wall" between us; the same "vast-flowing vigor" flows up and down within us.

When Emerson writes about eyes, and about the expressiveness of the human body in general, the way he does in "Behavior," his words provide food for thought, not to mention priceless instruction, to anyone who aspires to write seriously about films. For the "spirits" that appear in the "window" that is the movie screen "invest themselves" in "new forms of their own" that possess the "wonderful expressiveness" of our own bodies, our own eyes. Through the "flux of moods" that "plays about the surface" of these "forms," these "spirits" appear to our mind as other selves, beings no different from us in nature.

Comedies of remarriage have faith that these "forms" are capable of "introducing us to the reality" that the "beautiful bottles" we behold do

carry the "liquor of life," that when we behold them, an "inundation of life and thought" that "moves all the springs of wonder" is, indeed, "discharged from one soul into another." Hitchcock, too, was drawn to this idea. But he was also drawn, as we have seen, to the idea that film is a medium of taxidermy—as if the "forms" projected on the movie screen are really as dead as Norman Bates's stuffed birds, and the "natural magic" of the "glance"—the spirit's, the camera's, the viewer's—has the power to breathe into them only an imitation of life. And this idea, too, has an affinity with Emerson's way of thinking. We have already considered Emerson's point, in "Intellect," that when the intellect casts on a "fact in our life" the "certain, wandering light" of a "lantern," we transform it into a "thought," a "truth," which is an object "impersonal and immortal. It is the past restored, but embalmed. A better art than that of Egypt has taken fear and corruption out of it" (418)—precisely André Bazin's metaphor for the film image.

In any case, the more we "clutch at" films—and the more we fetishize theories that purport to tell us a priori what films are and are not capable of expressing—the more they will "slip through our fingers." The alternative is to *receive* films, to read them, moment by moment, trusting to our experience to reveal the thoughts they are expressing in their indirect way, thoughts that are inseparable from the moods the camera captures and the moods those moods cast; inseparable from the ways their "flux of moods" moves us to take thought; and inseparable from the ways the films "introduce us into the reality"—the reality that baffles the intellect; the reality that we are, and are not, alone; the reality that we inhabit a world, or worlds, in which there are other selves whose nature is no different from our own.

"Every man, in the degree in which he has wit and culture," Emerson writes in "Intellect," "finds his curiosity inflamed concerning the modes of living and thinking of other men" (420). These are, as he elsewhere remarks, the very stuff of novels—and, of course, films. We naturally "aggregate" such "facts in our life," as Emerson calls them. As he puts it in an inspired gloss on Plato's allegory of the cave, "The walls of rude minds"—"rude" in the sense of raw, unpolished, as in "the rude bridge that arched the flood" in Emerson's "Concord Hymn"—are "scrawled all over with facts, with thoughts" (420). Each "fact in our life," in effect, is a memory, a trace of a past experience. And our past thoughts and "fancies" are, in this sense, "facts in our life" as well. "In common hours, we have the same facts as in the uncommon or inspired, but they do not sit for their portraits; they are not detached, but lie in a web" (423). To isolate a "fact in

our life" from "the web of our unconsciousness" (418), to "suffer the intel-
lect" to see it (419), is, metaphorically, to shine a lantern on an object and
make it sit for its portrait—as if (to invoke the irresistible metaphor) we
were pointing a camera at it, isolating it in a close-up, and projecting its
image on a movie screen. And it is not simply to illuminate this "fact" but
also to read its inscription.

Emerson's wording suggests that, owing to the nature of the object the
lantern illuminates, and to the nature of the lantern itself, there is no dif-
ference between seeing the object and reading what the lantern's light re-
veals to be inscribed on it. The light reveals the object to *be* an inscription.
And to see it thus illuminated *is* to read it. Again, Emerson's metaphorical
language pictures the "action of the mind" in terms that make it irresist-
ible to draw parallels with film. As we observed in the introduction, the
projector is literally a lantern. And the camera, metaphorically, is a lan-
tern, too.

In Emerson's view the intellect dissolves the difference between seeing
and reading. For Emerson, indeed, dissolving differences is what the intel-
lect *does*. "Nature shows all things formed and bound. The intellect pierces
the form, overleaps the wall" (the wall, the boundary, that separates one
thing from another; the wall that binds, seemingly imprisons, an individ-
ual's mind). By "making a fact the subject of thought," the intellect raises
that fact above the "considerations of time and place, of you and me, of
profit and hurt" that "tyrannize over" men's minds, "separates the fact con-
sidered from . . . all local and personal reference, and discerns it as if it
existed for its own sake." It is because the mind's vision "is not like the vi-
sion of the eye, but is union with the things known" (417–18), that the intel-
lect has the power to dissolve the difference between seeing and reading.
But to read Cary Grant's expression in the close-up Hitchcock presents to
us at the moment in *North by Northwest* at which Roger learns who Eve
Kendall really is, or to read Ingrid Bergman's expression in any of her
close-ups in the racetrack sequence of *Notorious*, all we have to do is see it.
The medium of film, too, is capable of dissolving the difference between
seeing and reading, hence capable of dissolving the difference between the
vision of the eye and the vision of the mind, between what our eyes liter-
ally see and what our imaginations conjure. How could the medium not
possesses such powers, given that films express themselves—make their
thoughts knowable—by their "moods of faces and motions and settings"?

As I have said, Emerson understands the "facts in our life" that the in-
tellect "raises" to be traces of past experiences—traces that we behold in a

"state of rapture" when a lantern appears, as if by magic, and isolates such a "fact" from the "web of our unconsciousness" by shining its "certain, wandering light" upon it. Film images, too, are traces of the past. The "faces and motions and settings" projected on the movie screen were once present to the camera that filmed them. In turn, our experiences of films become "facts in our life" that we have "aggregated naturally," like all the other "facts" woven into the "web of our unconsciousness." This is what makes it possible for Cavell to say, in the haunting opening sentence of *The World Viewed*, "Memories of movies are strand over strand with memories of my life."[12]

When a lantern shines a "certain, wandering light" on a "fact in our life," an intuition dawns in us, a thought is conceived. We behold the "fact" as illustrating a principle, a truth. Because the vision of the mind, unlike the vision of the eye, is "union with the thing known," the intuition *is* the lantern. But it once was the lowly "fact in our life" it now illuminates. Facts become thoughts, thoughts facts; thoughts beget further thoughts. Hence Emerson's formulation: "Every intellection is mainly prospective" (421). Our thoughts could not beget further thoughts, however, if the intellect were not "constructive," as he puts it, as well as "receptive." It is futile to try to "clutch at" an intuition we once rapturously beheld in an effort to keep it from falling back into the "web of our unconsciousness." For an intuition to become a full-fledged thought, we have to "pay the tuition" for the intuition by expressing it, making it available to ourselves and to others. We have to "bethink us where we have been, what we have seen, and repeat, as truly as we can, what we have beheld" (421). To "revisit the day" in this way, Emerson concludes, is what is called Truth.

This strikes me as a remarkably apt description of the practice of "reading" films as the preceding chapters exemplify it. Because memories of movies are strand over strand with memories of our lives, to read a passage from a film is to shine a "certain, wandering light" on particular "facts in our life" ("facts" that the camera/lantern has already "raised" by shining its light on them); to gaze rapturously upon them, discovering their value and the principles they exemplify; and to "pay the tuition" for our intuitions by finding words that "truly report what we have beheld," as I have tried my best to do in all the readings in this book.

The constructive intellect "produces thoughts, sentences, poems, plans, designs, systems"—and films, not to mention books about films. For a thought to be "reported," *published*, it needs "a vehicle of art by which it is conveyed to men." It "must become picture or sensible object," Emerson

writes. "We must learn the language of facts" (422). "The most wonderful inspirations die with their subject, if he has no hand to paint them to the senses. The rich, inventive genius of the painter must be smothered and lost for want of the power of drawing, and in our happy hours we should be inexhaustible poets, if once we could break through the silence into adequate rhyme. . . . As all men have some access to primary truth, so all have some art or power of communication in their head, but only in the artist does it descend into the hand" (422).

But film images are not handmade. Godard once defined film as "truth 24 times a second" to register the fact that the camera is a machine that can do nothing but capture whatever takes place in front of it, just as the projector is a machine that can do nothing but "report" something the camera has captured. This is what enables the camera, in tandem with the projector, to manifest an astonishing facility it shares with what Emerson, in a marvelous passage from "Intellect," calls the "mystic pencil" with which we "draw" our dreams: "As soon as we let our will go, and let the unconscious states ensue, see what cunning draughtsmen we are! We entertain ourselves with wonderful forms of men, of women, of animals, of gardens, of woods, and of monsters, and the mystic pencil wherewith we then draw has no awkwardness or inexperience, no meagreness or poverty; . . . the whole canvas which it paints is life-like, and apt to touch us with terror, with tenderness, with desire, and with grief" (423).

Having no will to let go, the camera—the "mystic pencil" that "draws" films—likewise "has no awkwardness or inexperience, no meagreness or poverty." Because the "whole canvas which it paints" is reality itself, albeit reality re-created in its own image, the world on film is not only "life-like"; it is life itself, and our experiences of films become "facts in our life." The "language of facts" is film's mother tongue.

In Hitchcock's films, which are "works of genius" in Emerson's sense, every framing, every cut, every camera movement, at once inscribes a thought and "pays the tuition" for that intuition. Thus they dissolve the difference—in a way only films can—between the "receptive" and the "constructive" intellect. But films do not *automatically* express thoughts. It is entirely possible for the camera to isolate a face in a close-up, allowing us to recognize the mood it expresses, without "raising" that expression, illuminating it, revealing it to be a legible inscription of the *film's* thought, the way Hitchcock's camera does.

Nor do films *automatically* "touch us with terror, with tenderness, with desire, and with grief" any more than novels do. "Society is the stage on

which manners are shown," Emerson writes in his essay "Behavior." "Novels are their literature" insofar as they are "the journal or record of manners." He goes on: "The novels are as useful as Bibles if they teach you the secret, that the best of life is conversation, and the greatest success is confidence, or perfect understanding between sincere people" (1049). This is the gospel Emerson's essays preach in the hope that readers will see the light and know that we—and America—can, and must, change; that we can, and must, walk in the direction of the unattained but attainable self and help move America a step closer to the more perfect community that is its dream and its promise. And Emerson's essays aspire to practice the gospel they preach.

"Why not realize your world?" is the challenge "Experience" poses to itself. Indeed, every Emerson essay aspires to rise to this challenge, to take a step in the direction of overcoming or transcending the discrepancy, which baffles the intellect, between the "world [we] converse with in the city and in the farms" and the world we "think" (491). Taking such a step requires "raising" the world of the everyday. It also requires bringing down to earth our thoughts of a more perfect world, acknowledging what is of value in what is closest to us, embracing what is "handsome" in our condition.

Teaching us the "secret" that "the best of life is conversation, and the greatest success is confidence, or perfect understanding between sincere people," preaching this gospel, is precisely the aspiration of Hollywood comedies of remarriage. They, too, aspire to practice what they preach. If novels can teach this secret, how much better equipped to do so are films—on condition that such sincere and understanding heroes and heroines can be discovered, "complete persons" with "the holiday in their eye," subjects of the camera whose form and manners, projected on the movie screen, are such that we will really see them as "fit to stand the gaze of millions," as he puts it in "Manners" (529).

A novel can describe such a person, not show one. A novel can assert that a character is a hero whose eyes have no "mud at the bottom" of them (1043). But when in *North by Northwest* Hitchcock's camera "shines a lantern" on Cary Grant's face at the moment of his moral awakening, we see, and know, that this man *is* such a hero; we see with our own eyes that the "report" we are receiving is true. Because the world projected on the movie screen *is* reality, albeit reality transformed by the medium, it stands in no need of being "realized." This gives films a unique and remarkable advantage over novels in preaching—and practicing—the Emersonian gospel that we can, and must, "realize" the world we "think."

In arguing that Hitchcock's career was driven by the conflict or tension between embracing and resisting Emersonian perfectionism, the preceding chapters in no way suggest that what he was resisting was the aspiration of "realizing" the world he "thought." Far from it. *The Murderous Gaze* demonstrates, and *Must We Kill the Thing We Love?* confirms, that Hitchcock's lifelong commitment to the art of pure cinema compelled him to strive to make virtually every shot communicate a thought—a thought it makes knowable—at the same time it captures, and expresses, a mood. "What a man is irresistibly urged to say, helps him and us," Emerson writes in "Behavior." "In explaining his thought to others, he explains it to himself: but when he opens it for show, it corrupts him" (551). That Hitchcock's films say what he was irresistibly urged to say is something I was irresistibly urged to say in *The Murderous Gaze*, and irresistibly urged to say again in *Must We Kill the Thing We Love?* Hitchcock was irresistibly urged to express the thought, or we might say the suspicion, that human beings do not possess, even metaphorically, the freedom to be reborn.

From the beginning of Hitchcock's career, the shadow of a doubt darkened the Hitchcock thriller. We can think of this shadow as the thought that we are fated always to kill the thing we love. Or as the thought that we are all in private traps from which we can never be freed. Or that we all have "mud at the bottom of our eye," hence that insofar as it is Hitchcock's own thoughts that his films make knowable, insofar as the camera is the instrument of this merely human author, it, too, has "mud at the bottom" of its eye, as it were. Or as the thought that the art of pure cinema corrupted him, his films, and his viewers.

How this shadow came to be lifted, how this doubt came to be overcome or transcended, how Hitchcock came to abandon the way of thinking that had defined his identity as an artist, and how he came to embrace what Emerson calls the wonderful "way of life," is the story this book tells.

Notes

Introduction

1. Stanley Cavell, *Pursuits of Happiness: The Hollywood Comedy of Remarriage* (Cambridge, MA: Harvard University Press, 1981).

2. Stanley Cavell, *Contesting Tears: The Hollywood Melodrama of the Unknown Woman* (Chicago: University of Chicago Press, 1996).

3. See Stanley Cavell, *Cities of Words: Pedagogical Letters on a Register of the Moral Life* (Cambridge, MA: Belknap, 2004).

4. See Stanley Cavell, "*North by Northwest*," in *Cavell on Film*, ed. William Rothman (Albany: State University of New York Press, 2005), 41–58.

5. Cavell, *Cities of Words*, 3 passim.

6. William Rothman, *Hitchcock: The Murderous Gaze*, 2nd ed. (Albany: State University of New York Press, 2012), 3. Originally published as *Hitchcock—The Murderous Gaze* (Cambridge, MA: Harvard University Press, 1982). Unless otherwise indicated, citations are to the second edition.

7. Ralph Waldo Emerson, "Circles," in *Essays and Lectures*, ed. Joel Porte (New York: Literary Classics of America, 1983), 403. Except where otherwise noted, all subsequent citations of Emerson's works come from Porte's compilation and are referenced parenthetically in the text.

8. Stanley Cavell, "Concluding Remarks presented at Paris Colloquium on *La projection du monde* (1999)," in *Cavell on Film*, 282.

9. William Rothman, *Documentary Film Classics* (New York: Cambridge University Press, 1997), 168.

10. Stanley Cavell, *Conditions Handsome and Unhandsome: The Constitution of Emersonian Perfectionism* (Chicago: University of Chicago Press, 1990), 1.

11. Susan Smith has much to say on suspense, and on other aspects of Hitchcock's style as well, in her original and insightful book *Hitchcock: Suspense, Humour and Tone* (London: BFI, 2000).

12. Stanley Cavell, *The World Viewed: Reflections on the Ontology of Film* (Cambridge, MA: Harvard University Press, 1979), 24.

13. Quoted in François Truffaut, with Helen G. Scott, *Hitchcock* (New York: Simon and Schuster, 1984), 73.

14. Rothman, *The Murderous Gaze*, 54.

15. Omar Khayyam, *Edward Fitzgerald, Rubáiyát of Omar Khayyám: A Critical Edition*, ed. Christopher Decker (Charlottesville: University Press of Virginia, 1997), 79.

16. Richard Allen, *Hitchcock's Romantic Irony* (New York: Columbia University Press, 2007) is Allen at his best. His essay "Hitchcock and Cavell"—*Journal of Aesthetics and Art Criticism* 64, no. 1 (2006): 43–53—decidedly is not. There he uses Hitchcock's films to rebut Cavell. The problem is that he proceeds, in textbook analytical philosophy fashion, by reducing Cavell's writings about film to a "theory" that no serious reader of Cavell would (or should) accept as a valid characterization of his thinking, and then refuting that straw man of a theory. In summarizing Cavell's ideas in a way that reduces them to an easily refutable theory, Allen virtually never quotes, or even closely paraphrases, Cavell's actual language. That may work with writing like Allen's but not with Cavell's. As any serious reader of Cavell could have predicted, the resulting summaries are reliably unreliable; they are always at least a little—and sometimes a lot—"off." Cavell's sentences, like Emerson's, say what he means, but they pointedly do *not* say what they may *seem* to mean if they are not read with the attention they call for.

17. Robin Wood, "Hitchcock and Fascism," in *The Hitchcock Annual Anthology: Selected Essays from Volumes 10–15*, ed. Sidney Gottlieb and Richard Allen (New York: Wallflower, 2009), 97–122.

18. Frank Meola, "Hitchcock's Emersonian Edges," in Gottlieb and Allen, *The Hitchcock Annual Anthology*, 113–31.

19. See William Rothman, "*Vertigo*: The Unknown Woman in Hitchcock," in *Images in Our Souls: Cavell, Psychoanalysis, and Cinema*, ed. Joseph H. Smith and William Kerrigan (Baltimore: Johns Hopkins University Press, 1987), 64–81.

1. The Wilde-er Side of Life

1. Marian Keane pointed out to me the significance of George Baker's teaching in this context.

2. James Harvey, *Romantic Comedy in Hollywood from Lubitsch to Sturges* (Cambridge, MA: Da Capo, 1998), 678.

2. Accomplices in Murder

1. Peter Brooks, *The Melodramatic Imagination: Balzac, Henry James, Melodrama, and the Mode of Excess* (New Haven, CT: Yale University Press, 1976).

2. Ibid., 37.

3. William Rothman, *Hitchcock: The Murderous Gaze*, 2nd ed. (Albany: State University of New York Press, 2012), 148.

4. Little Deaths

1. Stanley Cavell, *Cavell on Film*, ed. William Rothman (Albany: State University of New York Press, 2005), 96.

2. Ralph Waldo Emerson, "Behavior," in *Essays and Lectures*, ed. Joel Porte (New York: Literary Classics of the United States, 1983), 1037.

3. Cavell, *Cavell on Film*, 96.

4. Quotes: The Judy Holliday Resource Center, www.wtv-zone.com/lumina/judy/quotes.html.

5. Kathrina Glitre, *Hollywood Romantic Comedy: States of the Union, 1934–65* (Manchester: Manchester University Press, 2006).

5. "The Time to Make Up Your Mind About People Is Never"

1. This quote, from the 1941 *New York Herald Tribune* interview, can be found at www.labyrinth.net.au/~muffin/suspicion_c.html.

2. Ibid.

3. François Truffaut, with Helen G. Scott, *Hitchcock* (New York: Simon and Schuster, 1984), 142.

6. "But May I Trust You?"

1. See Robin Wood, "Hitchcock and Fascism," in *The Hitchcock Annual Anthology: Selected Essays from Volumes 10–15*, ed. Sidney Gottlieb and Richard Allen (New York: Wallflower, 2009), 97–122.

2. I am grateful to George Toles for reminding me of these complications in *Lifeboat* and for several other comments on a draft of this book that led me to improve it in ways both large and small.

7. Silence and Stasis

1. This discussion of the racetrack sequence of *Notorious* is indebted to, yet departs significantly from, my essay "Alfred Hitchcock's *Notorious*," *Georgia Review* (fall 1975): 884–929 That essay, in turn, was adapted from the third section of "Three Essays in Aesthetics," my doctoral dissertation, submitted to the Philosophy Department of Harvard University in 1973.

2. Ralph Waldo Emerson, "Behavior," in *Essays and Lectures*, ed. Joel Porte (New York: Literary Classics of the United States, 1983), 1042.

3. William Rothman, *The "I" of the Camera: Essays in Film Criticism, History, and Aesthetics*, 2nd ed. (New York: Cambridge University Press, 2004), xxii.

4. Ralph Waldo Emerson, "Intellect," in Porte, *Essays and Lectures*, 417.

11. Scottie's Dream, Judy's Plan, Madeleine's Revenge

1. See Stanley Cavell, *Contesting Tears: The Hollywood Melodrama of the Unknown Woman* (Chicago: University of Chicago Press, 1996); and William Rothman, "Vertigo: The Unknown Woman in Hitchcock," in *The "I" of the Camera: Essays in Film Criticism, History, and Aesthetics*, 2nd ed. (New York: Cambridge University Press, 2004), 221–40.

12. Never Again?

1. William Rothman, "*North by Northwest*: Hitchcock's Monument to the Hitchcock Film," in *The "I" of the Camera: Essays in Film Criticism, History, and Aesthetics*, 2nd ed. (New York: Cambridge University Press, 2004), 253.

2. William Rothman, *Hitchcock: The Murderous Gaze*, 2nd ed. (Albany: State University of New York Press, 2012), 201. .

13. A Loveless World

1. See William Rothman, *Hitchcock: The Murderous Gaze*, 2nd ed. (Albany: State University of New York Press, 2012), 255–347.

2. William Rothman, *The "I" of the Camera: Essays in Film Criticism, History, and Aesthetics*, 2nd ed. (New York: Cambridge University Press, 2004), 79.

14. Birds of a Feather

1. Charlotte Chandler, *It's Only a Movie: Alfred Hitchcock, a Personal Biography* (New York: Simon and Schuster, 2005), 272.

15. A Mother's Love

1. Stanley Cavell, "Concluding Remarks presented at Paris Colloquium on *La projection du monde* (1999)," in *Cavell on Film*, ed. William Rothman (Albany: State University of New York Press, 2005), 282.

2. See Stanley Cavell, "Finding as Founding: Taking Steps in Emerson's 'Experience,'" in *Emerson's Transcendental Etudes*, ed. David Justin Hodge (Stanford: Stanford University Press, 2003), 110–40.

3. Ralph Waldo Emerson, "Experience," in *Essays and Lectures*, ed. Joel Porte (New York: Literary Classics of the United States, 1983), 492.

4. Ibid., 471.

5. Ibid., 473. The word *lubricity*, I cannot resist pointing out, has two suggestively linked meanings, since *lubricious* means "smooth and slippery" and also means "lewd or lascivious in attitude or behavior." Surely, the choice of this word confirms that Emerson intends what Cavell refers to rather delicately as the "auto-erotic force" of connecting the hand and objects.

6. Cavell, "Finding as Founding," 117.

7. Ibid., 133.

8. See Robin Wood, *Hitchcock's Films Revisited* (New York: Columbia University Press, 2002), 183.

9. Ralph Waldo Emerson, *Poems and Essays* (Boston: Houghton Mifflin, 1897), 3.

10. Tony L. Moral, *Hitchcock and the Making of "Marnie"* (Lanham, MD: Scarecrow, 2002), 4.

11. Emerson, "Experience," 479.

12. See *"Marnie"* and "Your Friend, Mr. Hitchcock: *Marnie* Revisited," in Wood, *Hitchcock's Films Revisited*, 173–97 and 388–405.

13. See Donald Spoto, *The Dark Side of Genius: The Life of Alfred Hitchcock* (New York: Ballantine, 1984), 504.

14. *The Girl* (2012), the BBC/HBO film that purports to tell the story of Hitchcock's relationship with Tippi Hedren, grossly embellishes Spoto's assertion that the director made an unwanted sexual advance on his star. *The Girl* portrays Hitchcock as a sadistic and distinctly creepy sexual predator, but not a single moment of the film rings true. Two facts make it clear that some healthy skepticism is in order in assessing Spoto's claim and the assertions by Hedren on which it is based. First, no other actress has ever reported having had a remotely comparable experience working with Hitchcock. Second, the other damning accusation Hedren has repeatedly leveled against Hitchcock—that after she rejected him sexually, he spitefully refused to release her from her exclusive contract with him and deliberately ruined her career—is not corroborated by actual events. In *Hitchcock's Hollywood Hell: The Making of "Rebecca" and Other Hollywood Stories* (U.K.: Baroliant Press [Kindle ed.], 2013), Brian Hannan argues convincingly that this charge has no factual basis. Shortly after *Marnie*, Hitchcock sold Hedren's contract to Universal. The studio arranged for her to have a substantial role in Chaplin's *A Countess from Hong Kong*. After that, her services were not in great demand, and Universal terminated her contract. None of this was Hitchcock's doing. That the facts contradict Hedren's story doesn't prove that she is intentionally lying when she tells it; time plays tricks on our memories, especially when our egos are involved, as hers obviously is. Nor does it prove, of course, that she isn't telling the truth when she accuses Hitchcock of treating her abusively. But if we're not in a position to judge Tippi Hedren to be a liar, we are certainly not in a position to judge Hitchcock to be a sadistic sexual predator.

15. Moral, *Hitchcock and the Making of "Marnie,"* 129.

16. See Wood, "Your Friend, Mr. Hitchcock," 394.

17. Ibid., 388.

18. See Sidney Gottlieb and Christopher Brookhouse, *Framing Hitchcock: Selected Essays from the Hitchcock Annual* (Detroit: Wayne State University Press, 2002), 217.

19. Quoted in Moral, *Hitchcock and the Making of "Marnie,"* 114.

20. Ibid., 119.

16. Every Story Has an Ending

1. I am indebted to Murray Pomerance for this piece of information. I had always been curious about why Burks, whose loyalty to Hitchcock was legendary, was not used for *Torn Curtain*. Of course, there may have been more to it than Boyle suggested. If so, we will probably never know.

2. Charlotte Chandler, *It's Only a Movie: Alfred Hitchcock, a Personal Biography* (New York: Simon and Schuster, 2005), 284.

3. See Patrick McGilligan, *Alfred Hitchcock: A Life in Darkness and Light* (New York: Regan Books, 2003), 677.

4. William Rothman, *Hitchcock: The Murderous Gaze*, 2nd ed. (Albany: State University of New York Press, 2012), 354.

5. See David Freeman, *The Last Days of Alfred Hitchcock: A Memoir Featuring the Screenplay of "Alfred Hitchcock's The Short Night"* (Woodstock, NY: Overlook, 1984).

6. Ibid., 89.

Conclusion

1. Ralph Waldo Emerson, "Self-Reliance," in *Essays and Lectures*, ed. Joel Porte (New York: Literary Classics of the United States, 1983), 269. All subsequent citations of Emerson's works come from Porte's compilation and are referenced parenthetically in the text.

2. Stanley Cavell, *Disowning Knowledge: In Seven Plays of Shakespeare* (Cambridge UK: Cambridge University Press, 1987), 4–5.

3. Stanley Cavell, *Emerson's Transcendental Etudes*, ed. David J. Hodge (Stanford: Stanford University Press, 2003), 125.

4. Stanley Cavell, "What Photography Calls Thinking," in *Cavell on Film*, ed. William Rothman (Albany: State University of New York Press, 2005), 116.

5. Stanley Cavell, *The World Viewed: Reflections on the Ontology of Film* (Cambridge, MA: Harvard University Press, 1976), 22.

6. Cavell, *Emerson's Transcendental Etudes*, 133.

7. Ludwig Wittgenstein, *Philosophical Investigations* (Hoboken, NJ: John Wiley and Sons, 2009), 110.

8. Cavell, *Emerson's Transcendental Etudes*, 135.

9. In the years since the publication of her early essay, Mulvey herself has thoughtfully revised its position in "Afterthoughts on Visual Pleasure and Narrative Cinema." See Laura Mulvey, *Visual and Other Pleasures* (New York: Palgrave Macmillan, 1989), 31–40. Although Mulvey's later writings have made substantial contributions to the field, they have not had anything like the impact of the original 1975 essay. Nor have they succeeded in mitigating its destructive effects.

10. Laura Mulvey, "Visual Pleasure and Narrative Cinema," in *Film Theory and Criticism: Introductory Readings*, ed. Leo Braudy and Marshall Cohen, 5th ed. (New York: Oxford University Press, 1999), 833–44.

11. Stanley Cavell, *Contesting Tears: The Hollywood Melodrama of the Unknown Woman* (Chicago: University of Chicago Press, 1996), 209. Cavell goes on to mount a

devastating critique of Mulvey's claim that the psychoanalytic theory of the fetish provides a key to understanding the power of the film image. He writes:

> Film assaults human perception at a more primitive level than the work of fetishizing suggests; that film's enforcement of passiveness, or, say, victimization, together with its animation of the world, entertains a region not of invitation or fascination primarily to the masculine nor even, perhaps yet closer, to the feminine, but primarily to the infantile, before the establishment of human gender, that is, before the choices of identification and objectification of female and male . . . have settled themselves, to the extent that they will be settled. And if it turns out that the theory of fetishism does not account for the experience of film, and if the theory thereby serves to disavow something about film, then it will follow, according to that theory, that the theory has been fetishized. (ibid.)

12. Cavell, *The World Viewed*, xix.

Acknowledgments

Chapter 7 incorporates material from my essay "Silence and Stasis" in *The Language and Style of Film Criticism*, ed. Alex Clayton and Andrew Klevan (London: Routledge, 2011). An earlier version of the reading of *Vertigo* in Chapter 11 appears in *Vertigo (Philosophers on Film)*, ed. Katalan Makkai (London: Routledge, 2012). Chapter 15 incorporates material from my reading of *Marnie* in *Hitchcock: The Murderous Gaze*, 2nd ed. (Albany: State University of New York Press, 2012). Portions of Chapter 16 are adapted from "The Universal Hitchcock," in *A Companion to Alfred Hitchcock*, ed. Thomas Leitch and Leland Poague (New York: Wiley Blackwell, 2011).

Marian Keane read drafts of the manuscript with extraordinary care and, with her customary perceptiveness, intellectual honesty, and persuasiveness, pulled no punches in making me recognize, among other things, that a book subtitled "Emersonian Perfectionism and the Films of Alfred Hitchcock" had to say more about Emerson than I had said in early drafts. Marian's comments on the manuscript, not to mention our many, many years of inimitable conversations, have led this to be a far better book. Conversations with James Laff helped me enormously in achieving the perspective on Emerson's work articulated especially in the introduction and the conclusion.

I am grateful to John Paul Russo, George Toles, and Charles Warren for their supportive and insightful comments on drafts of this manuscript, and to Murray Pomerance, both for our always provocative conversations about Hitchcock and for the inspiration I've drawn from his writings.

More than a word of thanks is also in order to the brilliant and dedicated master's and graduate students Eric Browning, Michael Hable, Oscar Jubis, Ian Pettigrew, Funing Tang, and Ricardo Zuleta, who helped make my teaching a joy for me during the time I was writing this book, and to my colleagues in the University of Miami Department of Cinema and Interactive Media.

My debt to Stanley Cavell, my teacher and friend, is immeasurable.

Kitty, the love of my life, is my greatest blessing.

Index

FILM AND CULTURE
A series of Columbia University Press
Edited by John Belton